LADY GAGA

TERRY RICHARDSON

LADY GAGA

TERRY RICHARDSON

GRAND
CENTRAL
PUBLISHING

NEW YORK BOSTON

Grand Central Publishing
Hachette Book Group
237 Park Avenue
New York, NY 10017

www.HachetteBookGroup.com

Printed in the United States of America

First Edition: November 2011
10 9 8 7 6 5 4 3 2 1

WOR

Grand Central Publishing is a division of Hachette Book Group, Inc.
The Grand Central Publishing name and logo is a trademark of Hachette Book Group, Inc.

Library of Congress Control Number: 2011936450

DEDICATED TO LITTLE MONSTERS

TERRY AND ME

Sometimes it seems as though I've waited my entire life to be photographed by Terry Richardson. With Terry, the relationship extends beyond the photograph, and if you're really lucky he will teach you something truly profound about yourself. I have discovered through him that "shame" is an obsolete notion and "apology" is an injustice to any performance. Perhaps it is his kind eyes behind those famous glasses, or the giggling noise he makes at 4:30 in the morning when he's caught me in bed. *Click, giggle, click, click, click*, "beautiful." To say he is a free spirit is a tremendous understatement, and to say that he (or I) make people uncomfortable, is spot on. We share these things in common. However, it is unique to Terry and his subjects that there are *no* limitations. At all. His heart is too wide. He makes me want to widen my own.

Terry finds beauty in the most intricate and unassuming of places. His photography beckons the question over and over again: Should there ever be limitations in art? Because when he captures me in a moment of such tandem artistic and human purity, I am convinced the answer is that we must push the boundaries of culture through love and acceptance. There is no moment too strange, no angle unflattering, no circumstance relying on blind artifice, and never a time that I feel embarrassed or unsafe. Awakened in me is a perverse liberation, inspiring me to feel that it is okay to view yourself as hyper-human. This is how Terry views me.

I am so *real*, he says, that I am *unreal*.

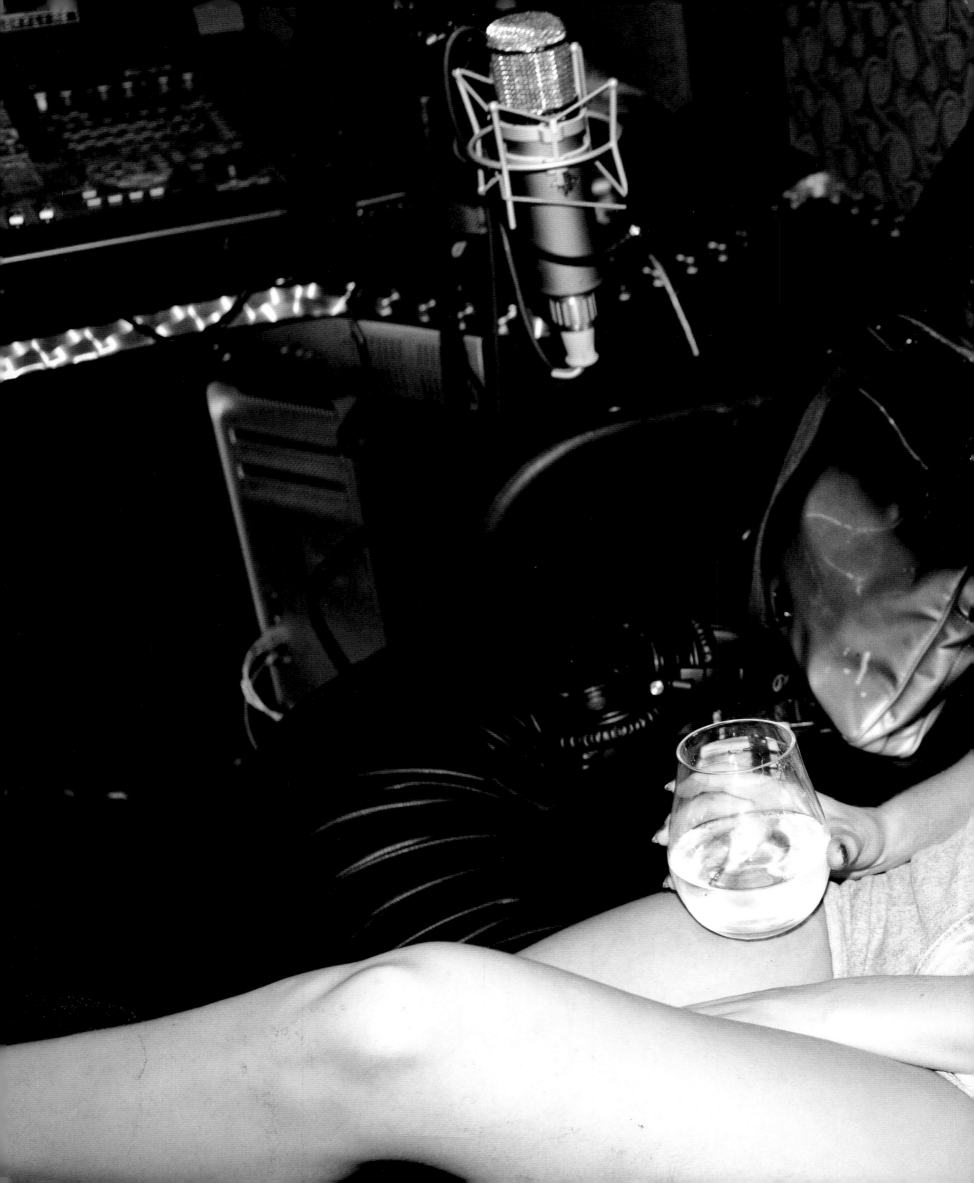

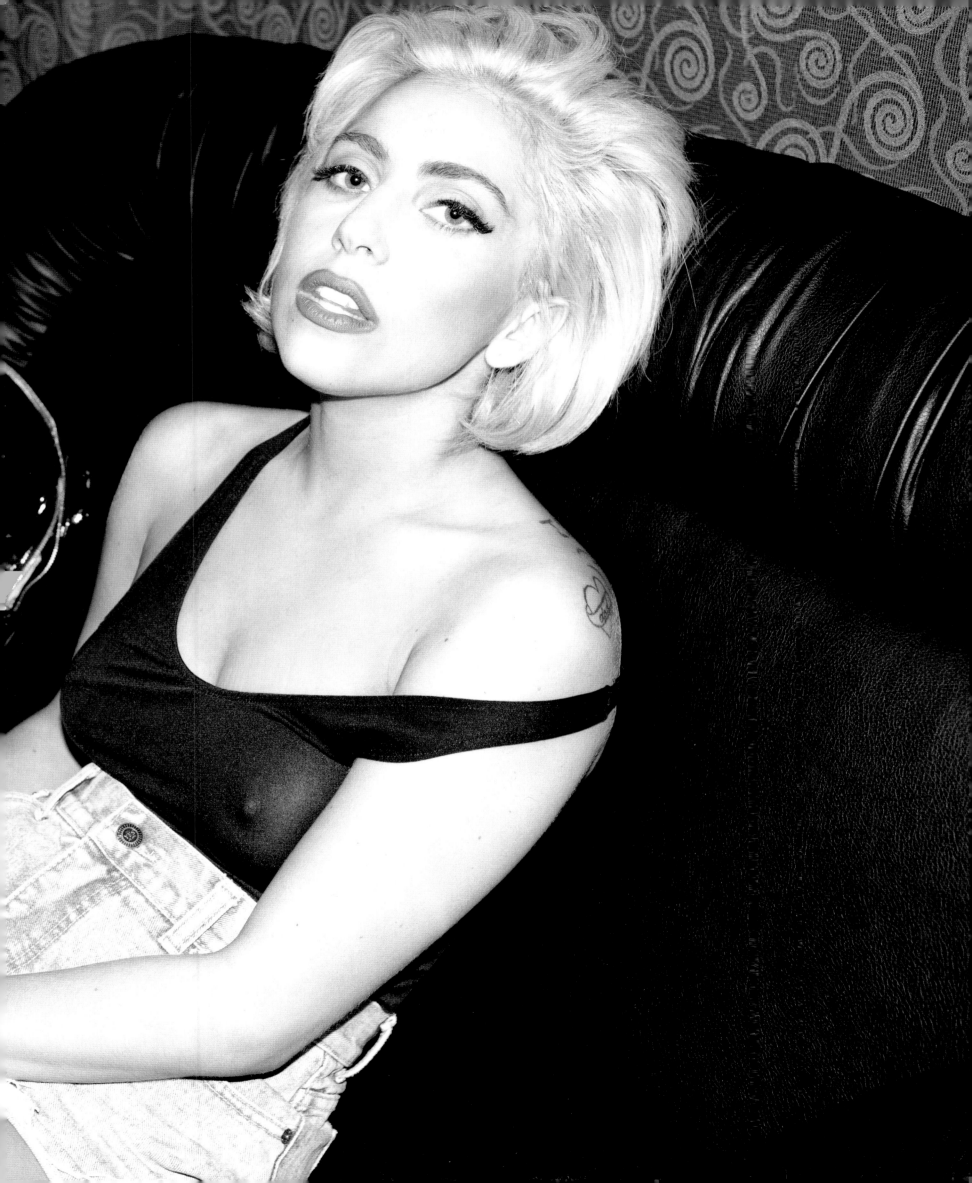

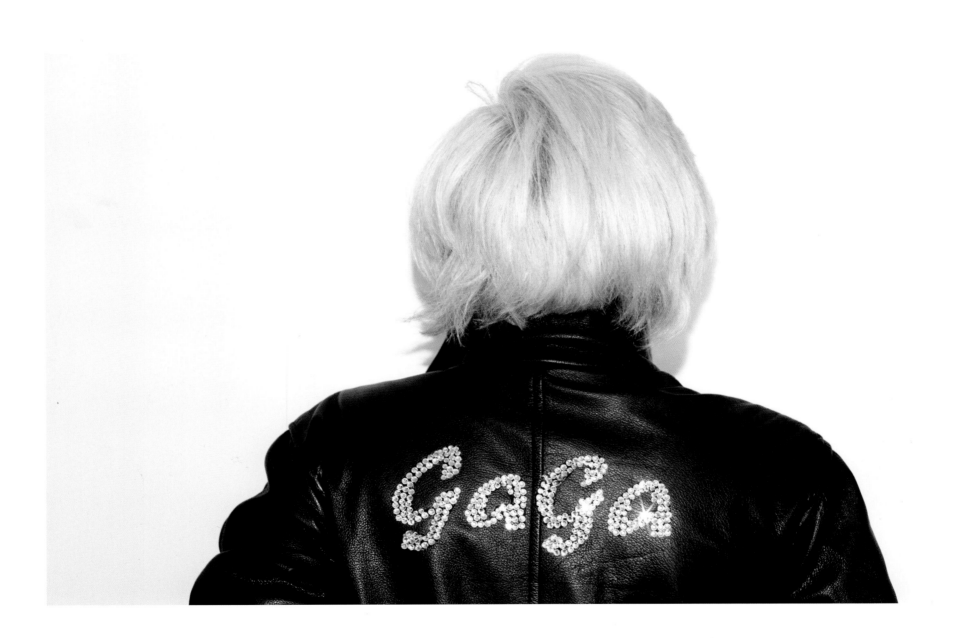

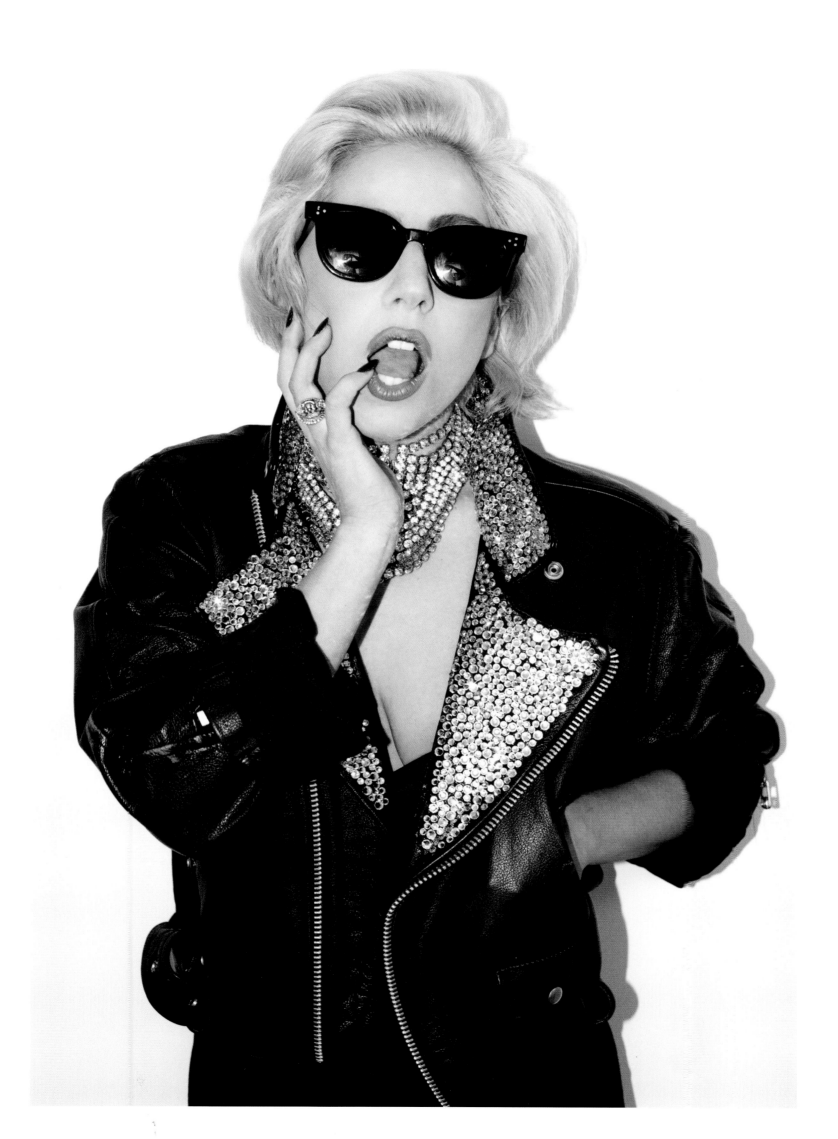

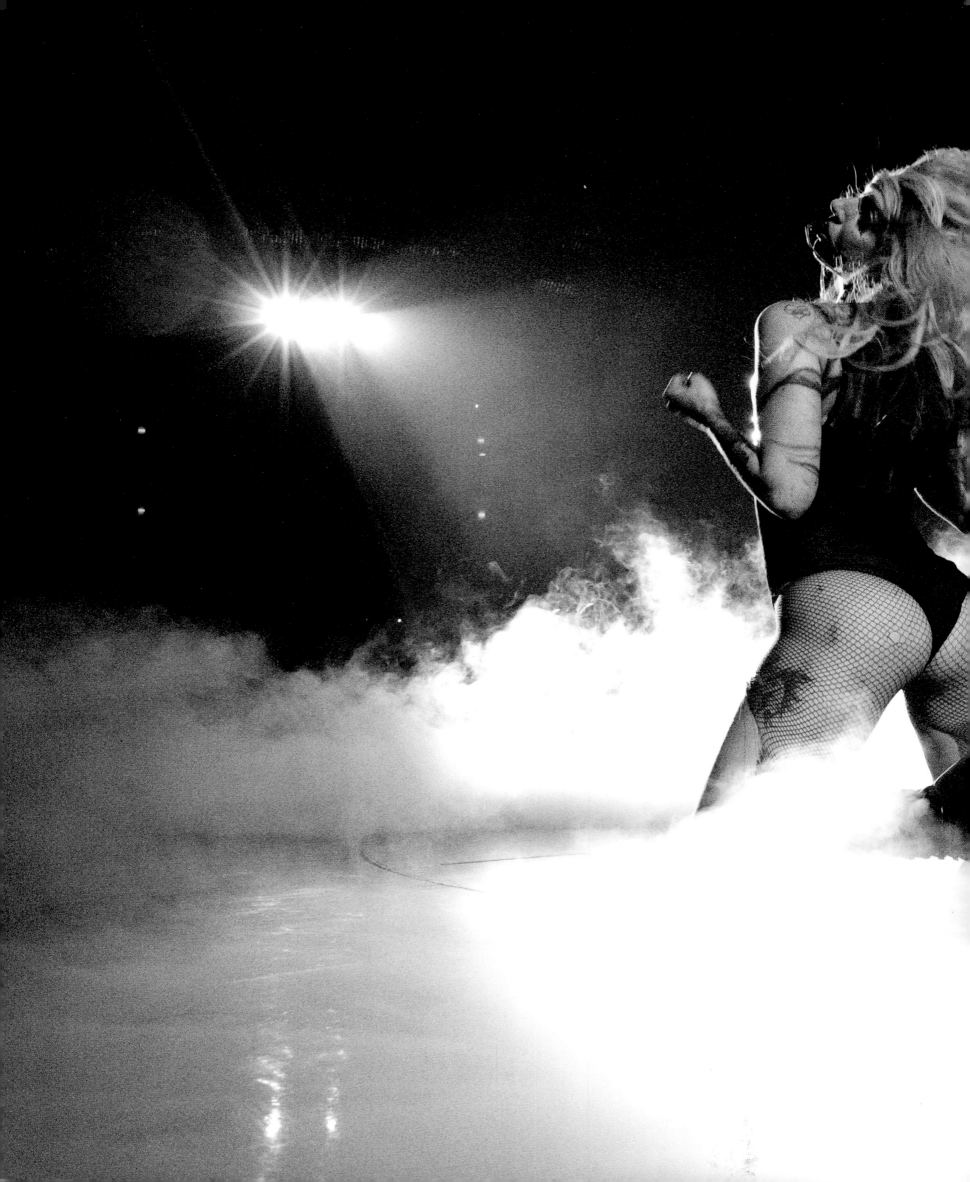

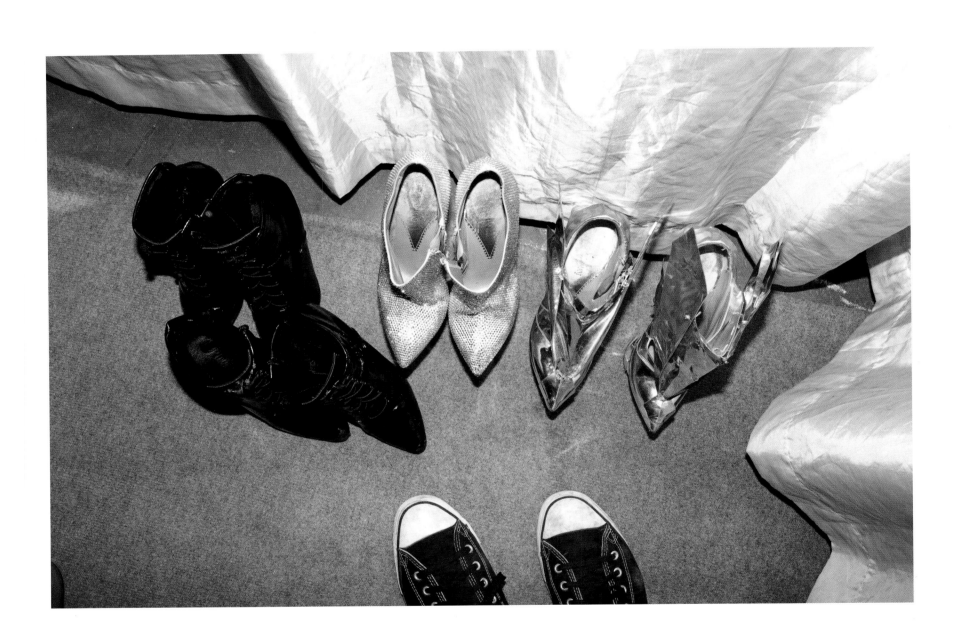

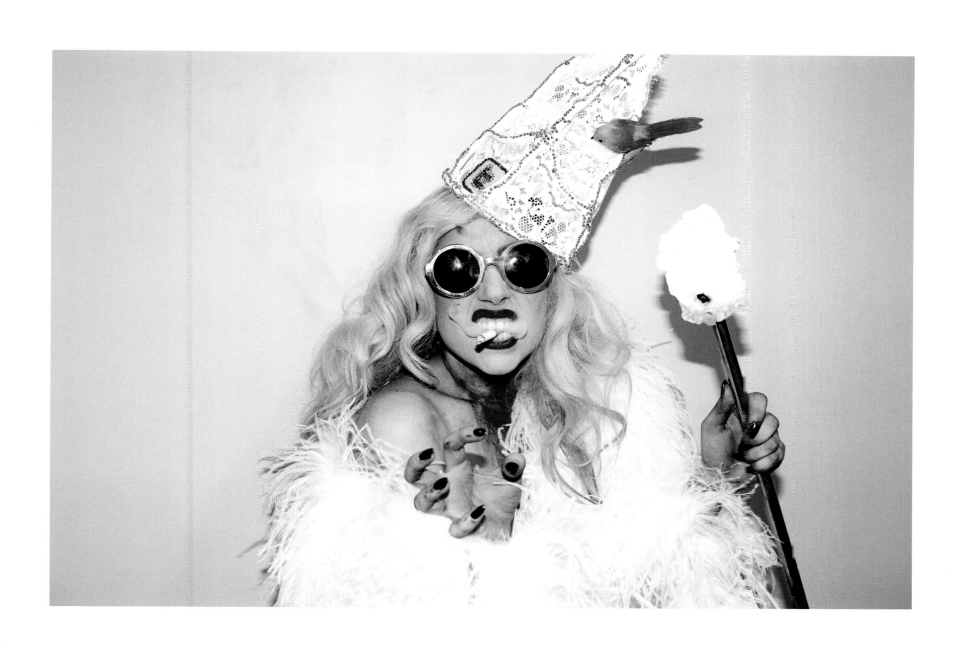

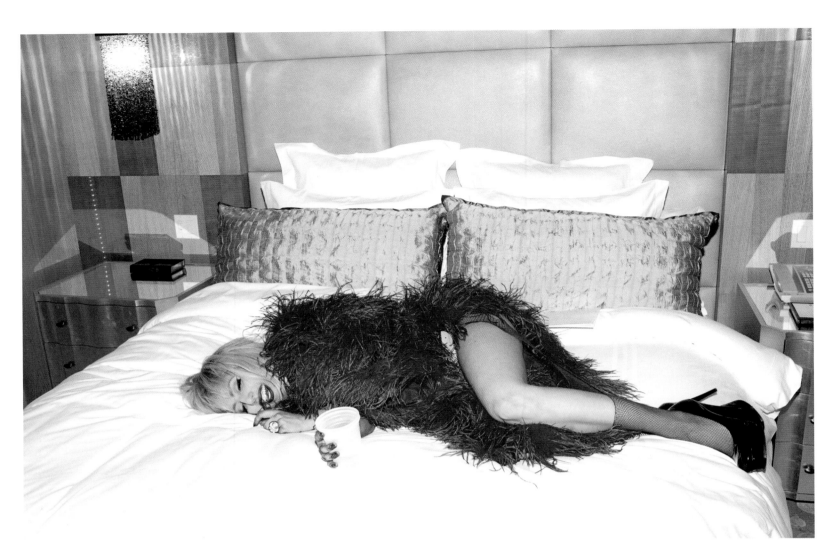

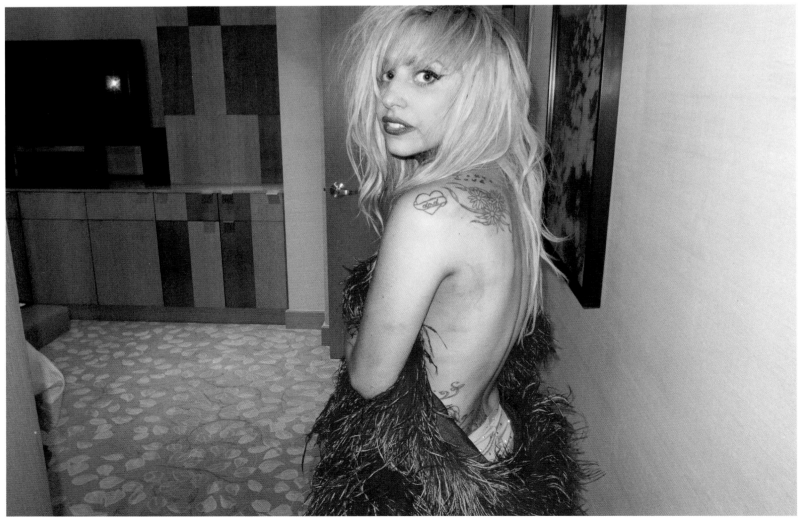

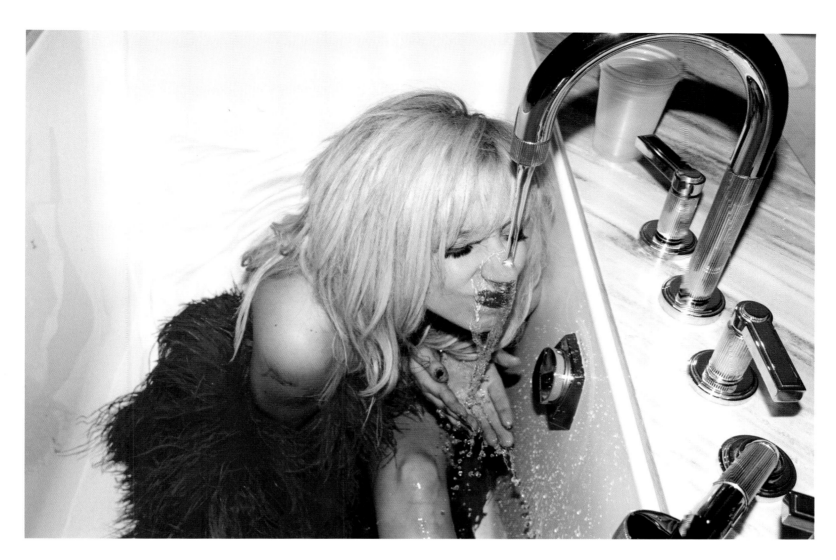
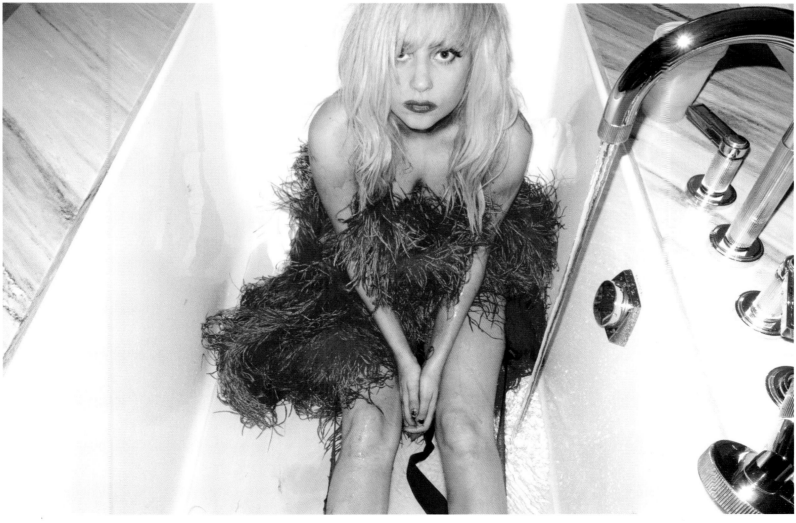

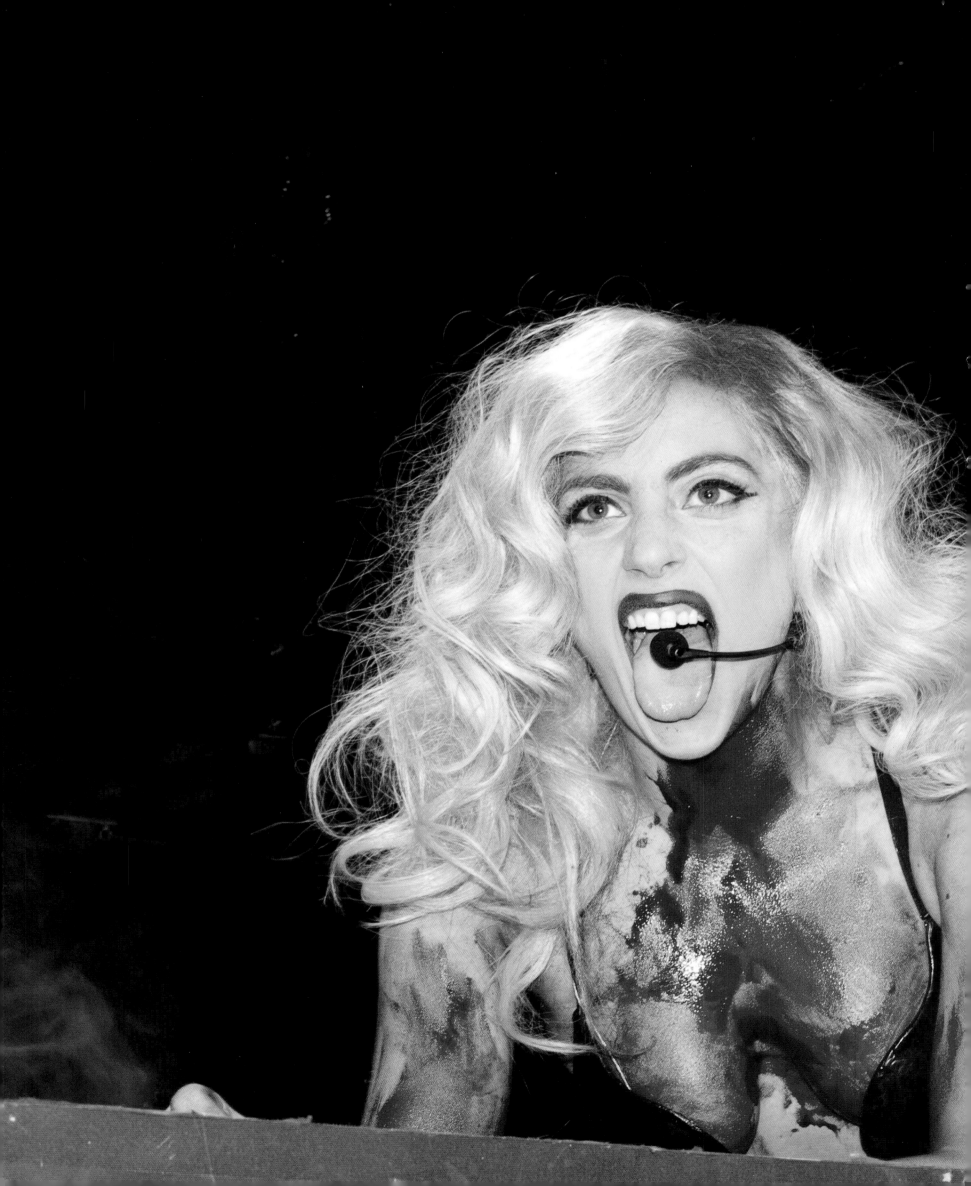

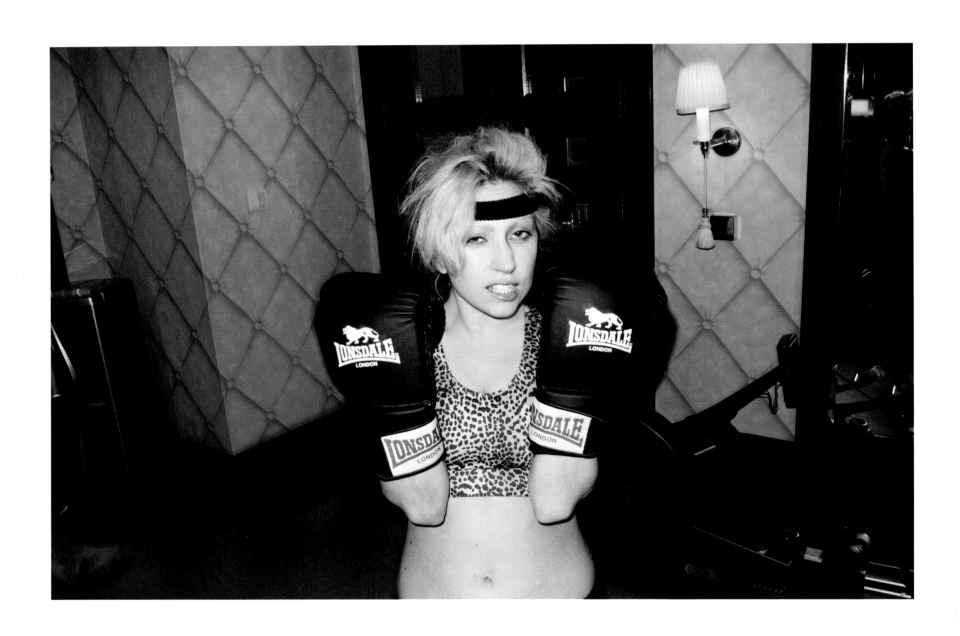

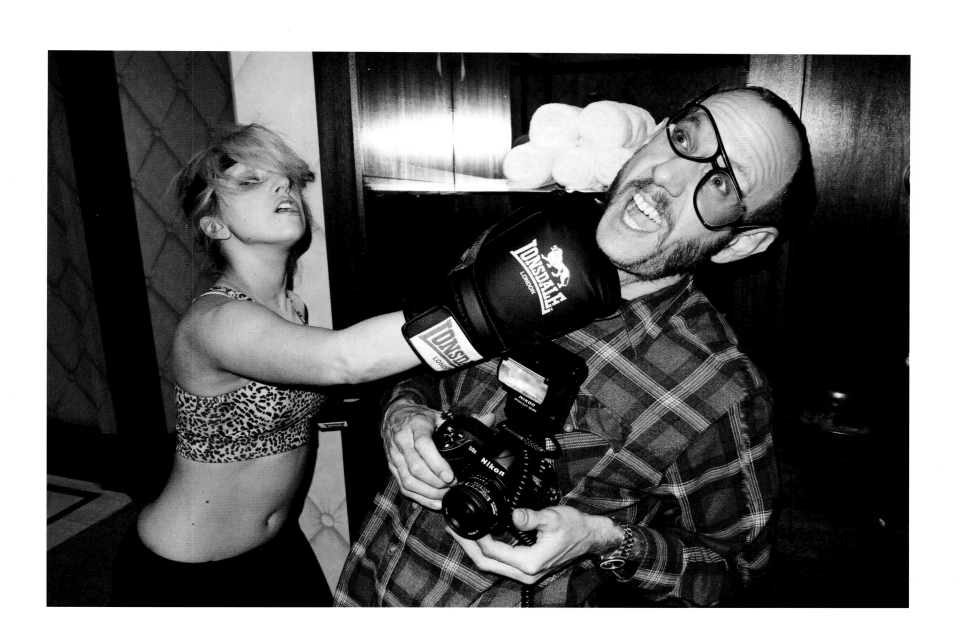

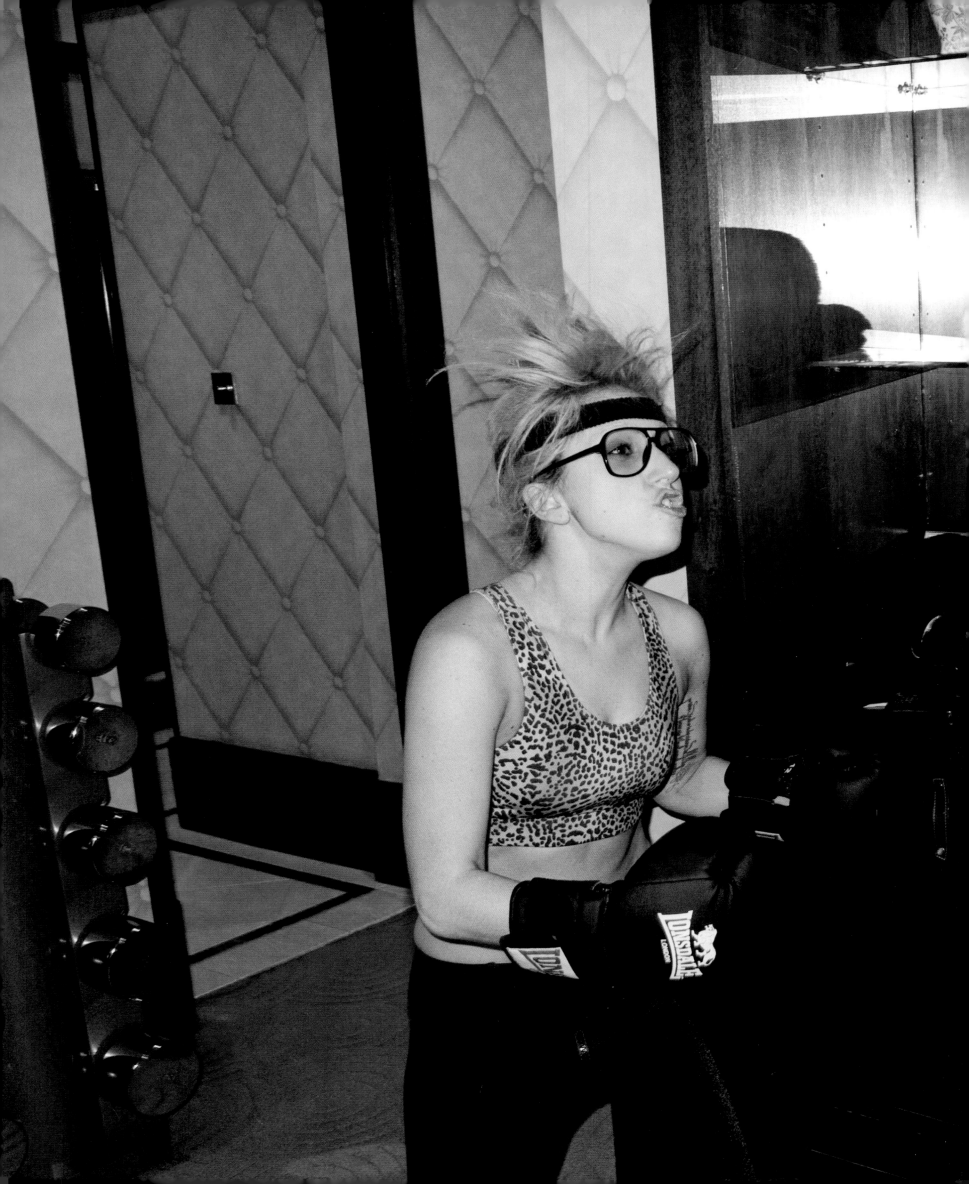

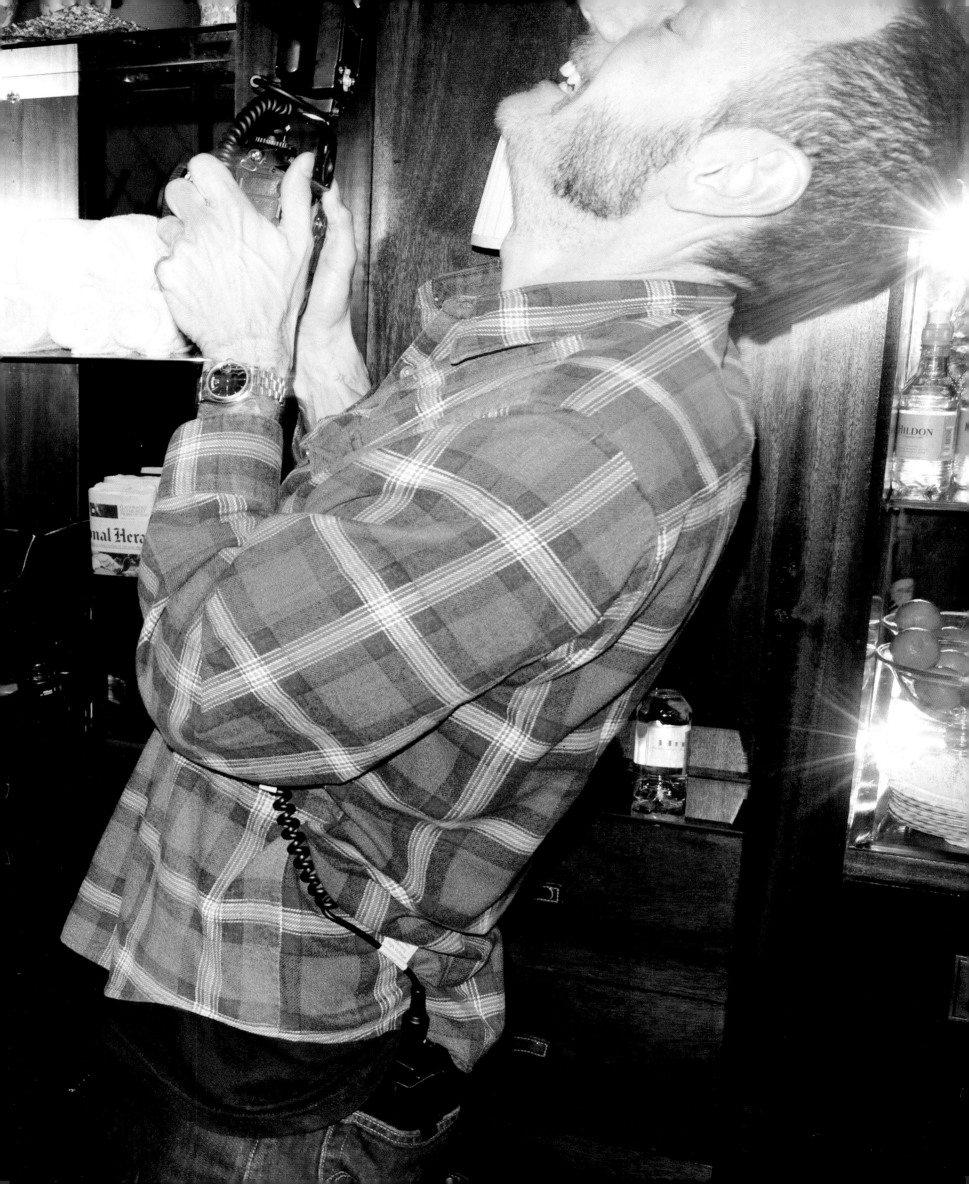

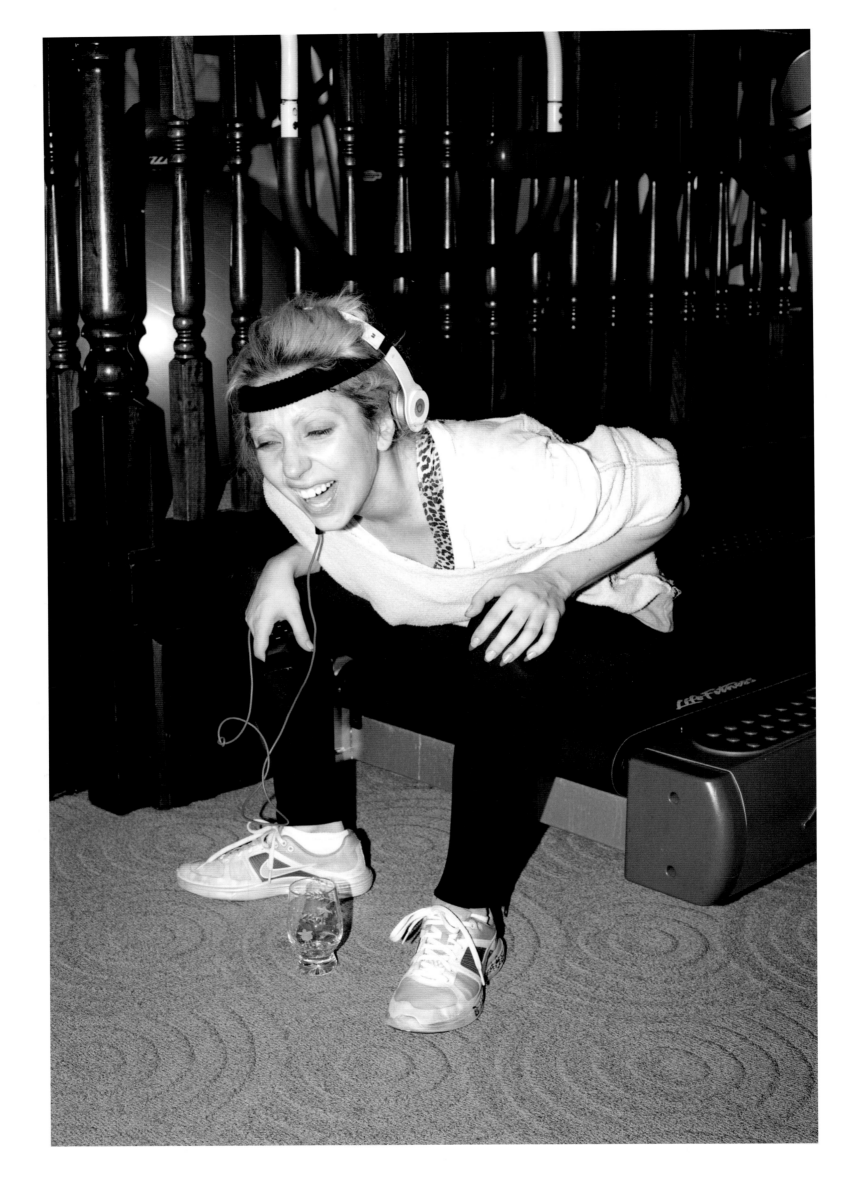

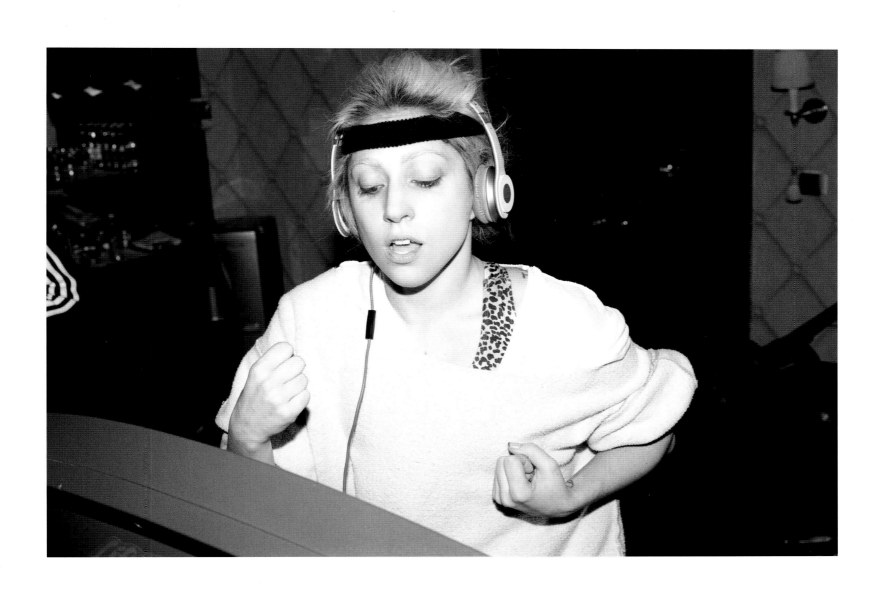

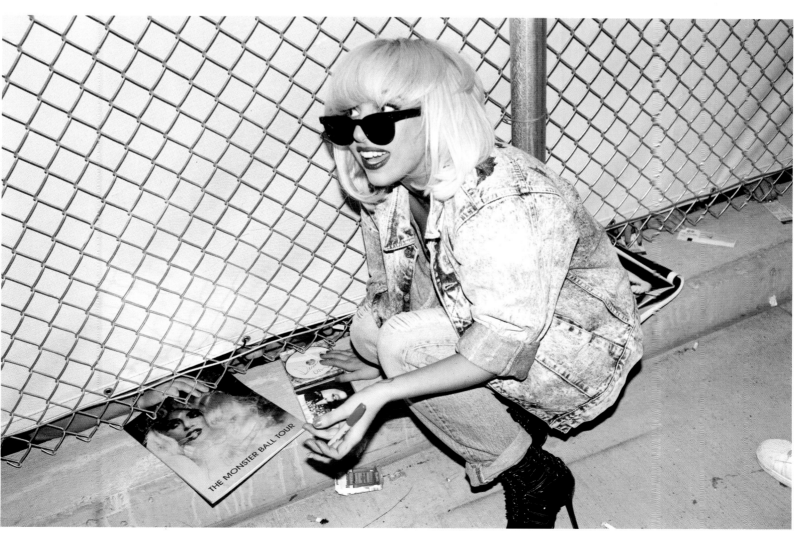

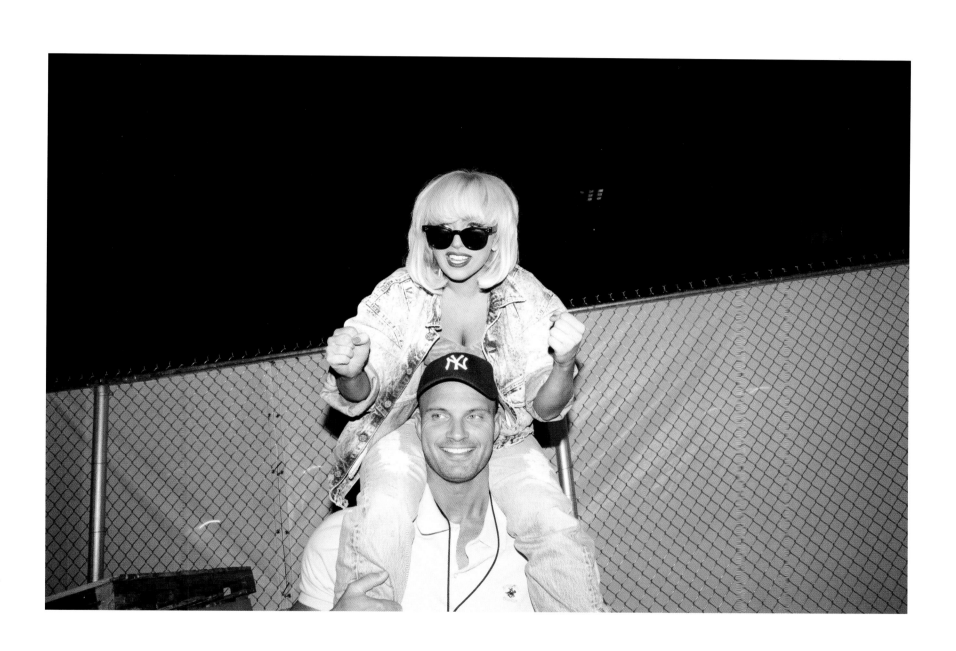

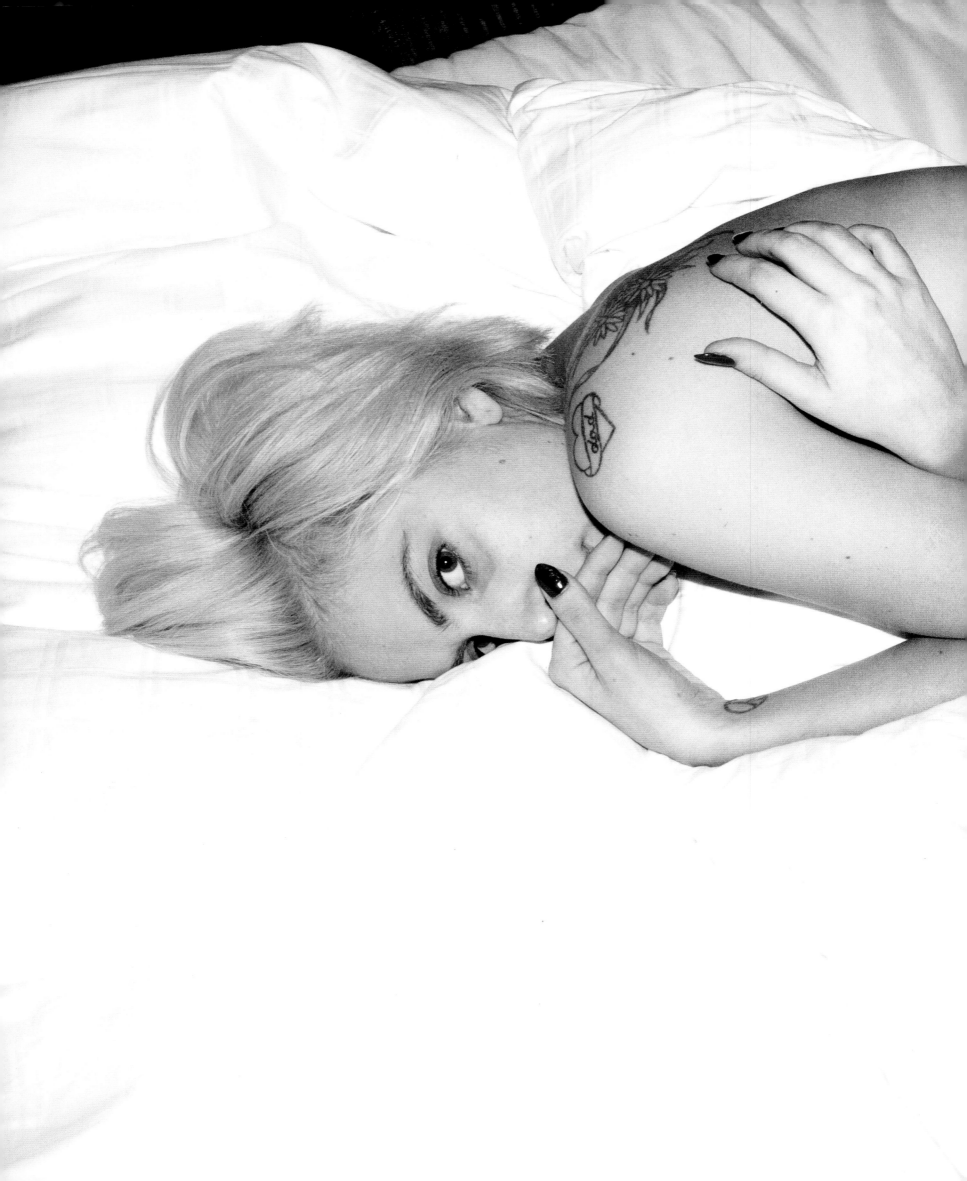

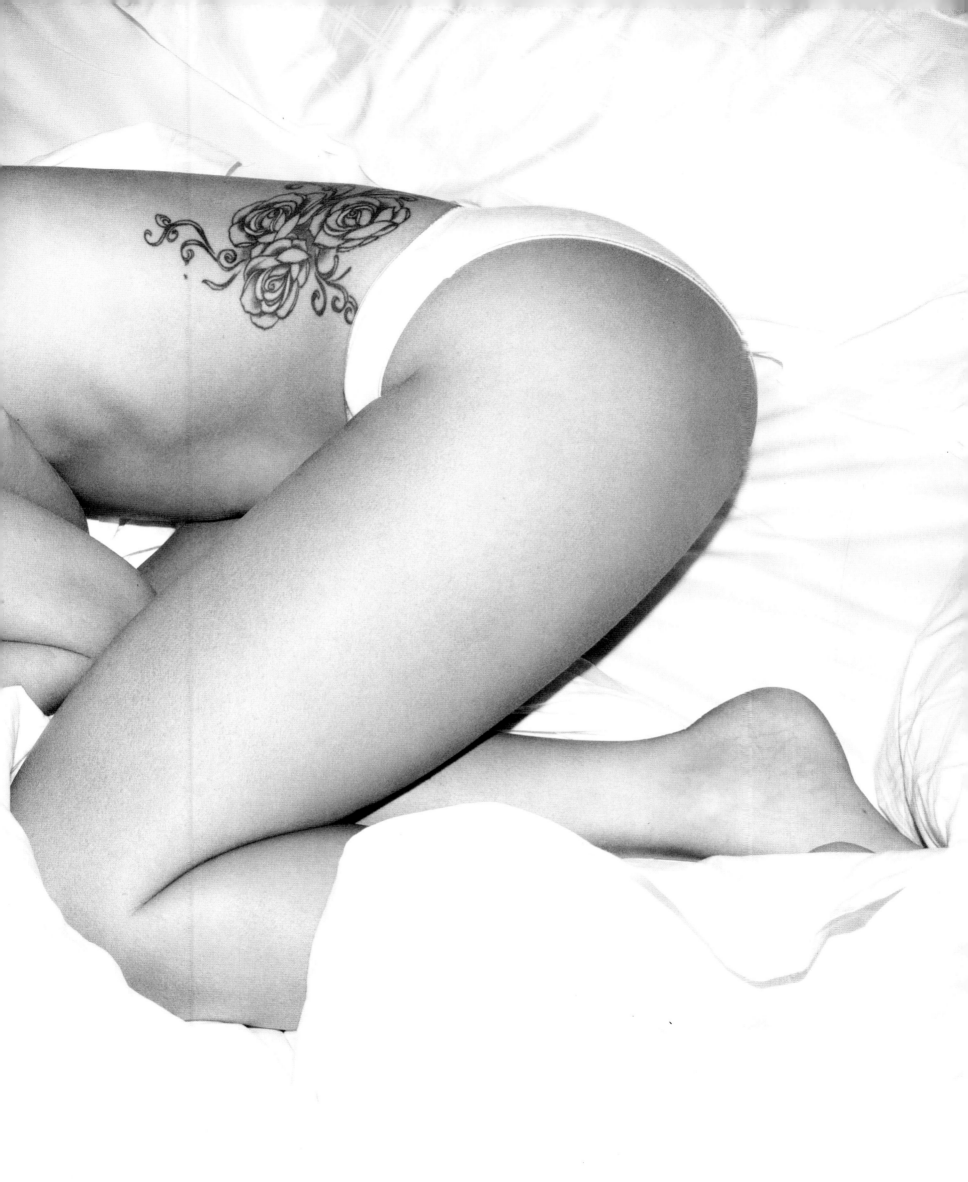

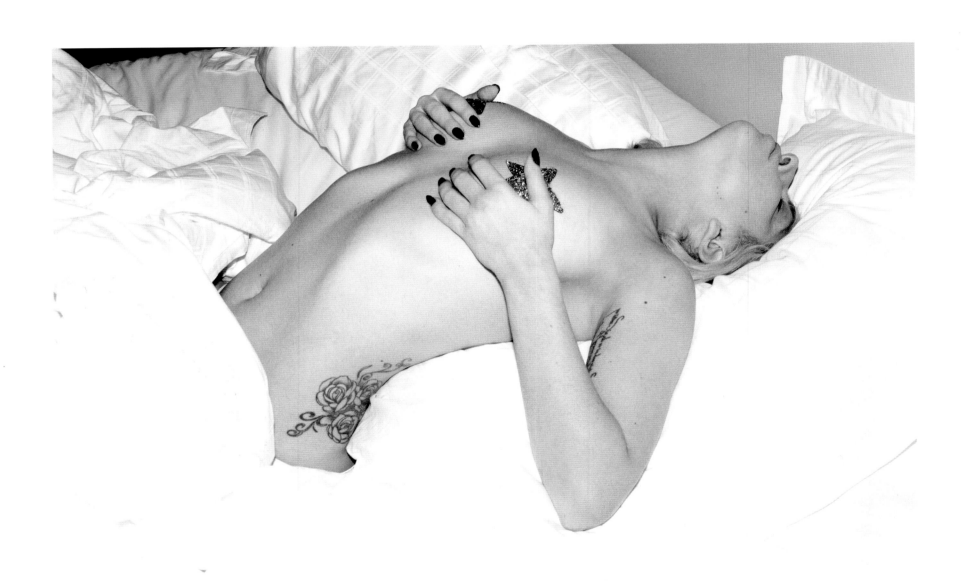

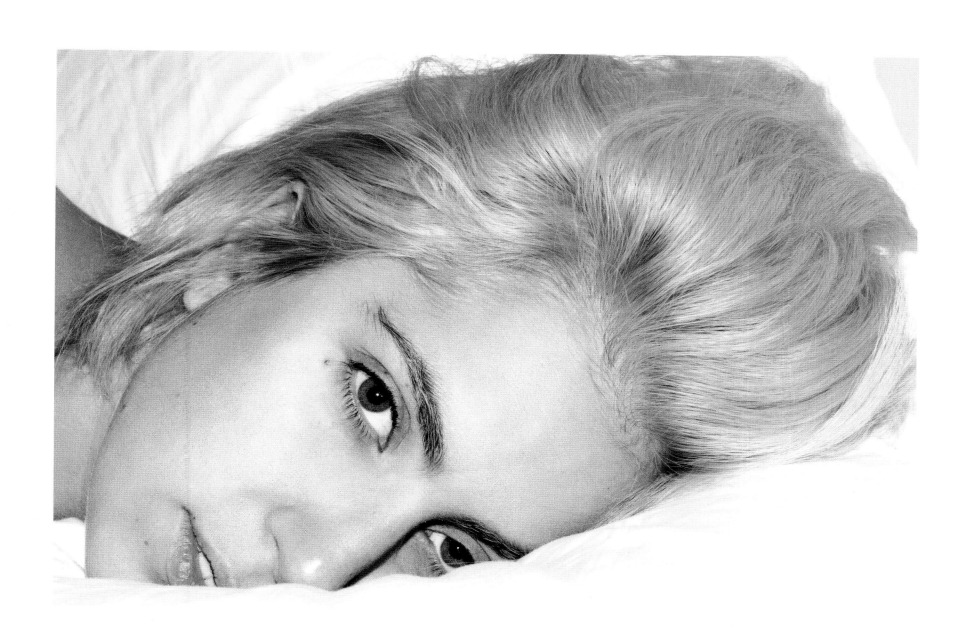

 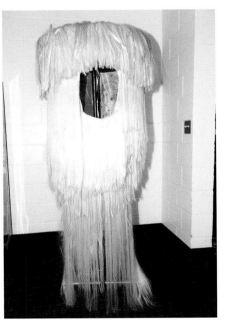

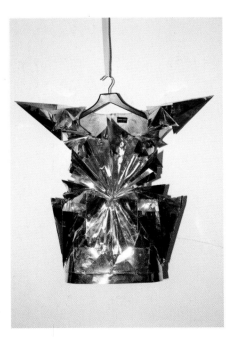 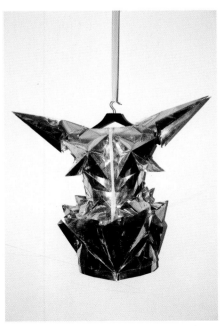 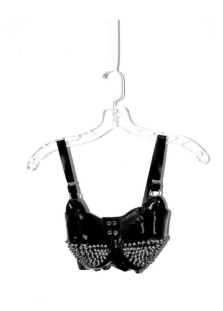

 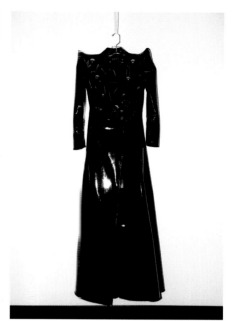

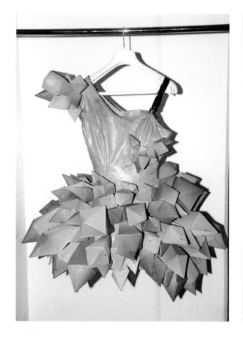 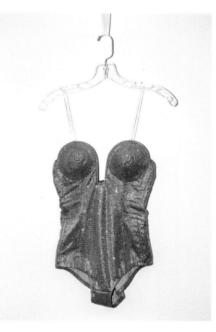 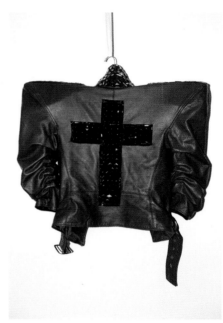

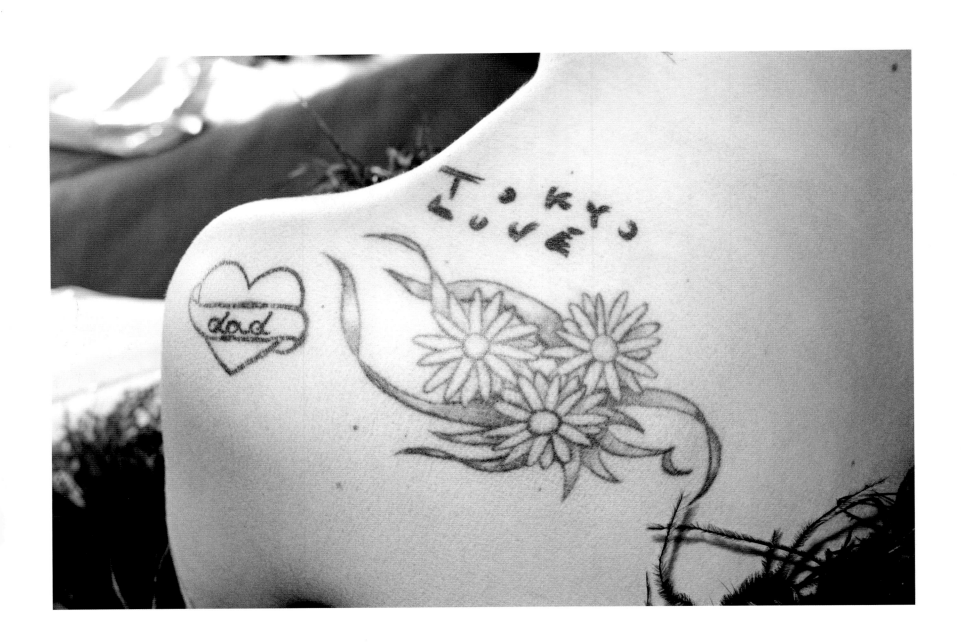

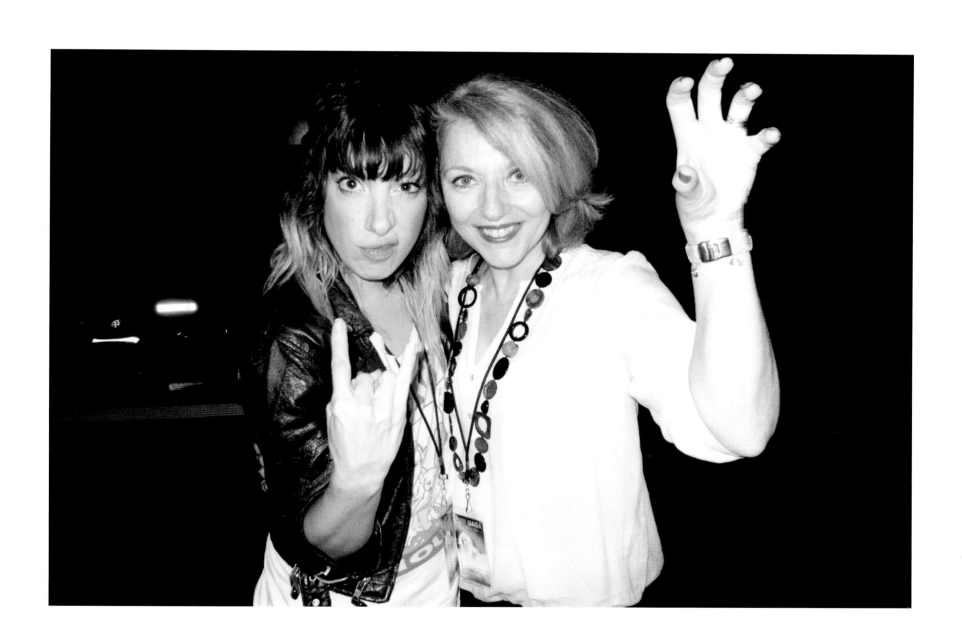

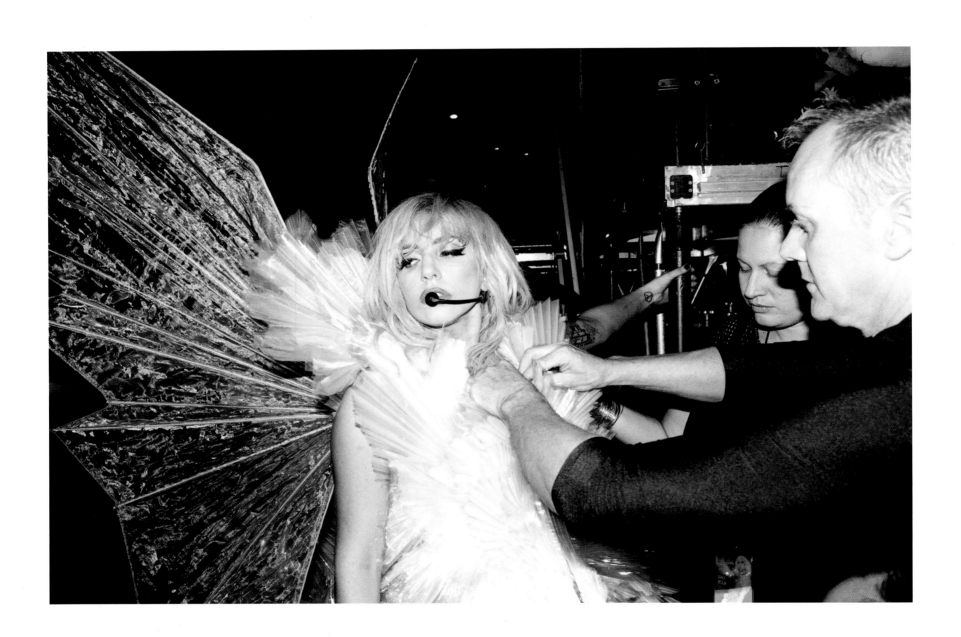

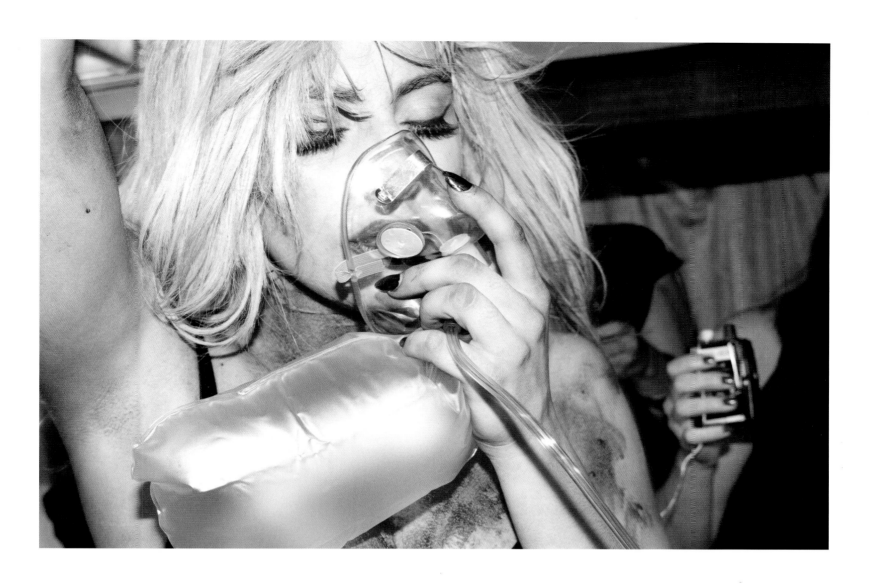

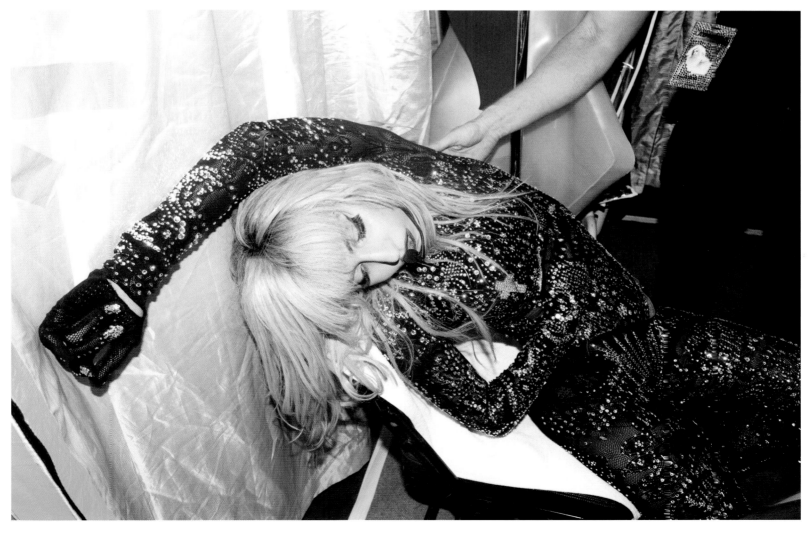

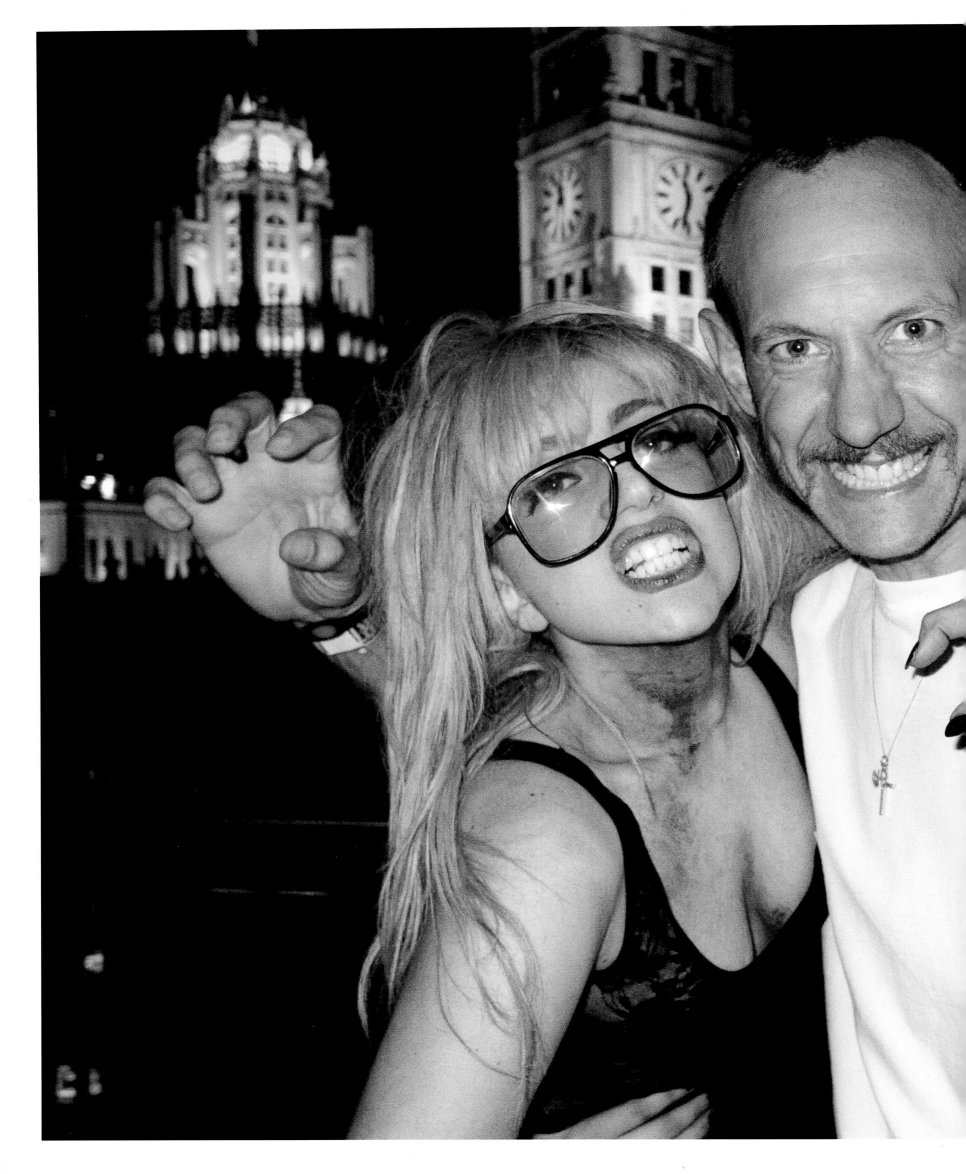

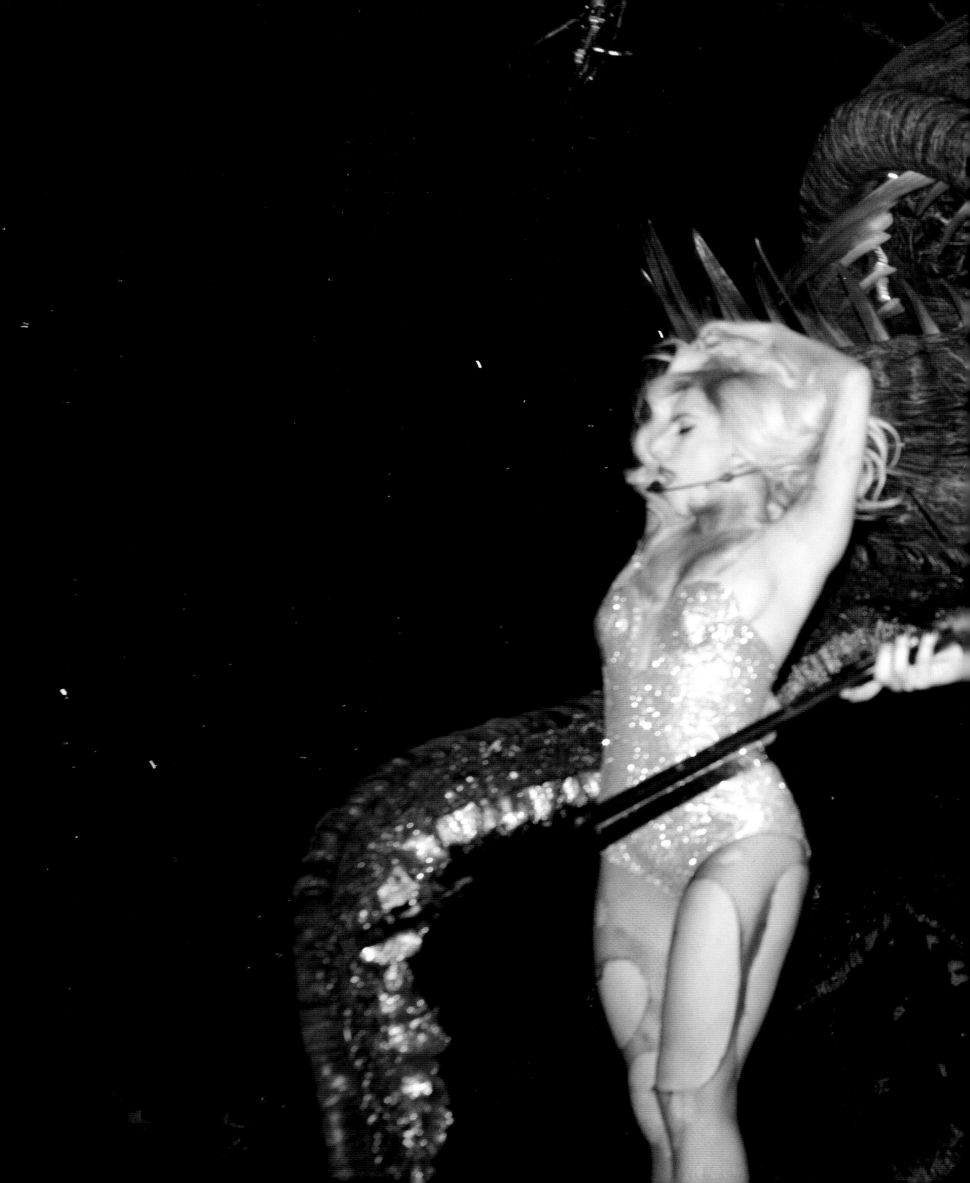

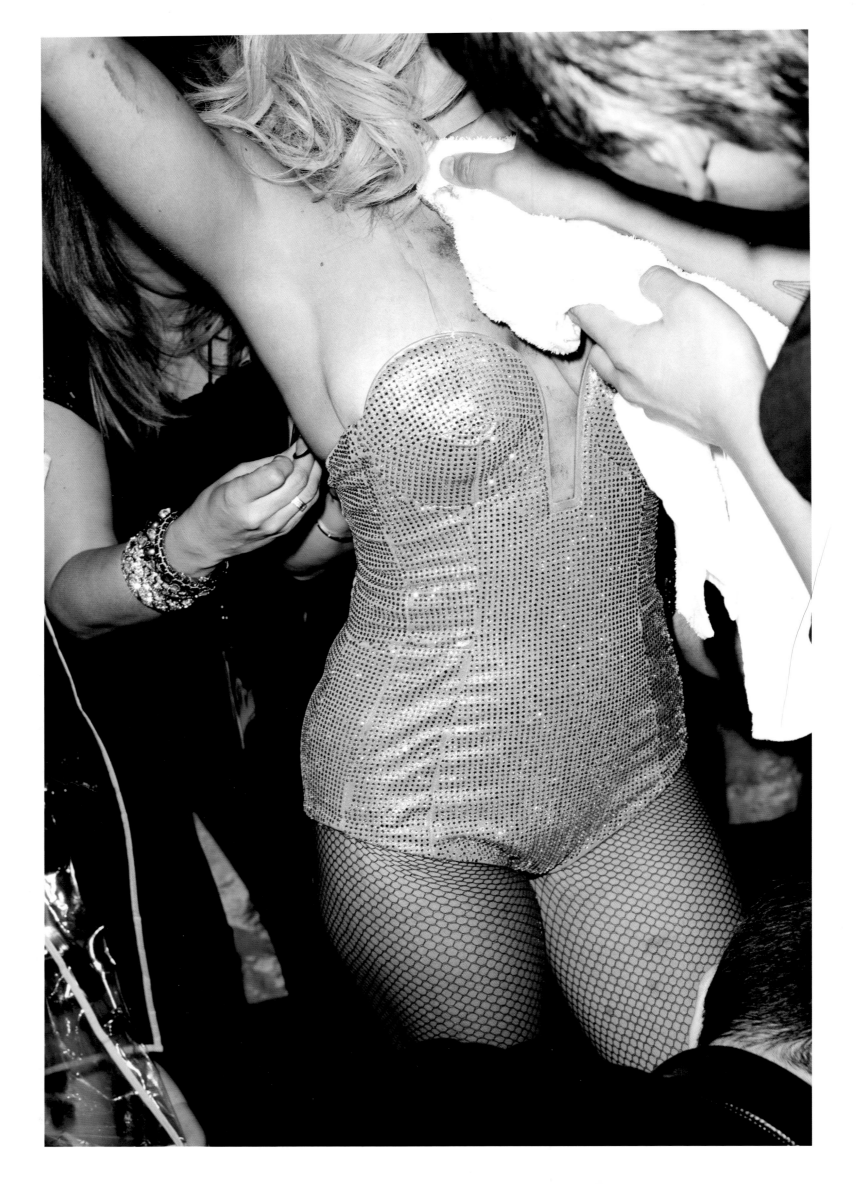

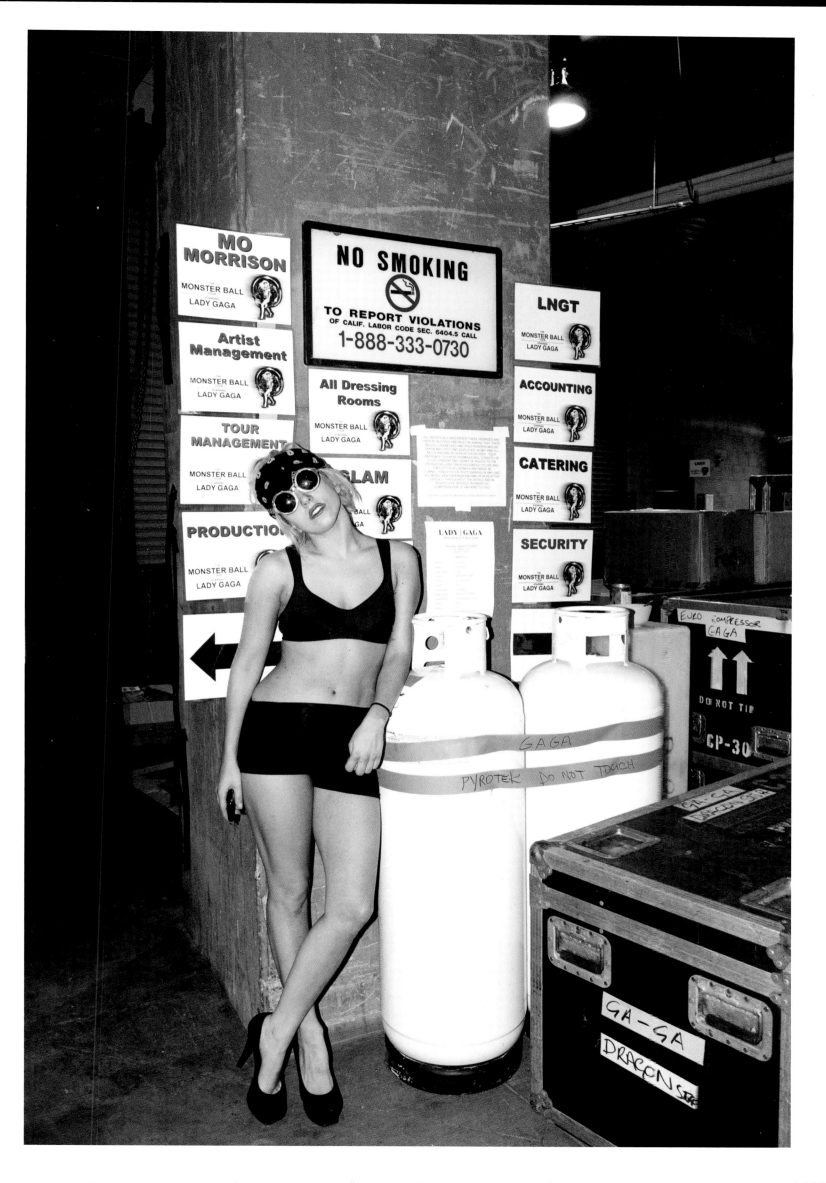

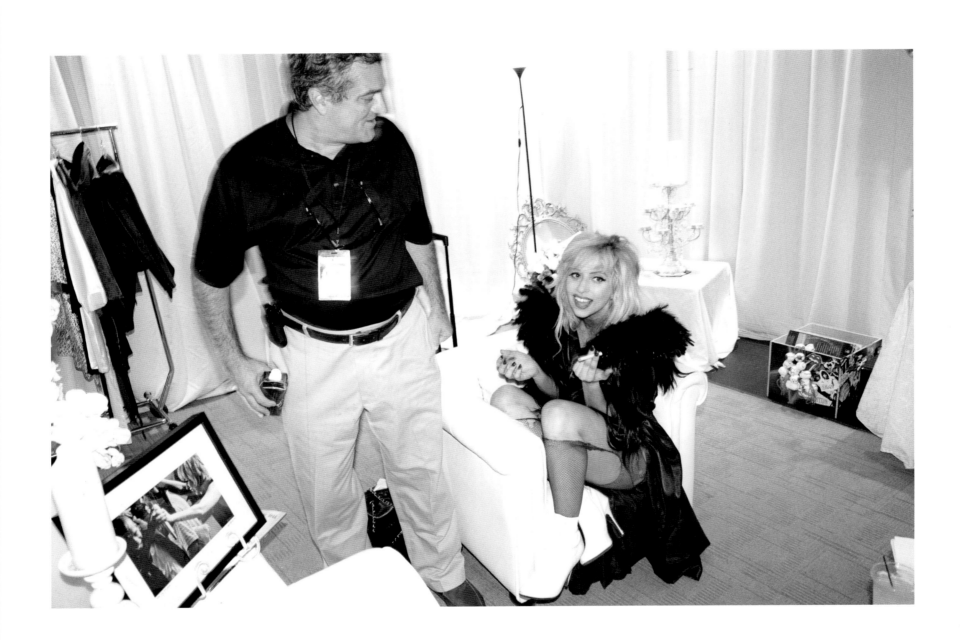

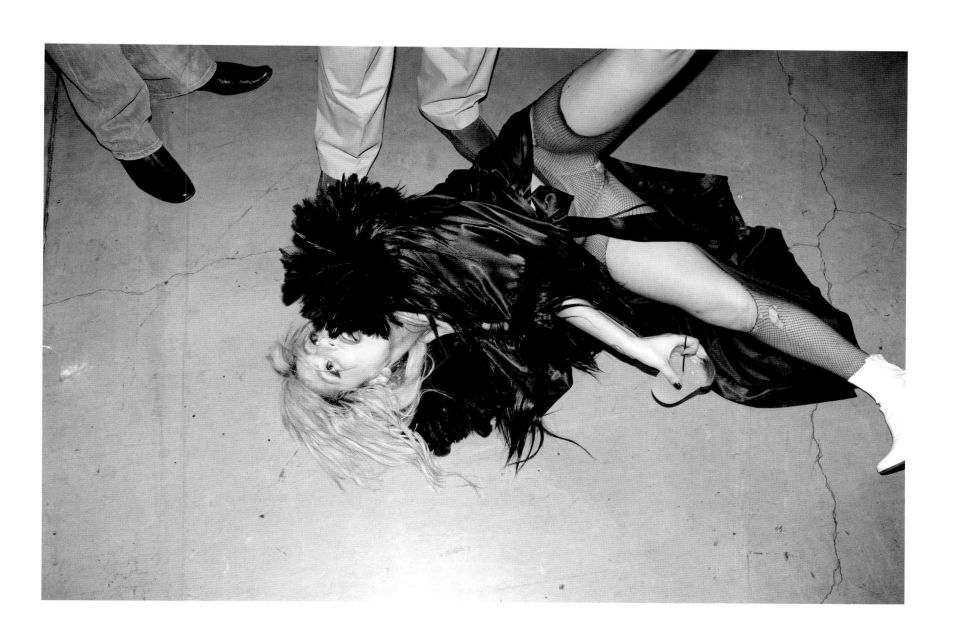

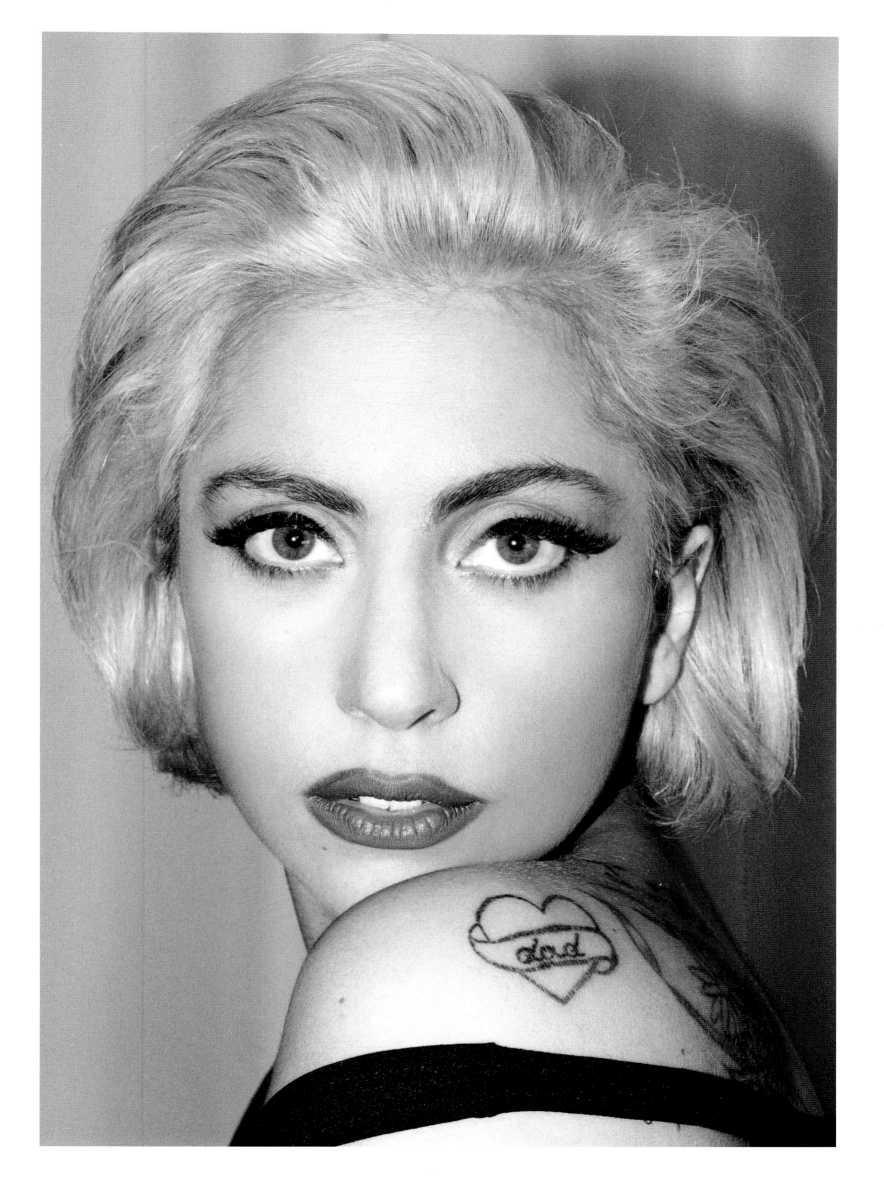

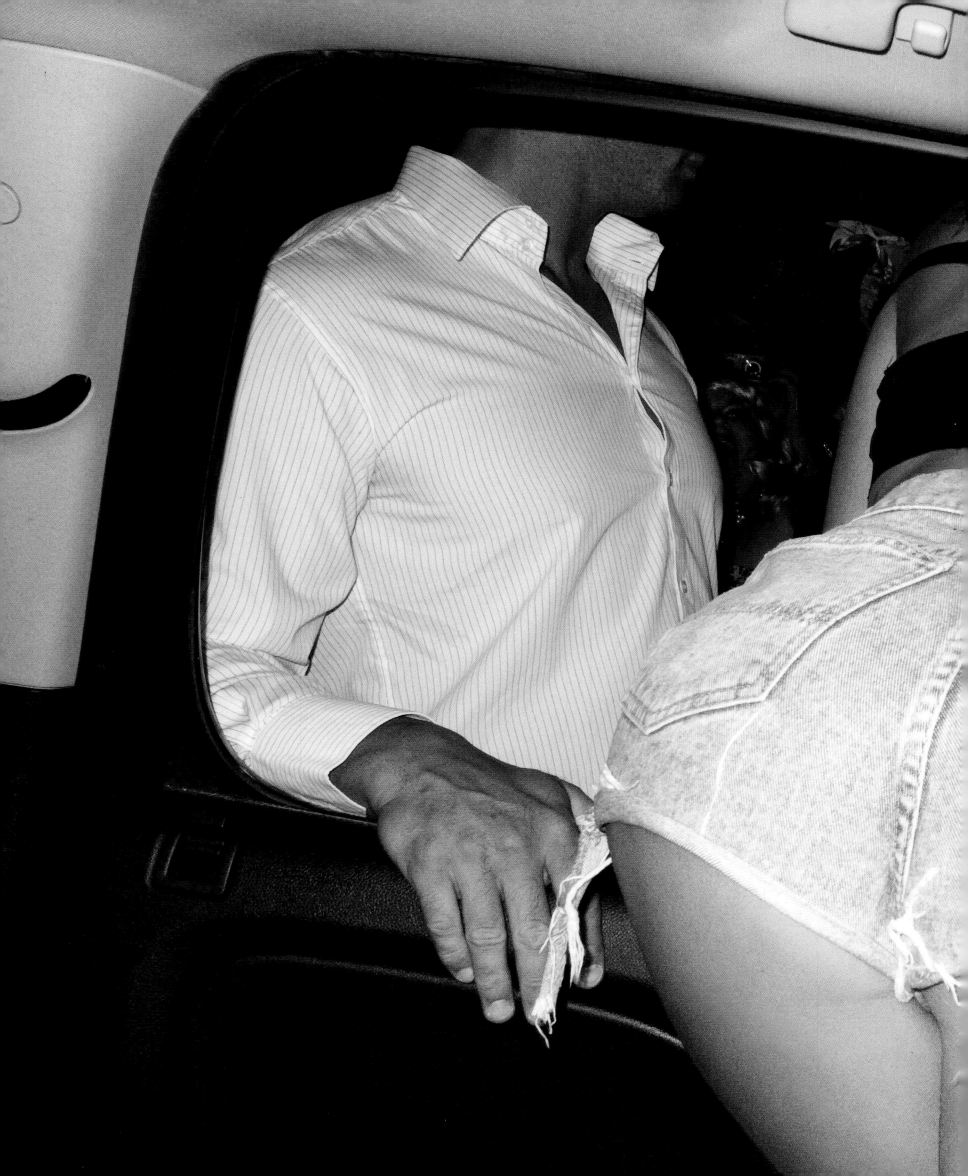

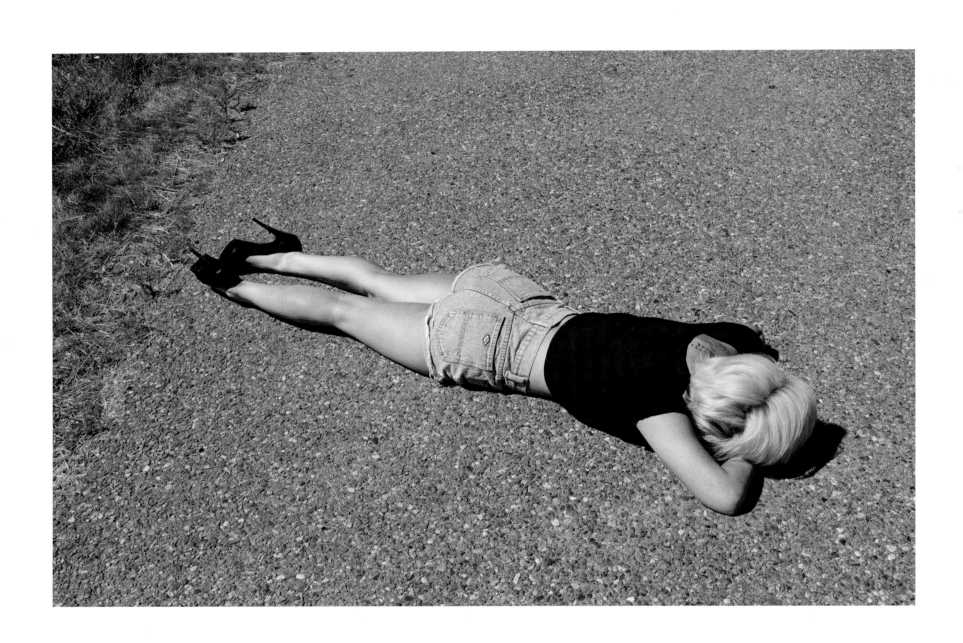

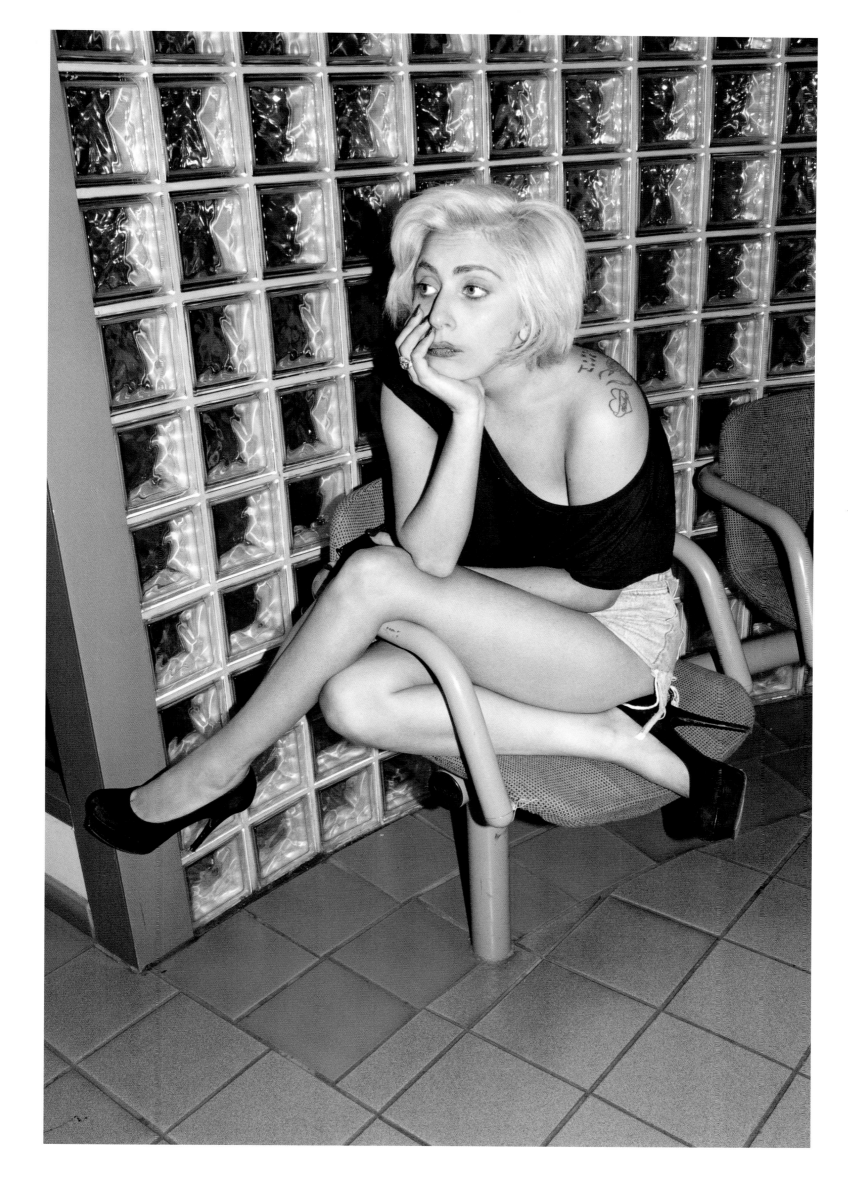

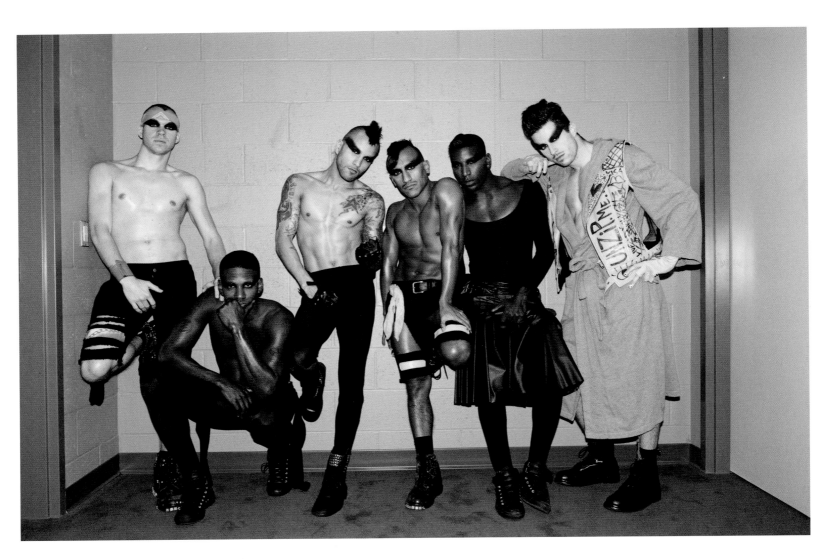

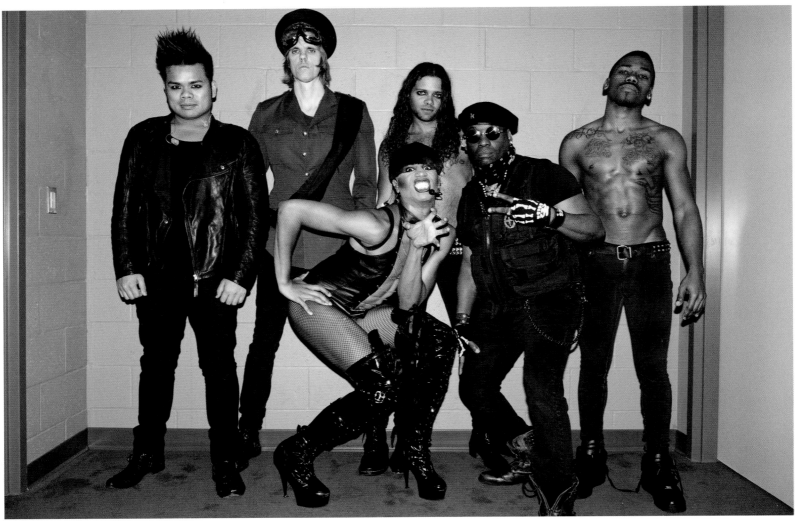

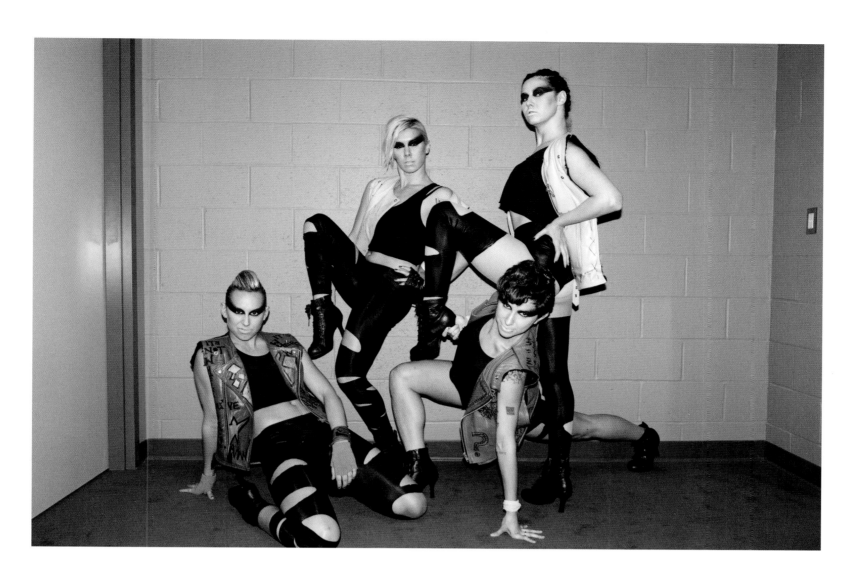
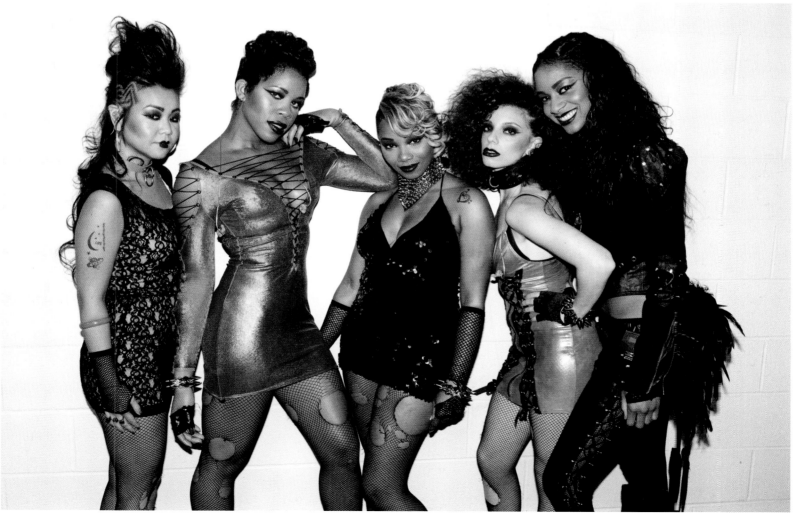

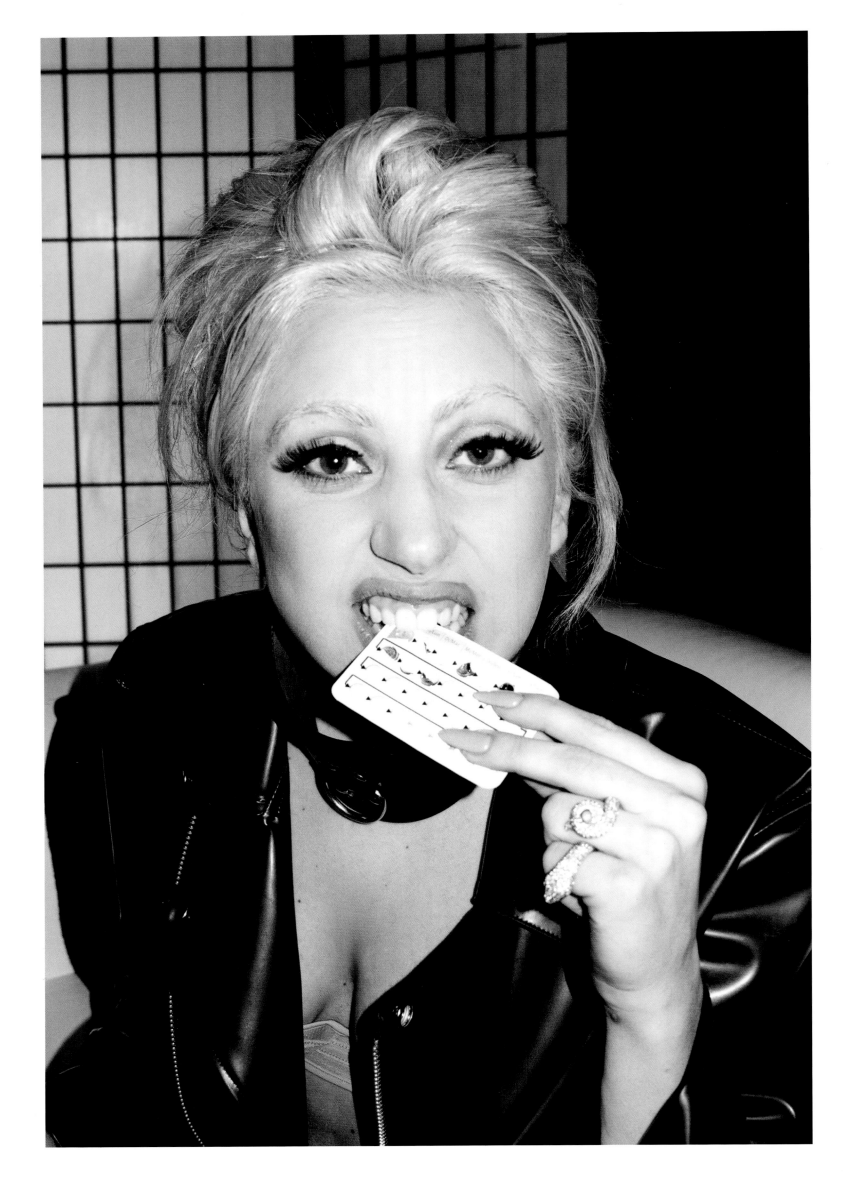

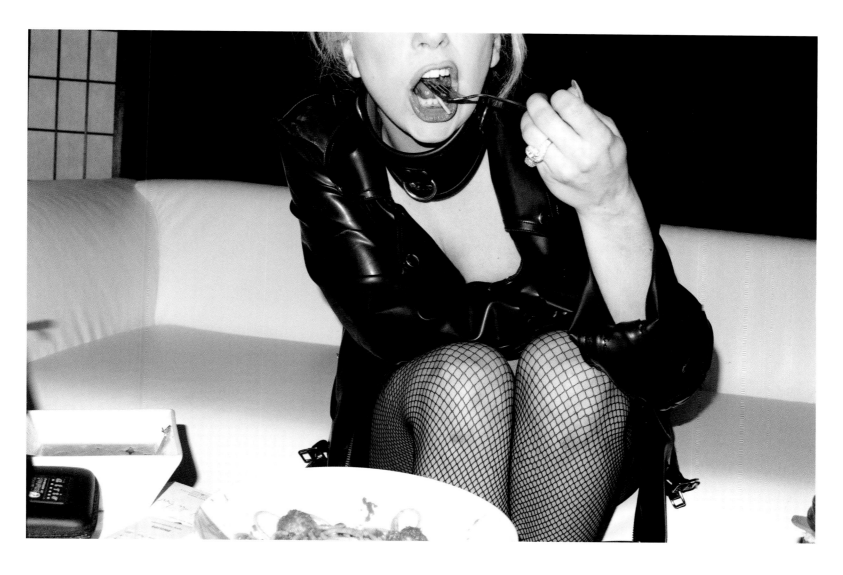
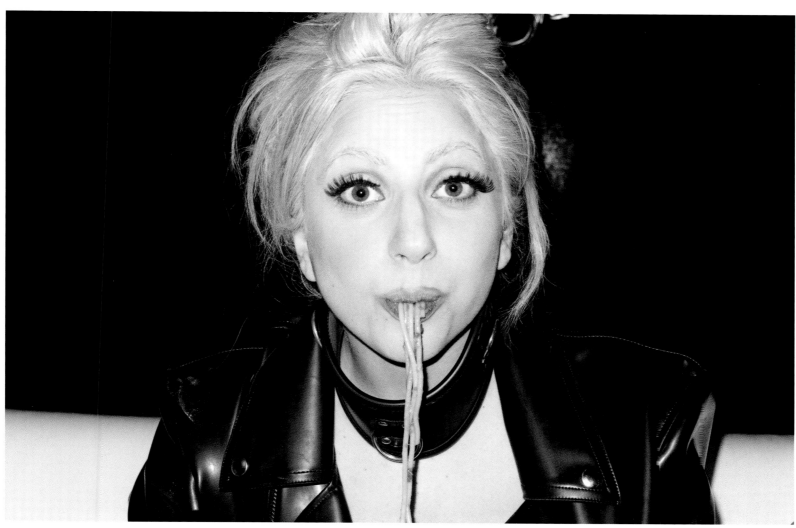

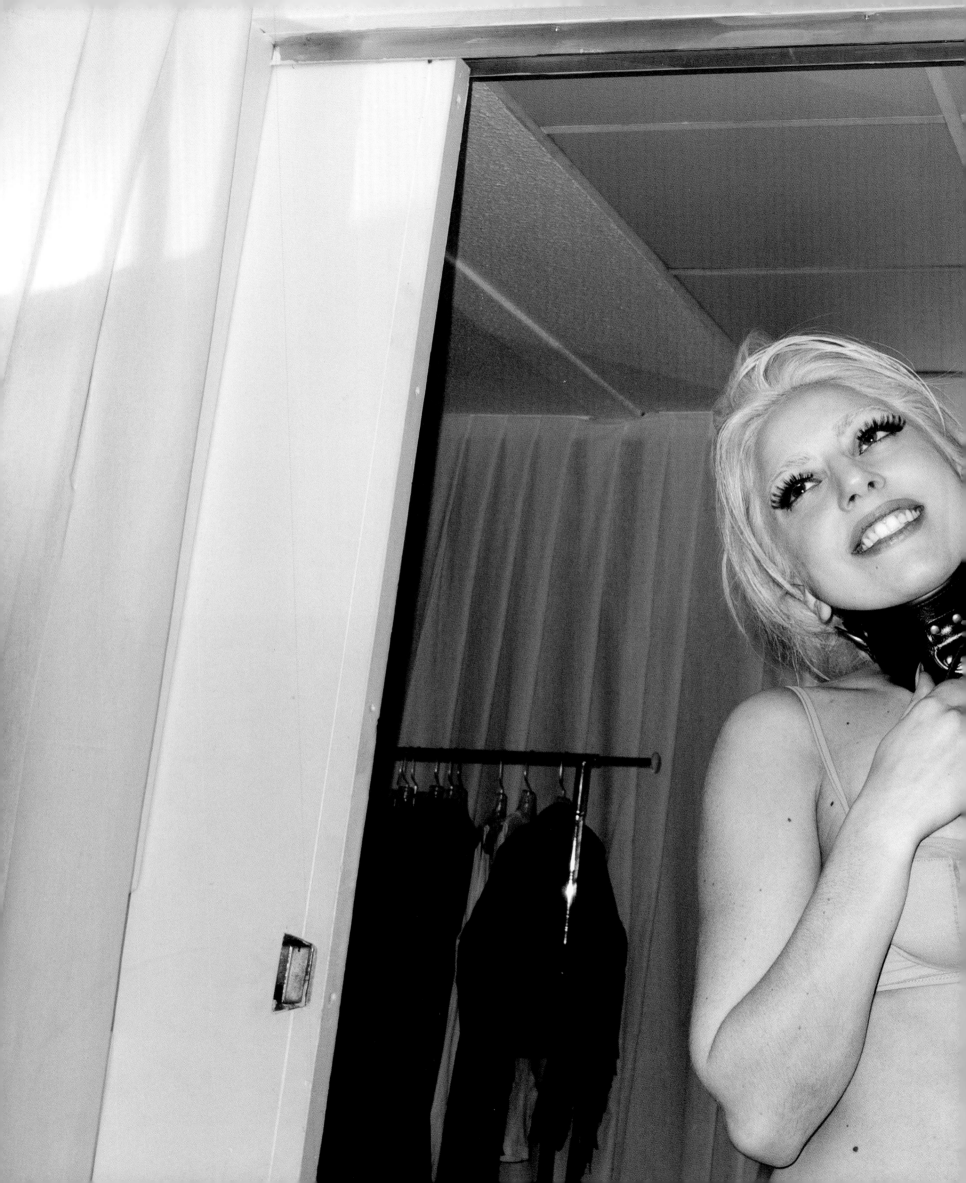

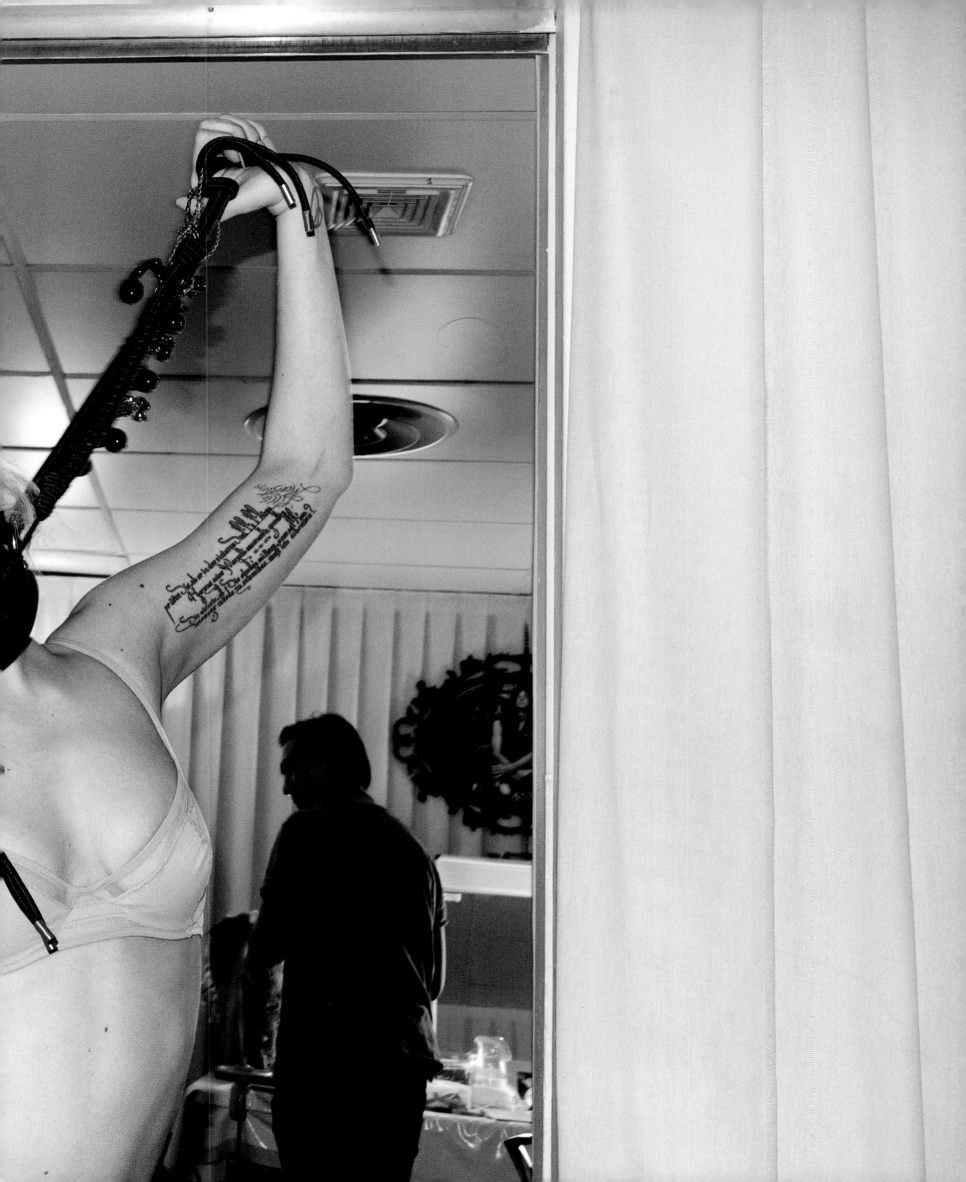

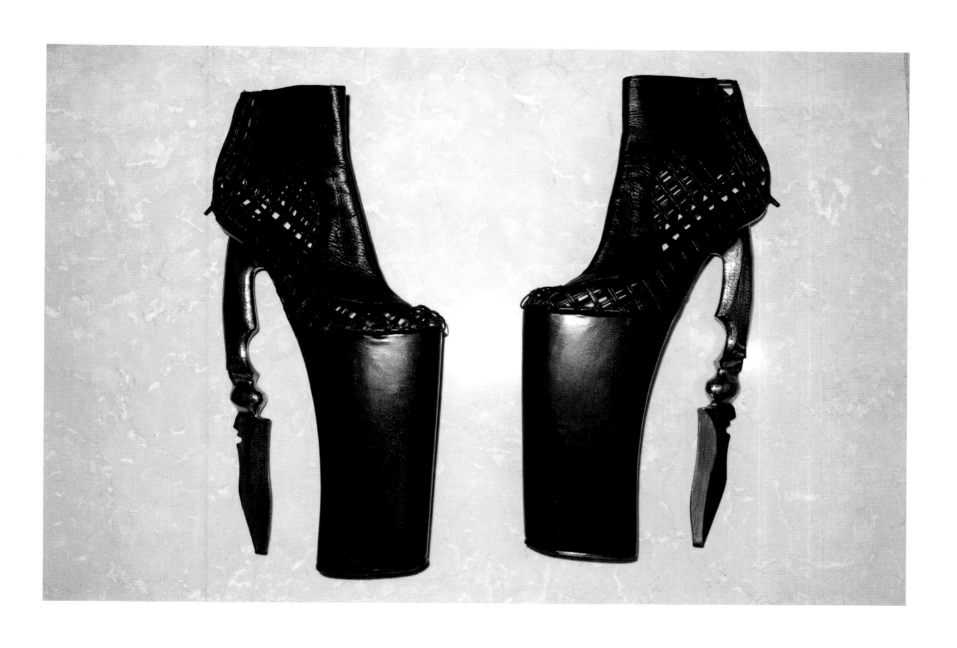

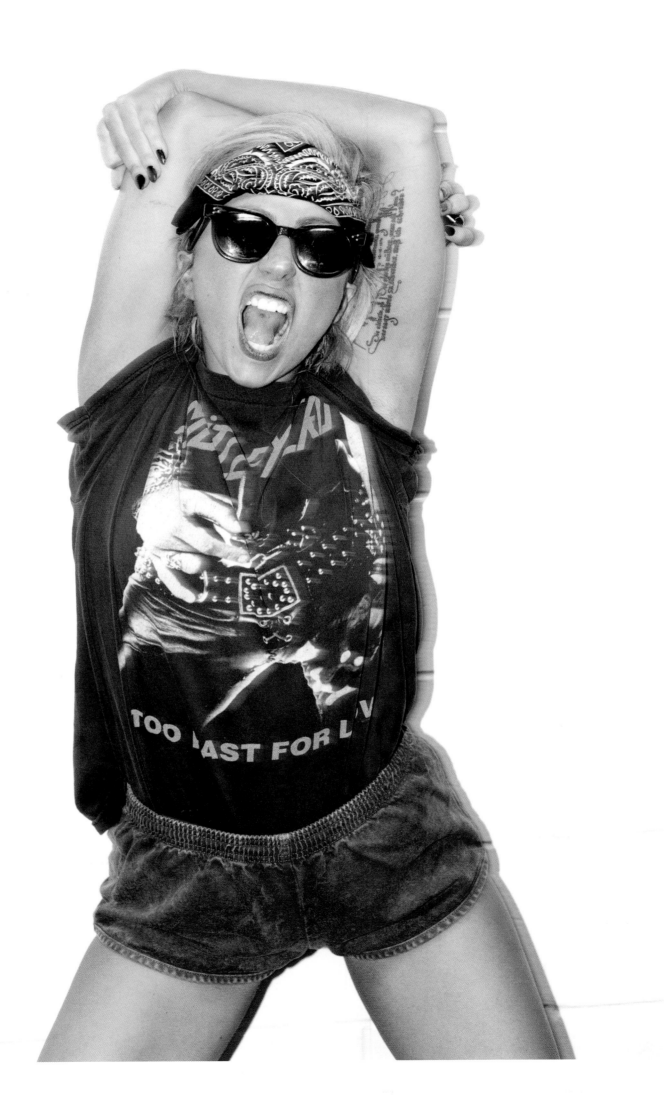

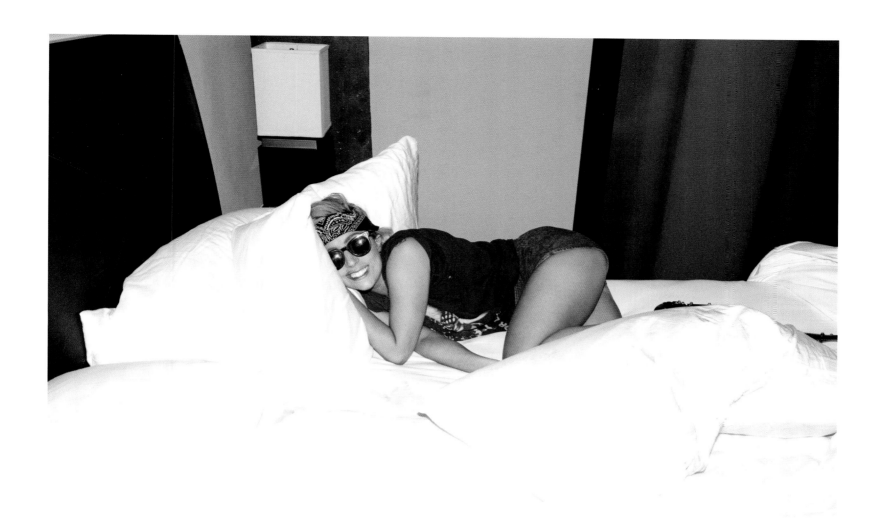
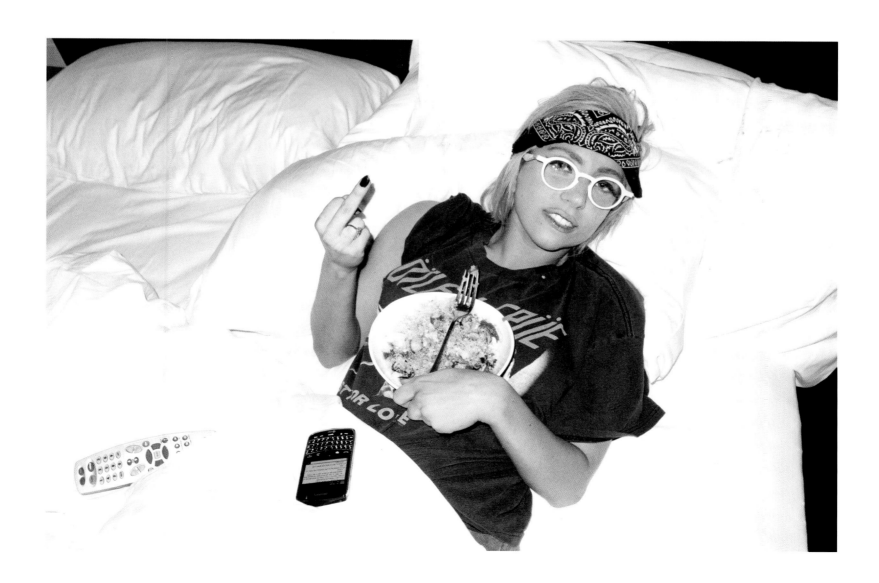

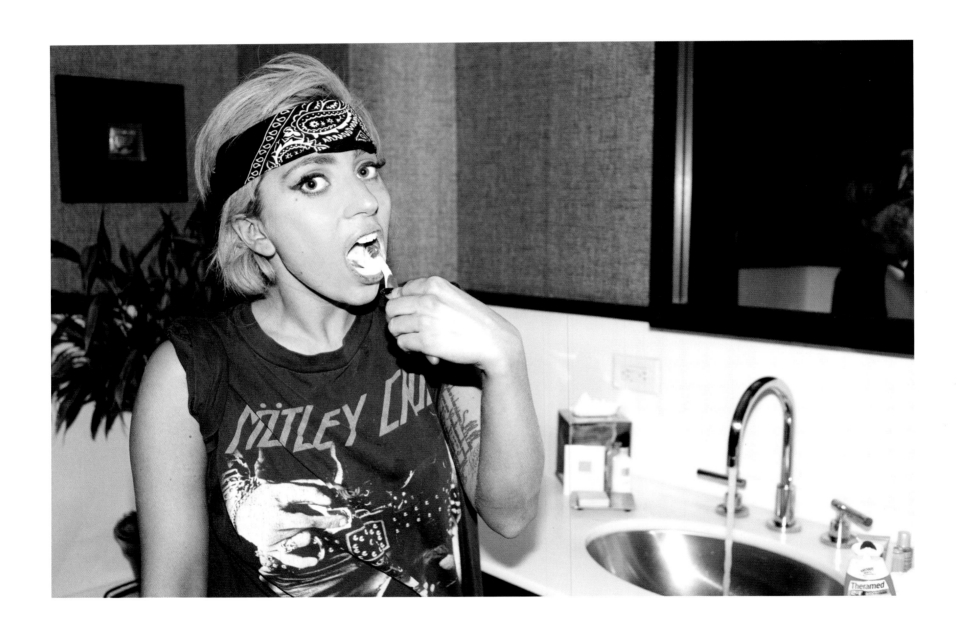

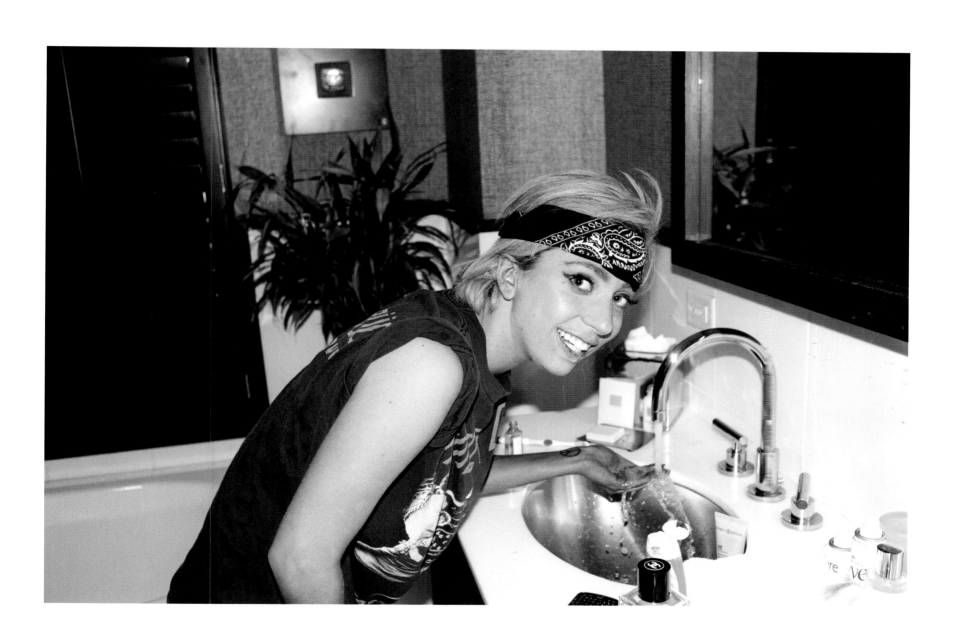

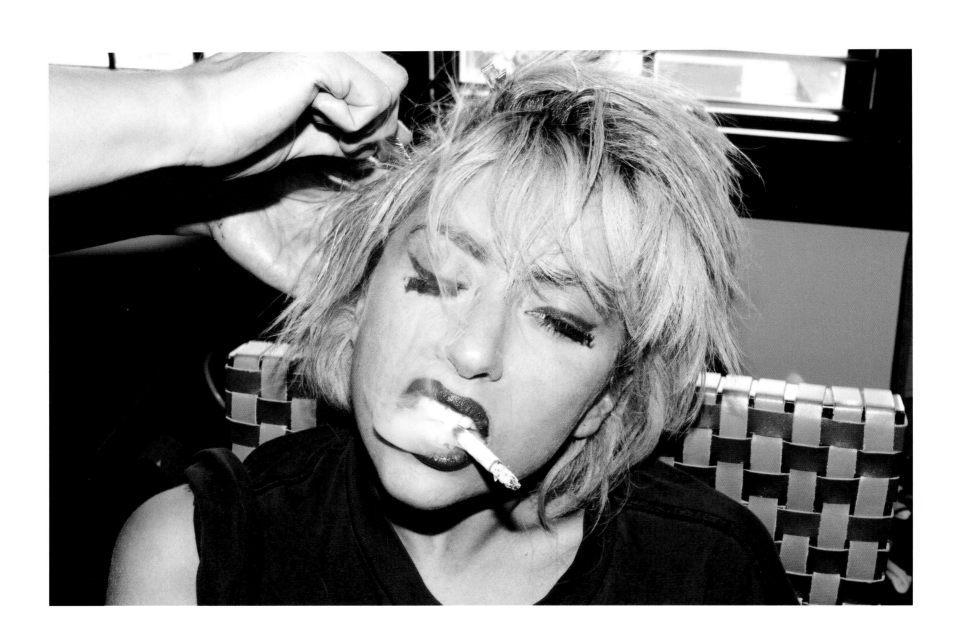

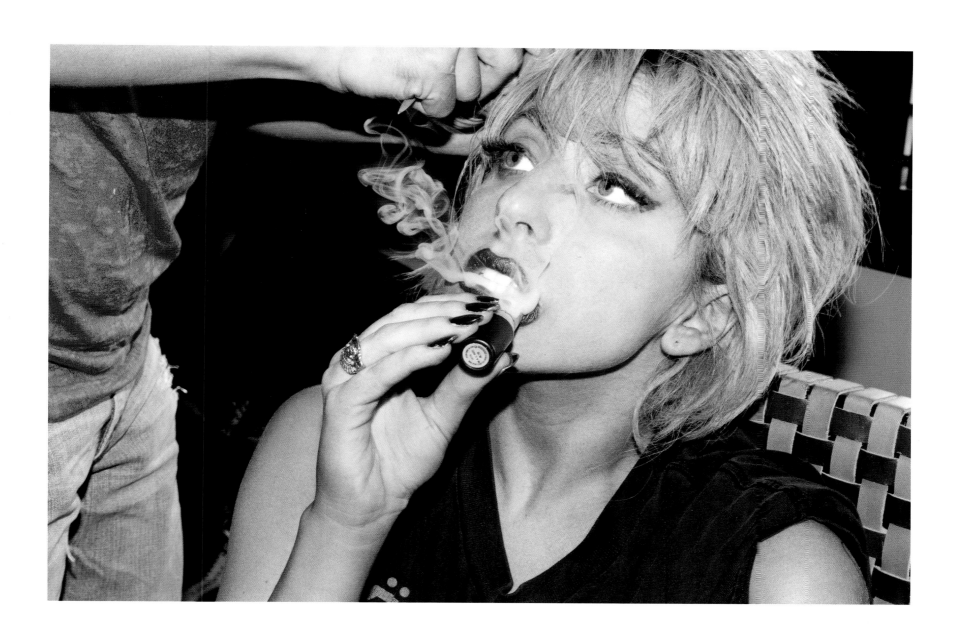

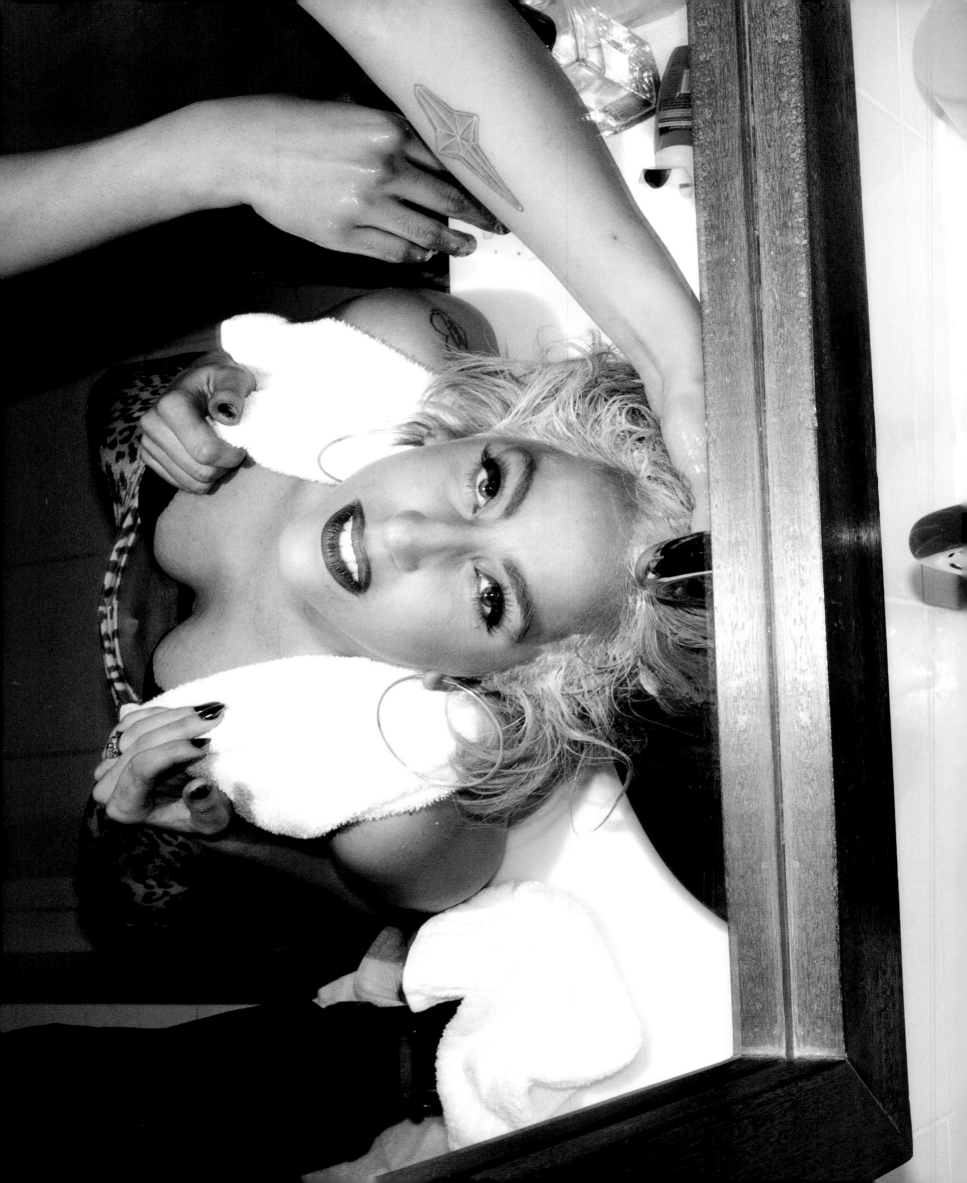

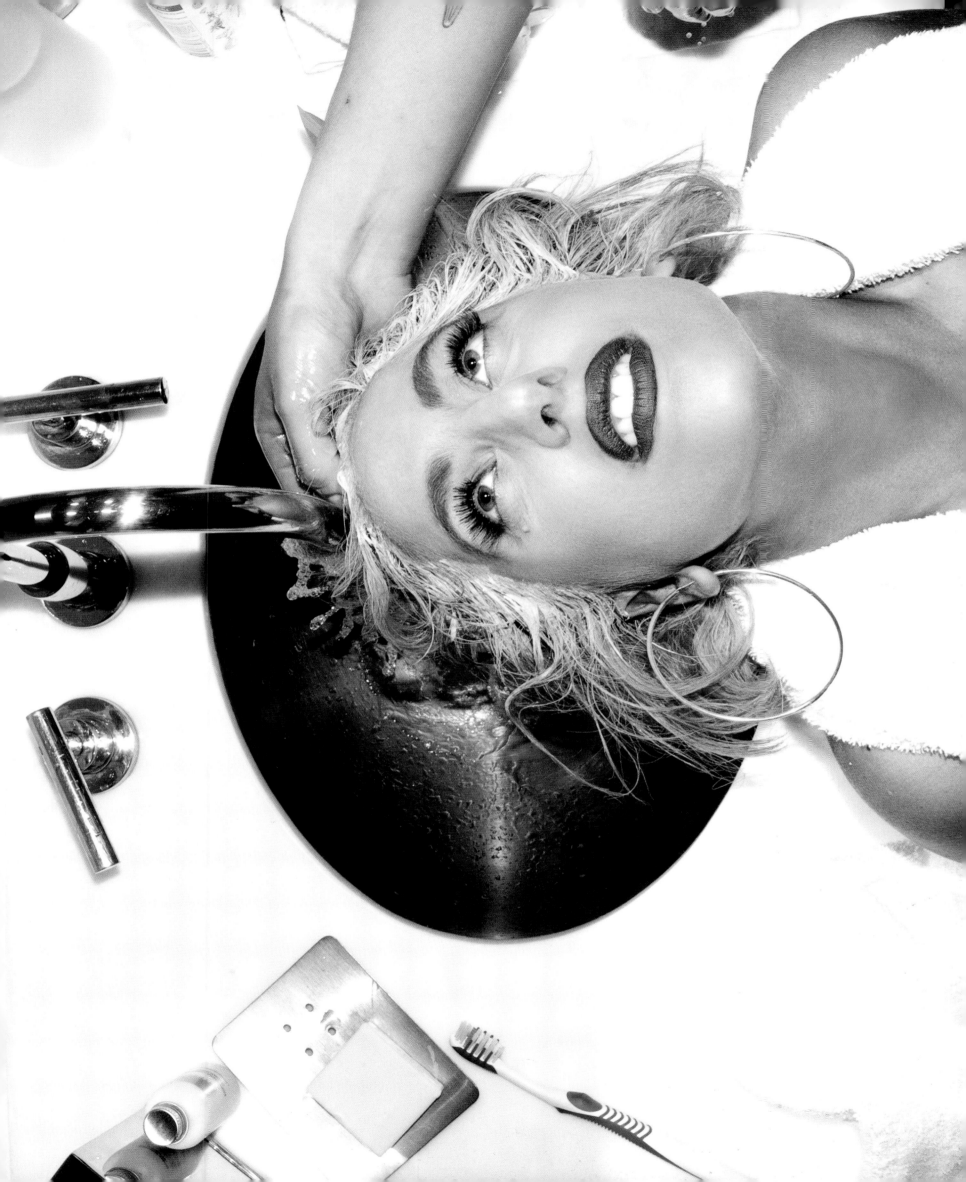

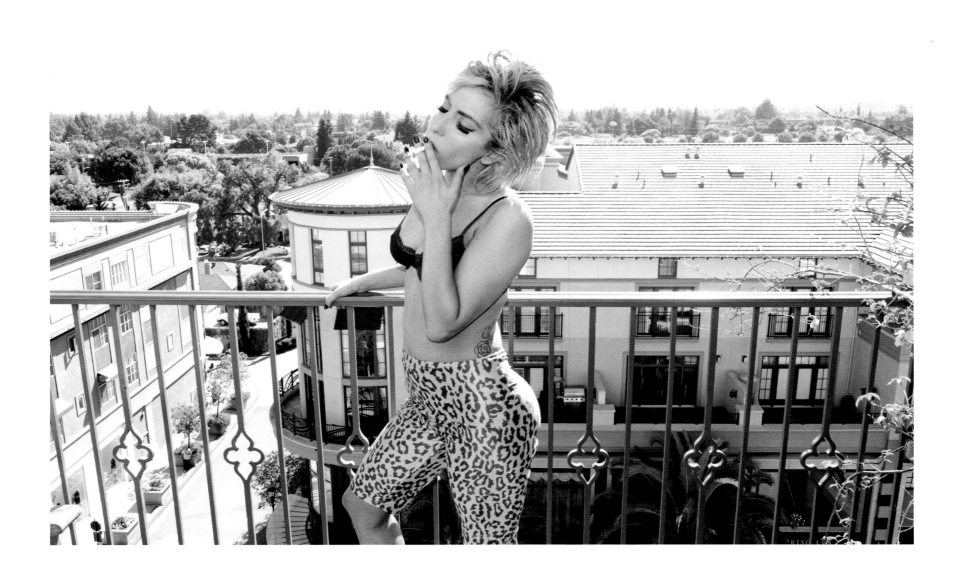

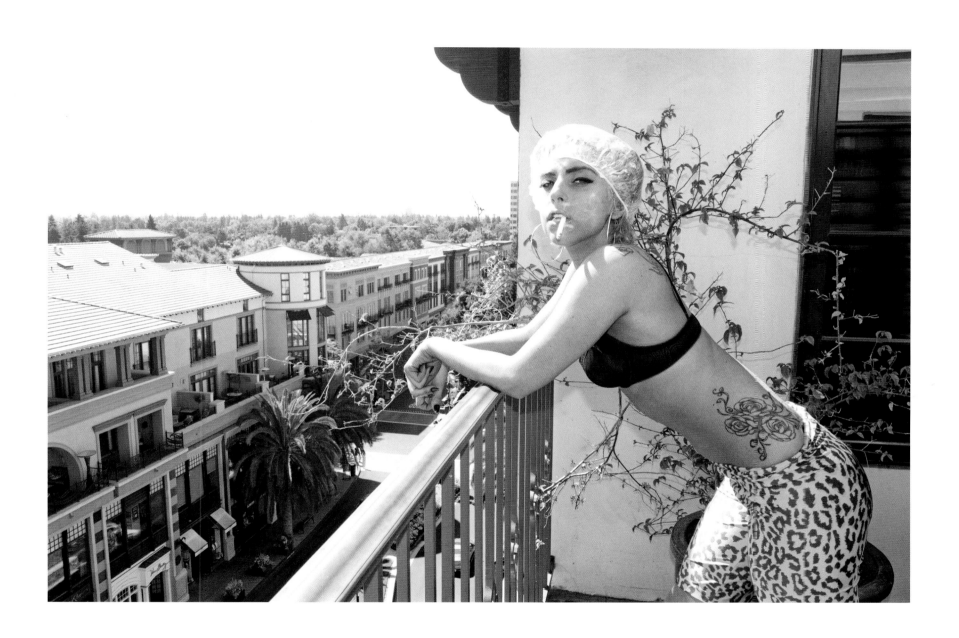

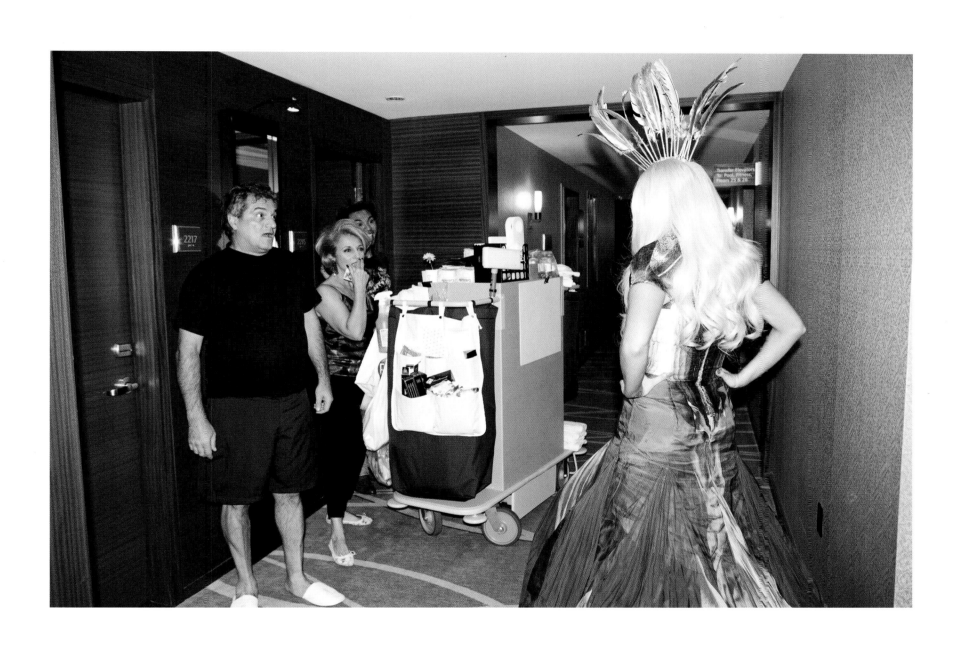

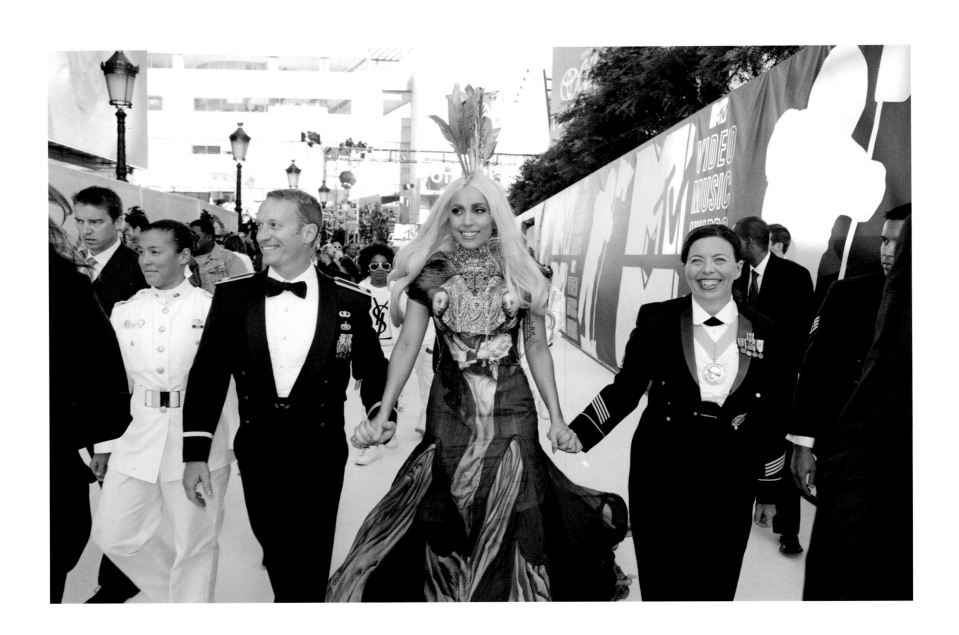

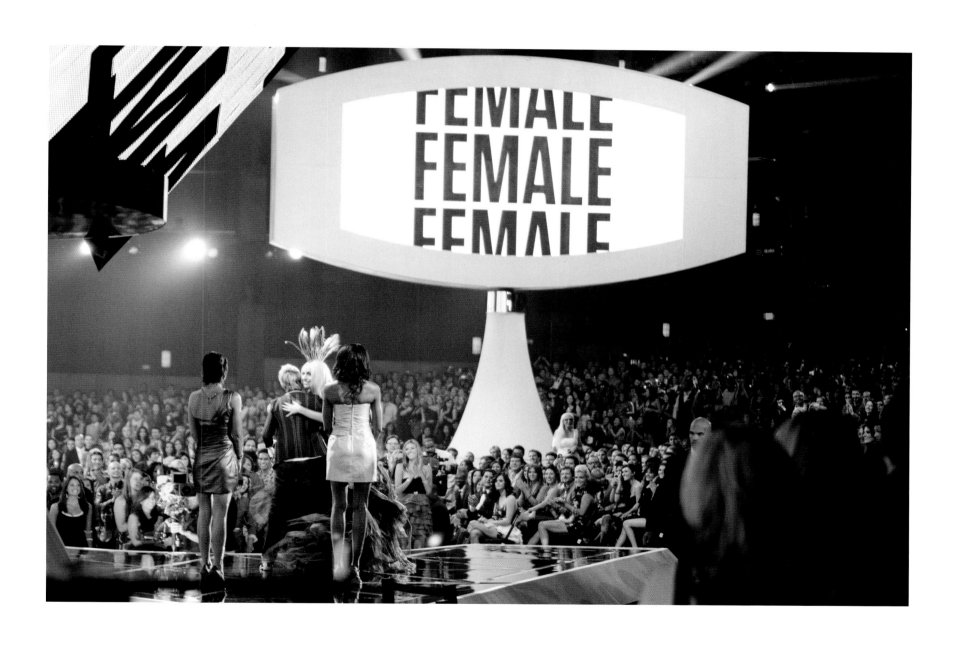

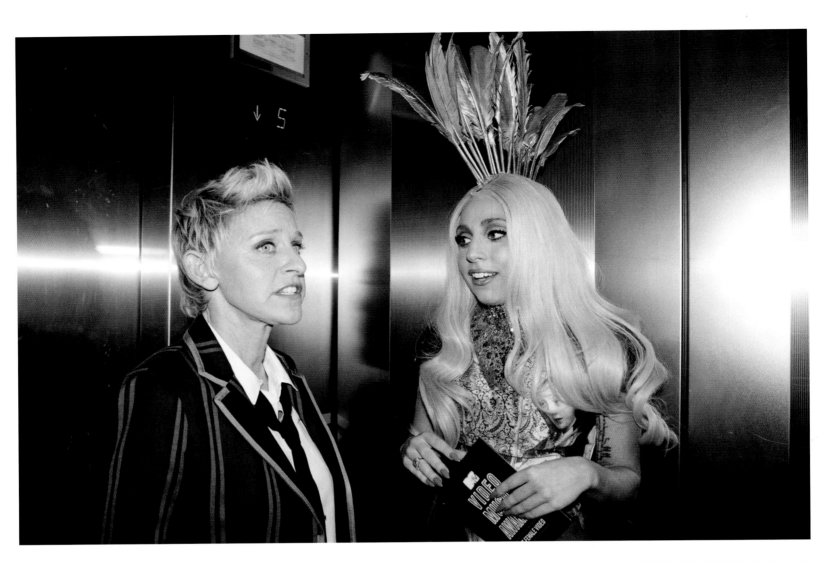
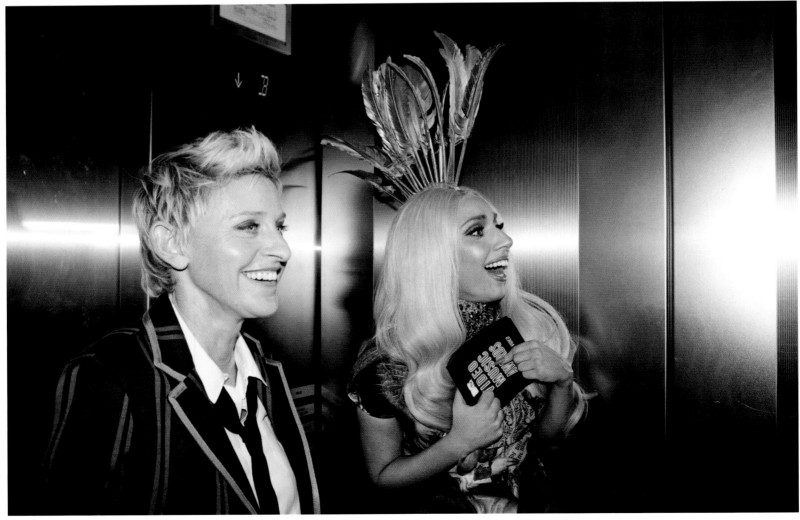

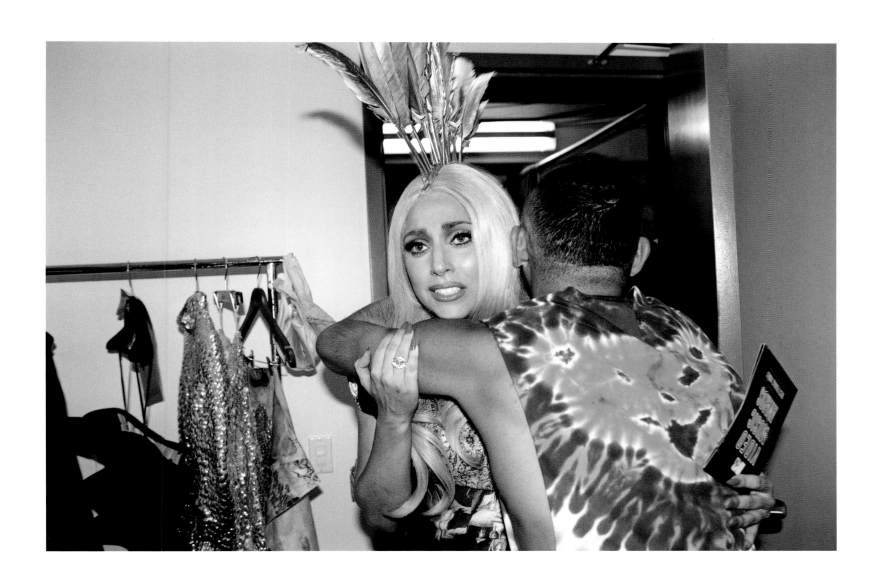

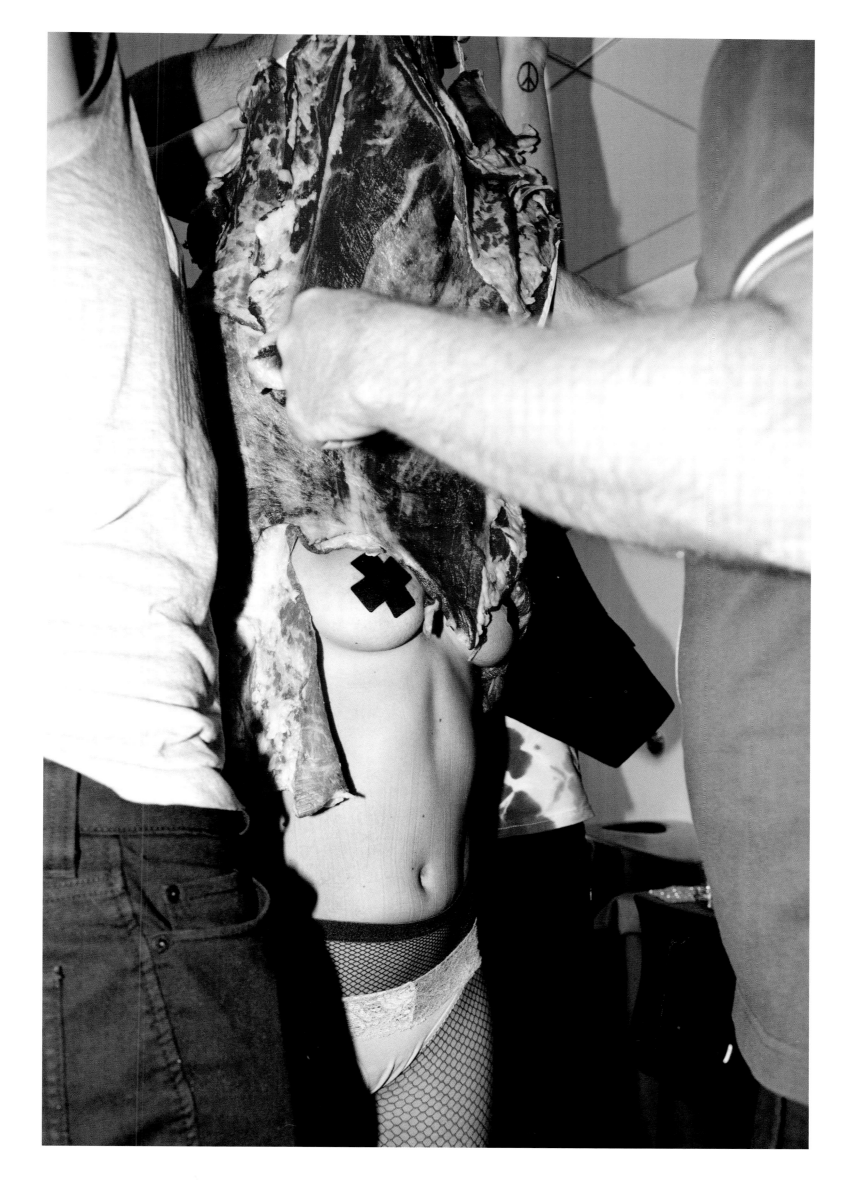

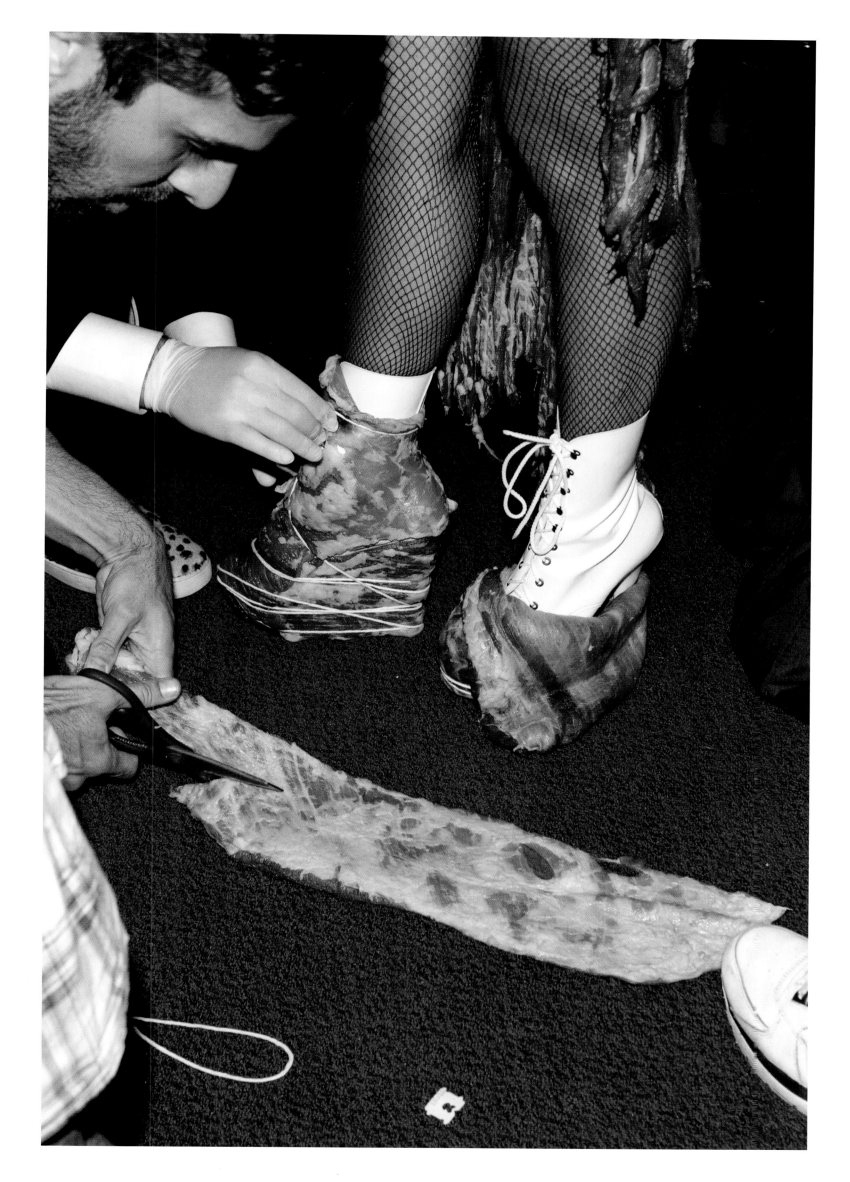

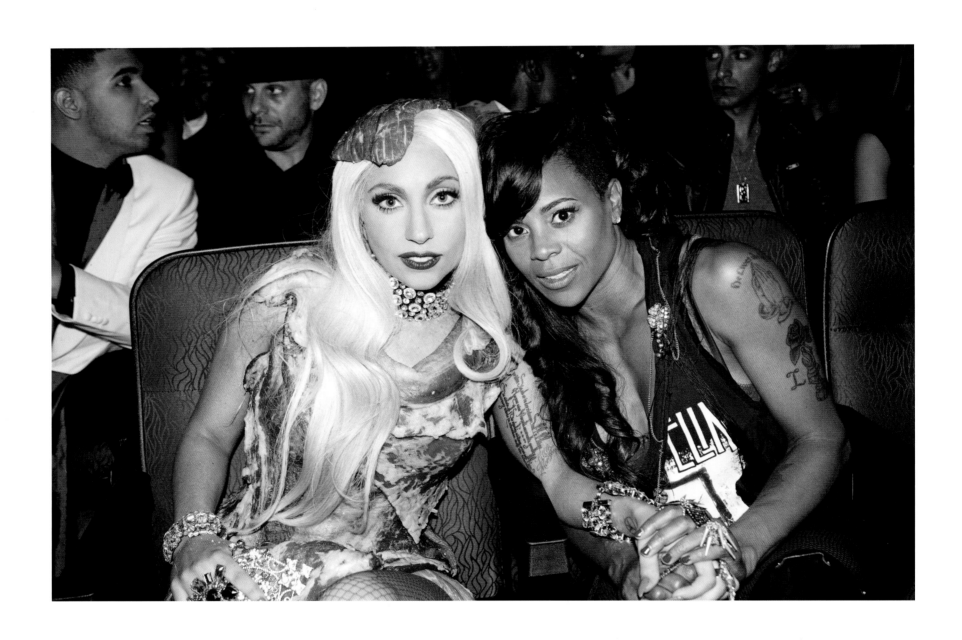

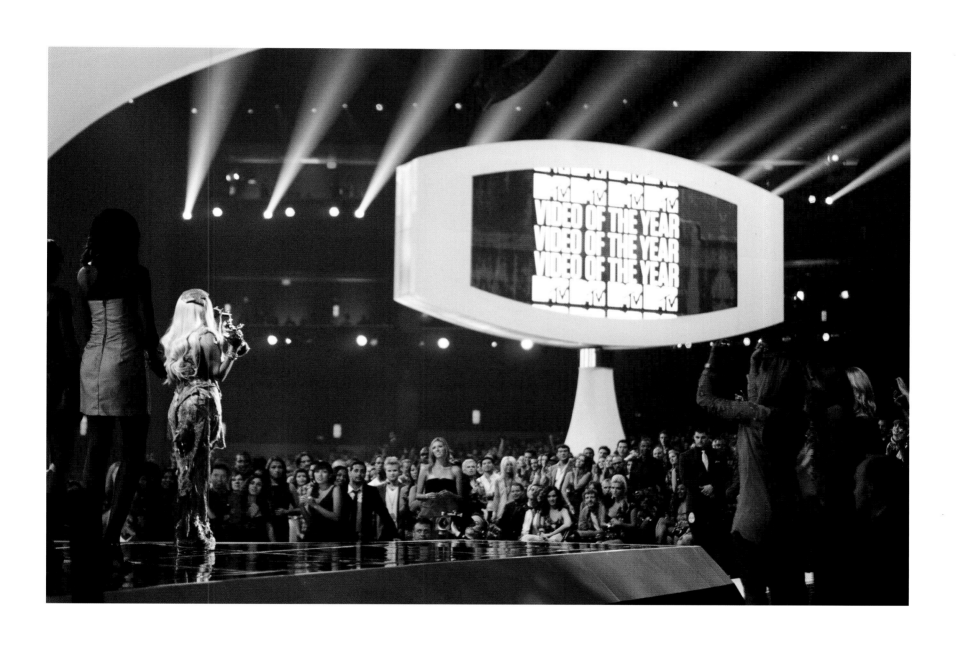

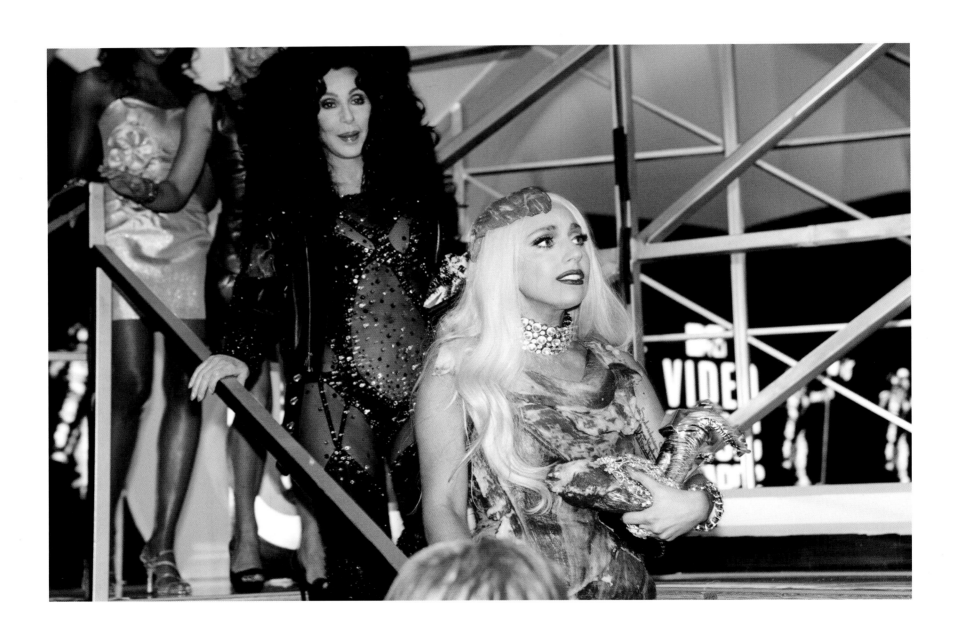

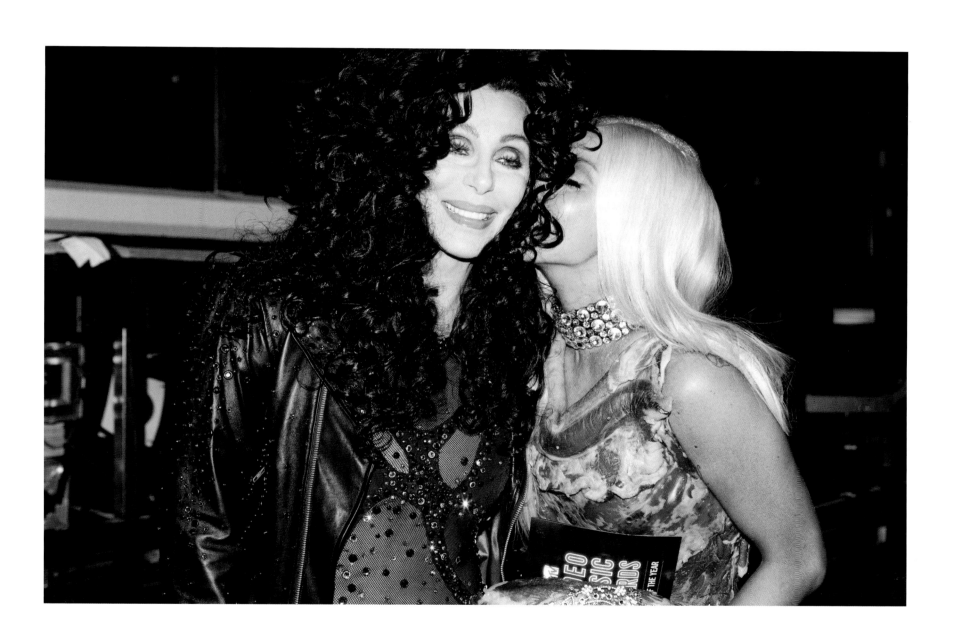

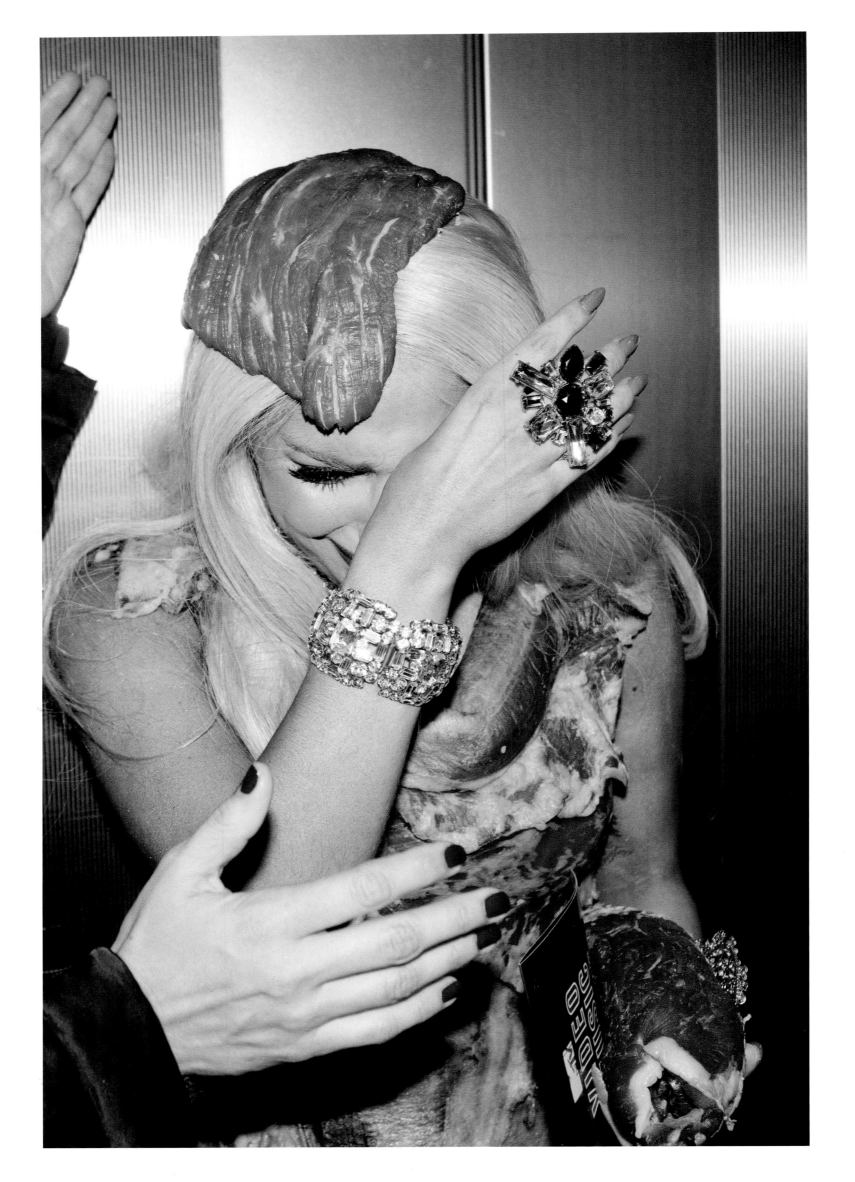

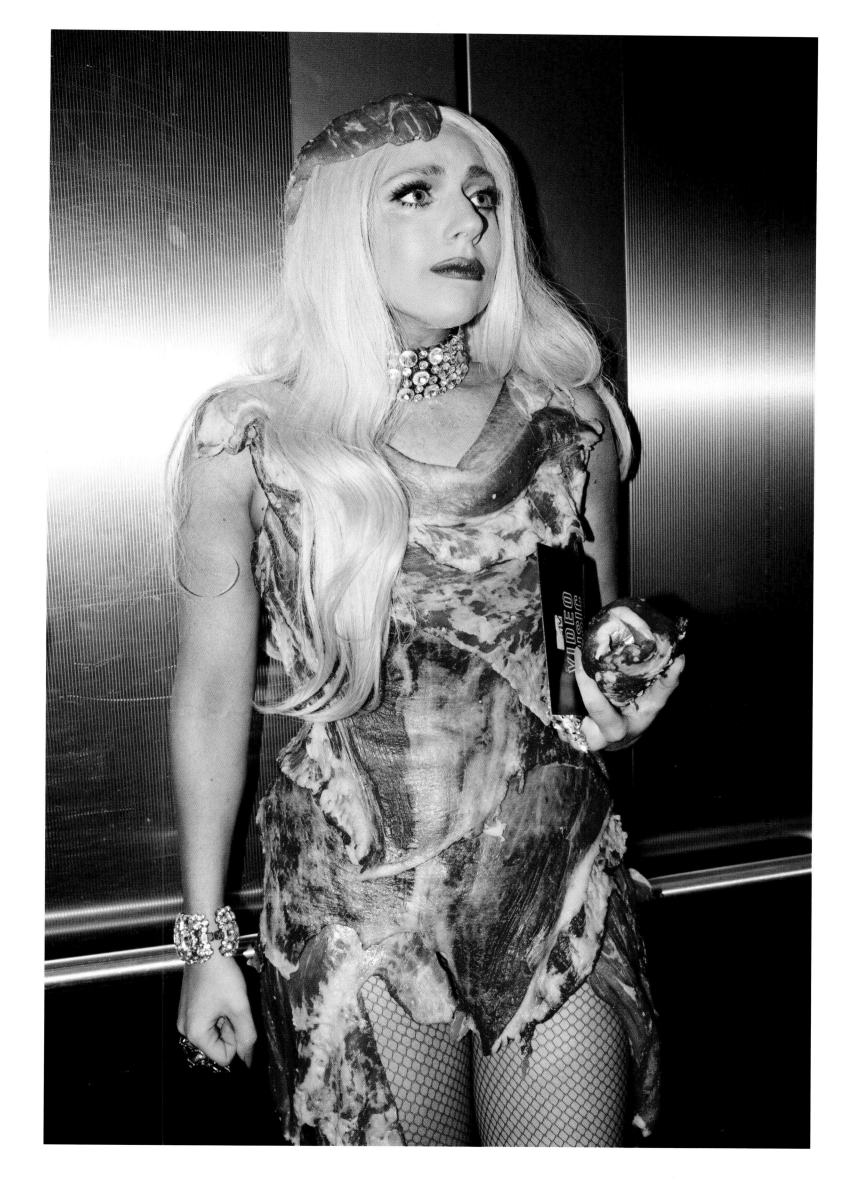

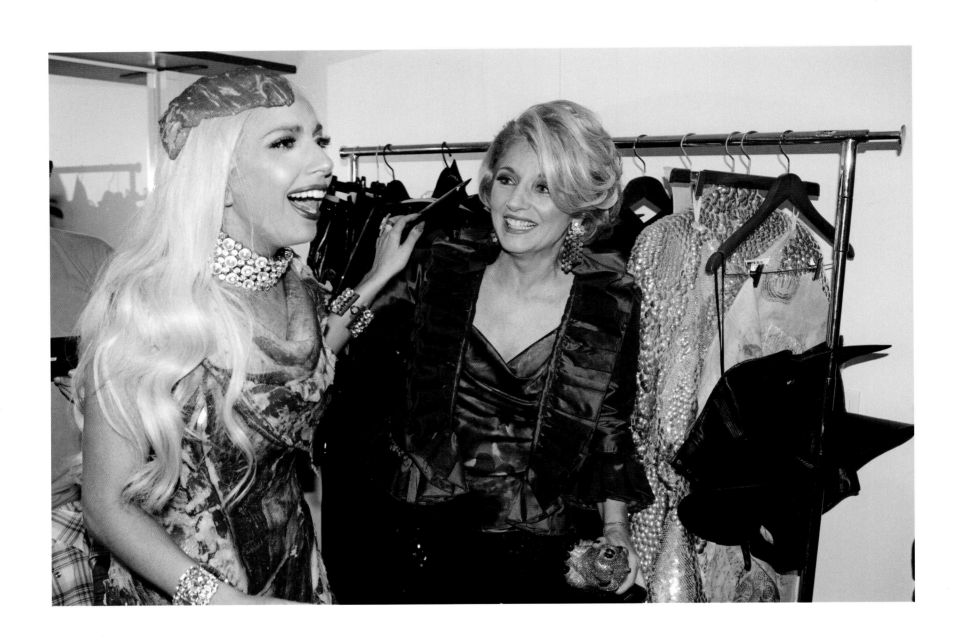

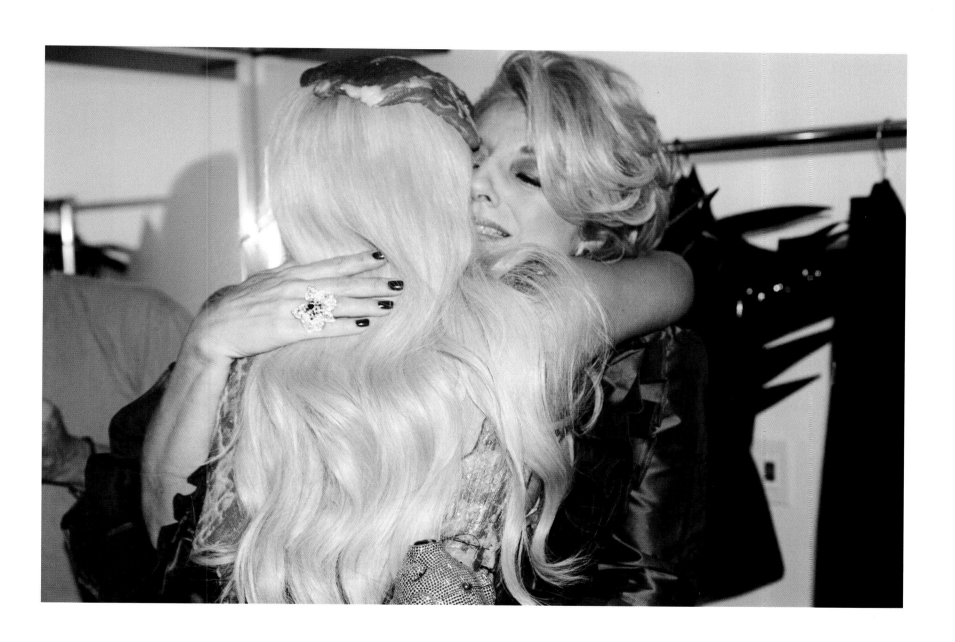

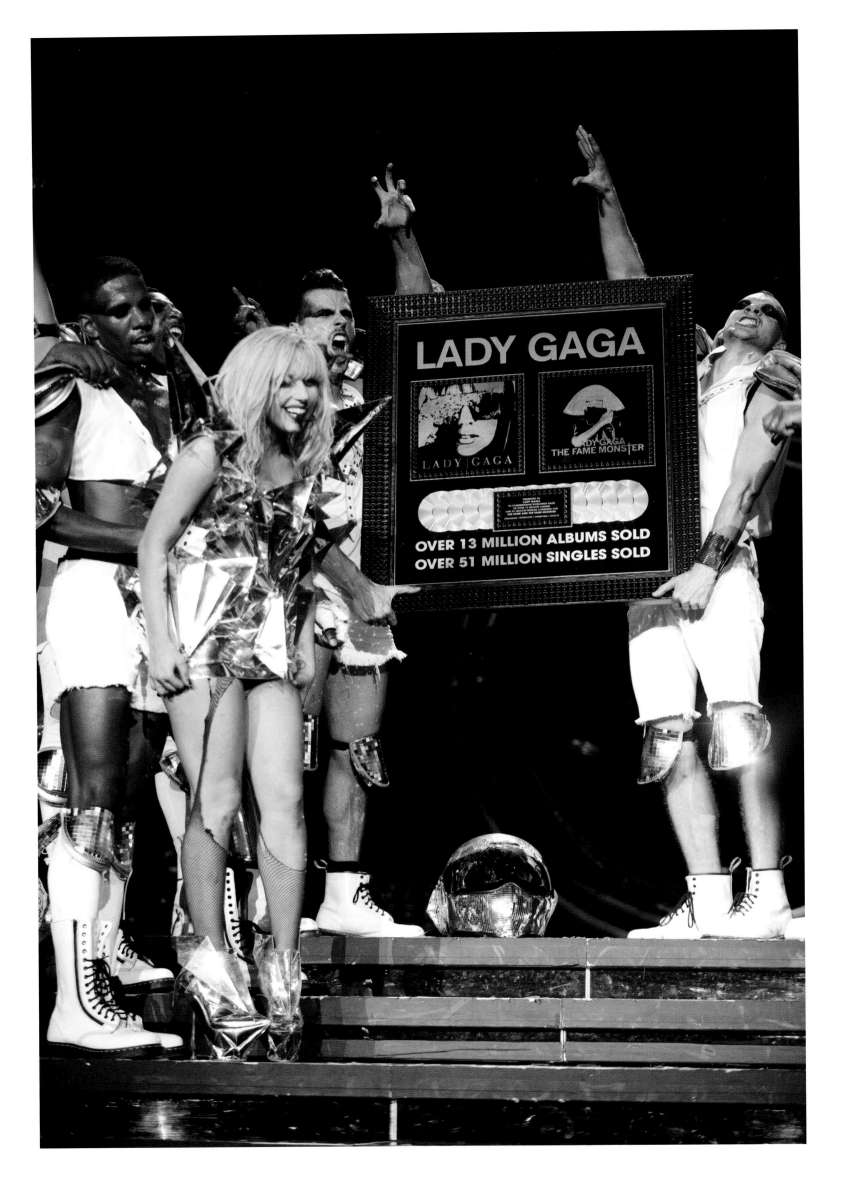

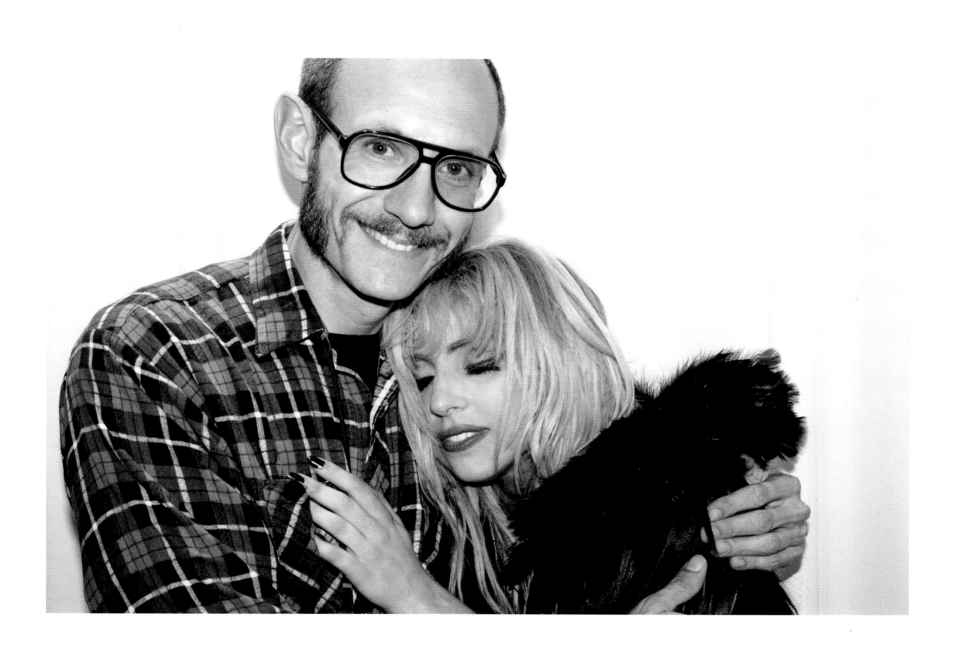

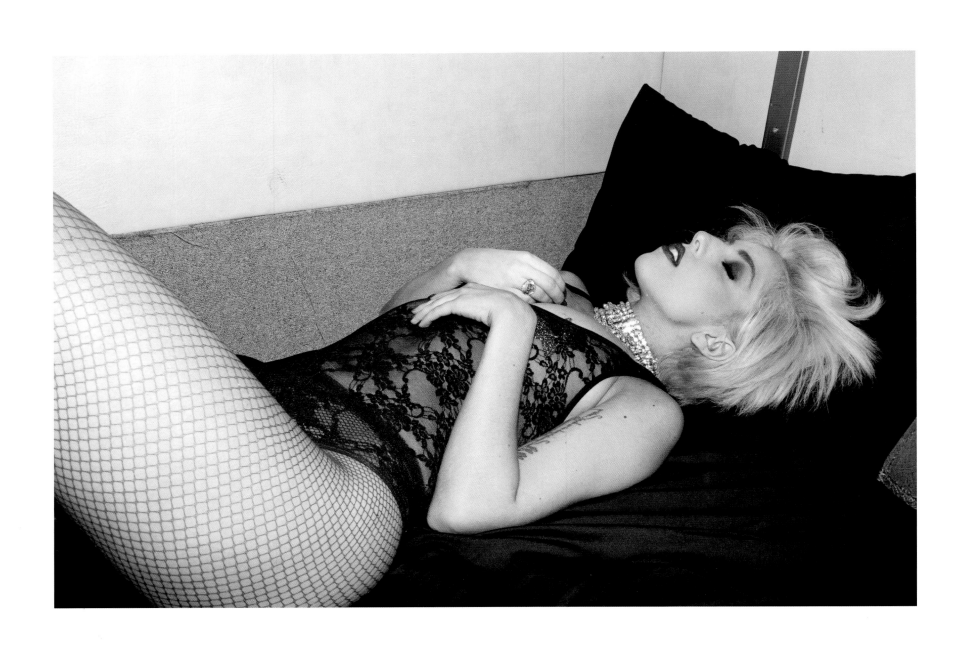

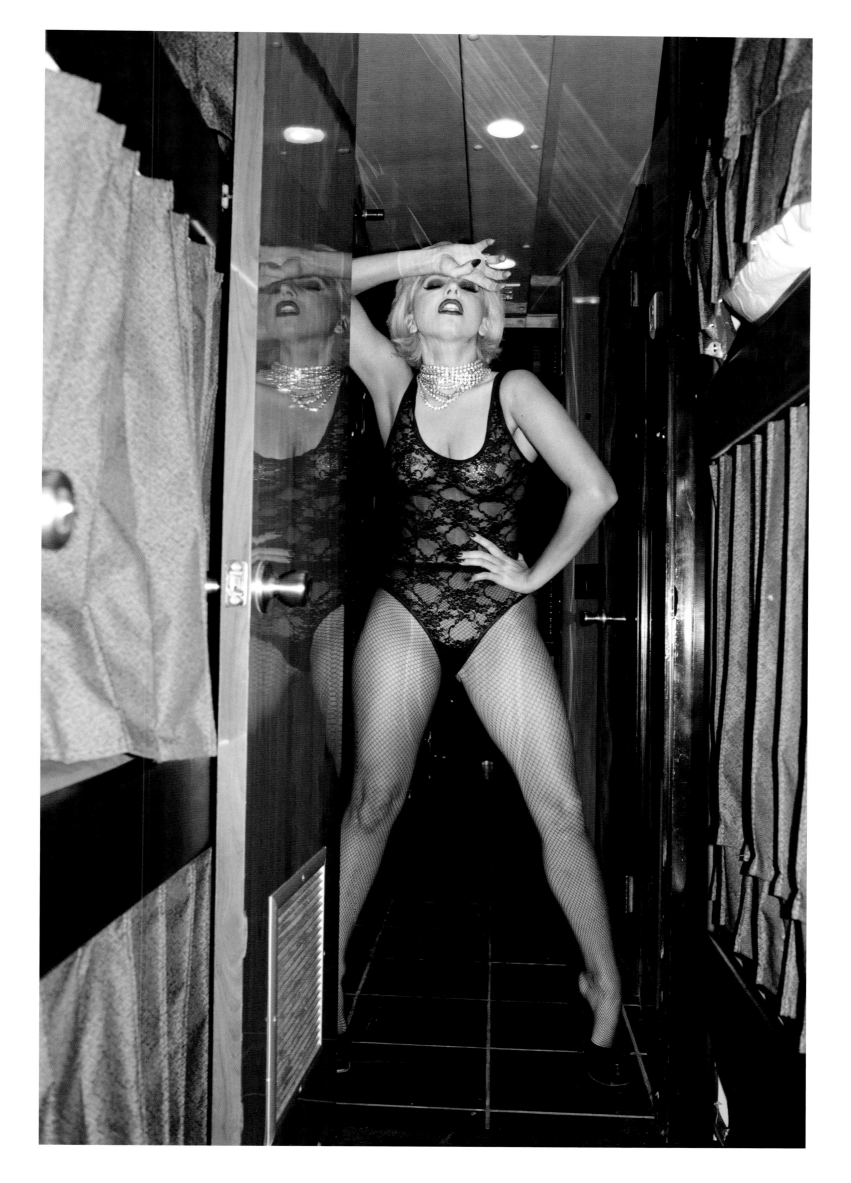

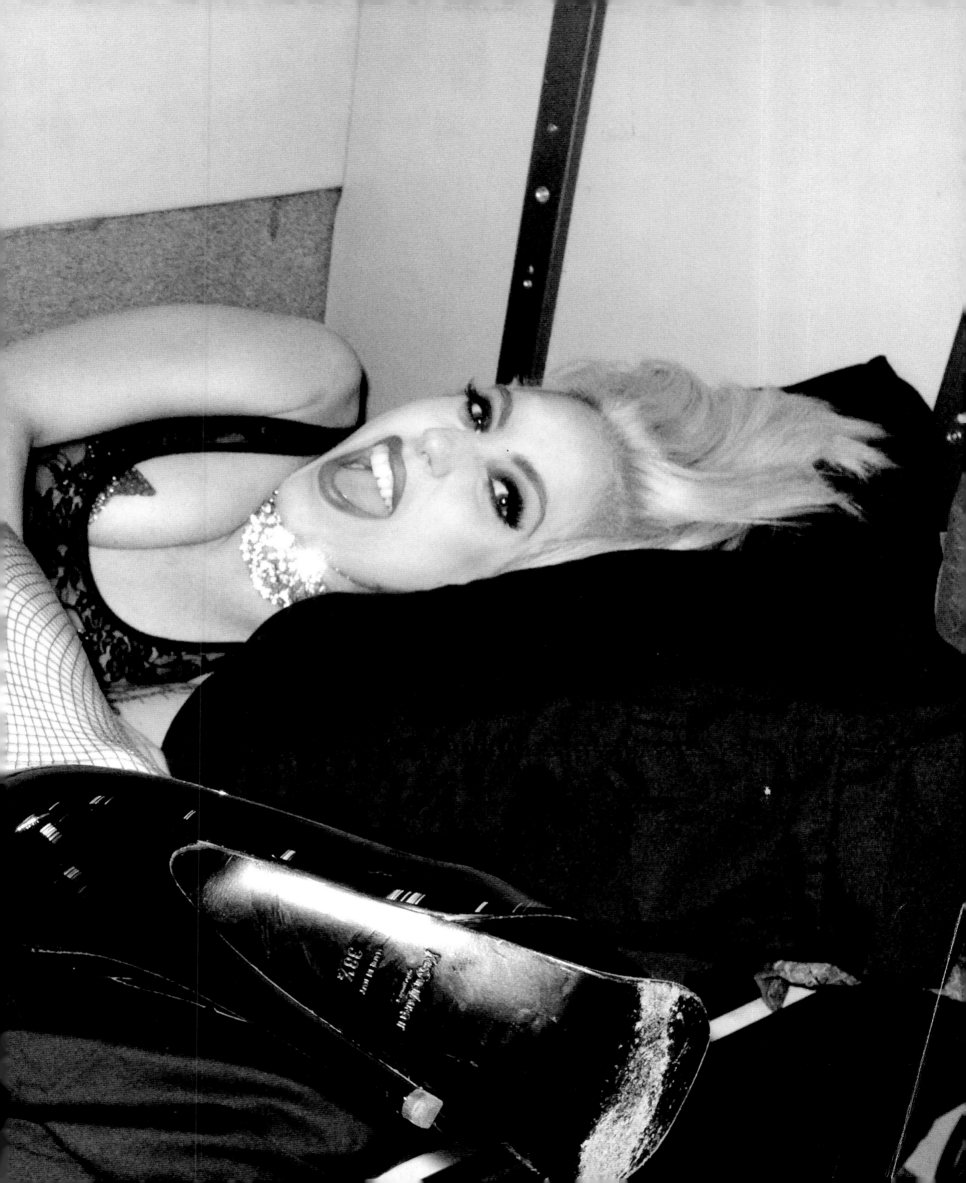

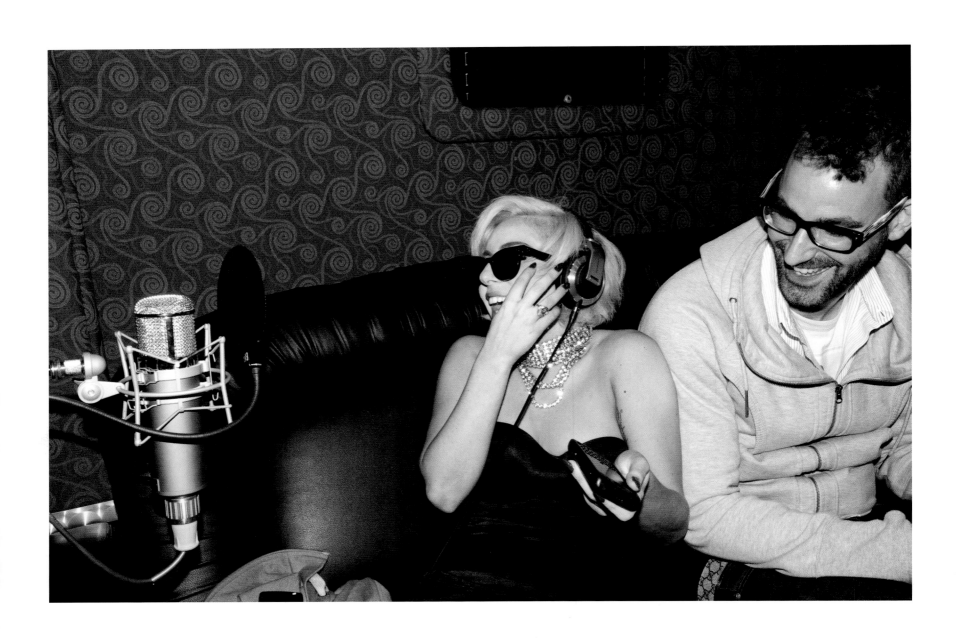

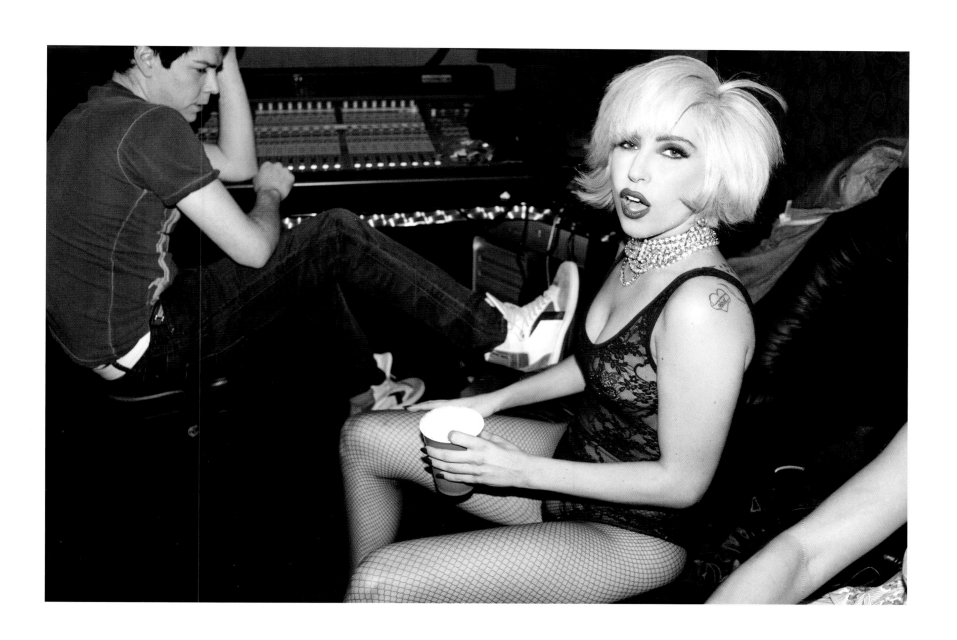

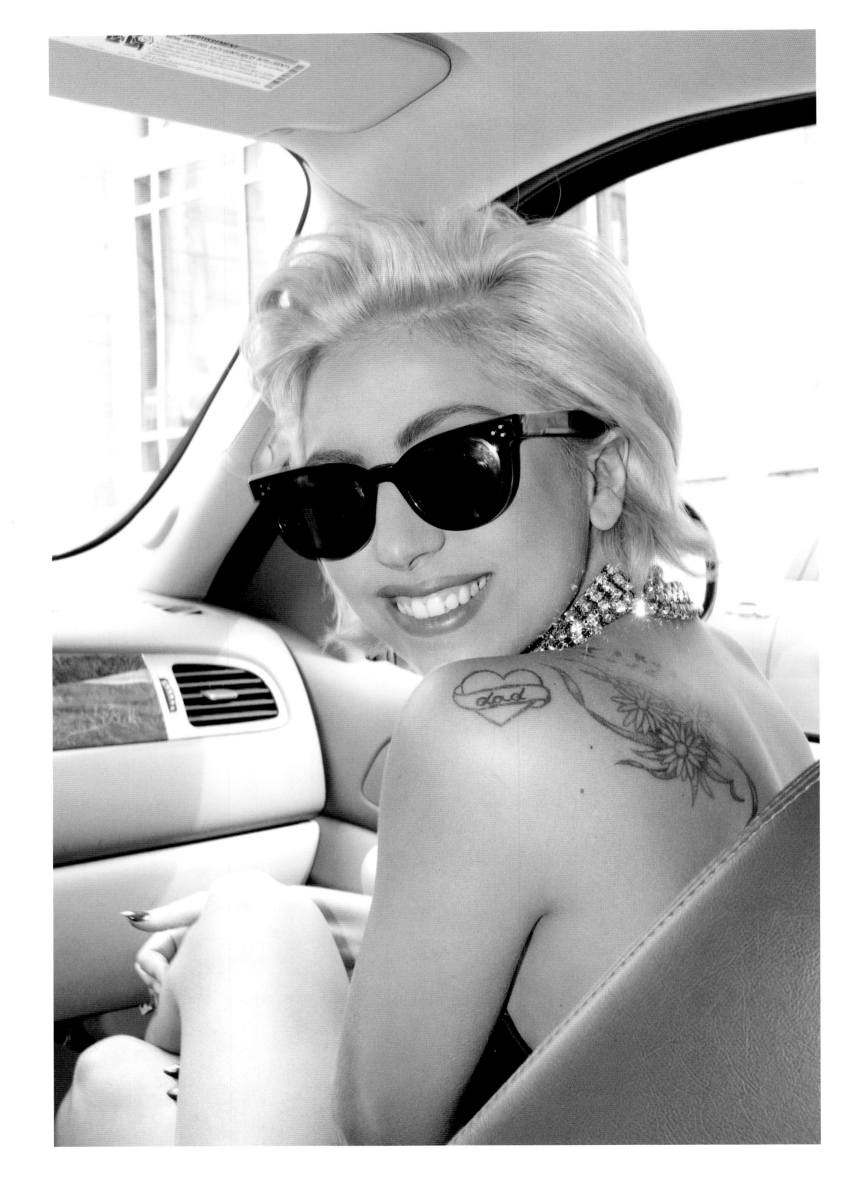

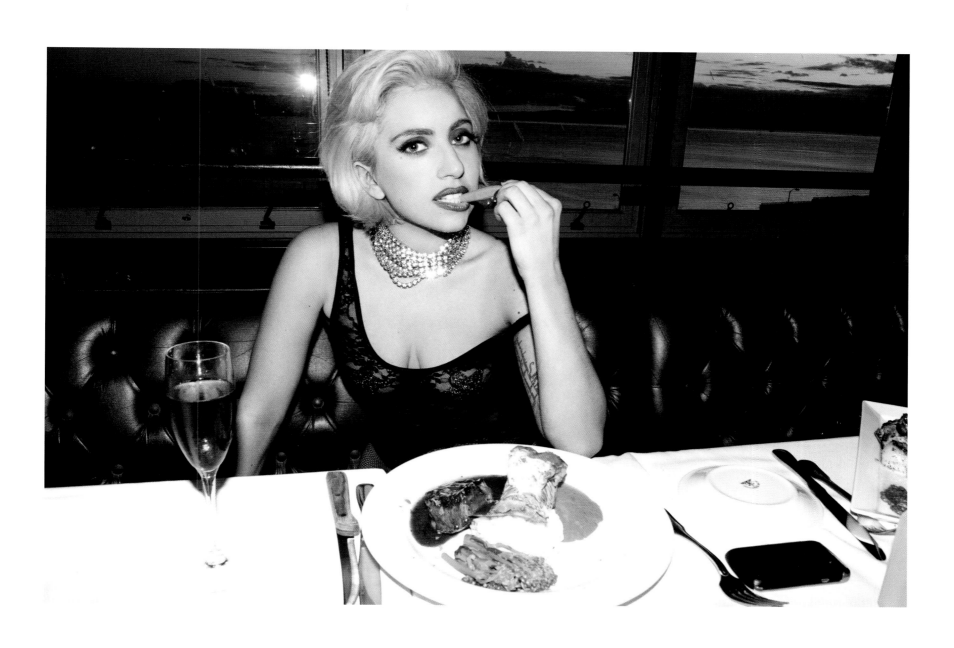

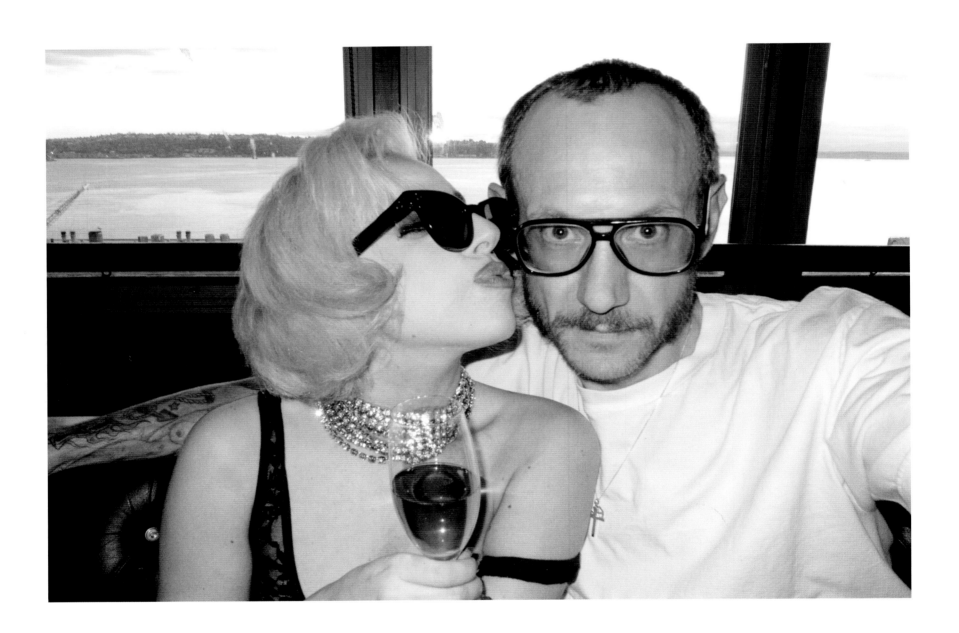

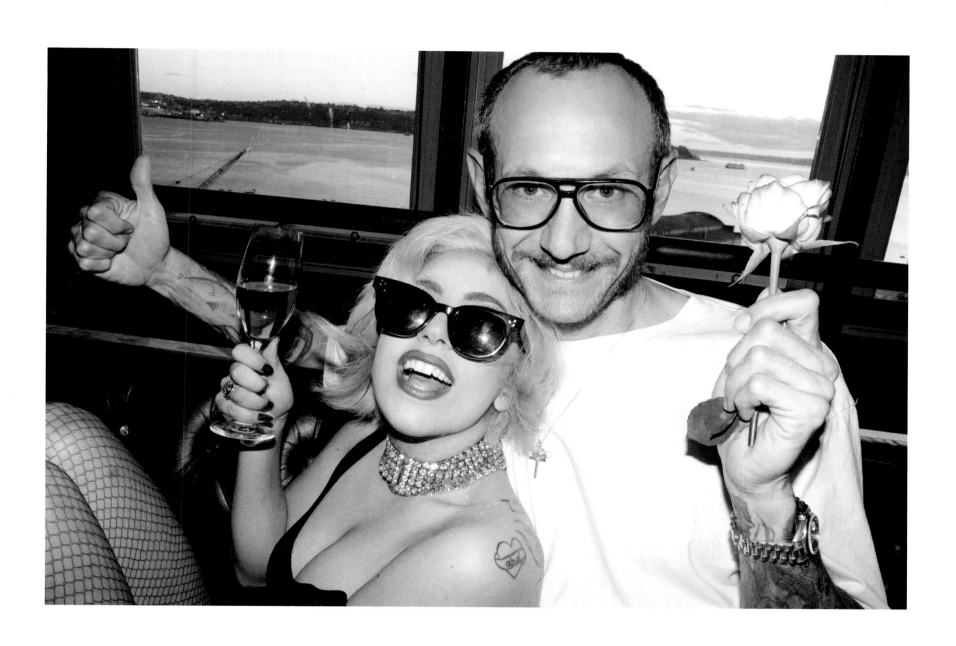

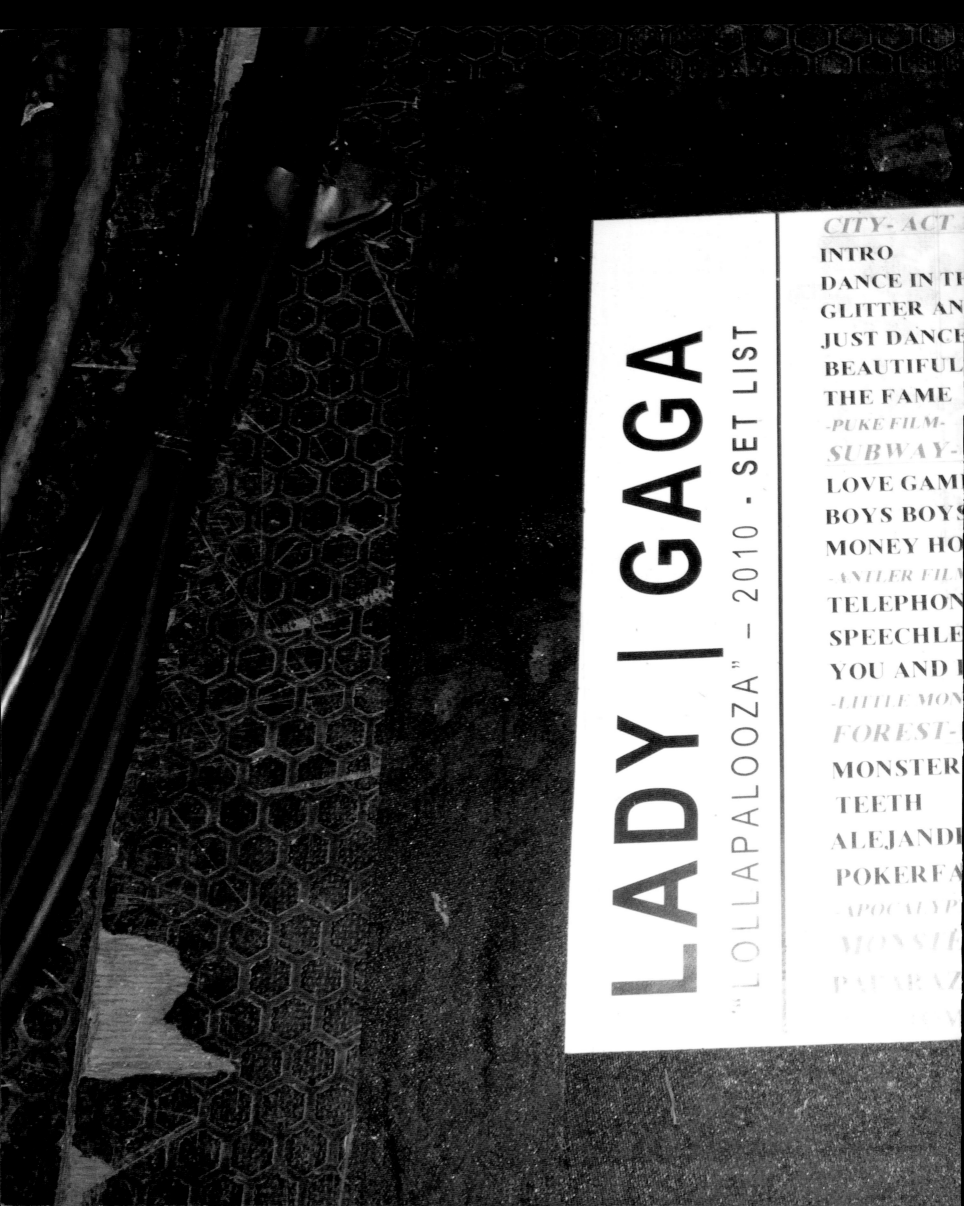

LADY | | GAGA

"LOLLAPALOOZA" – 2010 · SET LIST

CITY- ACT
INTRO
DANCE IN T
GLITTER AN
JUST DANCE
BEAUTIFUL
THE FAME
-PUKE FILM-
SUBWAY-
LOVE GAM
BOYS BOYS
MONEY HO
-ANTLER FILM
TELEPHON
SPEECHLE
YOU AND
-LITTLE MON
FOREST-
MONSTER
TEETH
ALEJANDI
POKERFA
APOCALYP
MONSTE
PAPARAZ

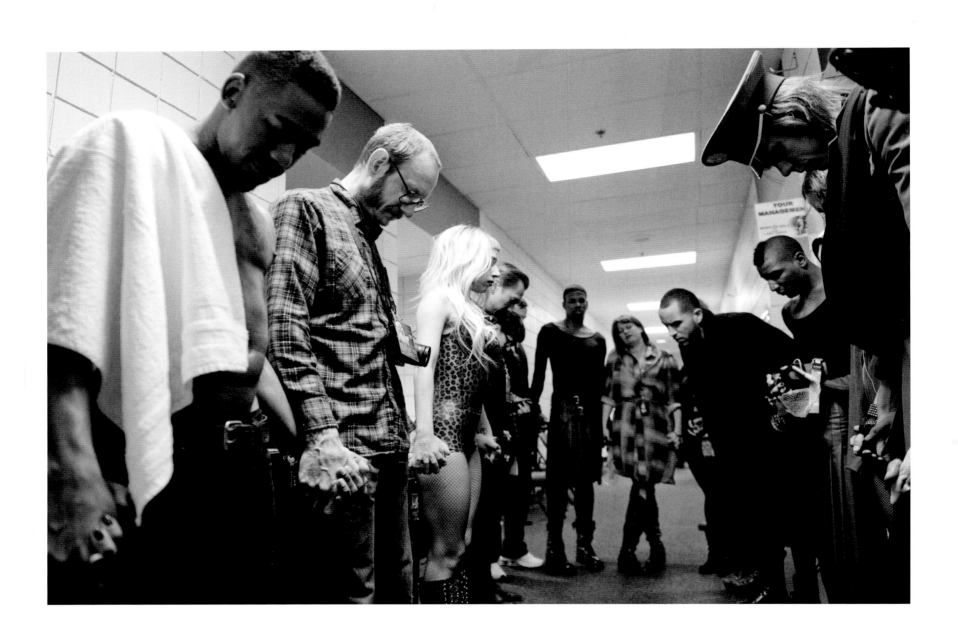

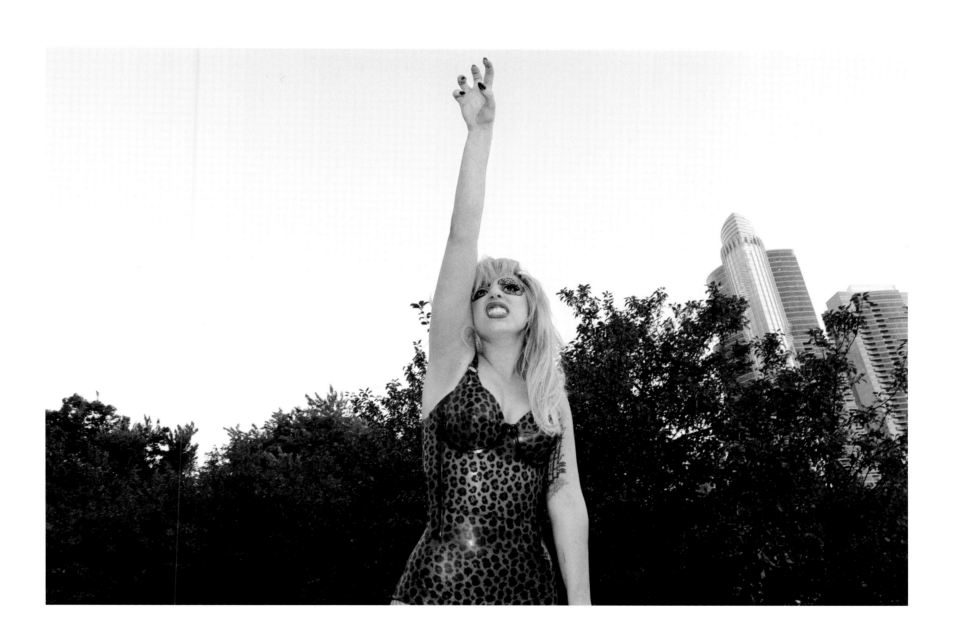

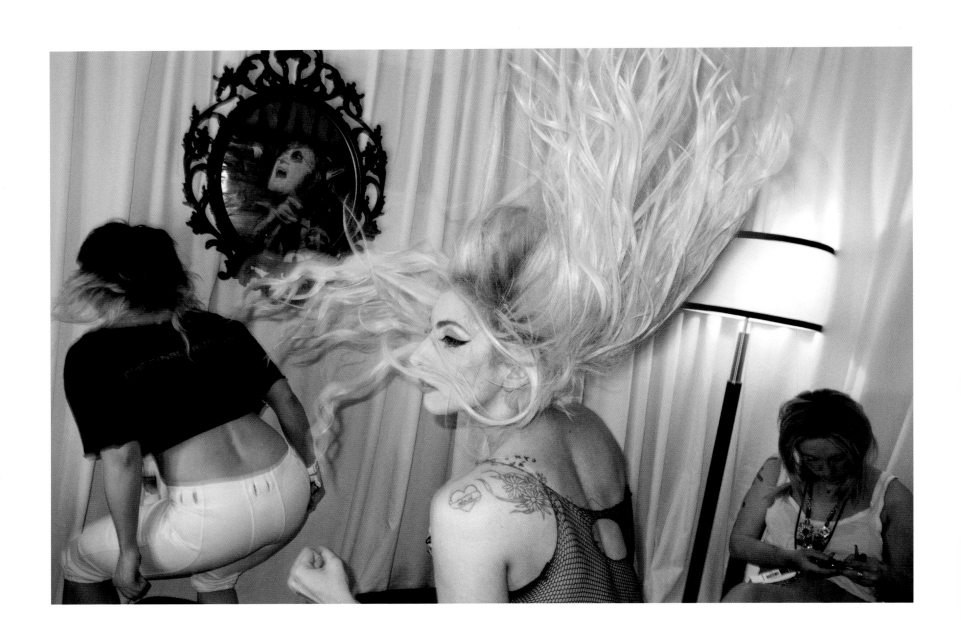

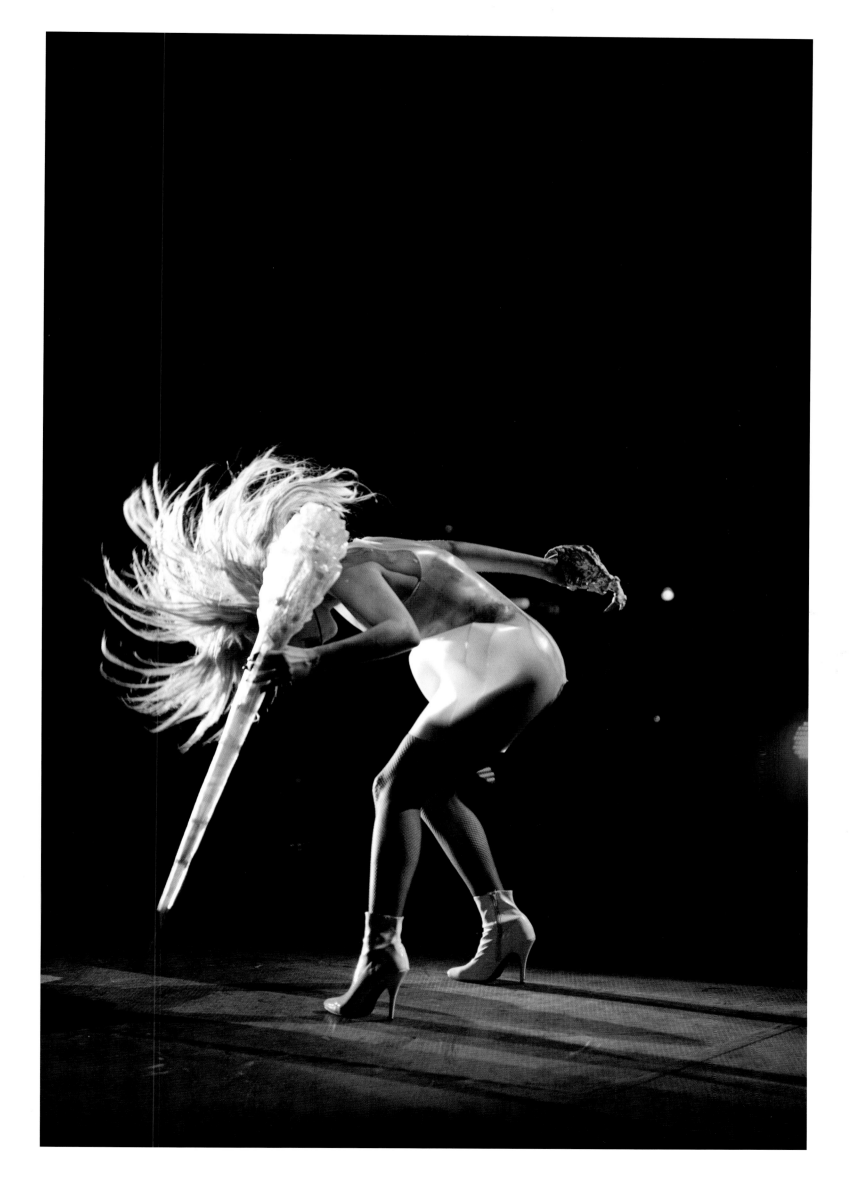

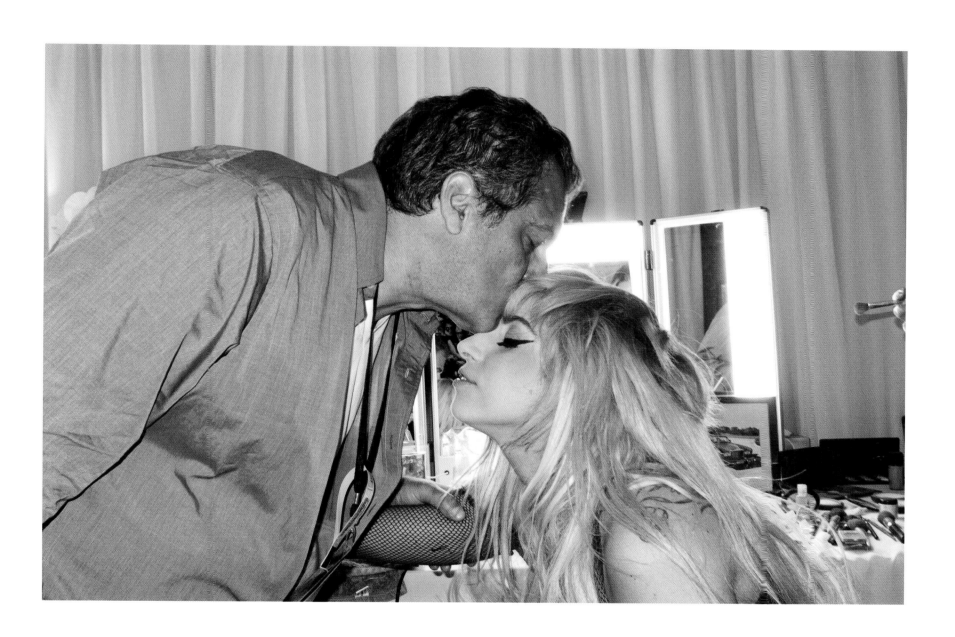

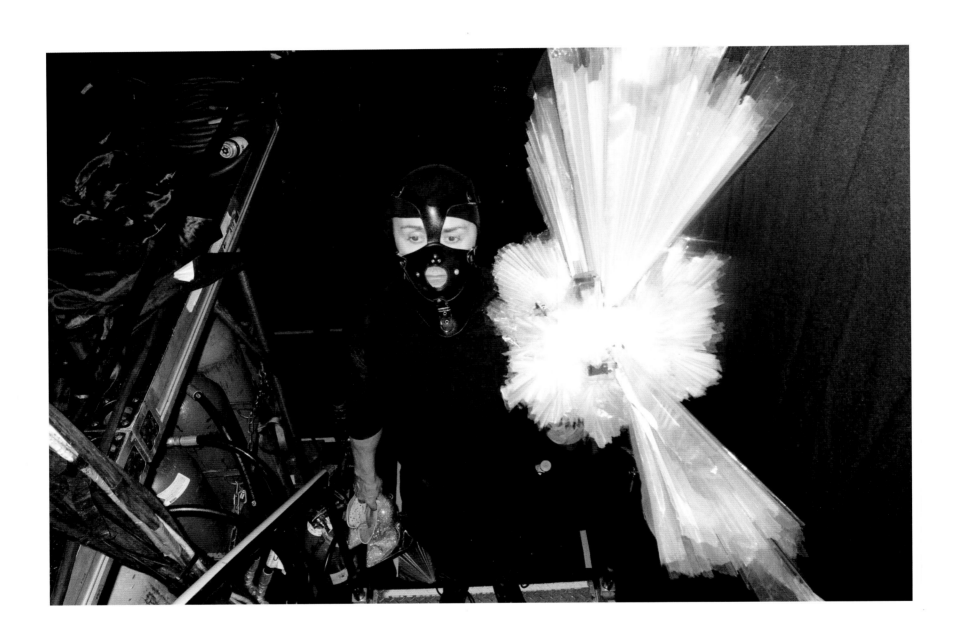

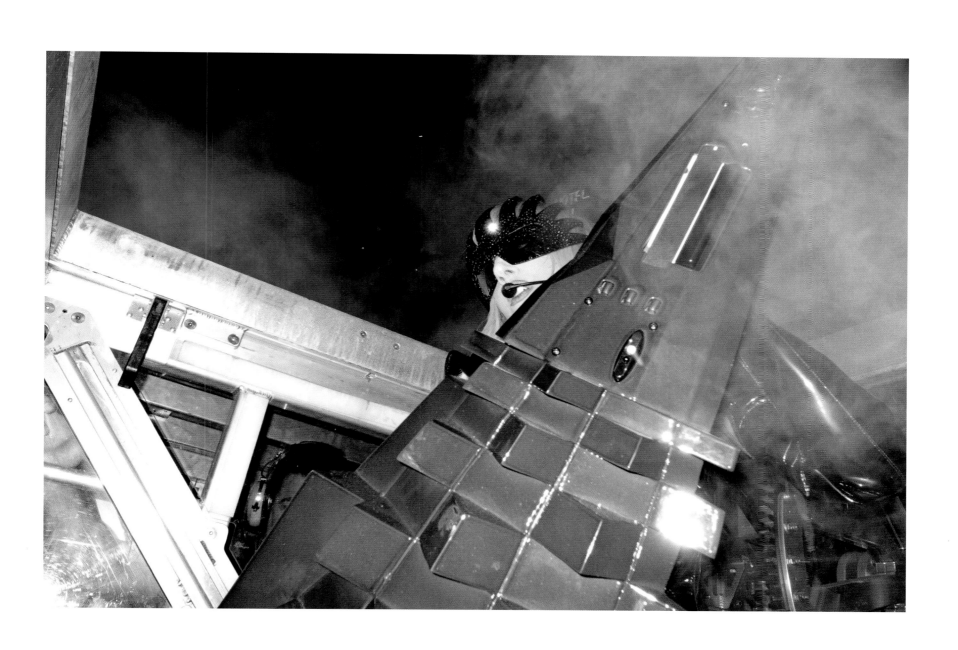

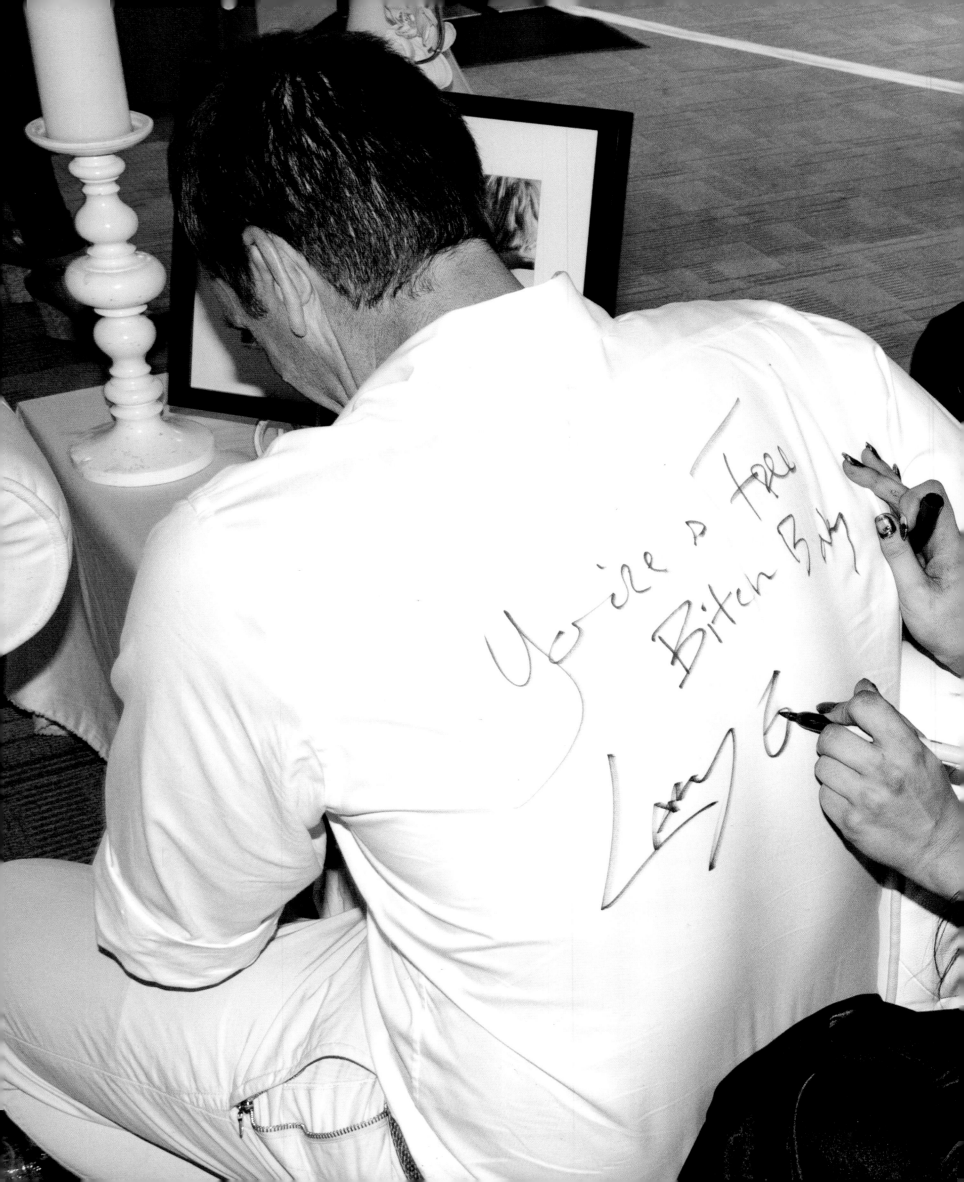

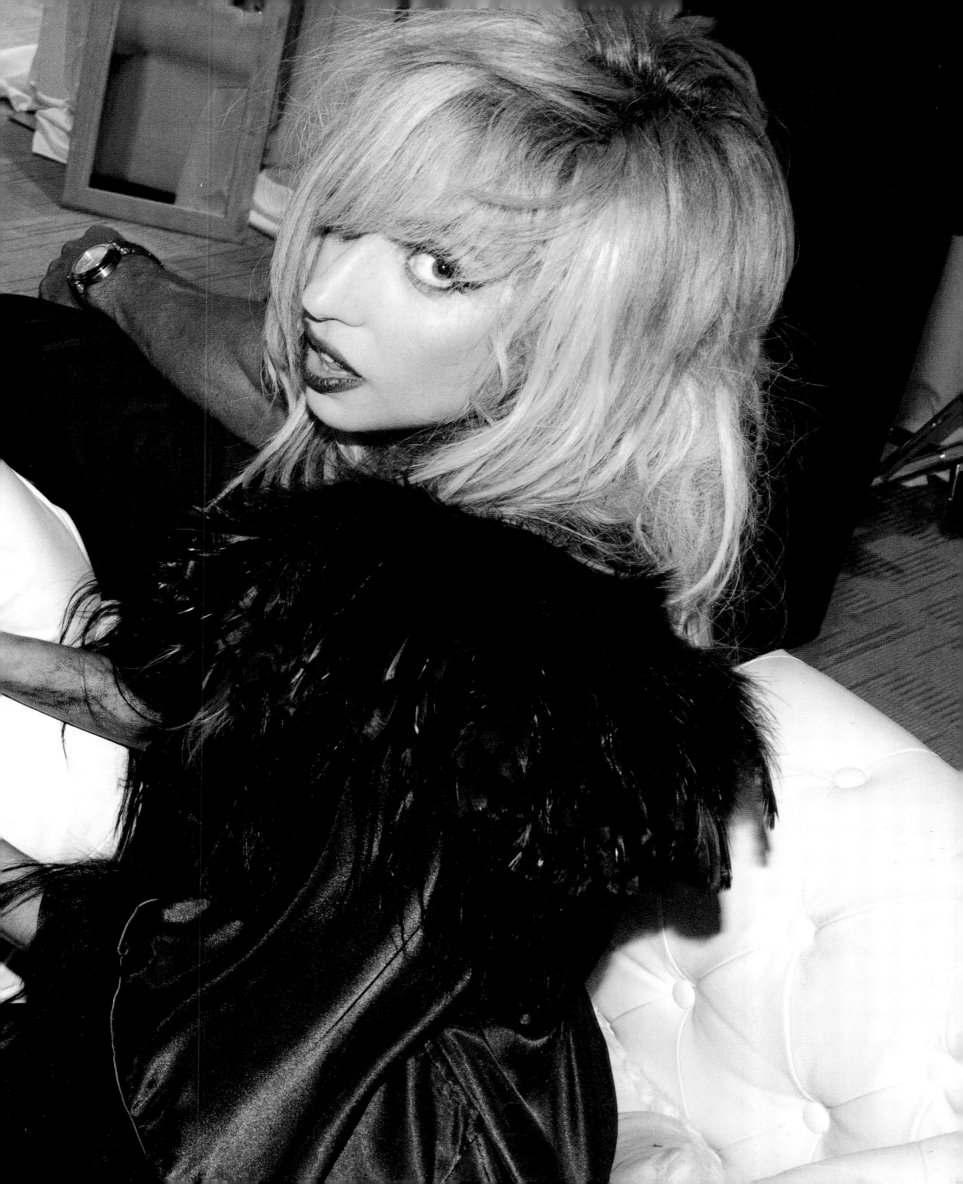

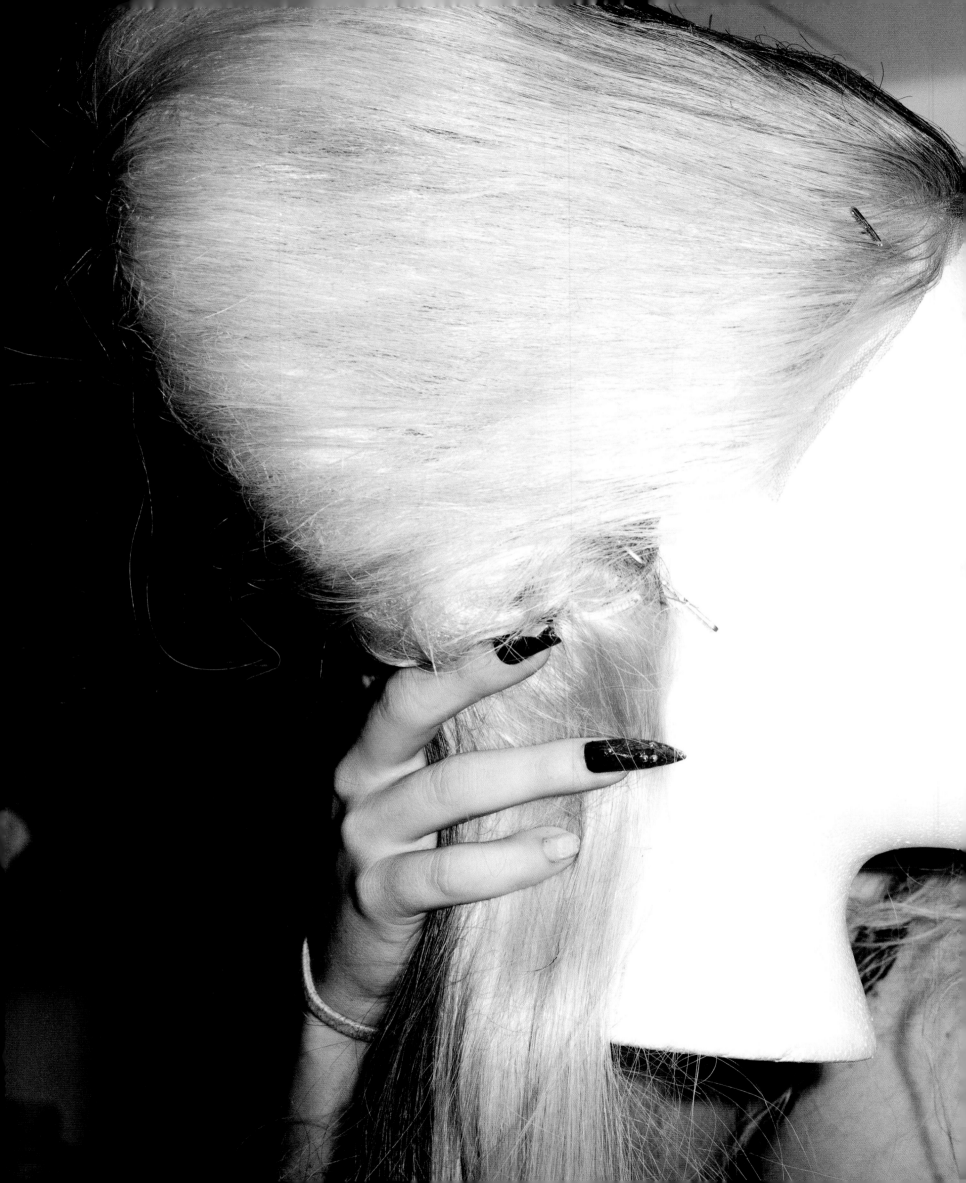

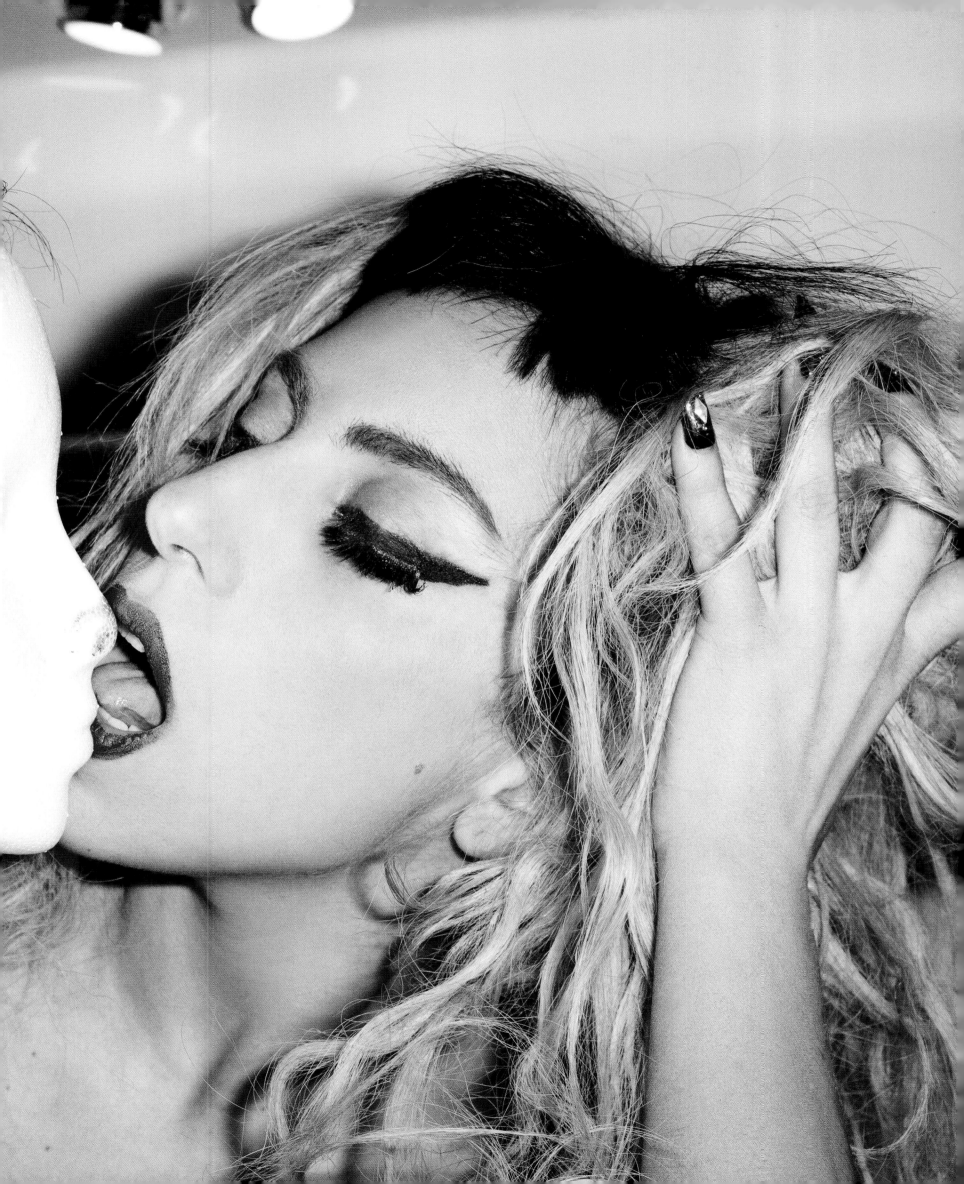

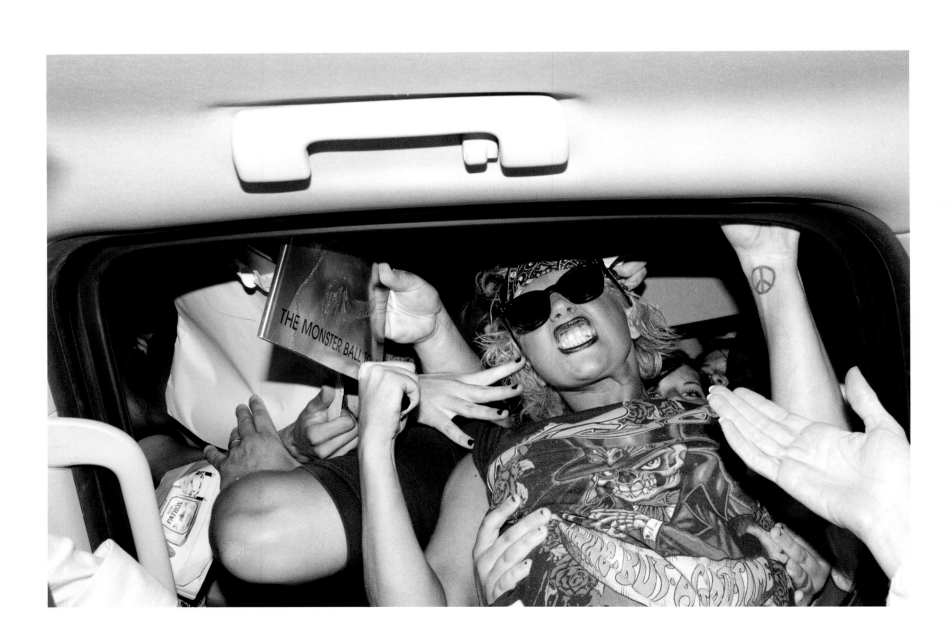

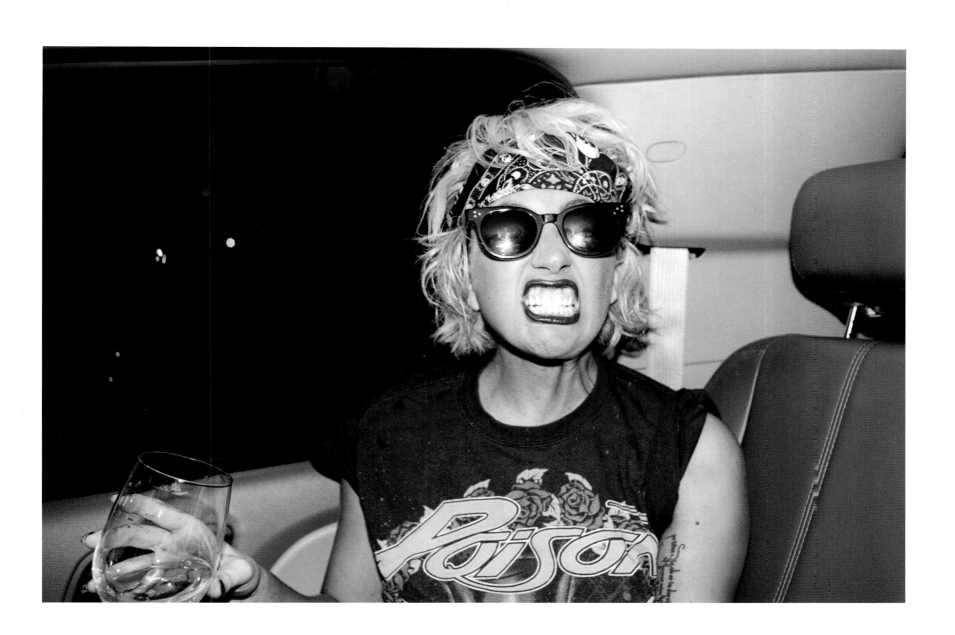

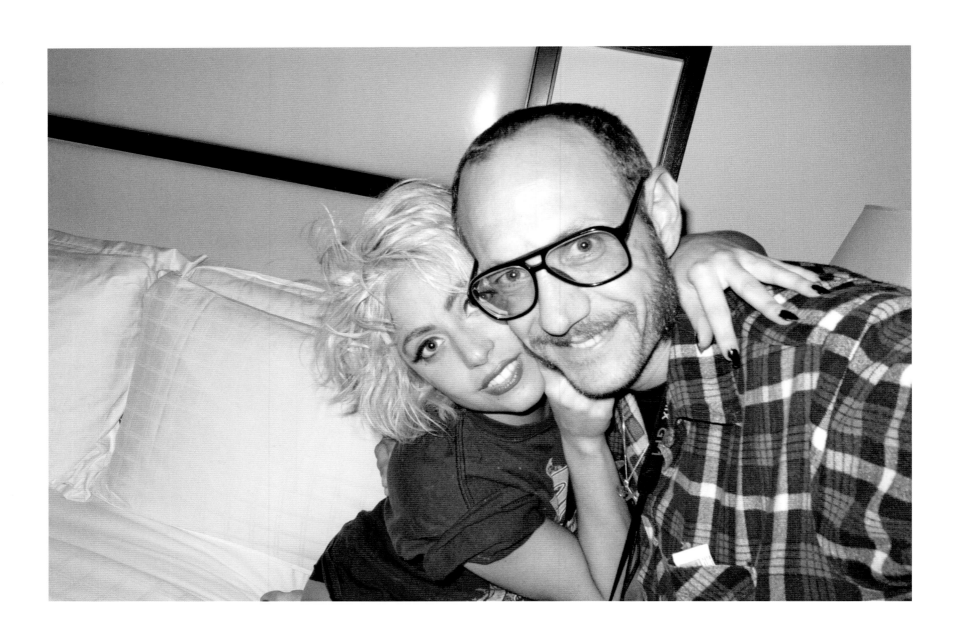

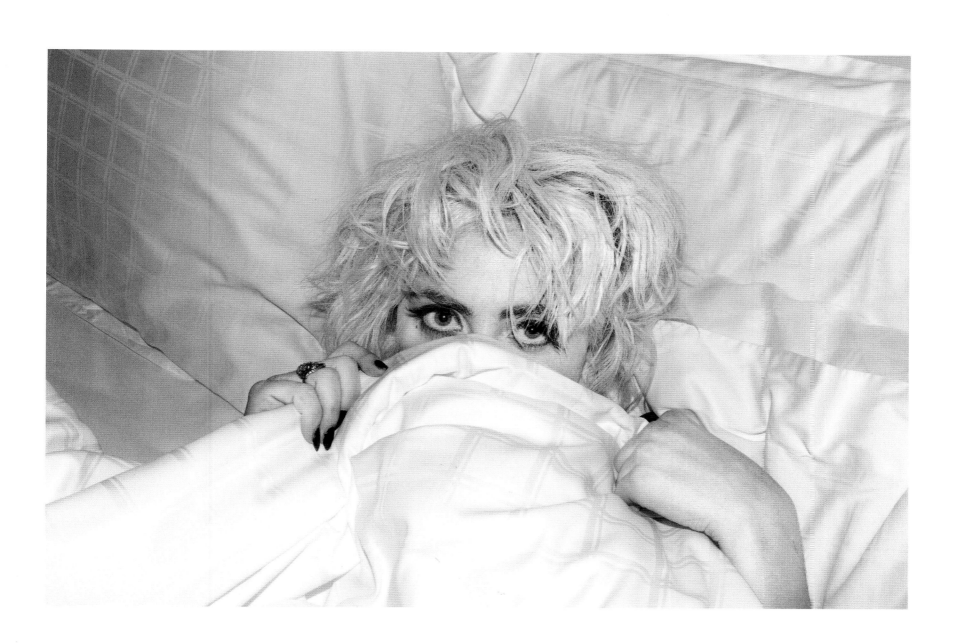

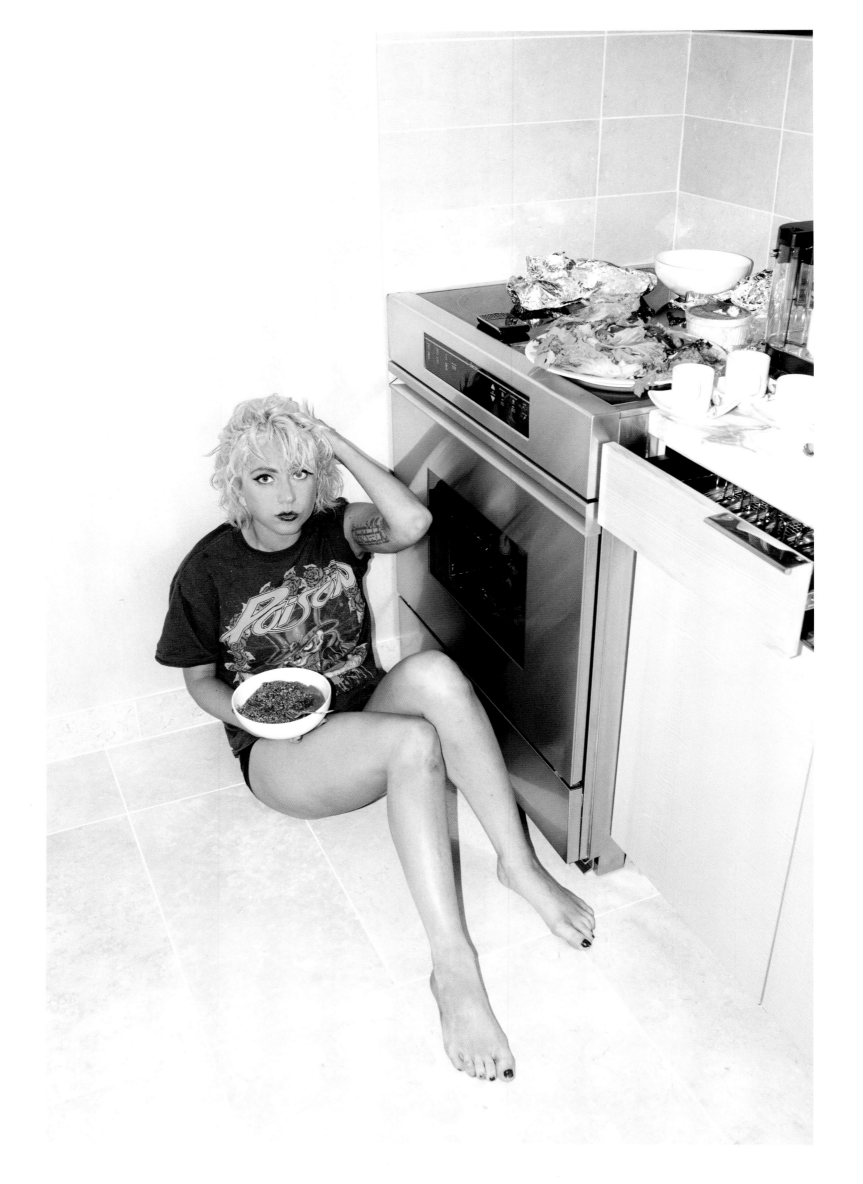

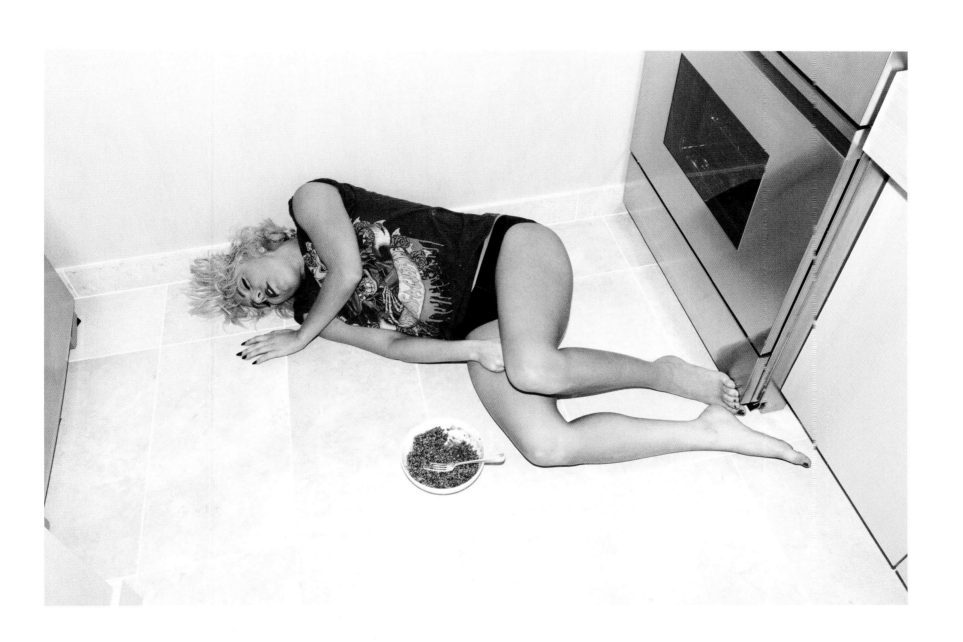

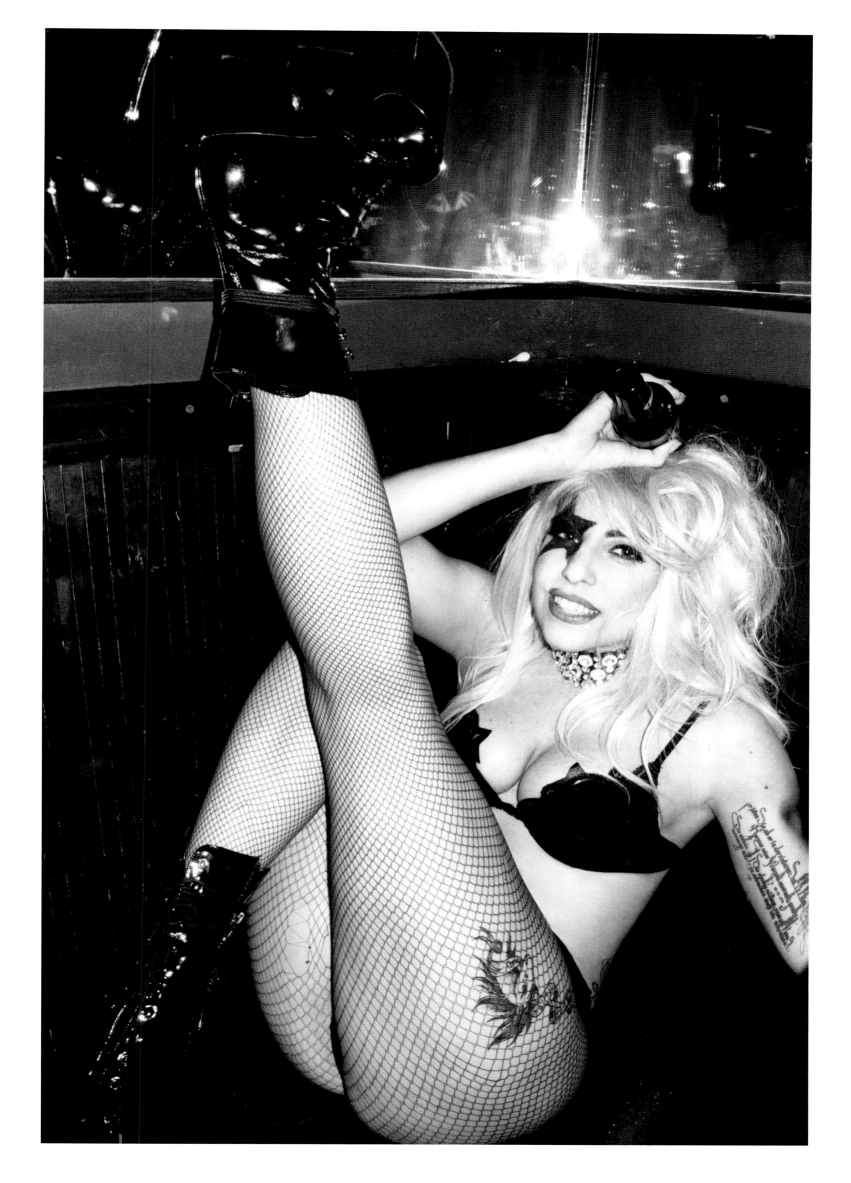

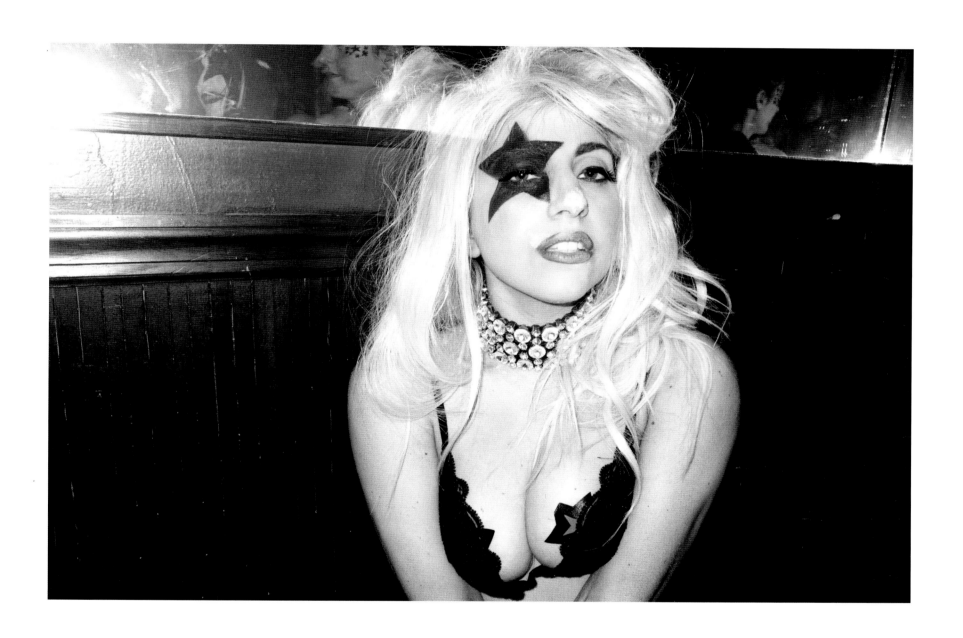

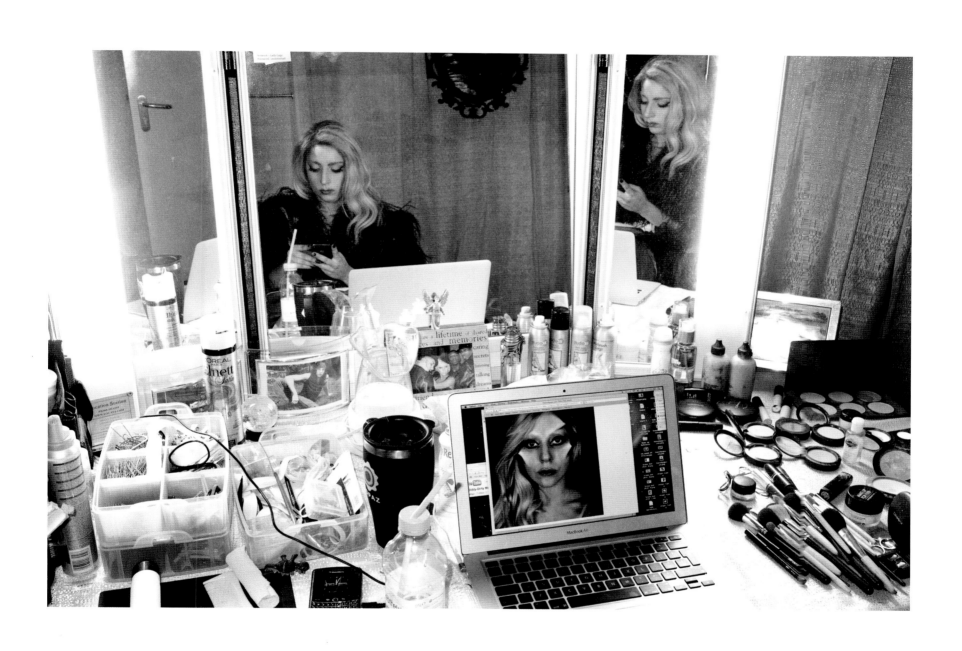

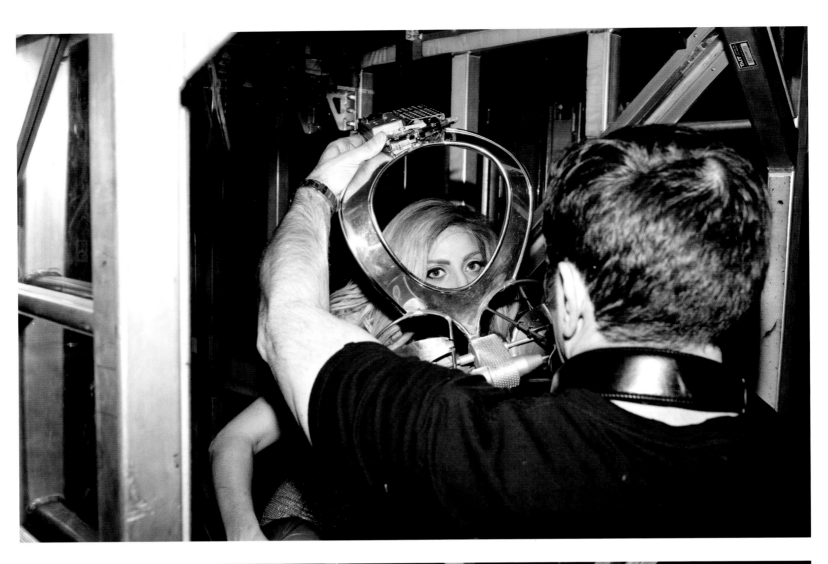
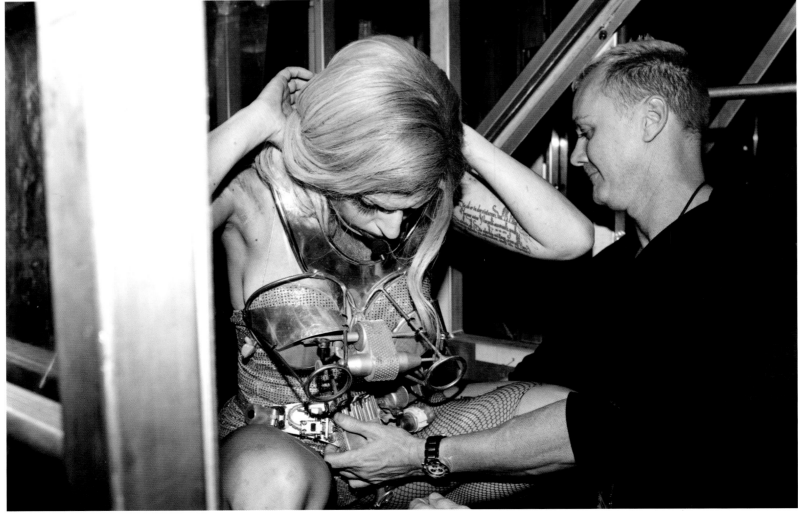

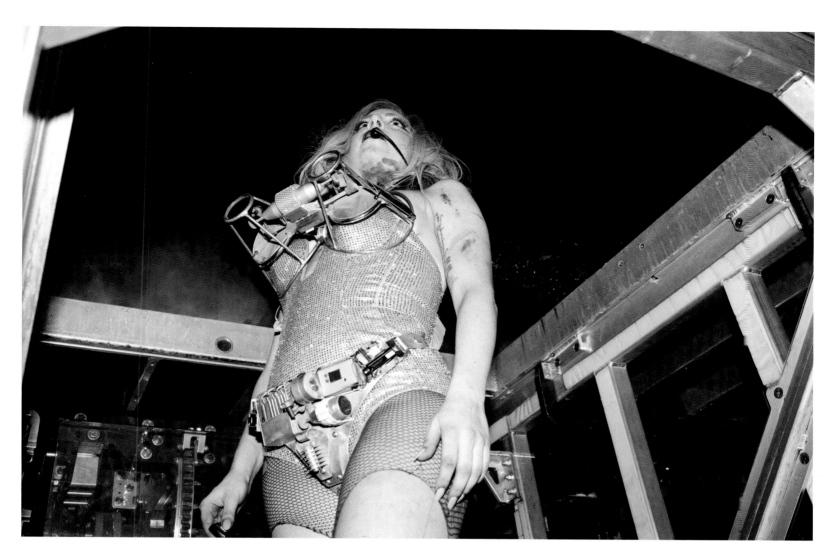
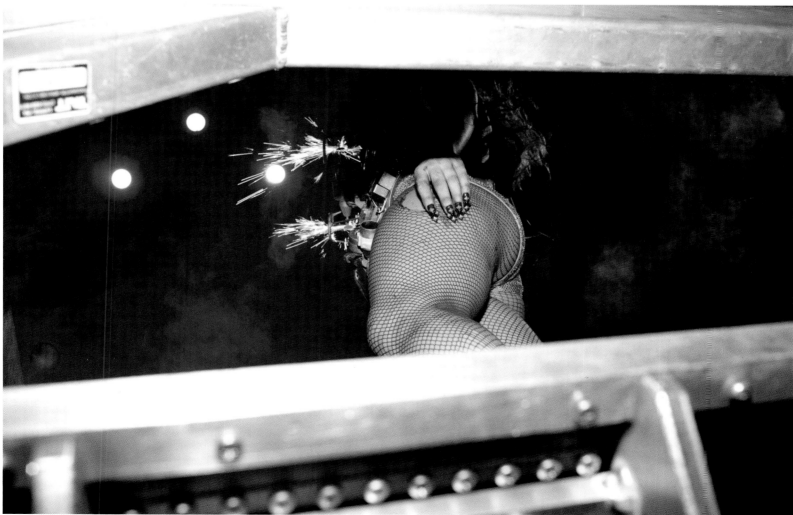

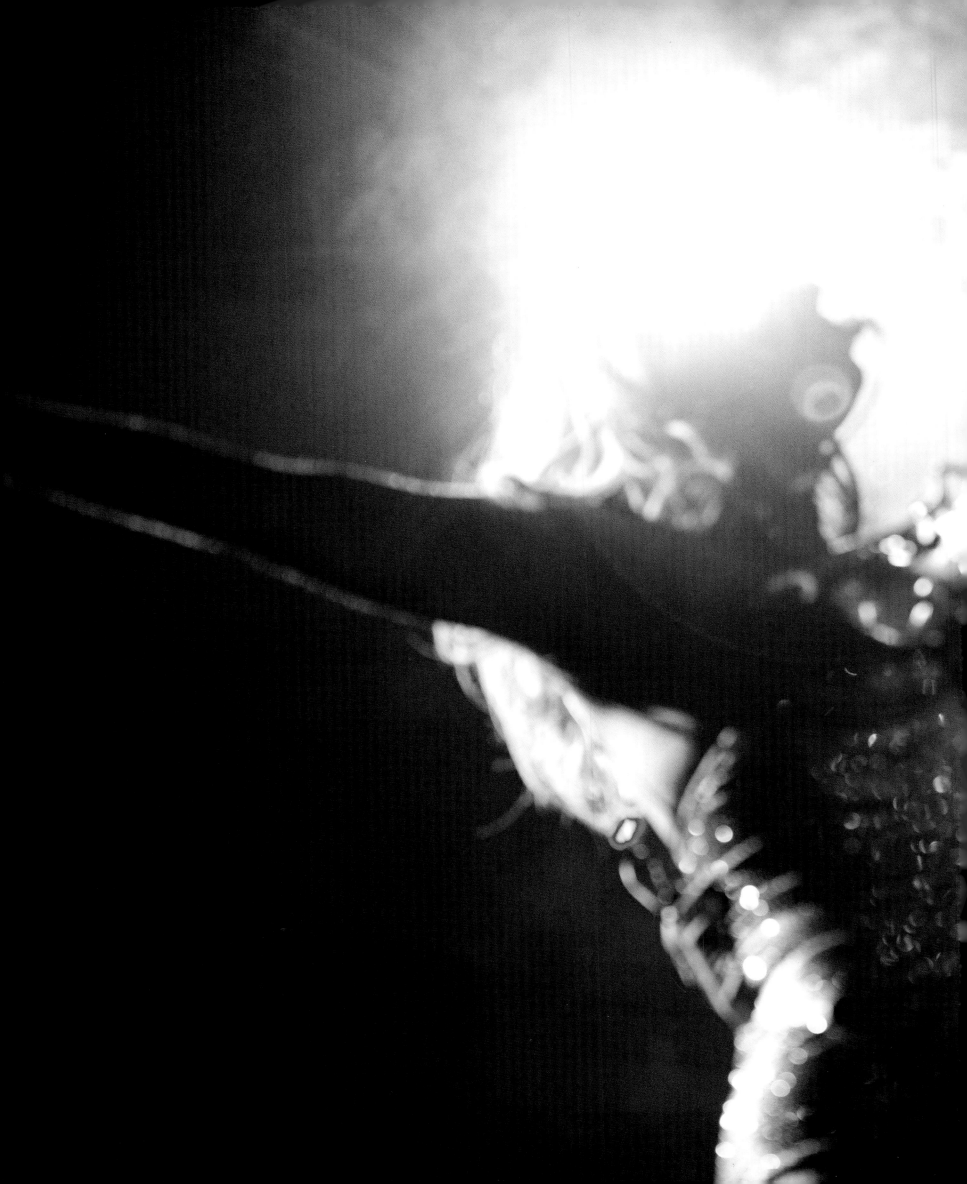

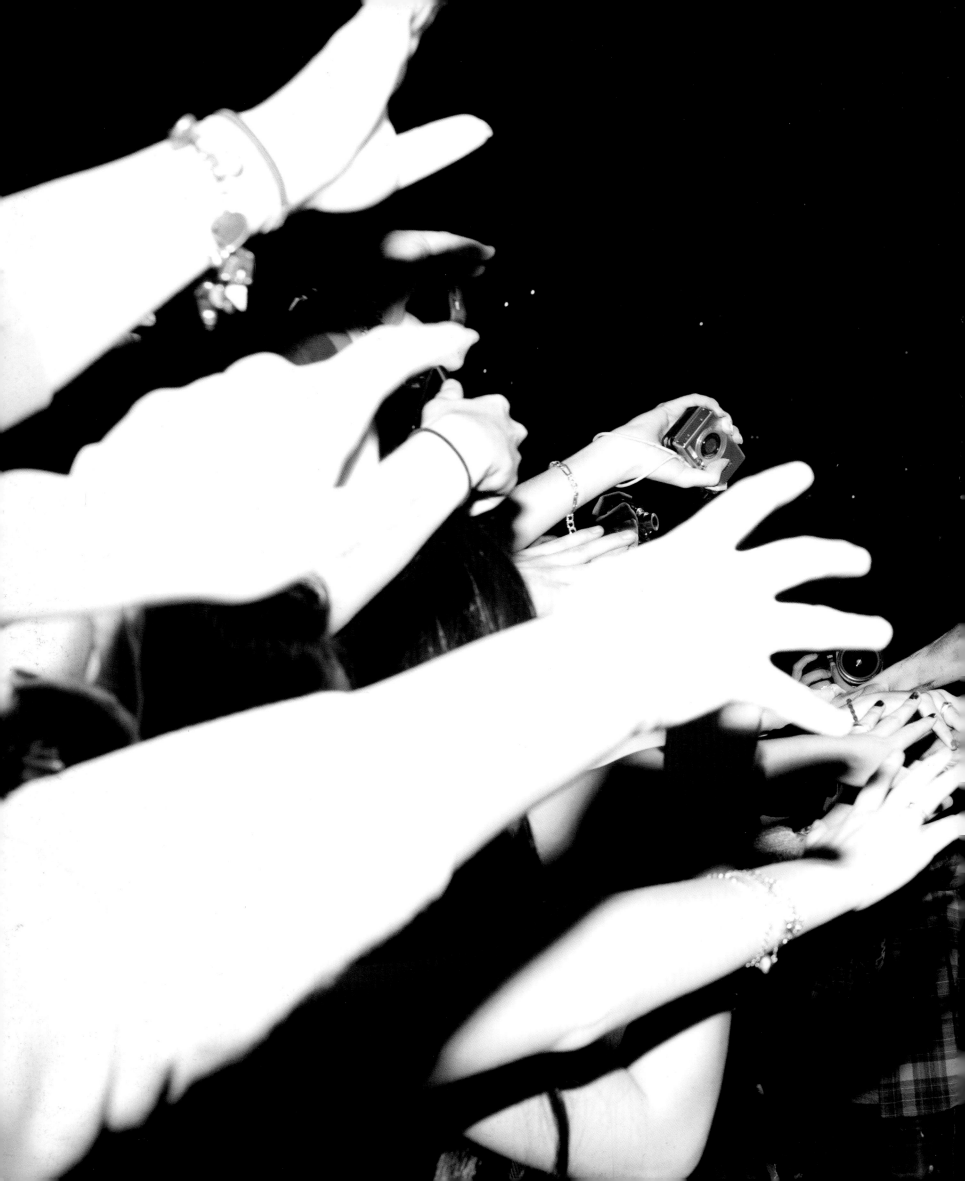

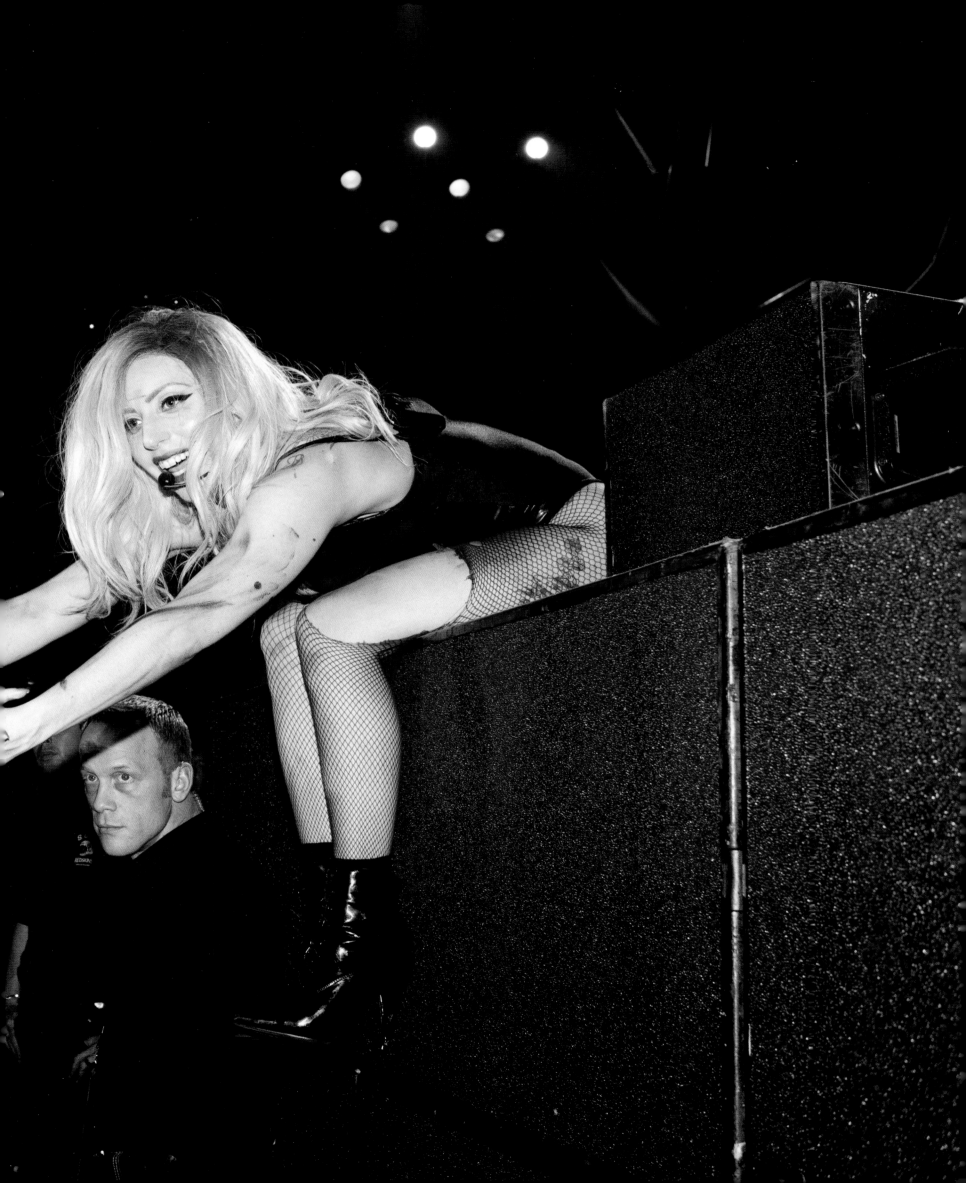

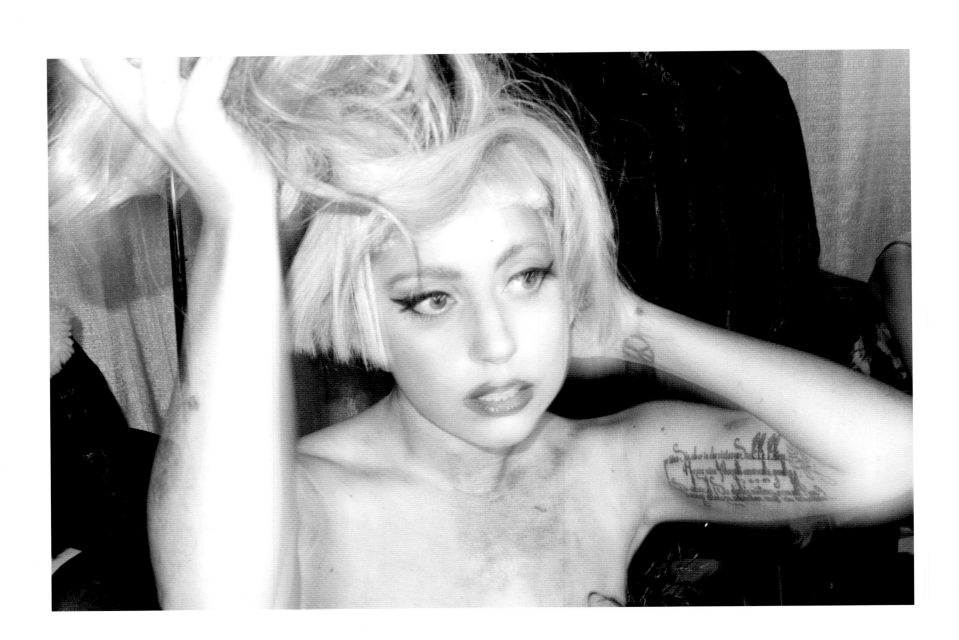

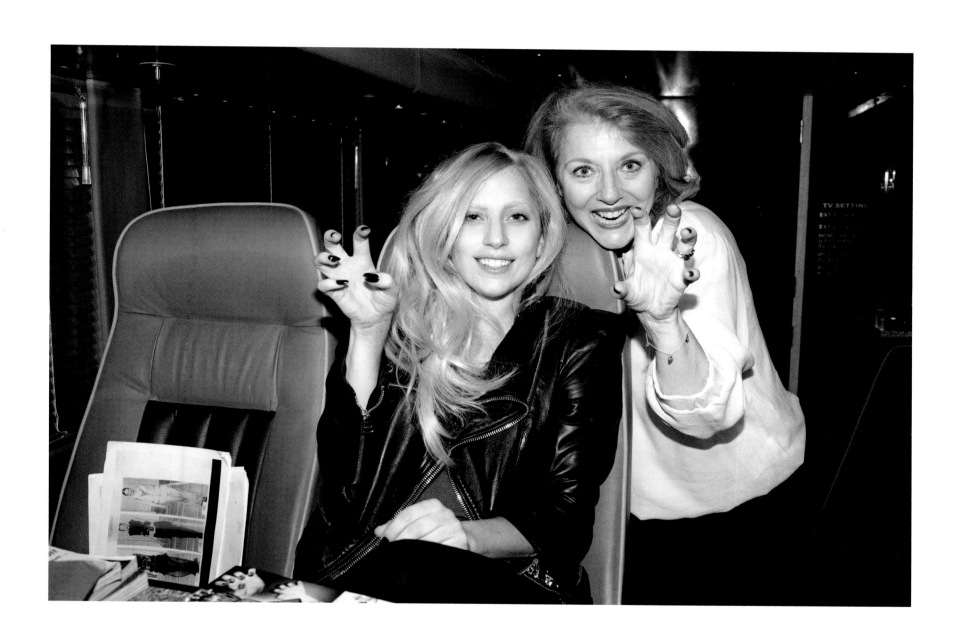

To my fellow Americans, and youth all over the world who are watching.
"Don't" Ask Don't Tell" is A law that was created in 1993, that prevents gays from serving OPENLY in the Military. Since then 14,000
Americans have been discharged from the Armed Forces, refused the
right to serve their country, and sent home regardless of honorable service or how valuable they may have been to their units. 400 soldiers under President Obama's administration alone were discharged
under Don't Ask Don't Tell. ADVOCACY by ORGANIZATIONS such as the
SLDN: The servicemembers legal defense network, have shown the INCONSISTENT
and unconstitutional enforcement of this law. Don't Ask Don't tell, asks that serving GAY AND LESBIAN soldiers, hide and keep private their
sexual ORIENTATION, under the protection and promise that the government will not ask them to TELL, or disclose their sexuality. SLDN's ADVOCACY prove these soldiers are being searched, superiors are going through their e-mails and private belonging, calling family members, and operating based on ASSUMPTIONS-ultimately the law is being enforced using gay-profiling, and gay soldiers have become Targots - WHAT IS THIS WORD?]. In short, not only is the law
UNCONSTITUTIONAL, but its not even being properly or fairly enforced by
the government. OUR FIGHT IS PART OF THE CIVIL RIGHTS MOVEMENT, to abolish laws
that harbor hatred and discrimination. Unfair Laws that like, DONT ASK
DONT TELL, were put in place to eliminate friction and violence, but only delays the process of ending this most serious prejudice.

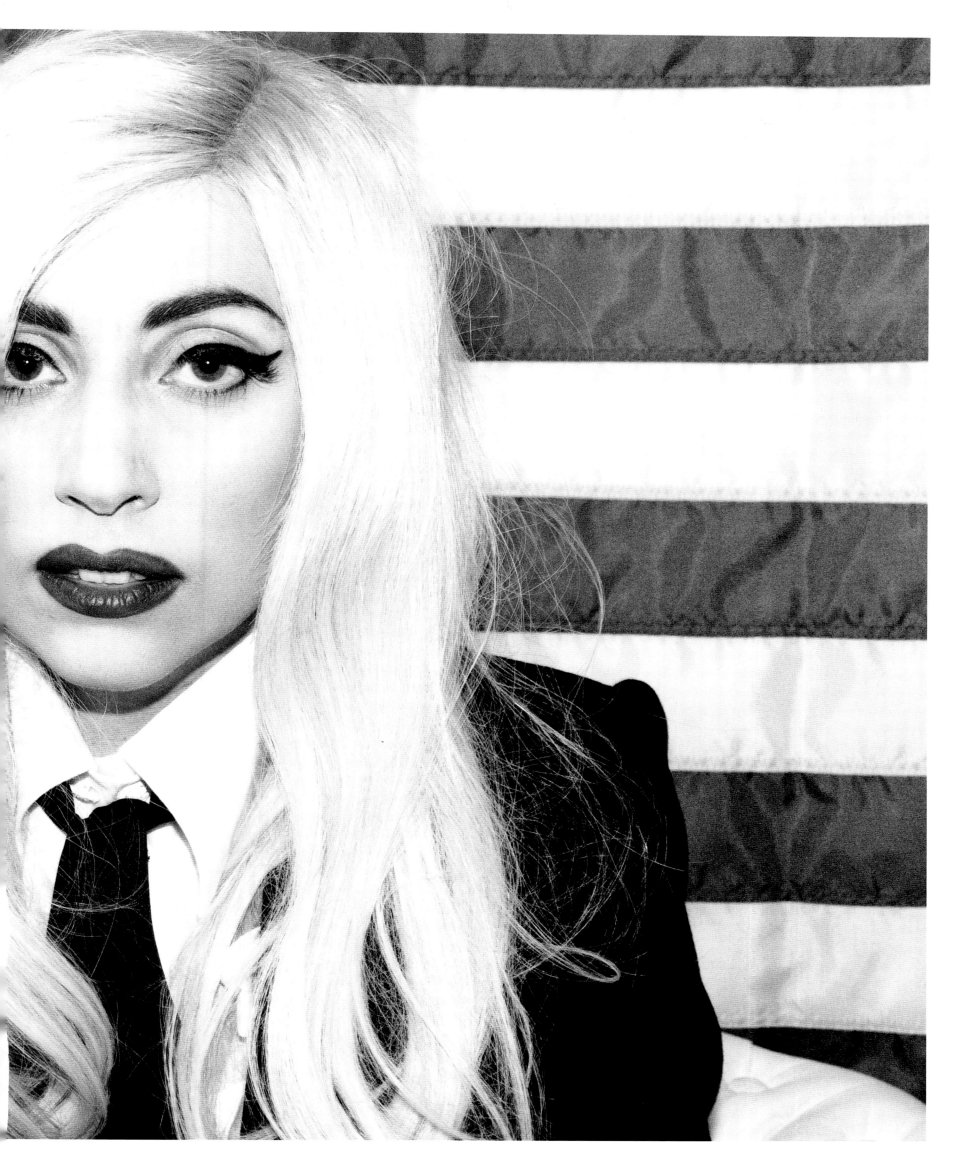

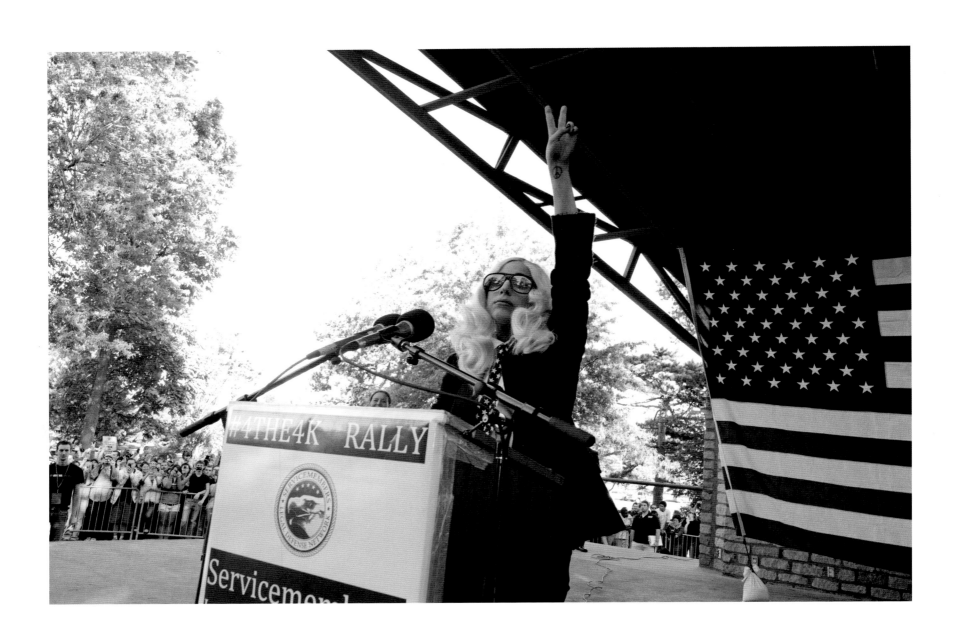

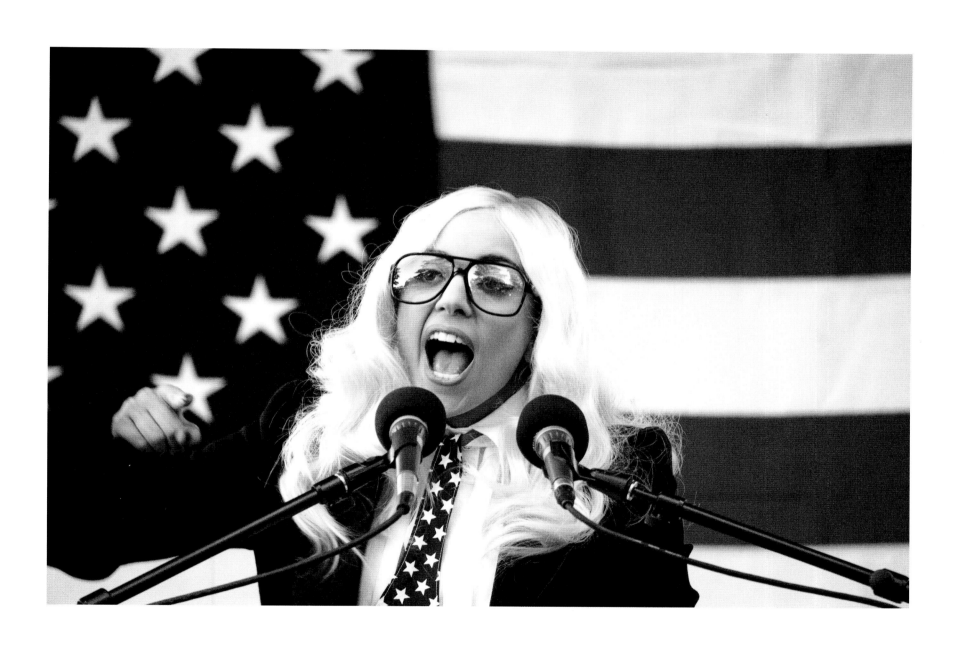

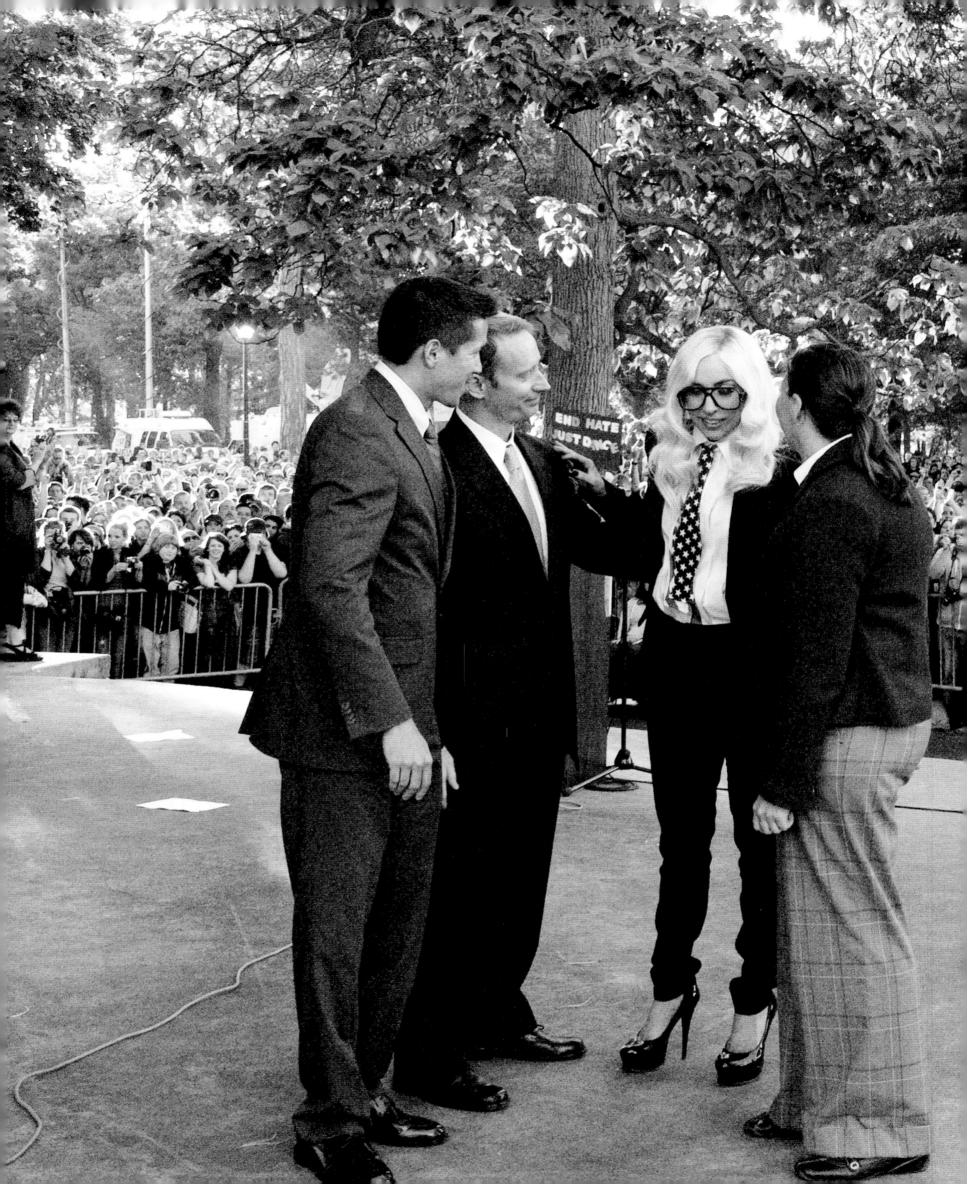

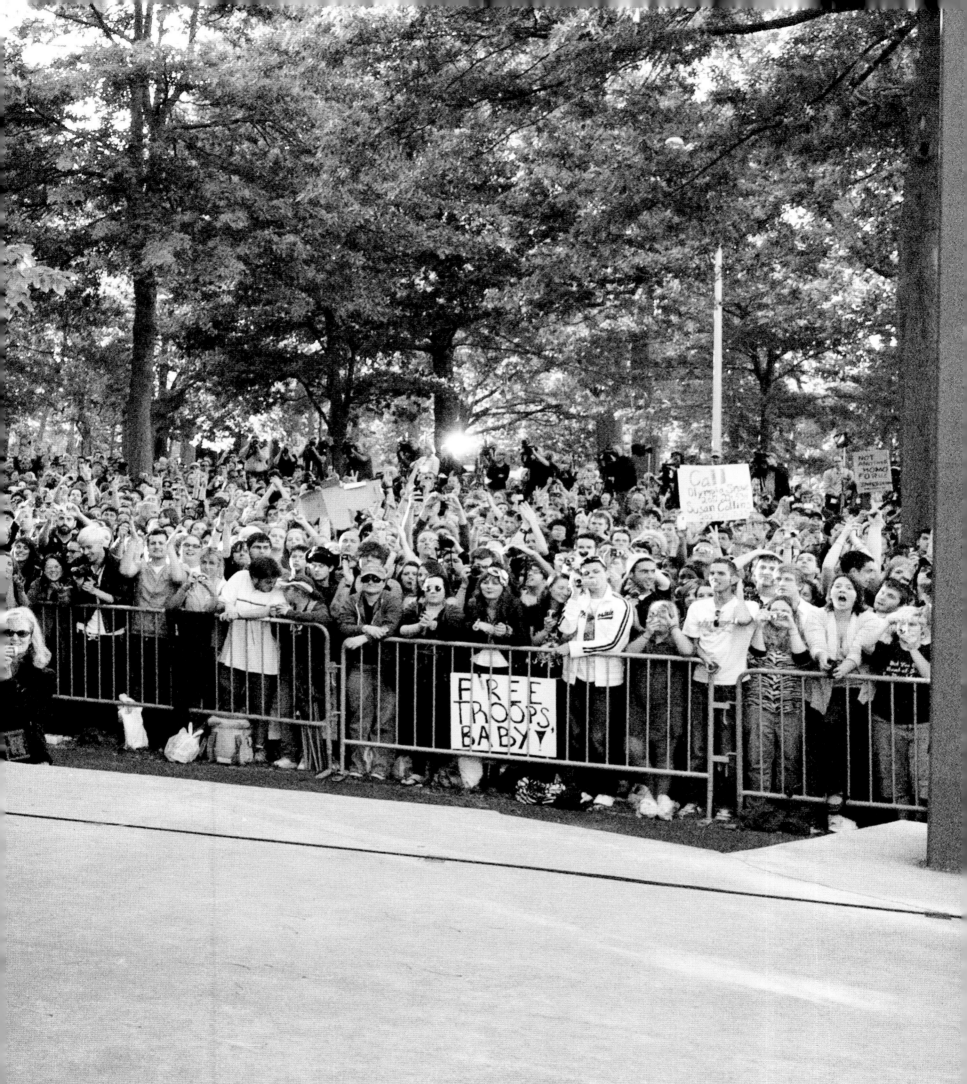

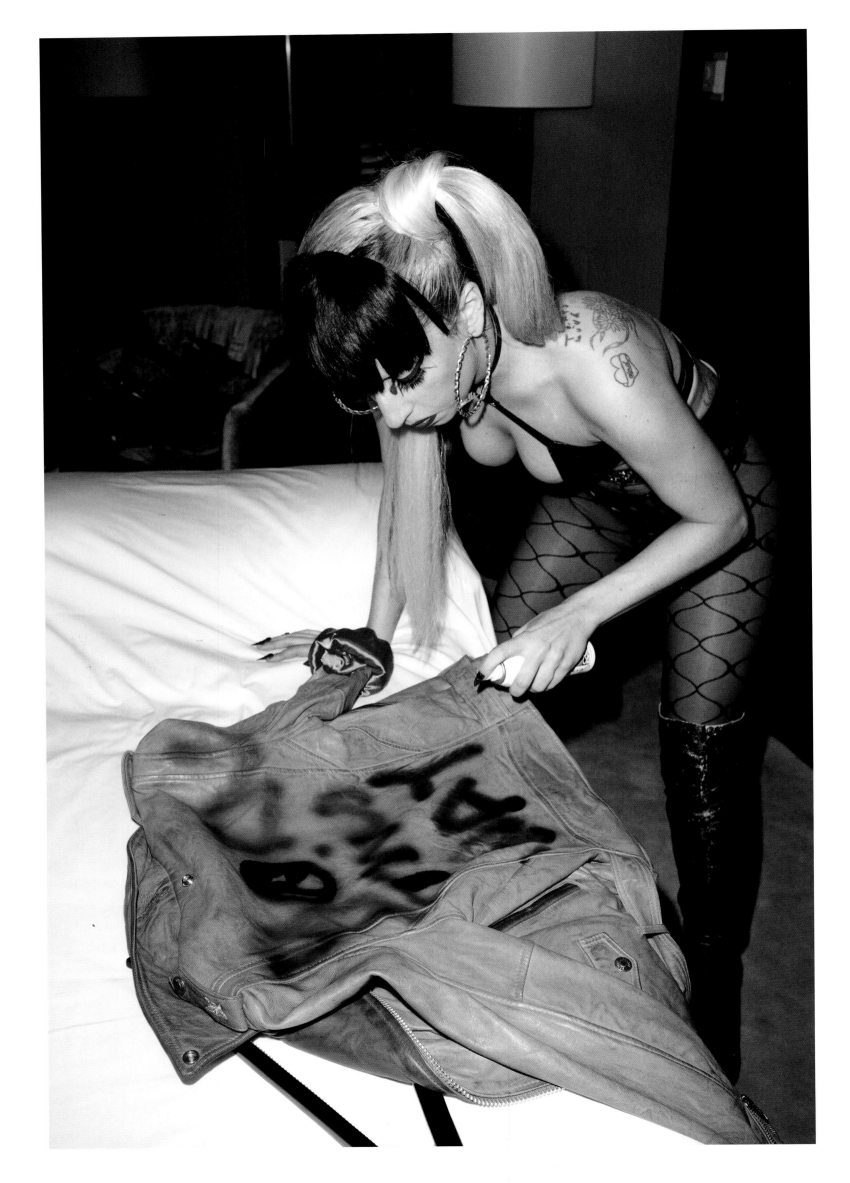

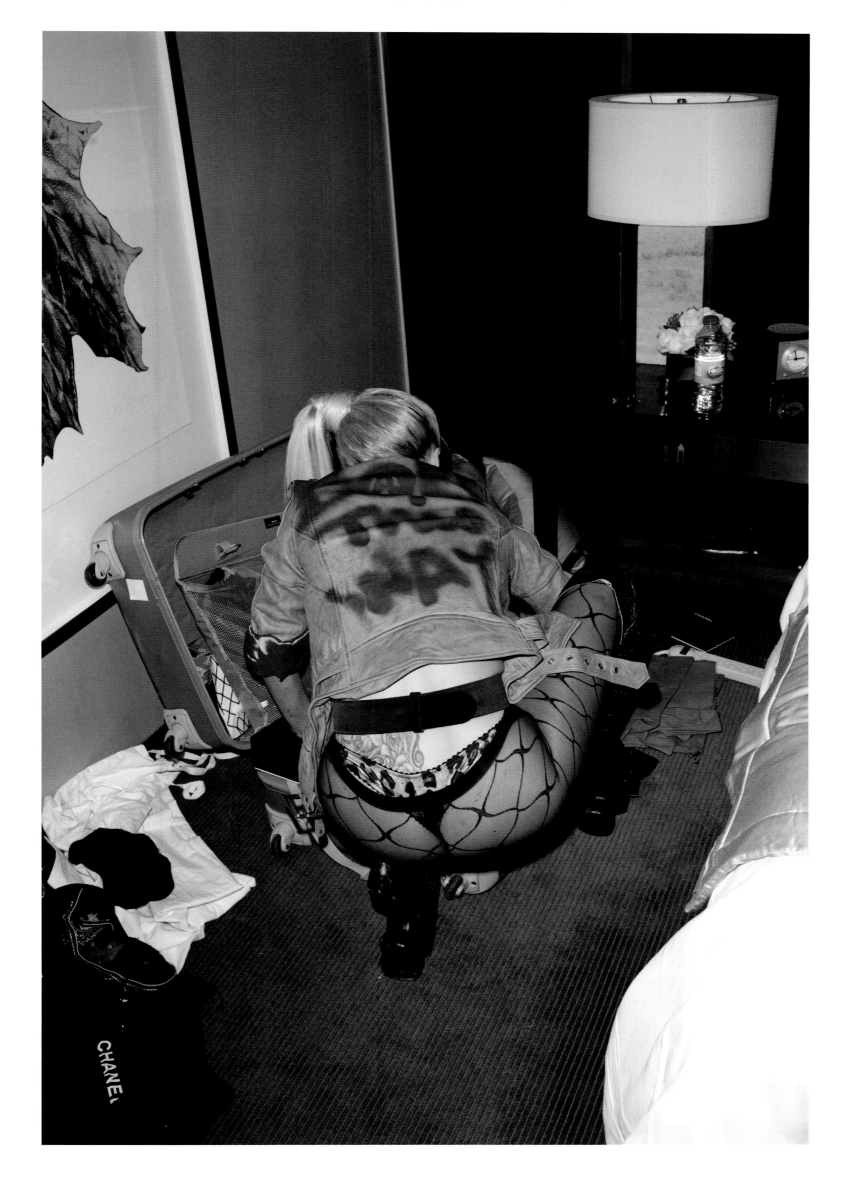

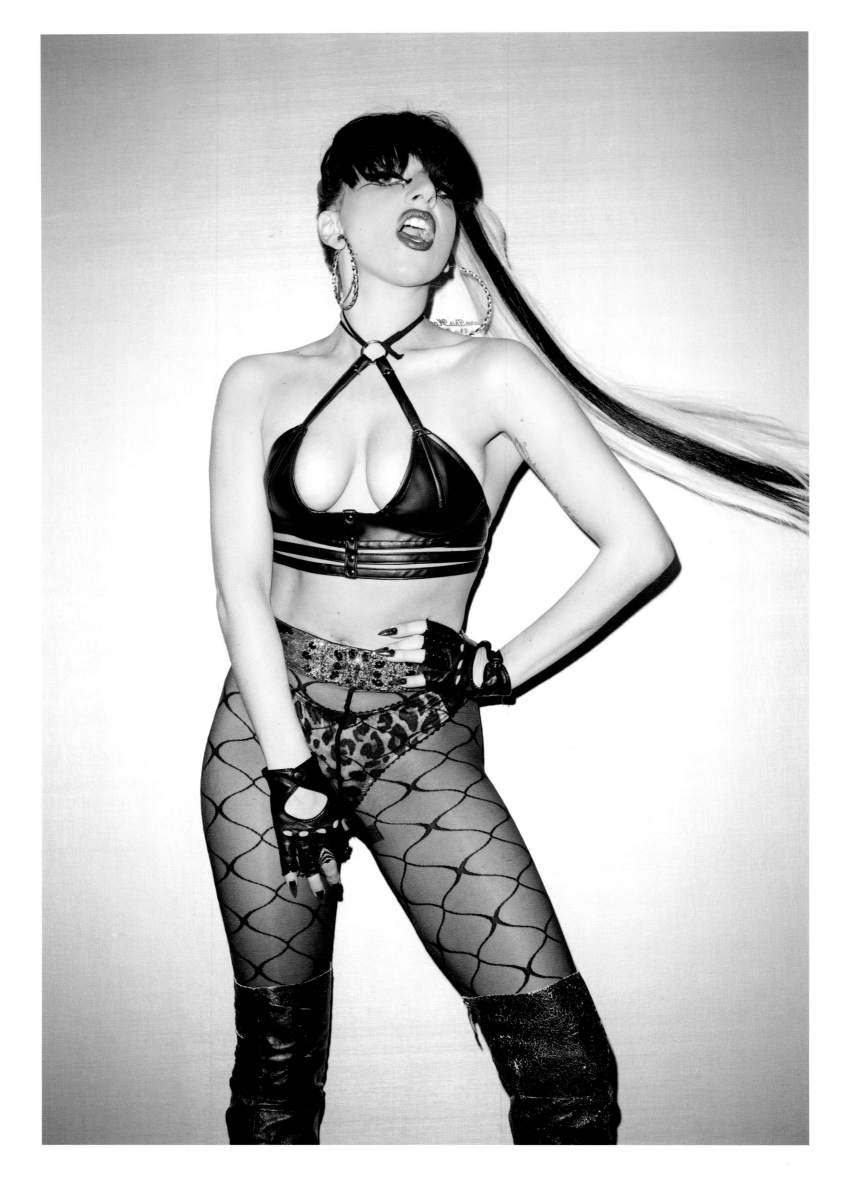

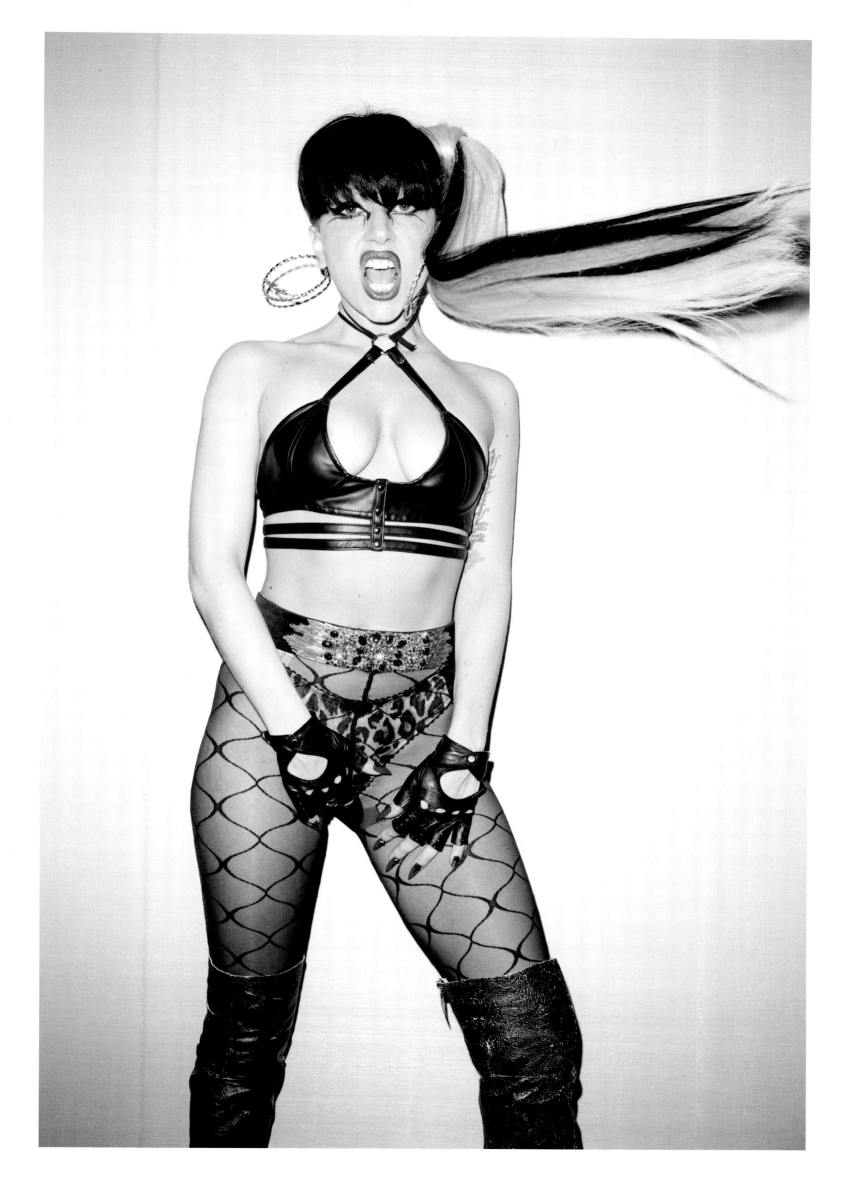

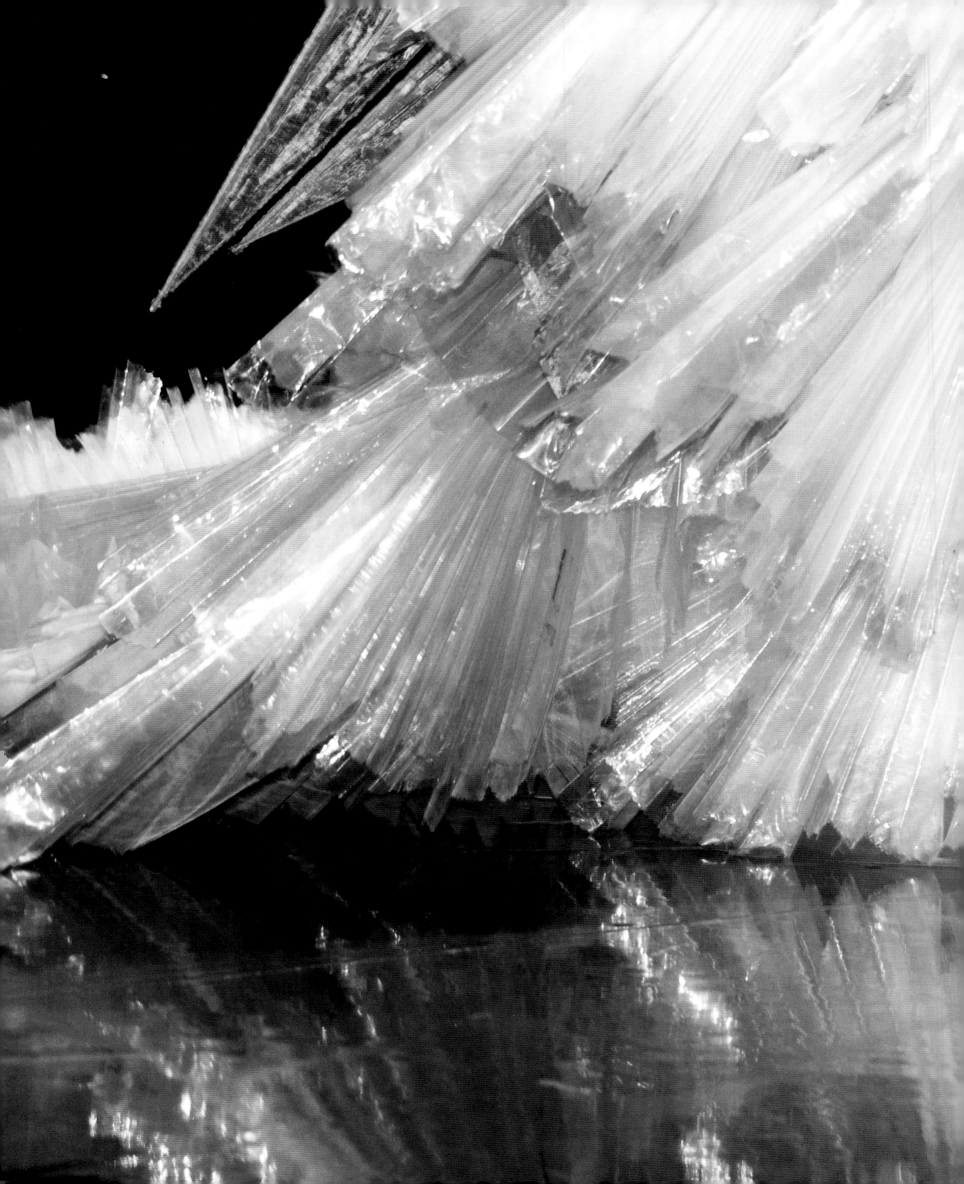

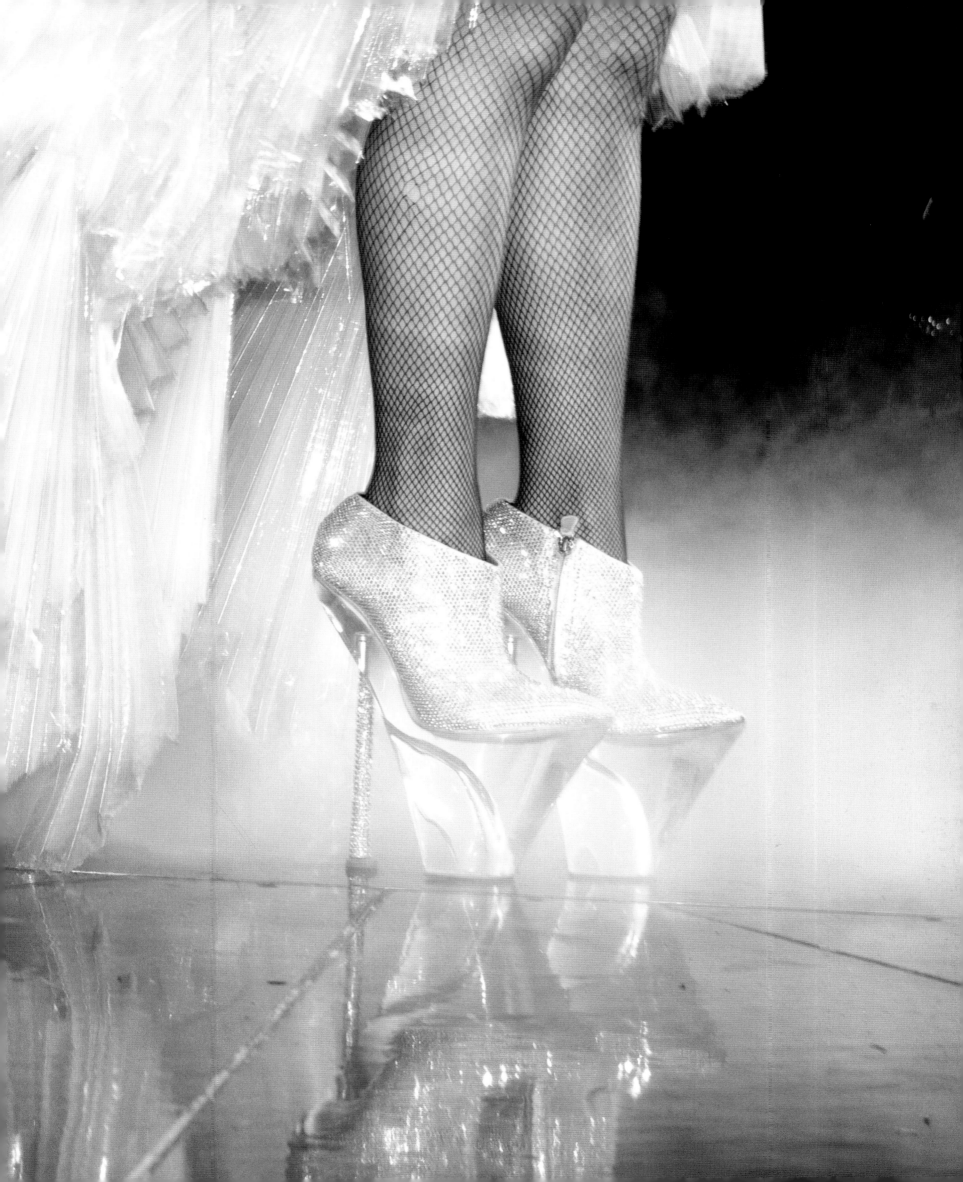

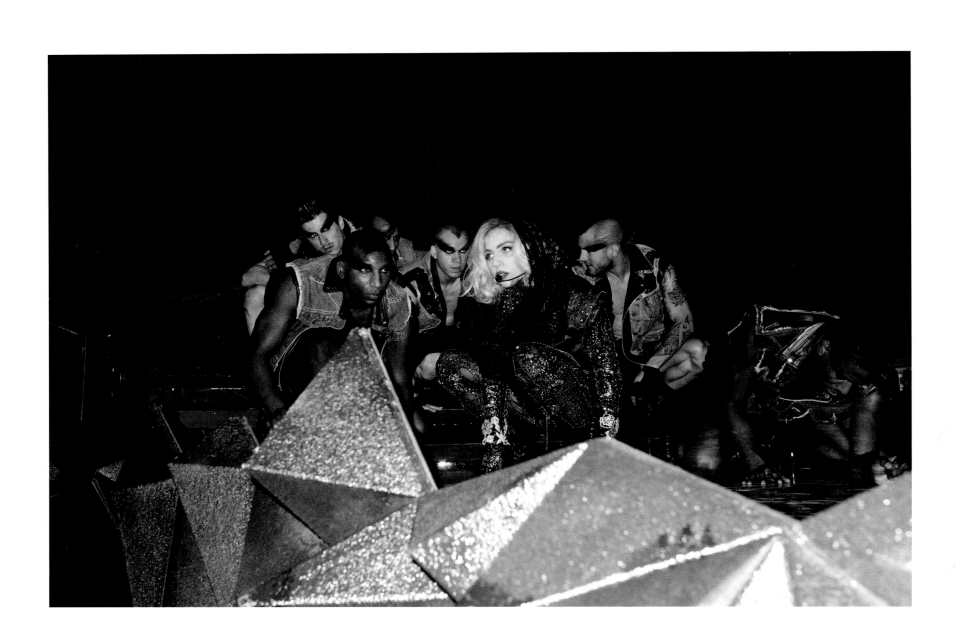

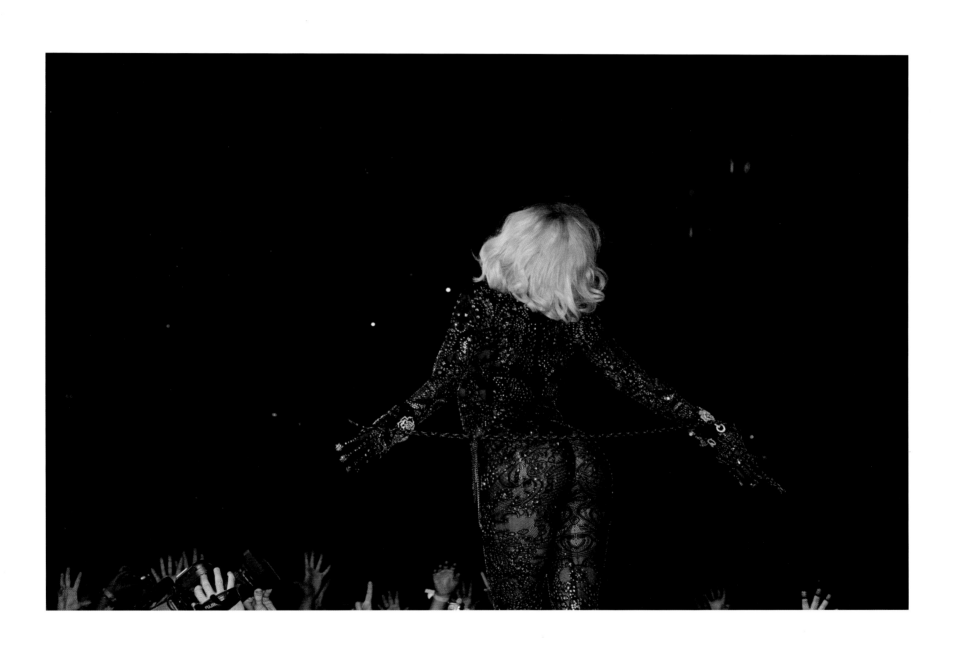

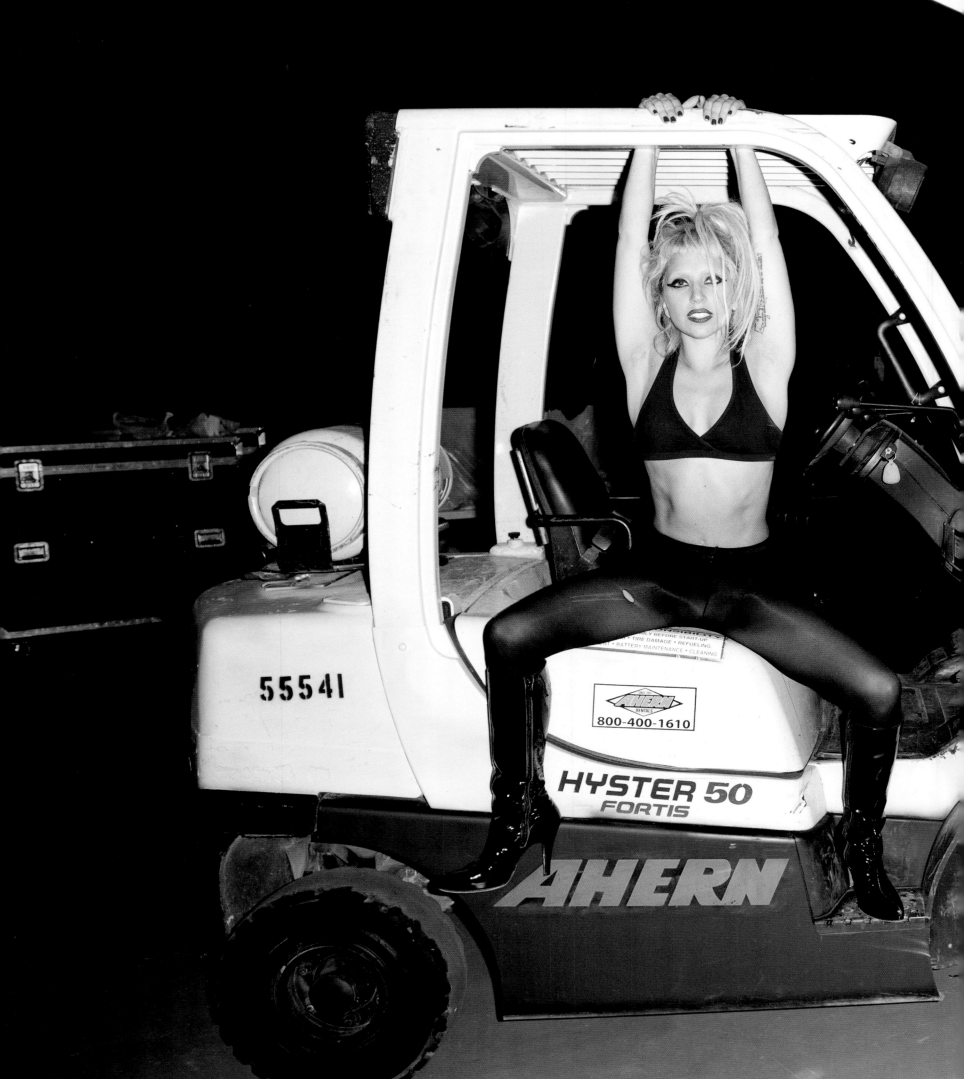

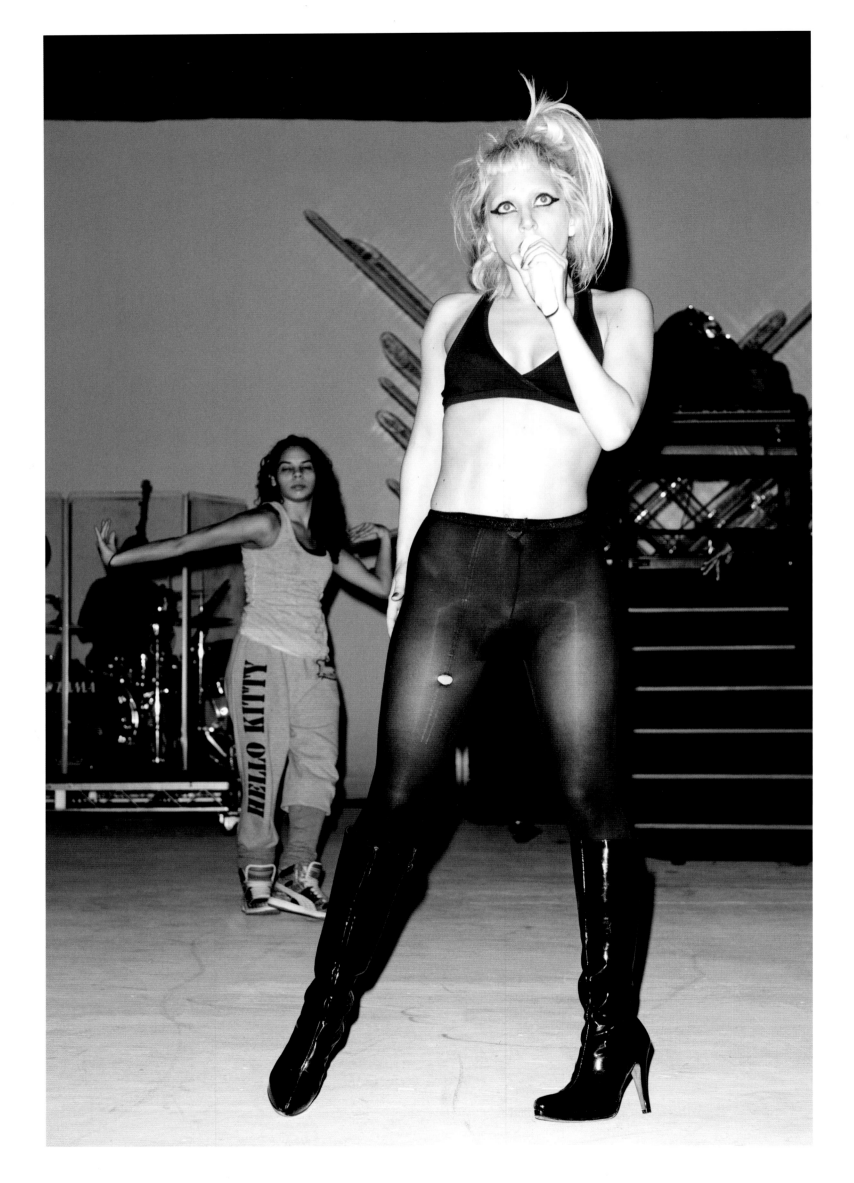

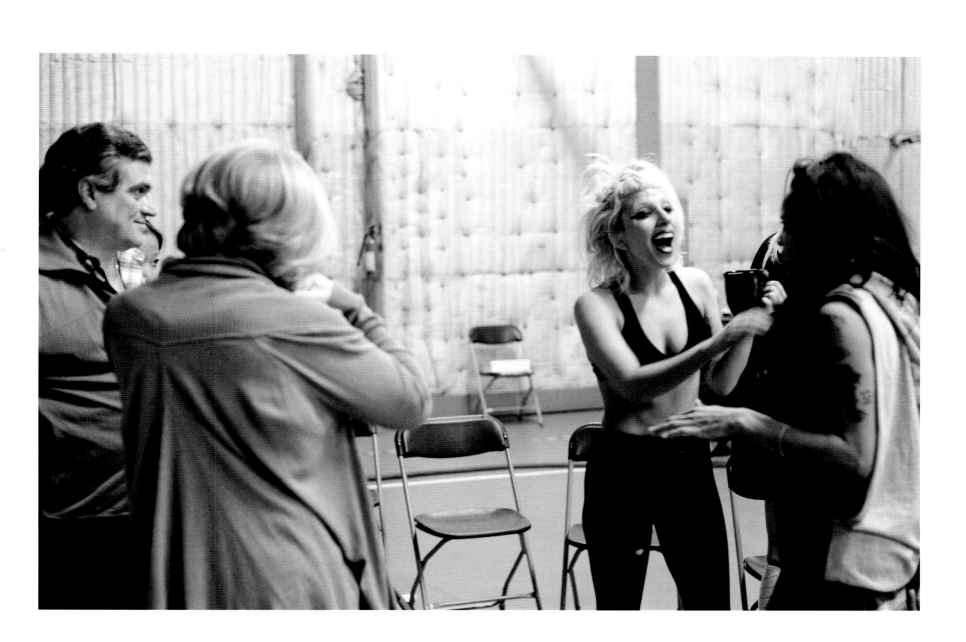

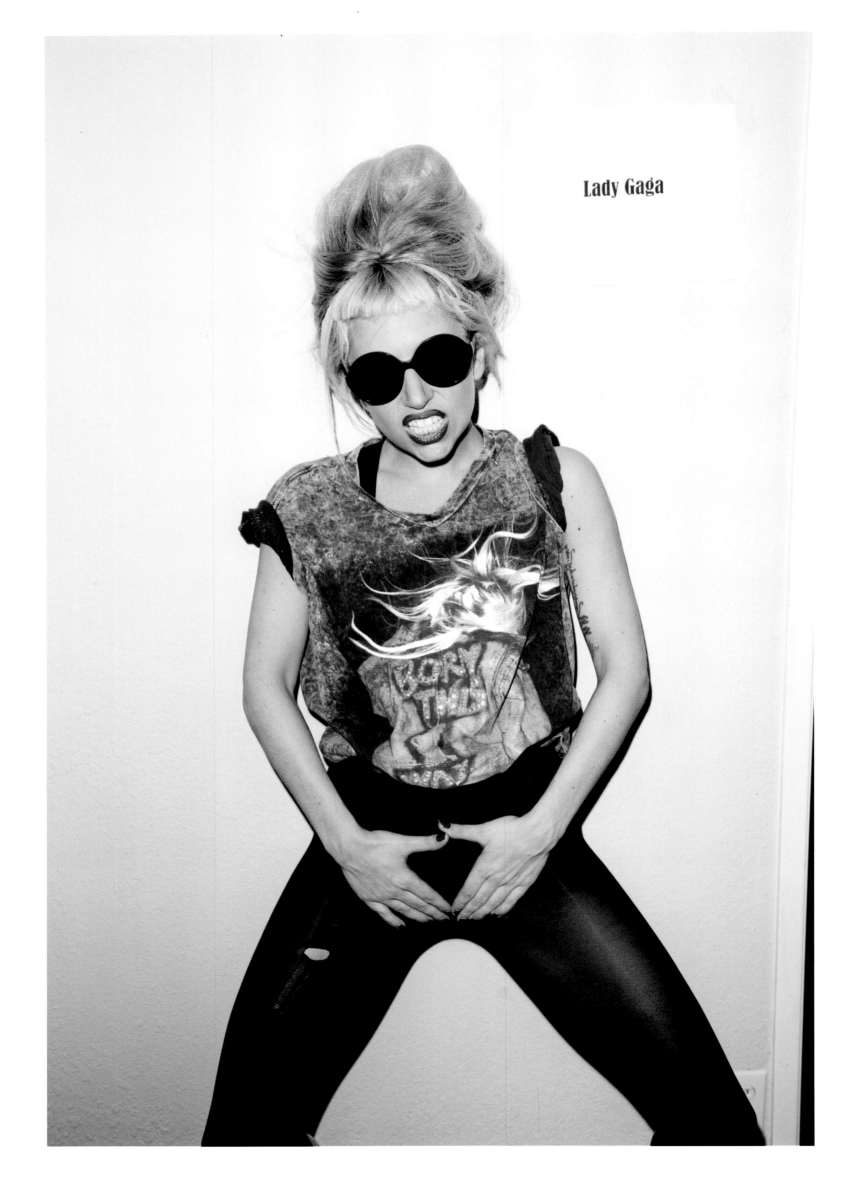

Lady Gaga

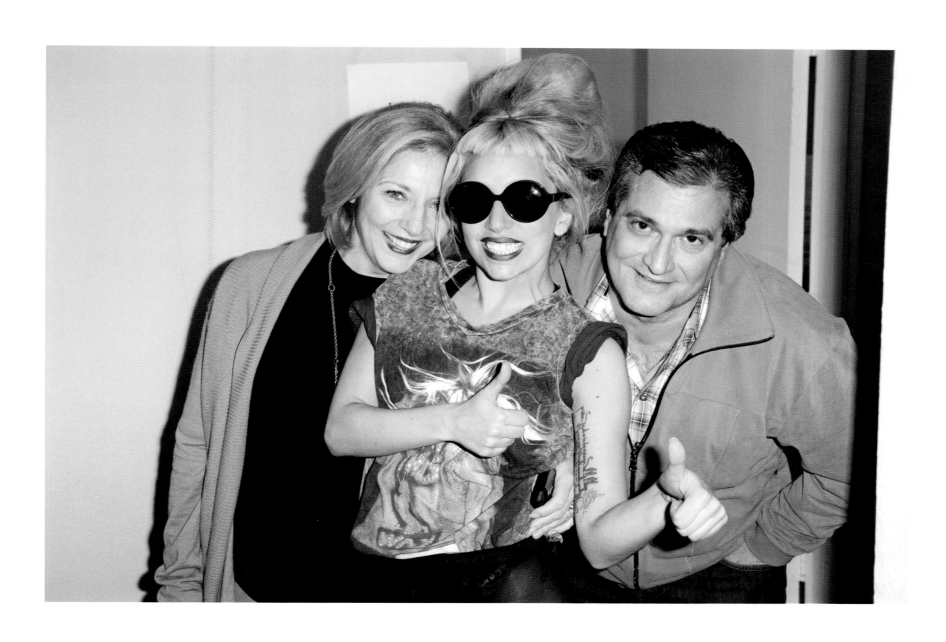

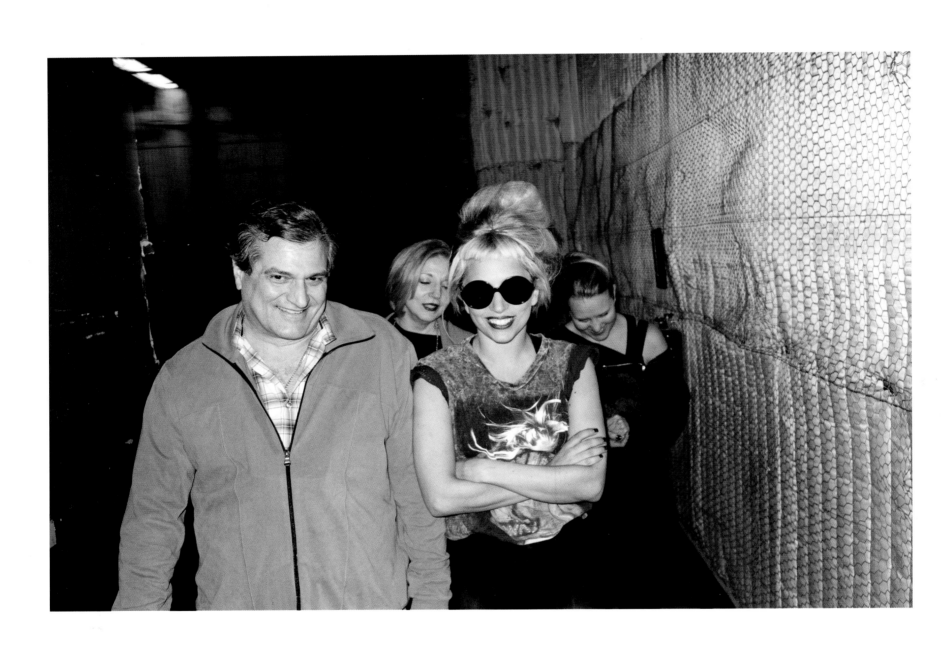

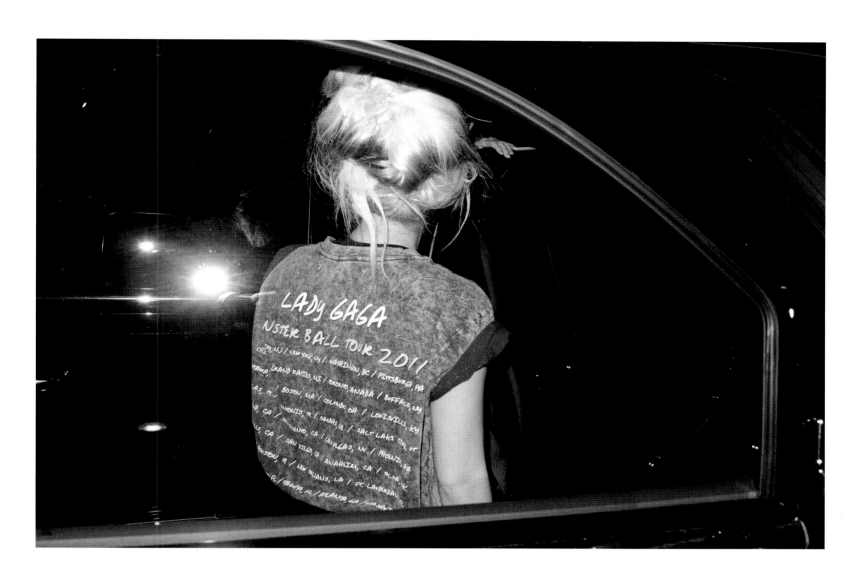

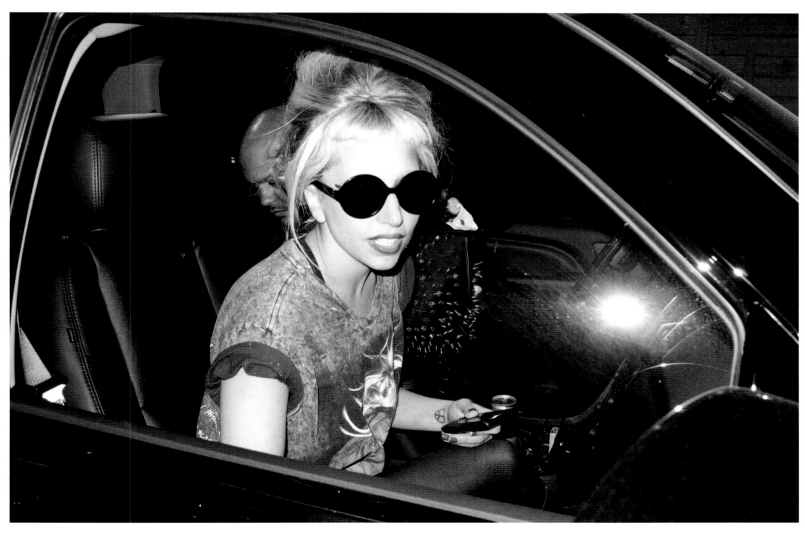

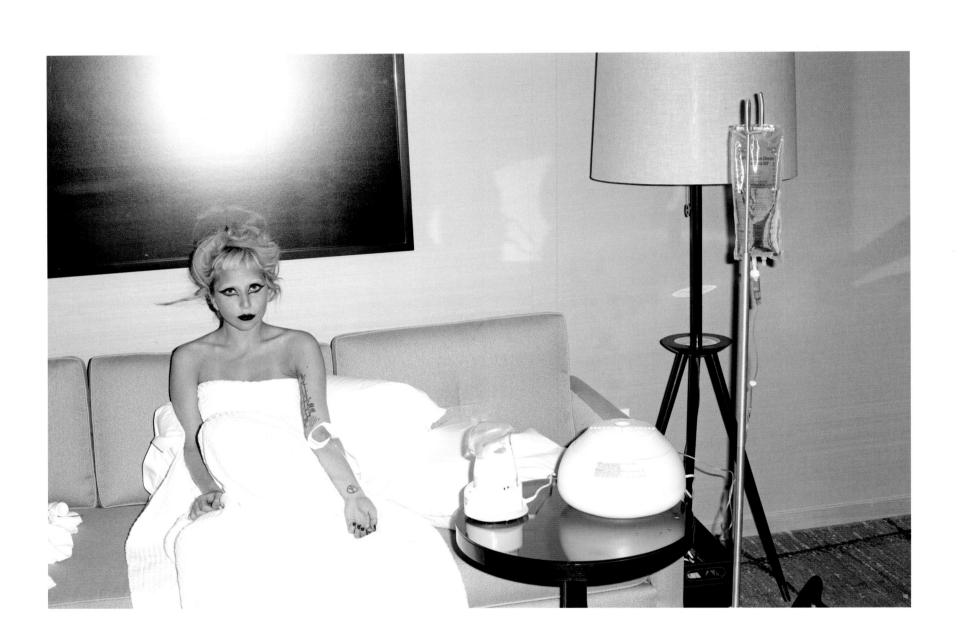

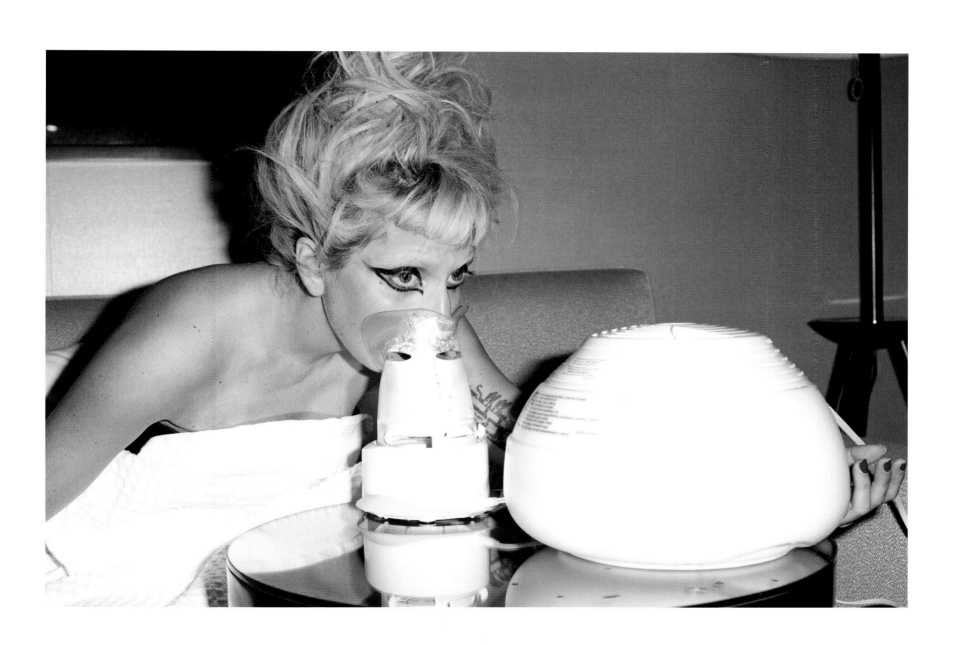

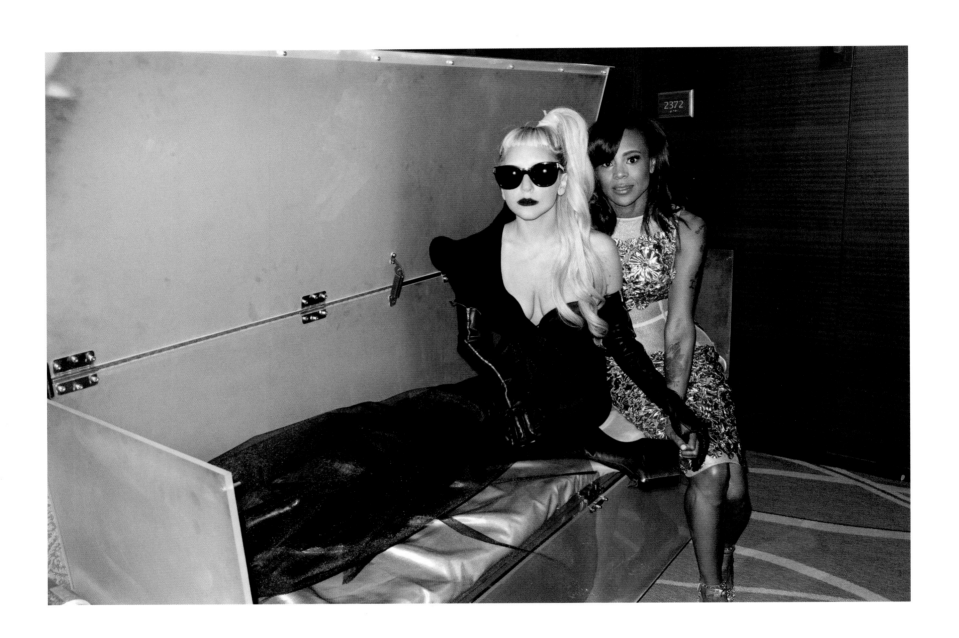

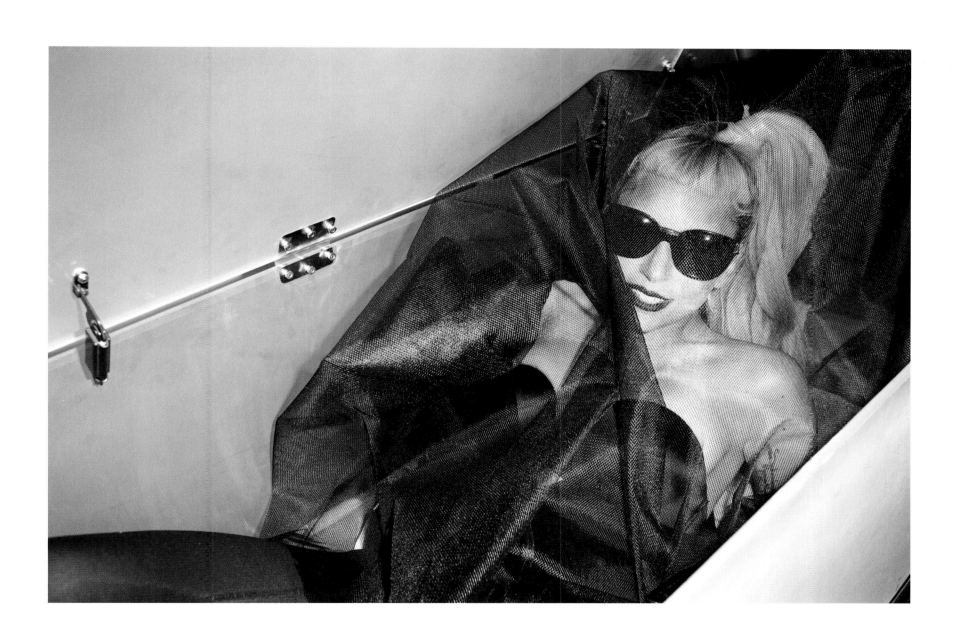

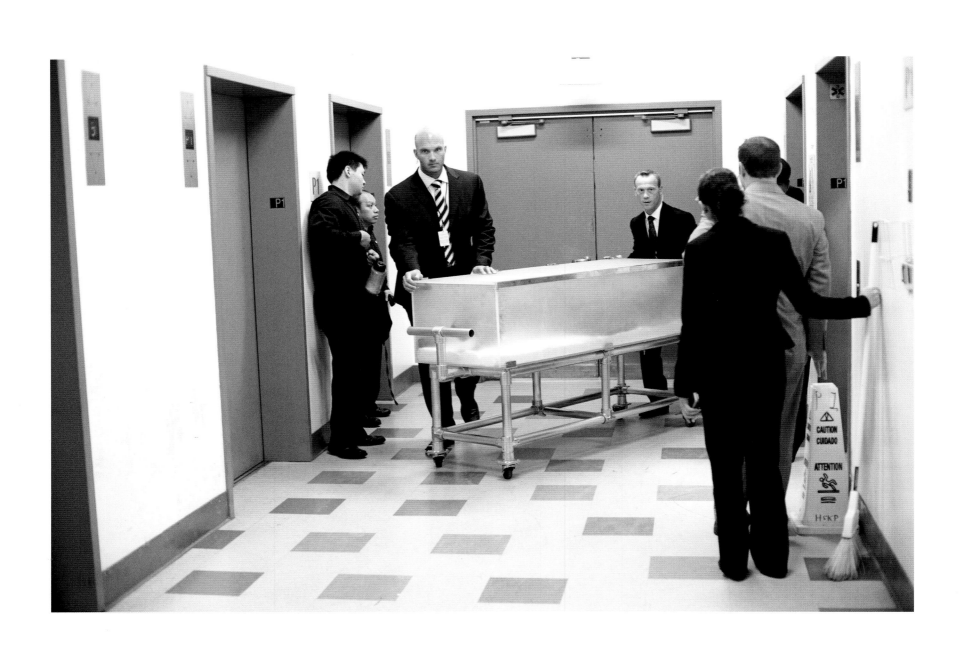

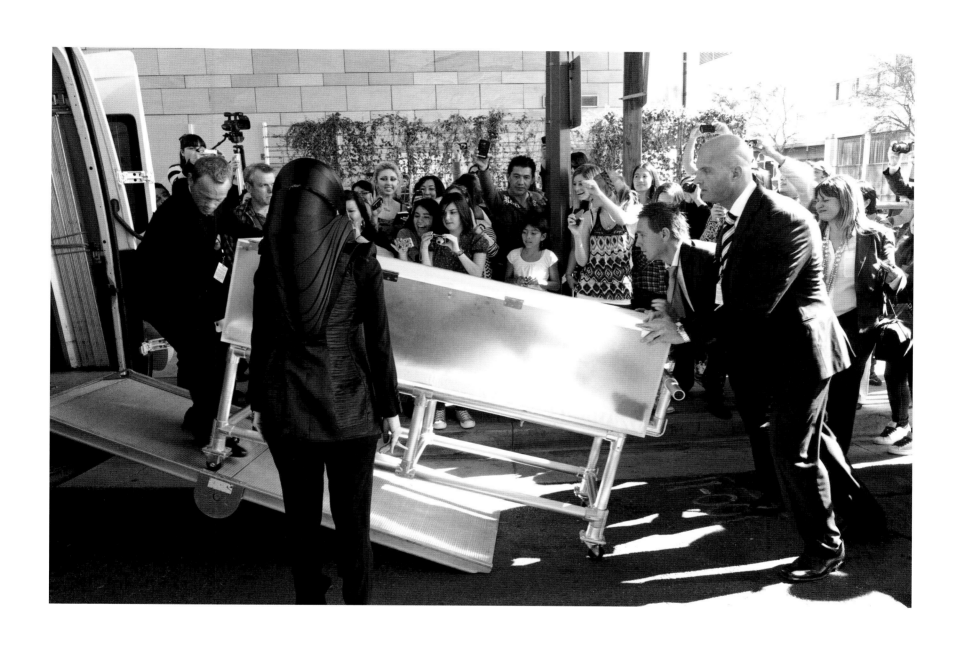

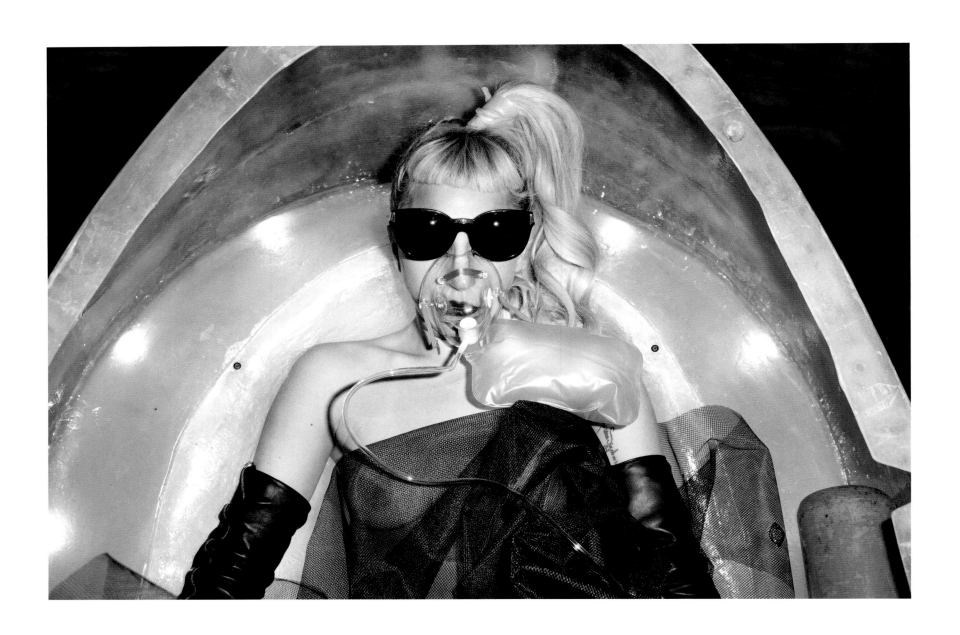

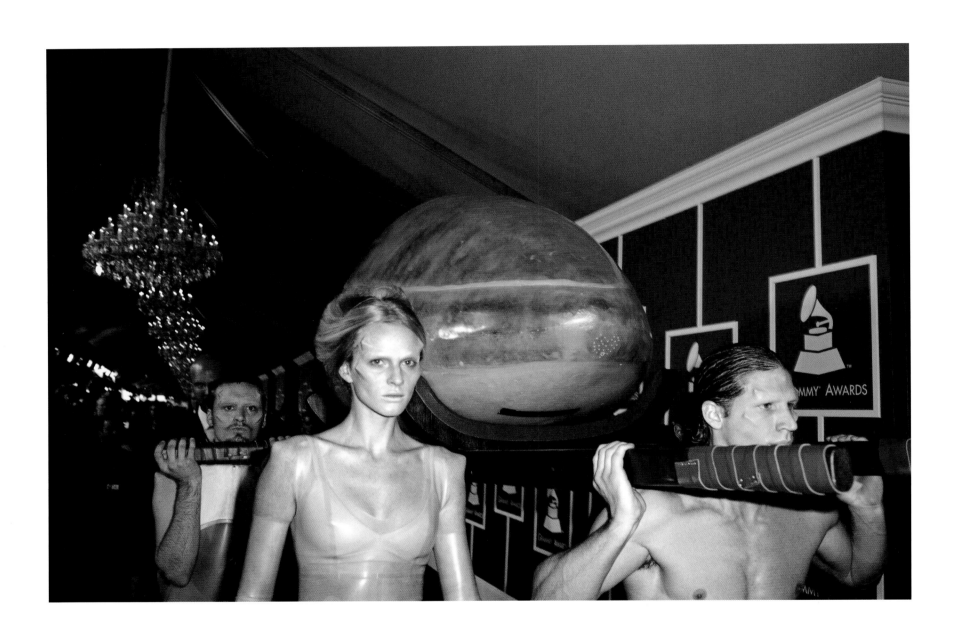

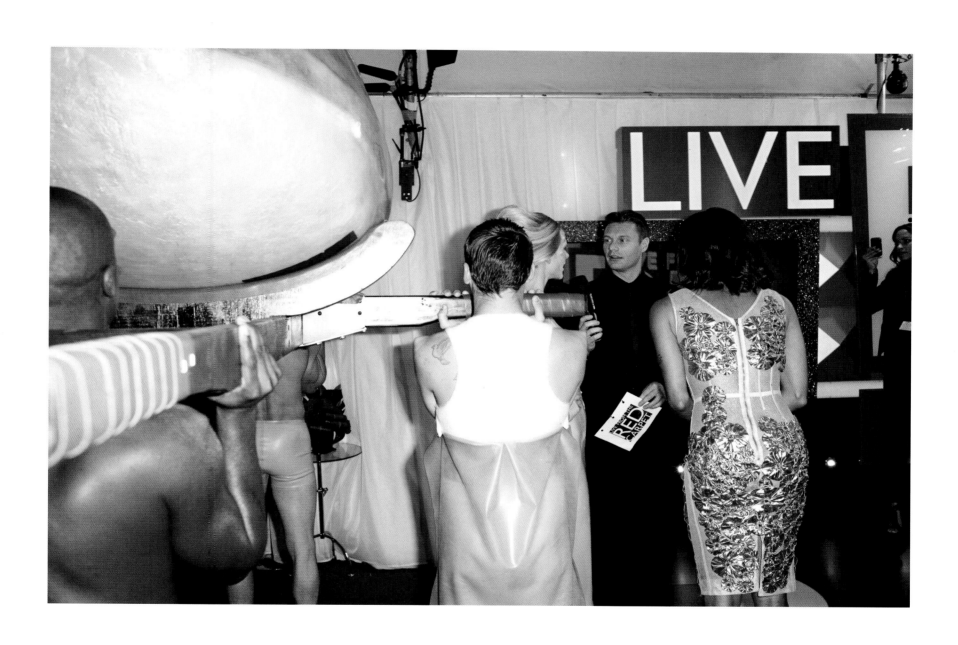

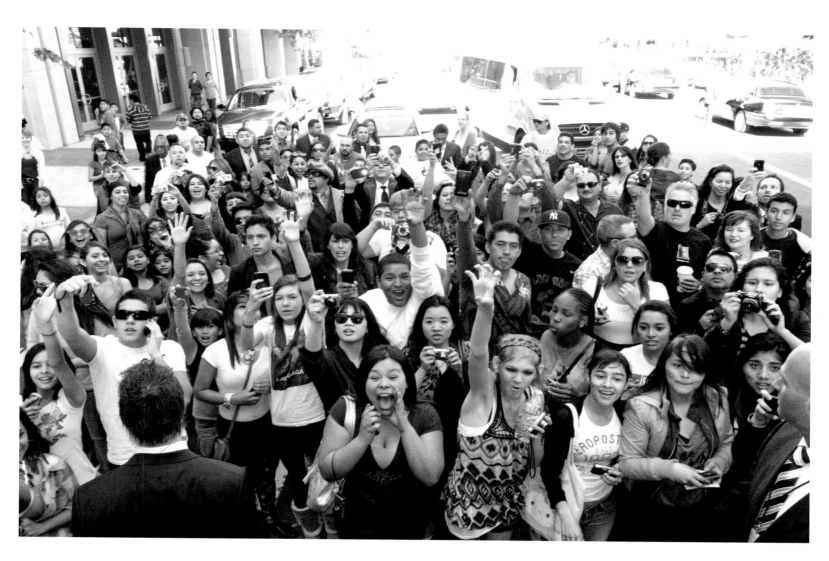

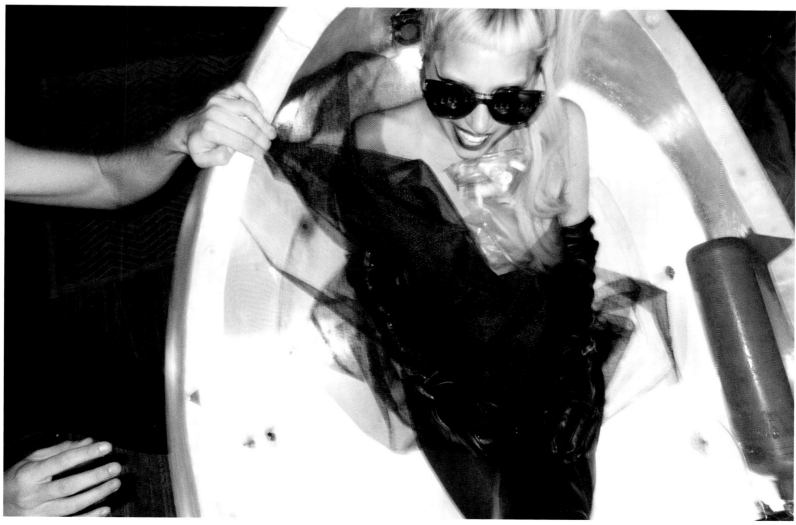

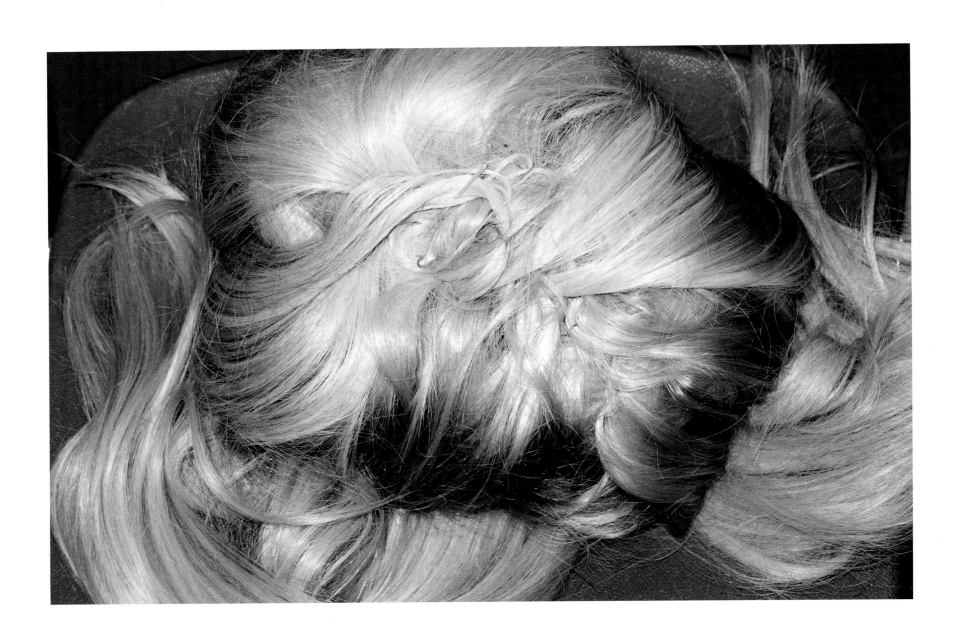

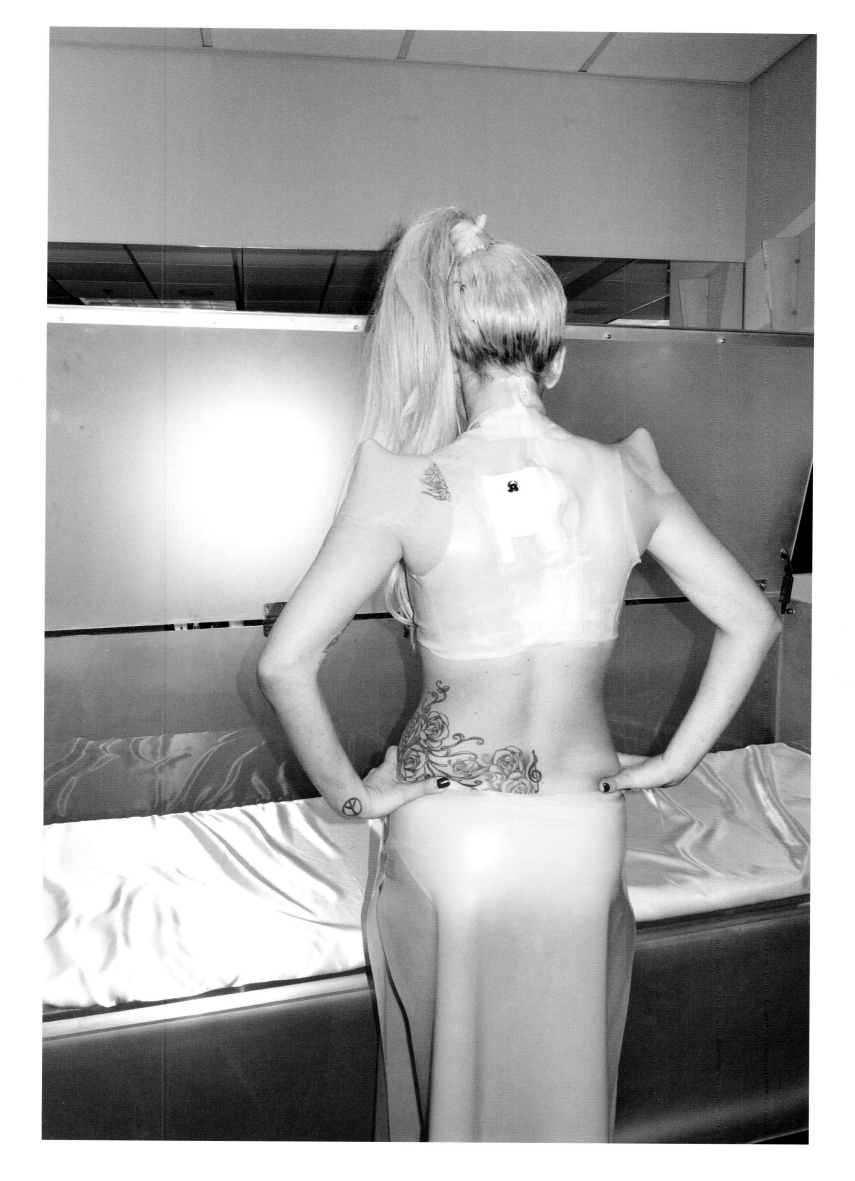

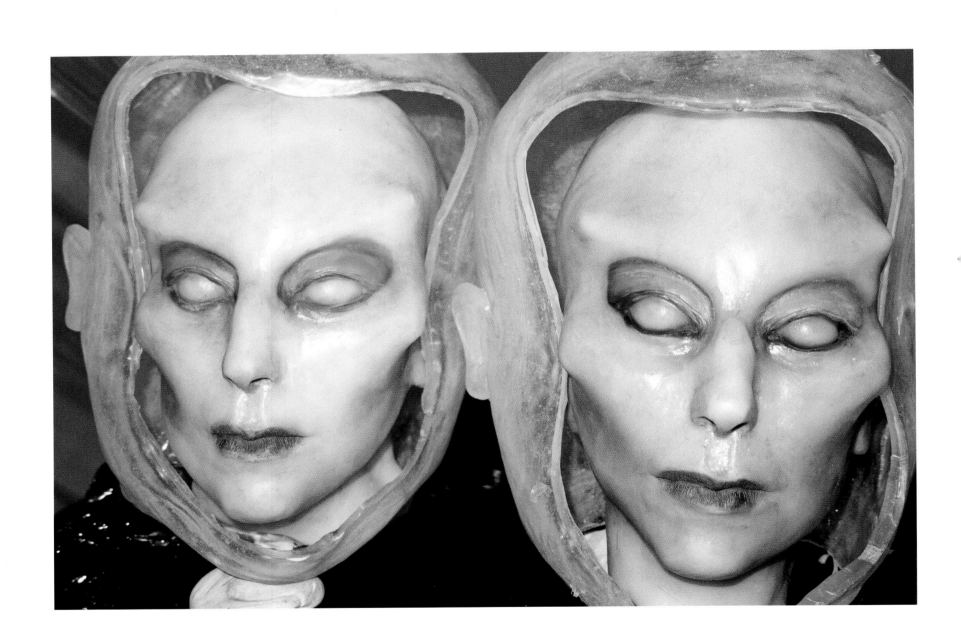

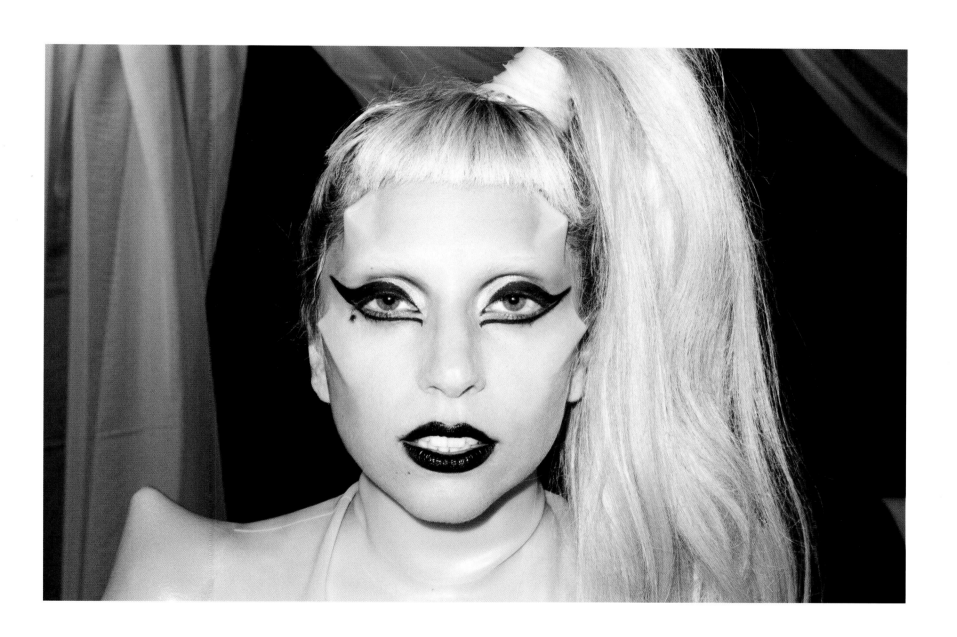

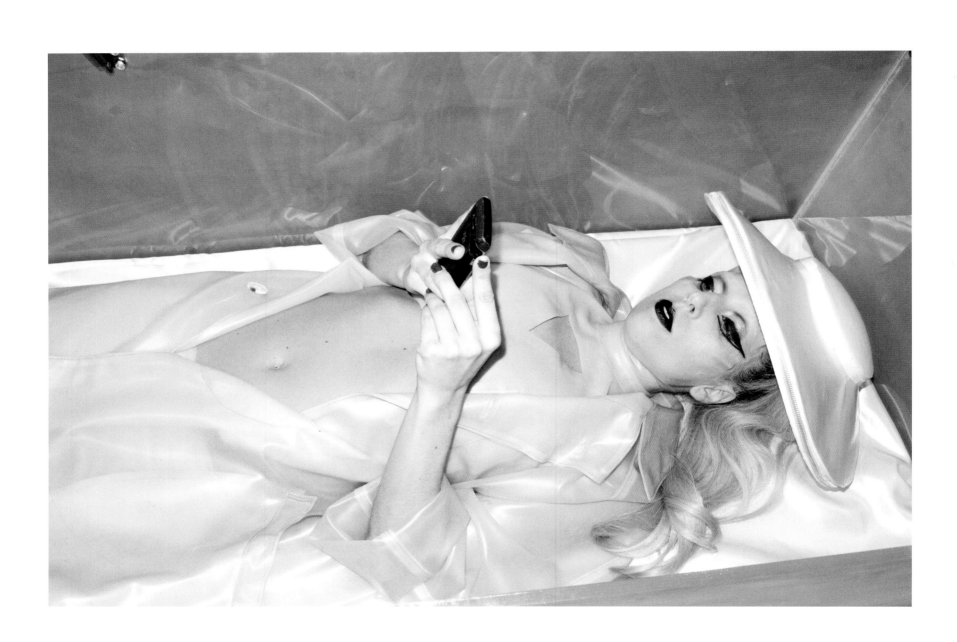

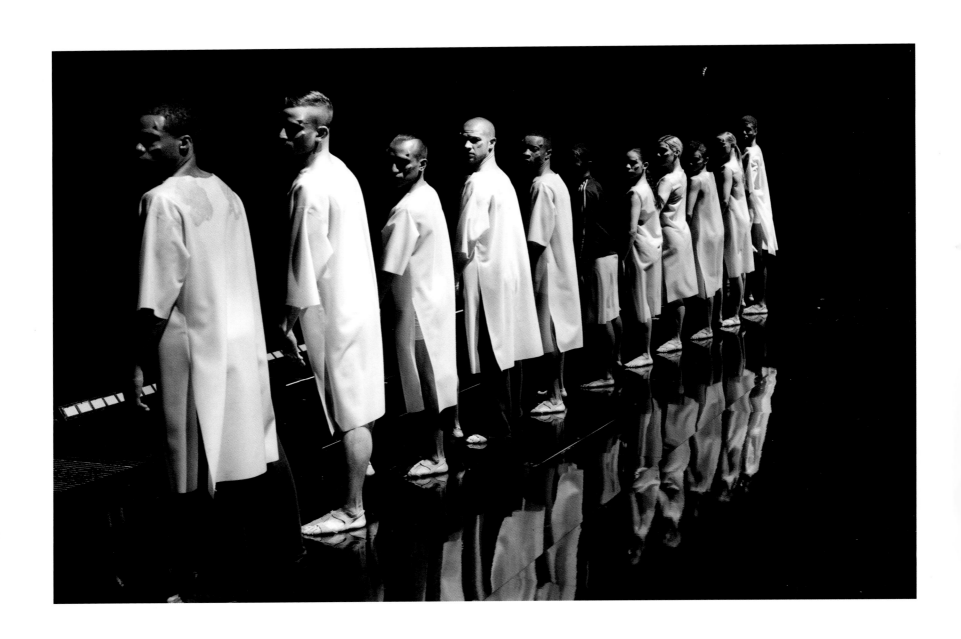

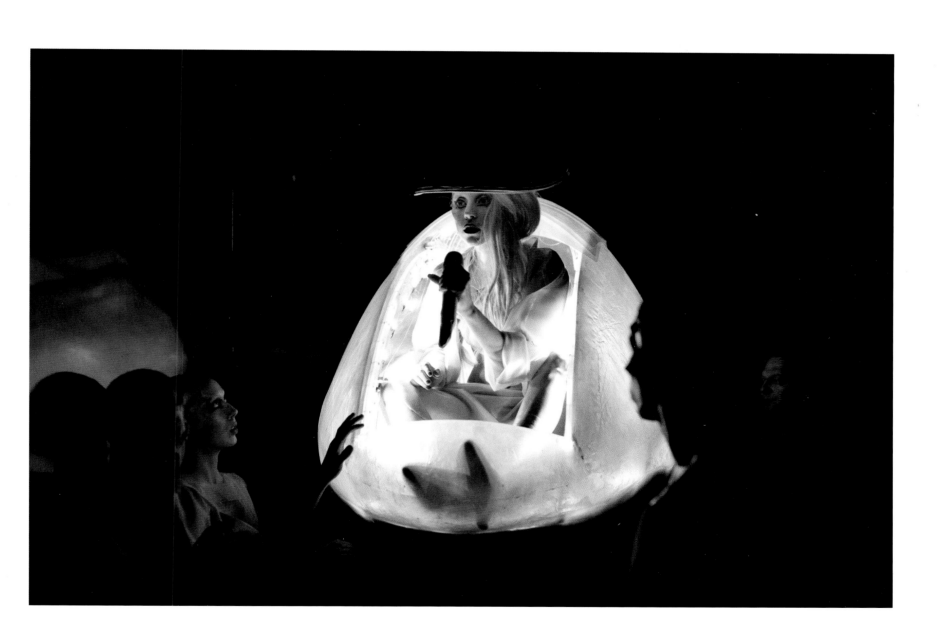

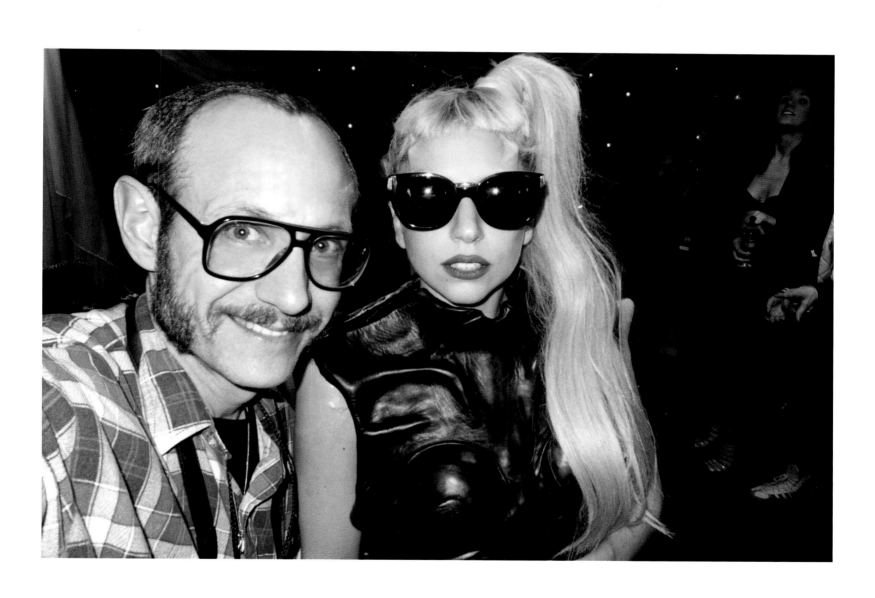

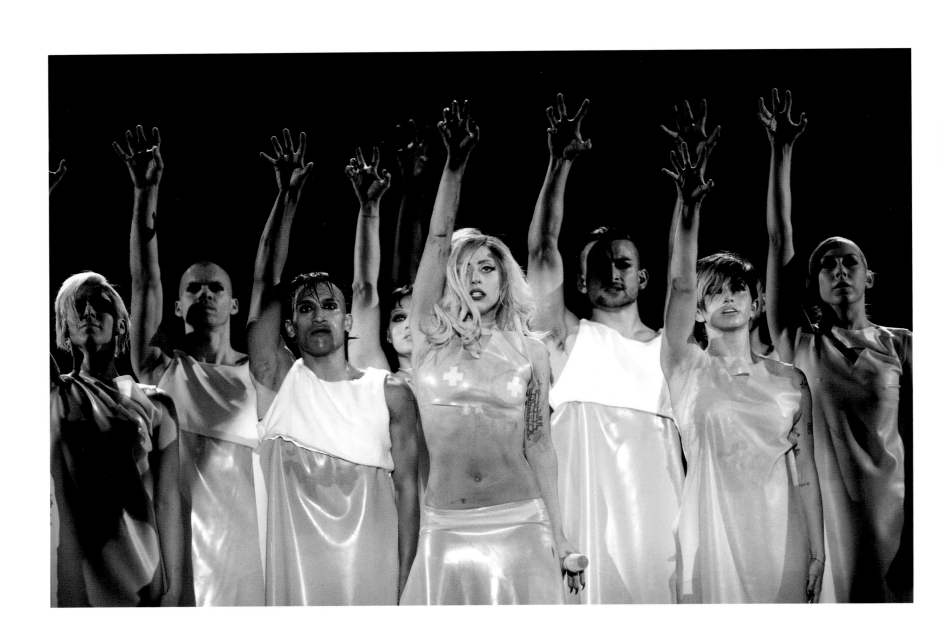

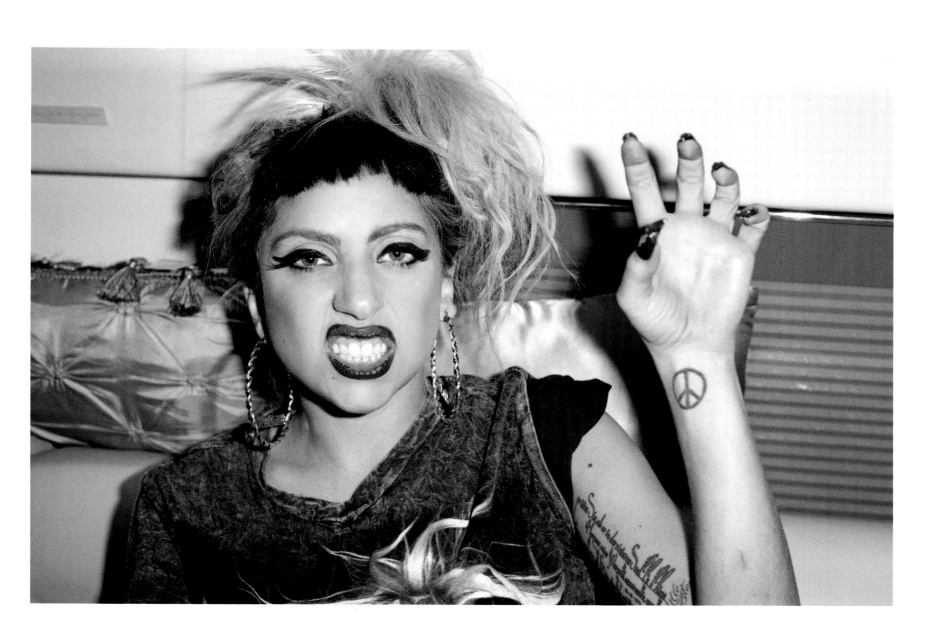

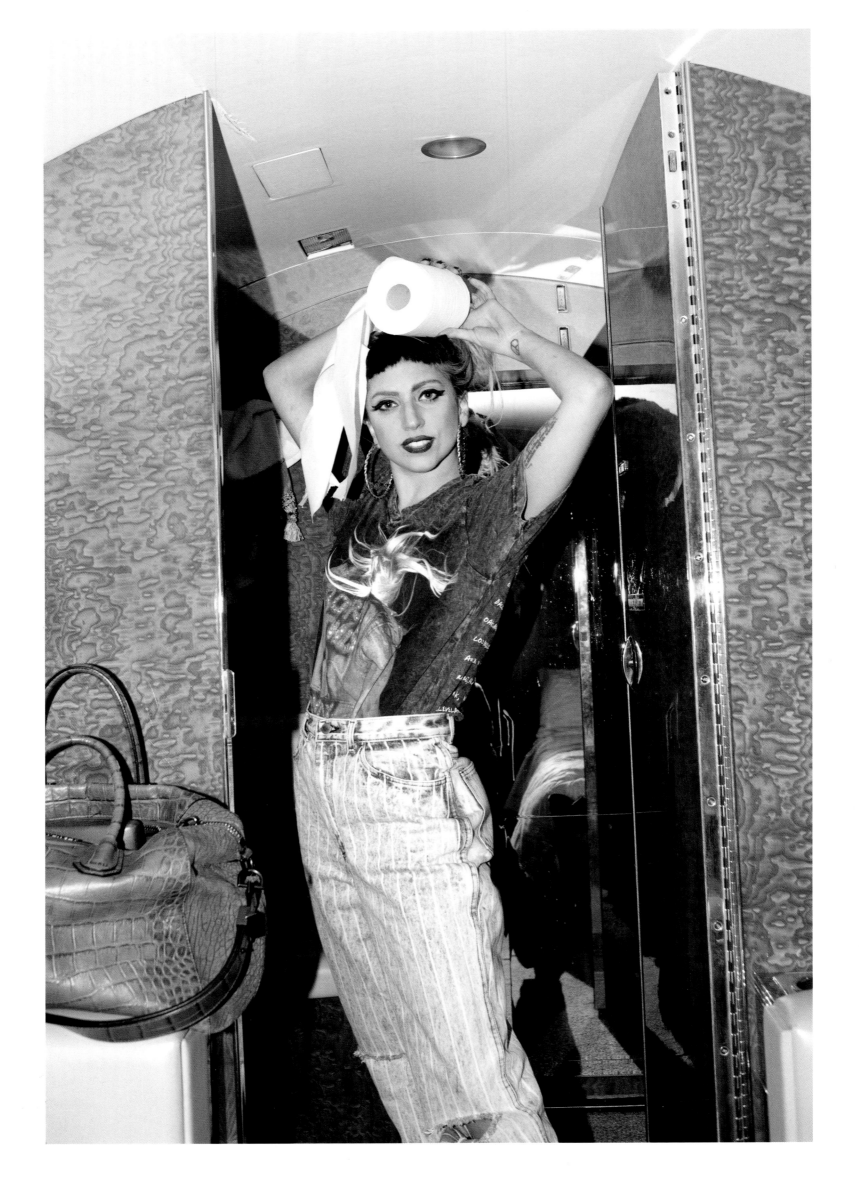

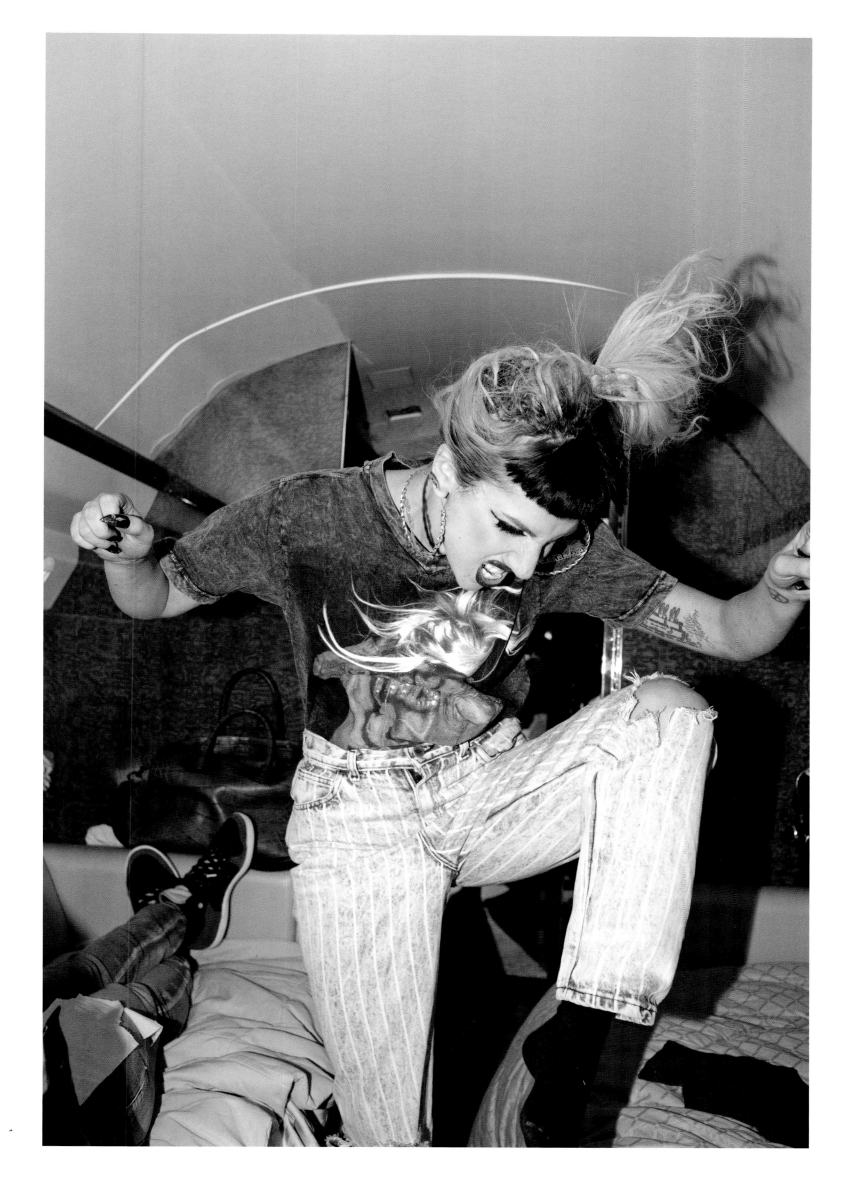

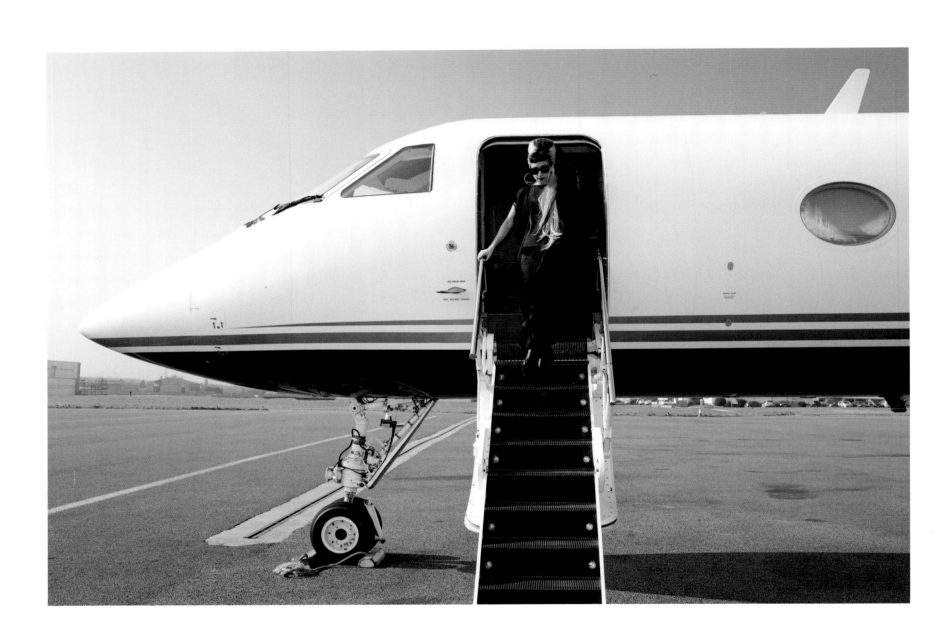

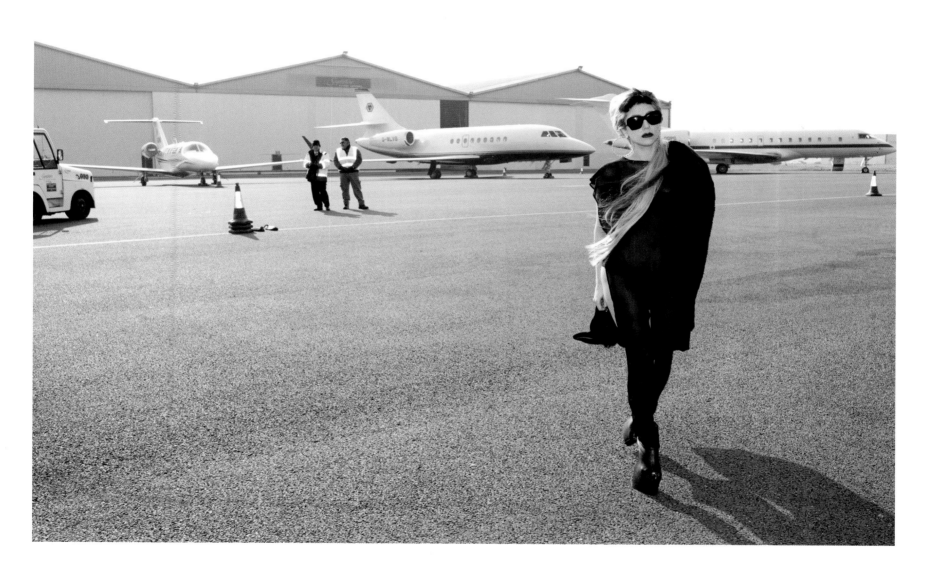

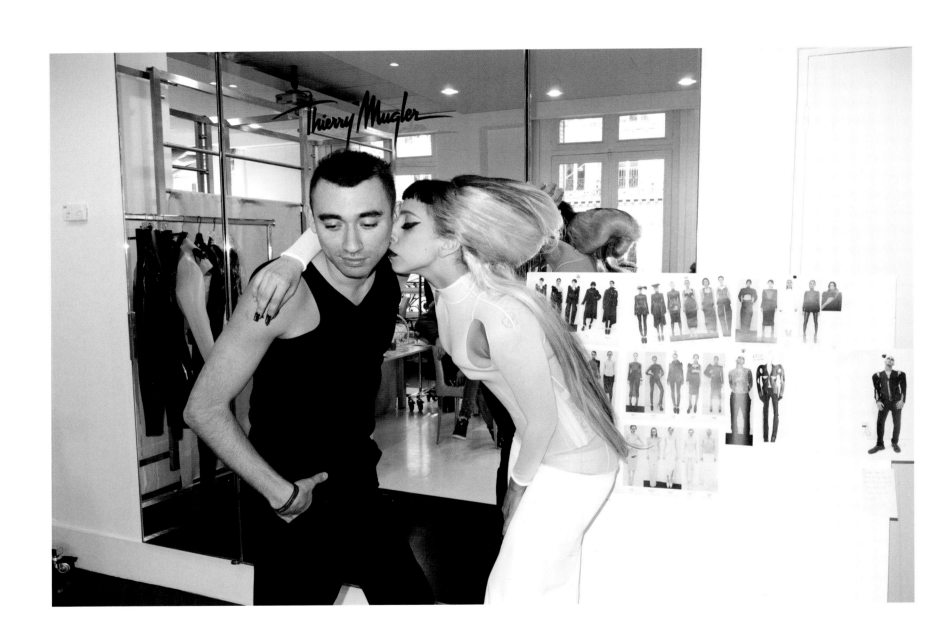

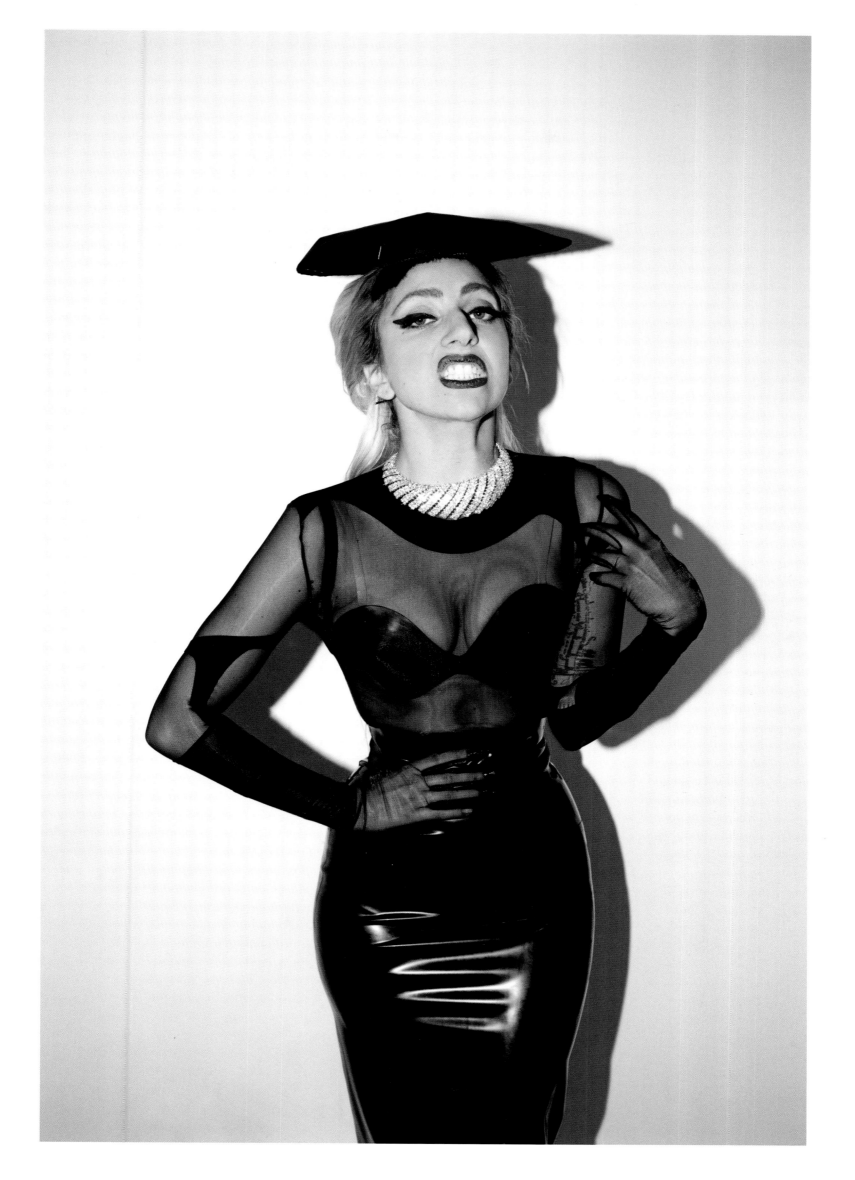

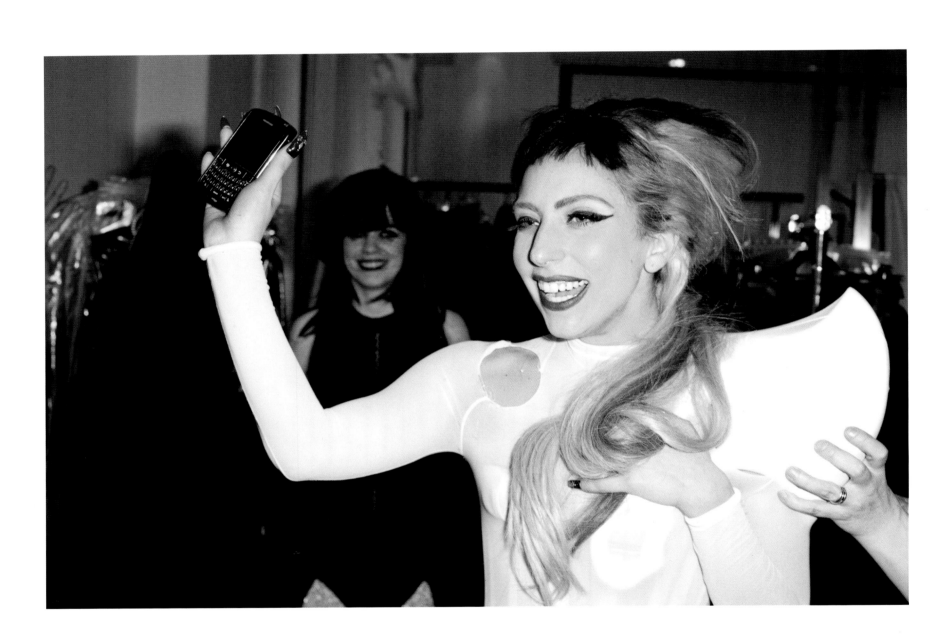

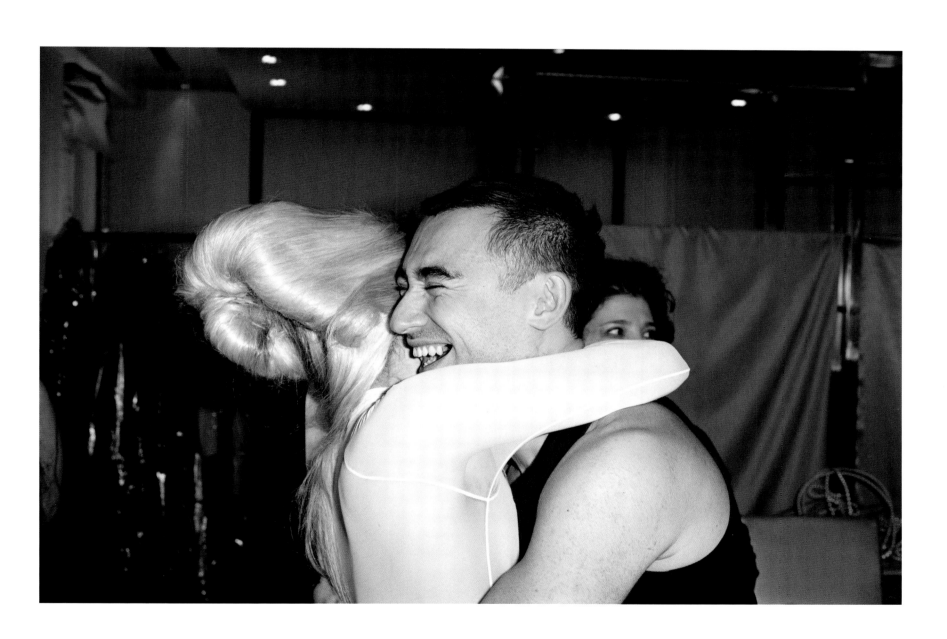

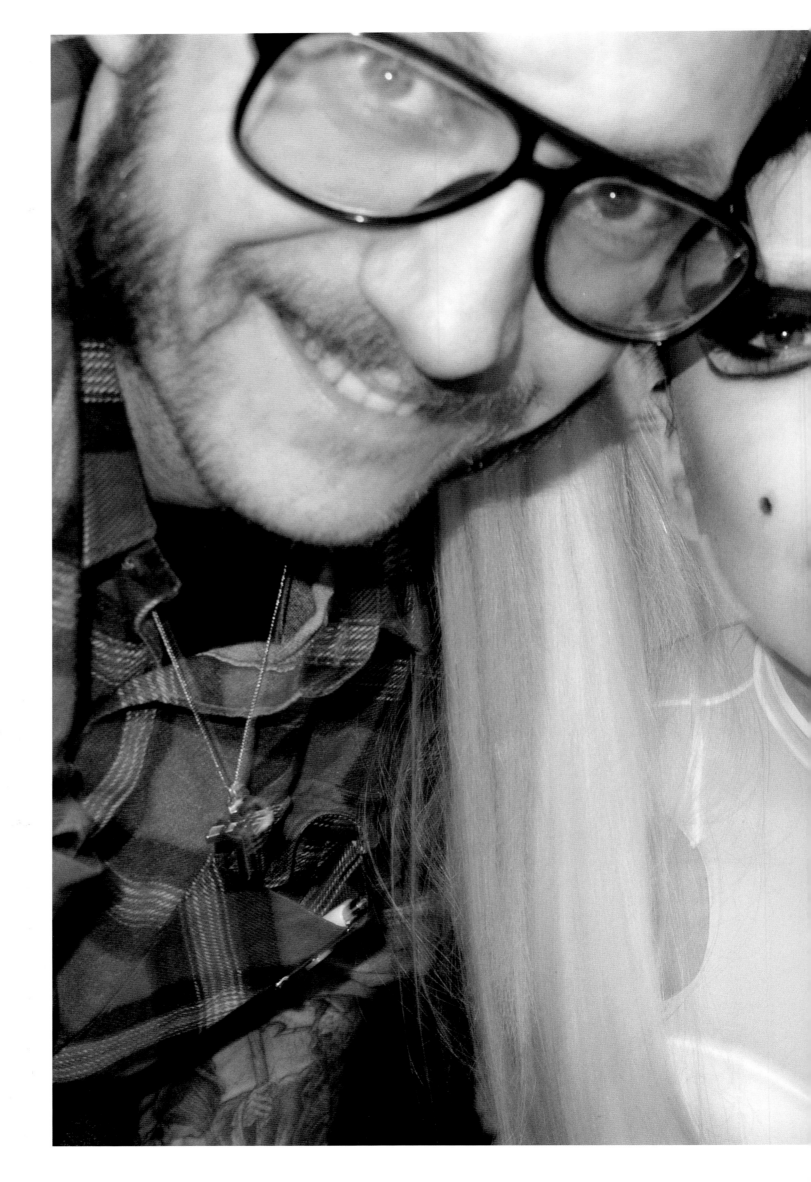

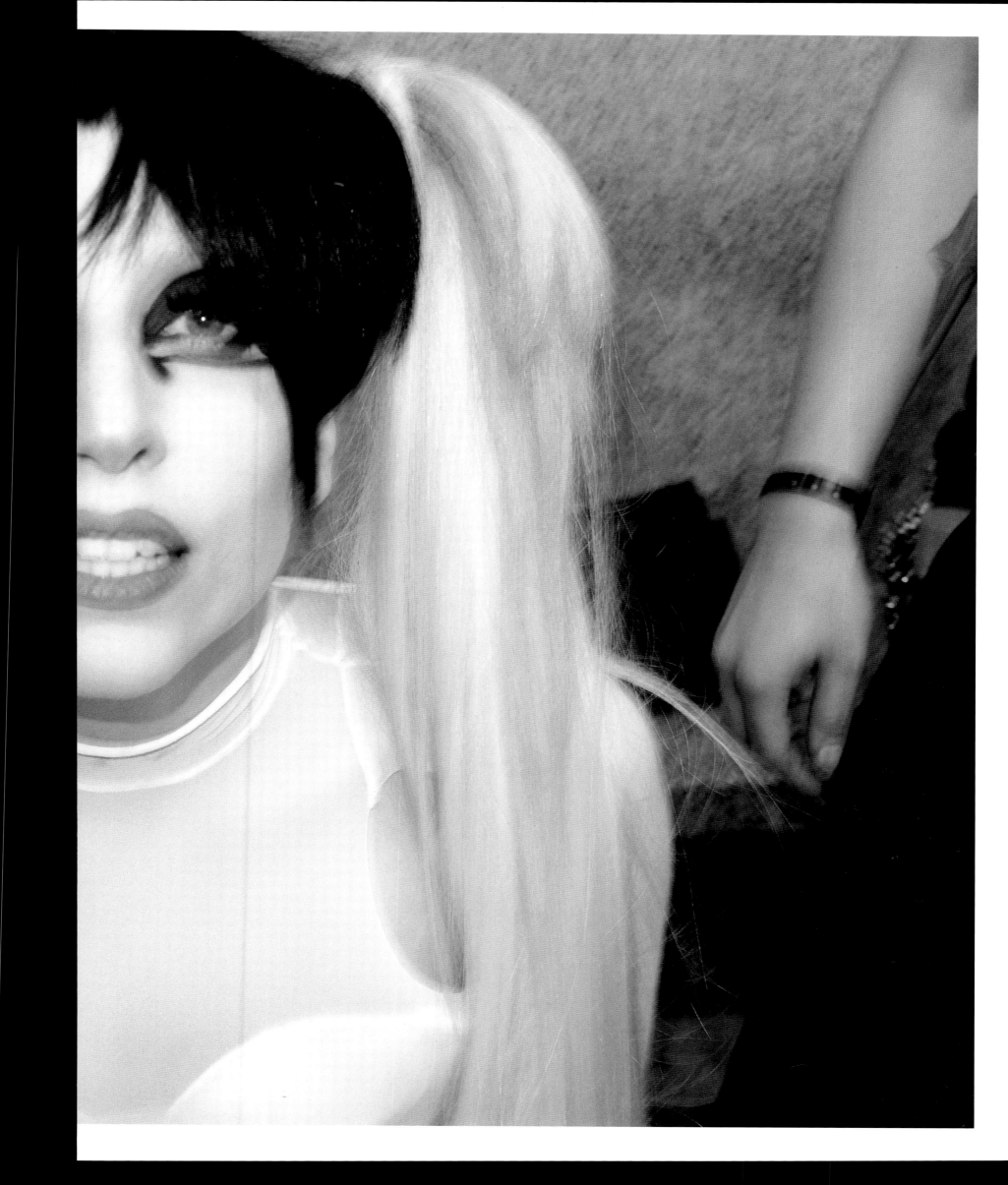

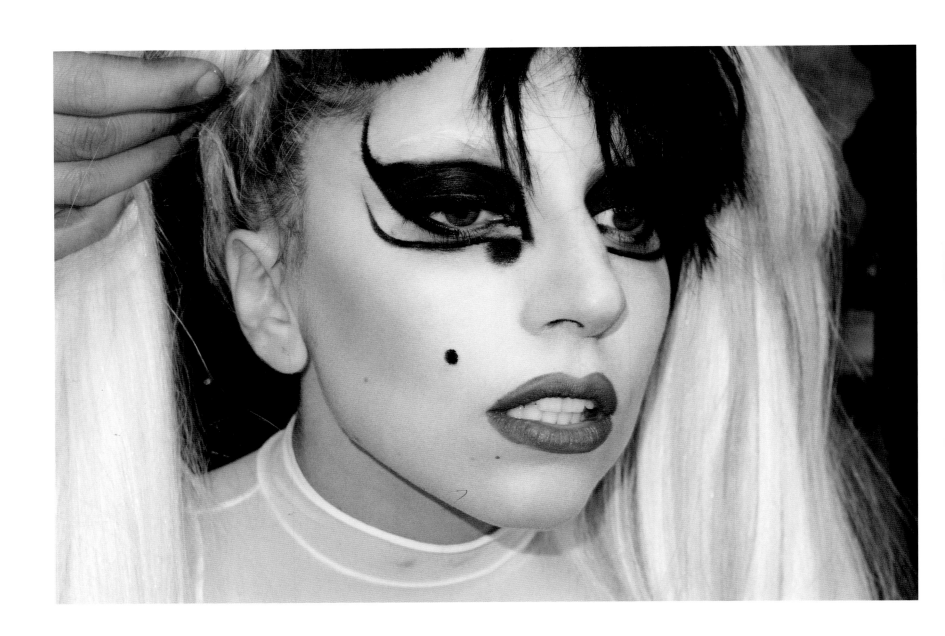

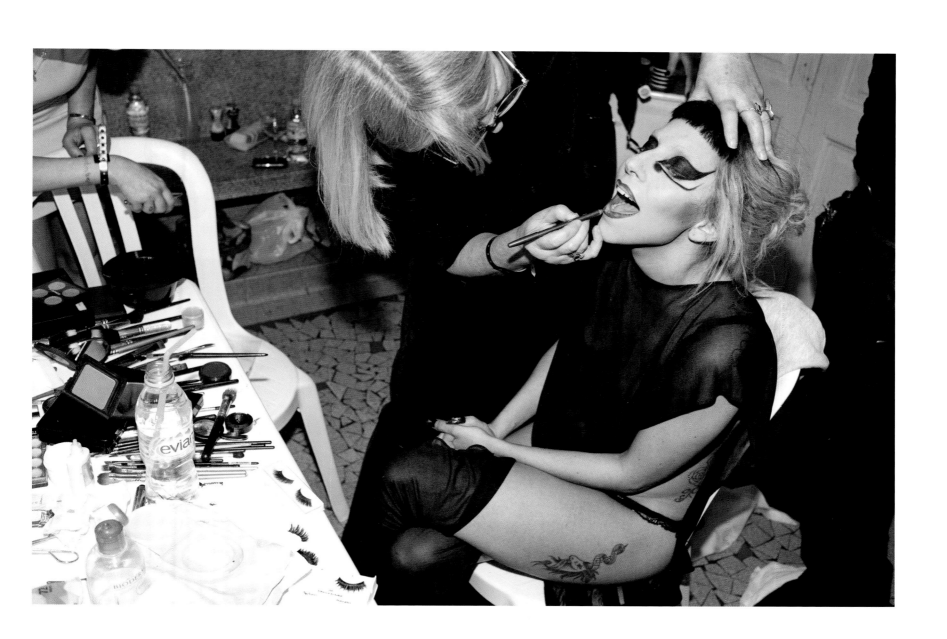

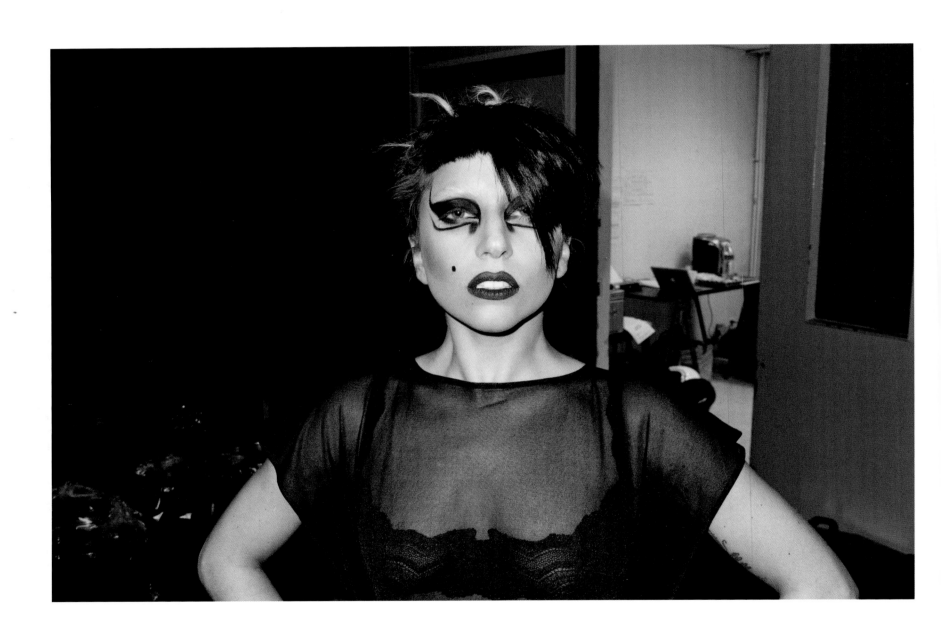

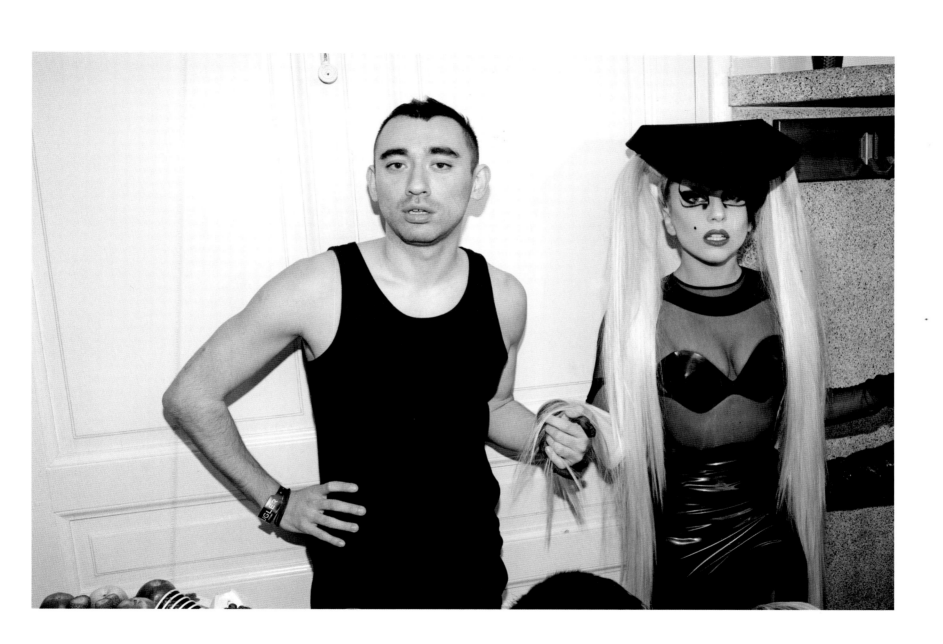

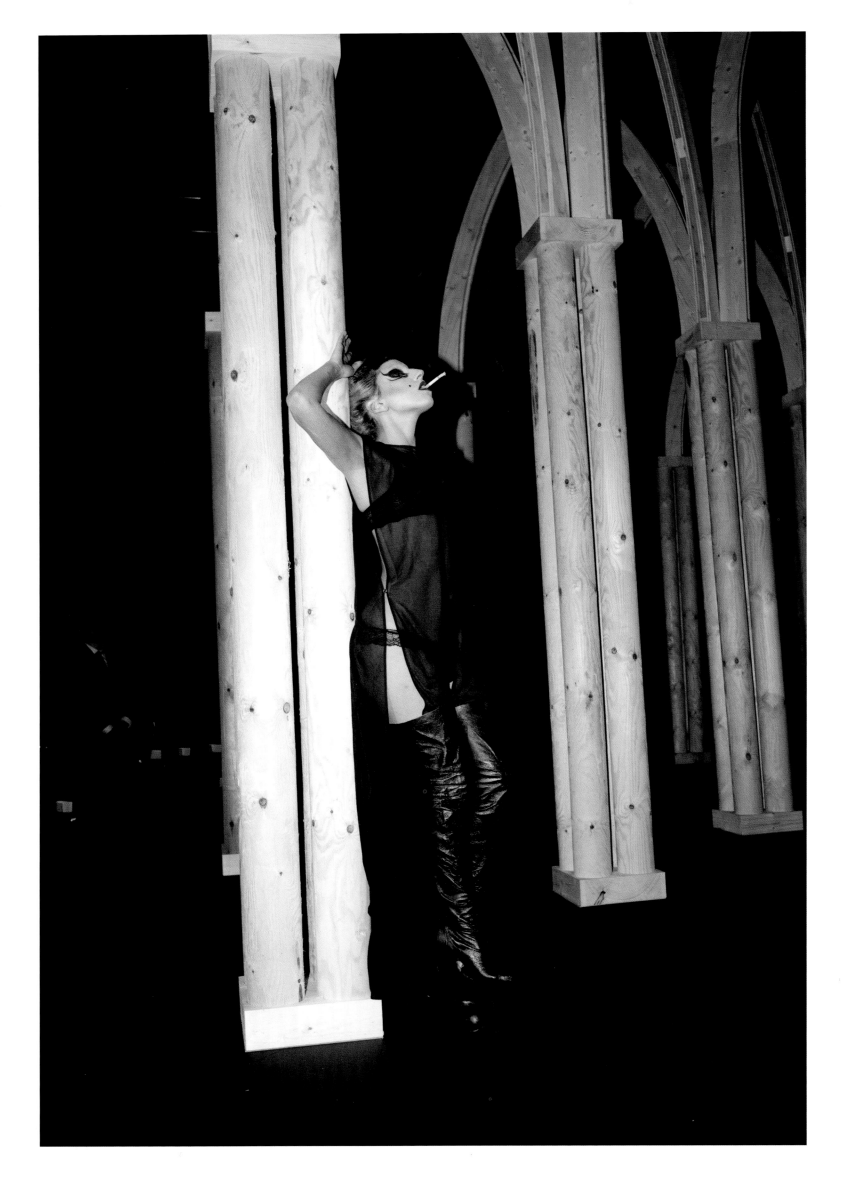

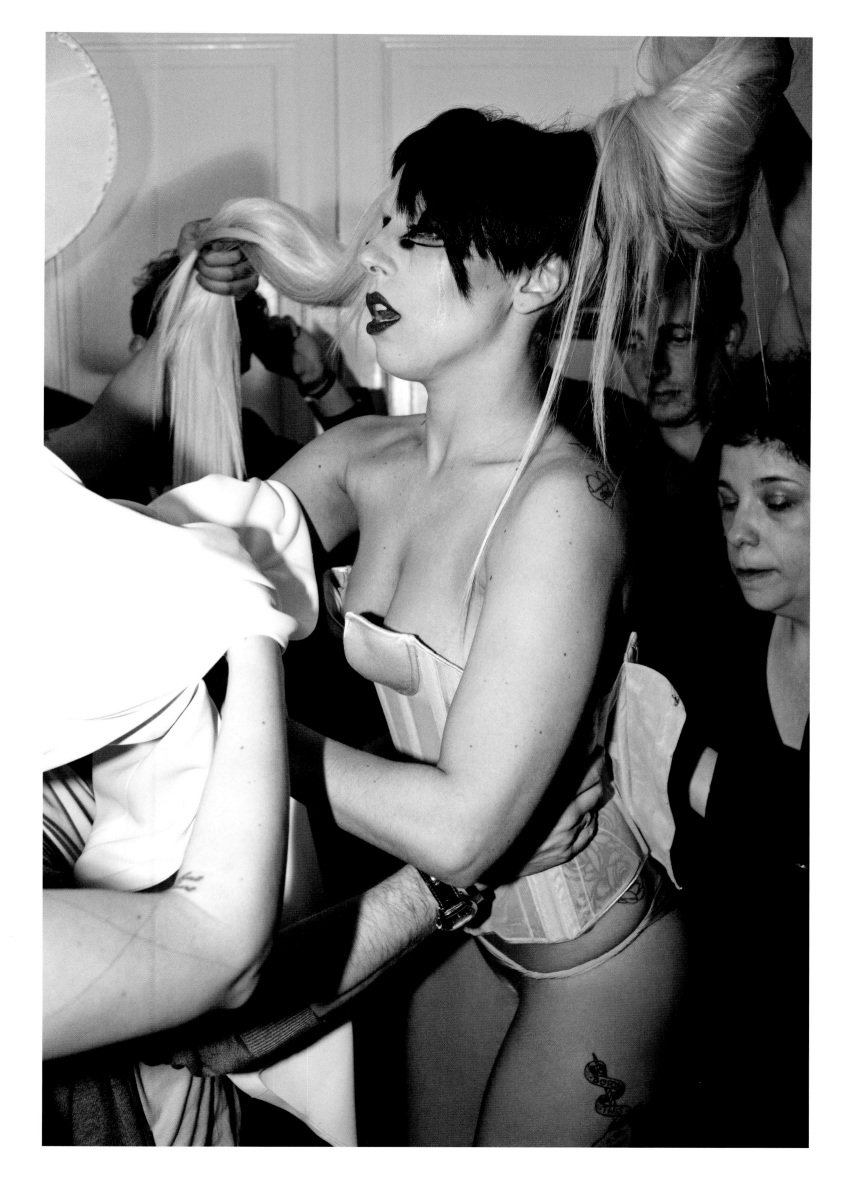

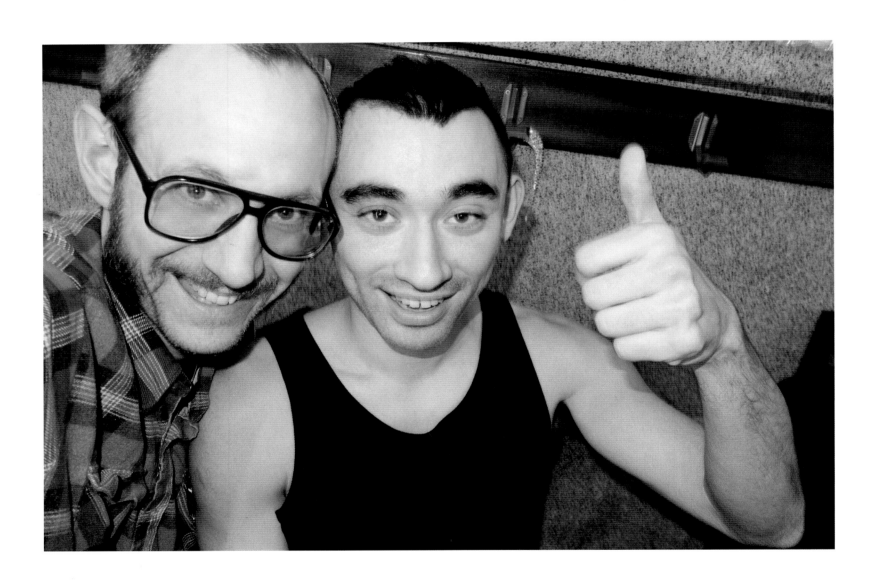

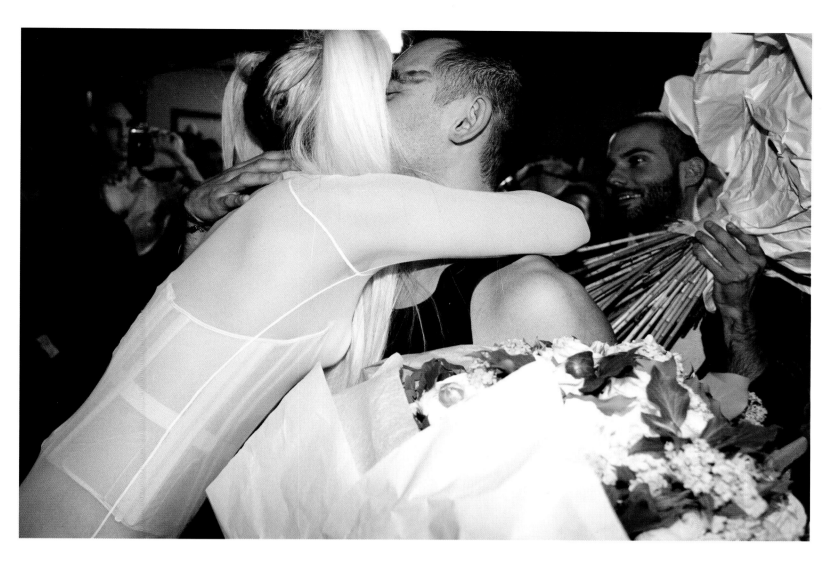

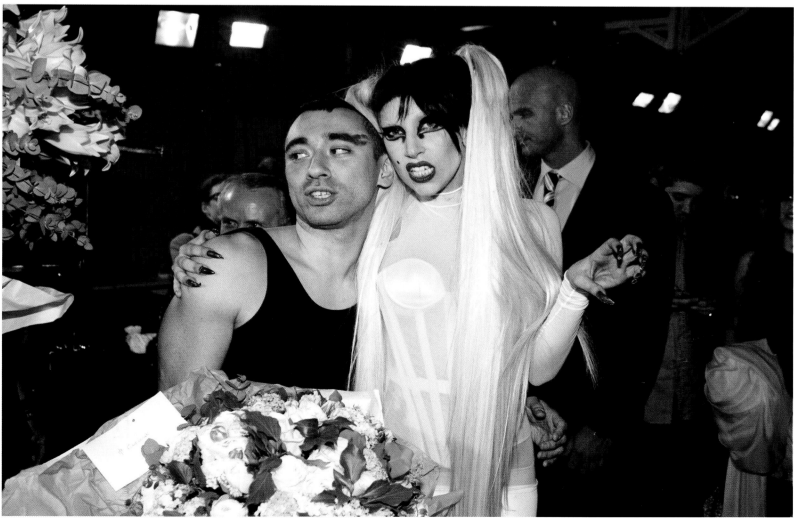

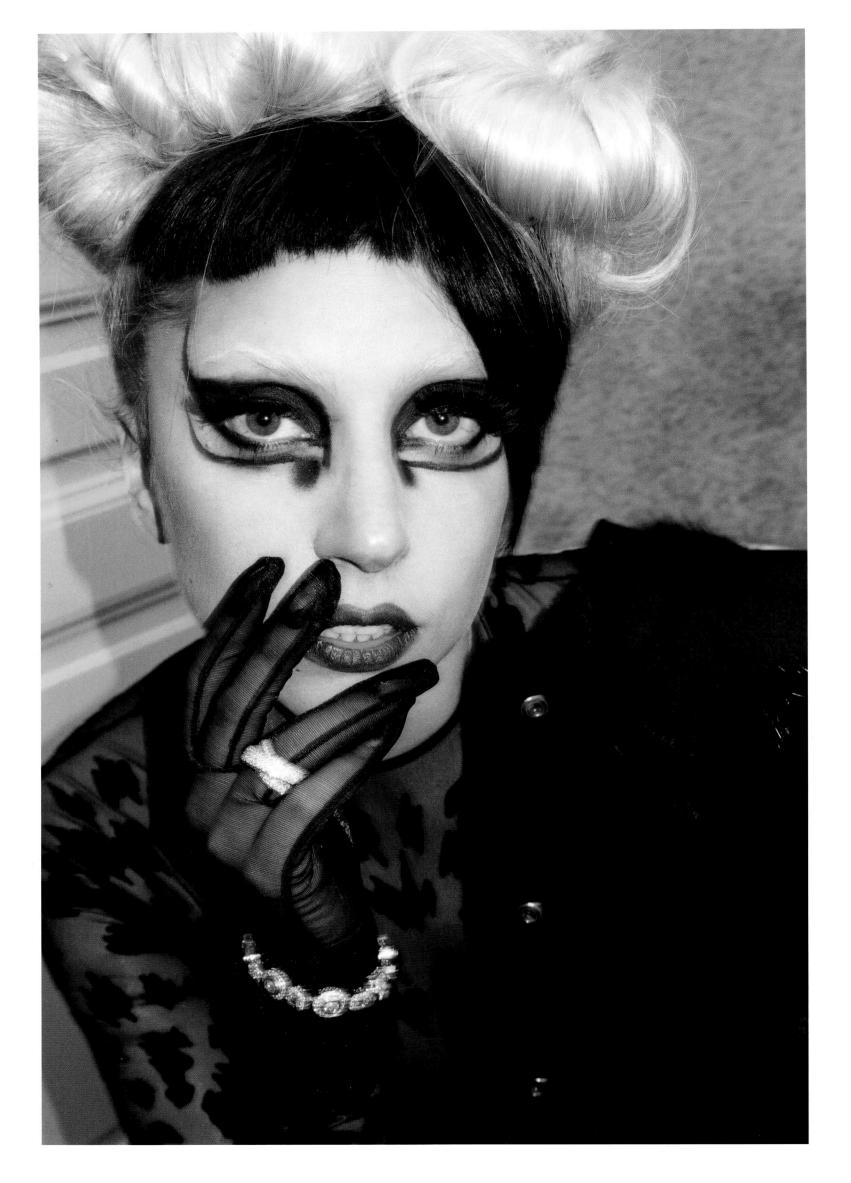

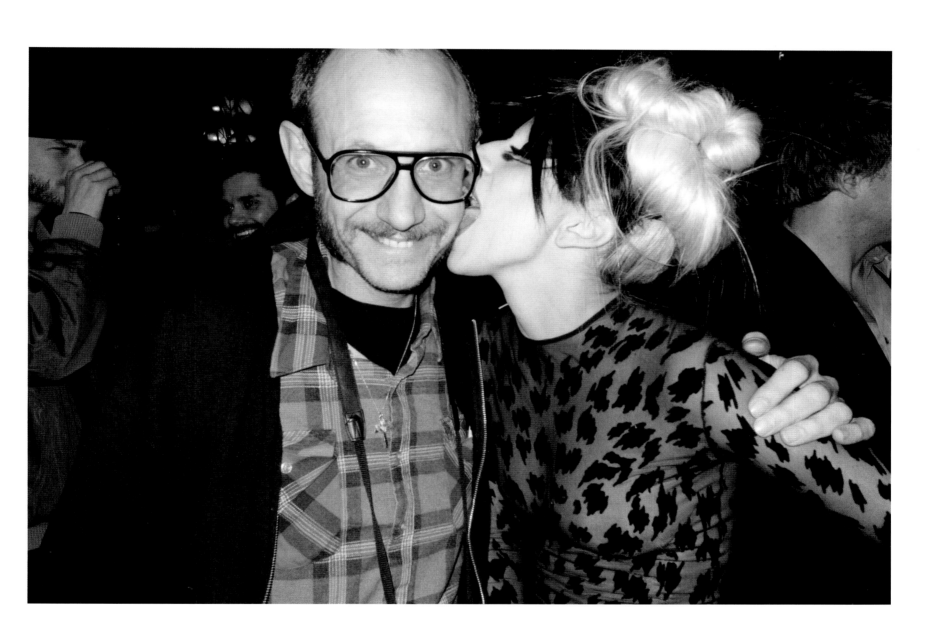

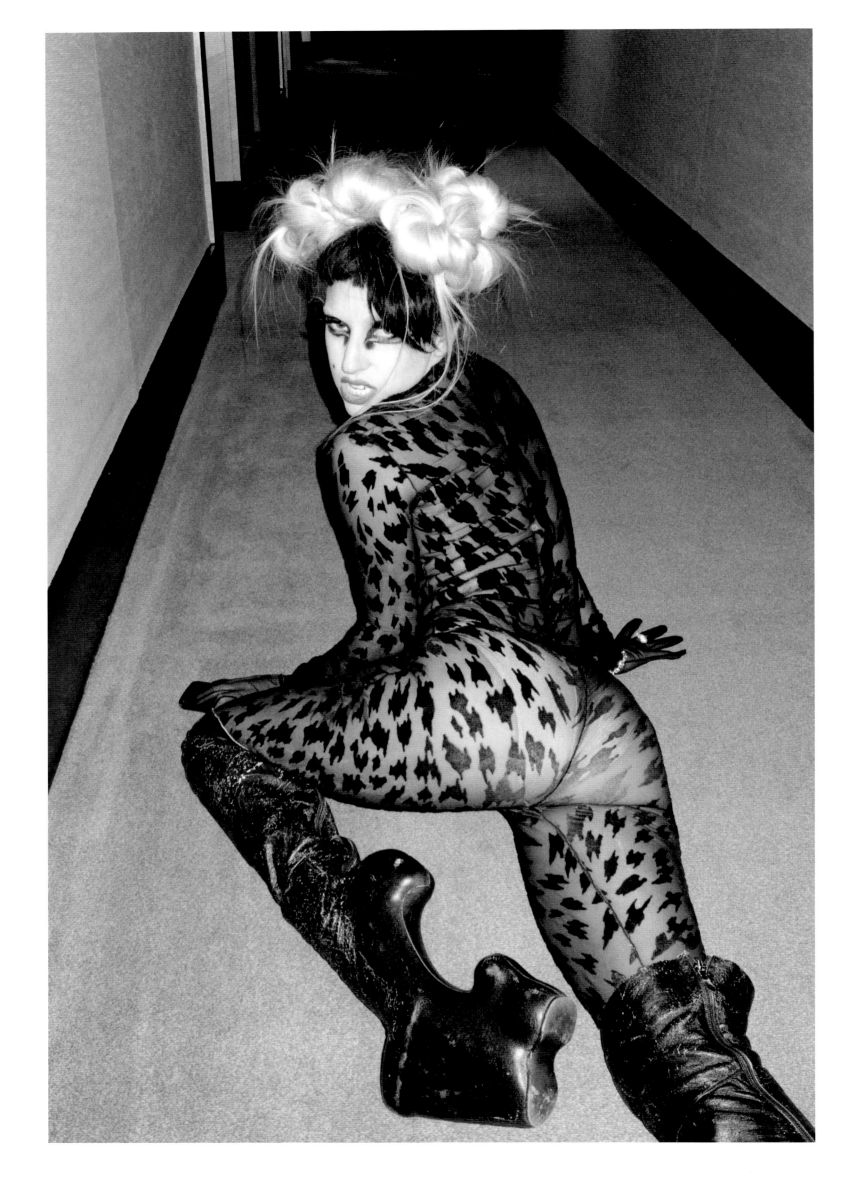

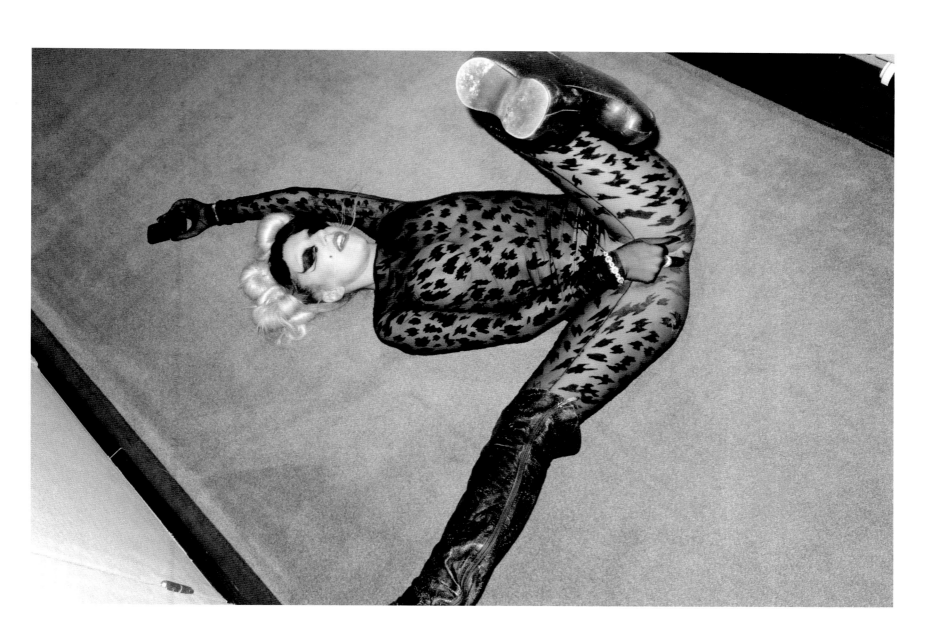

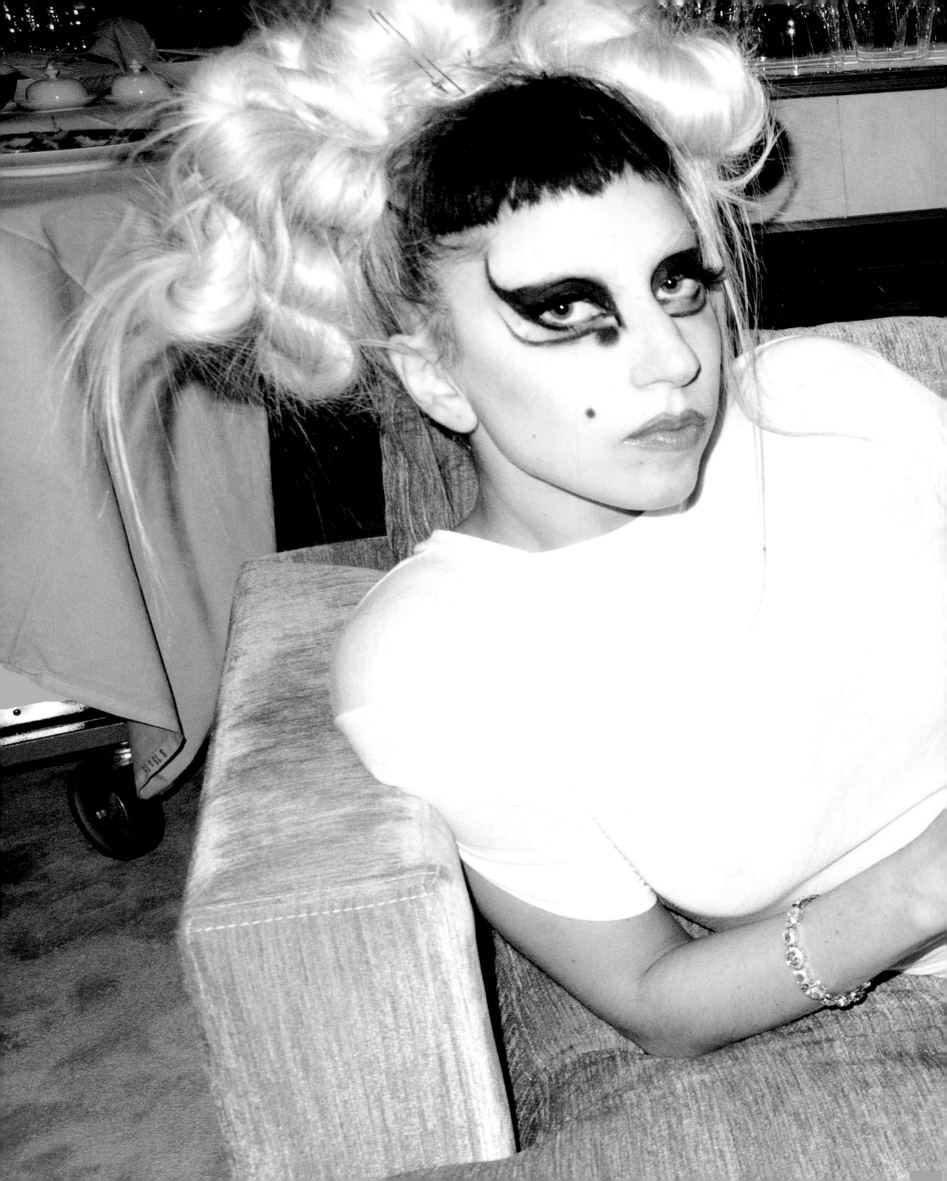

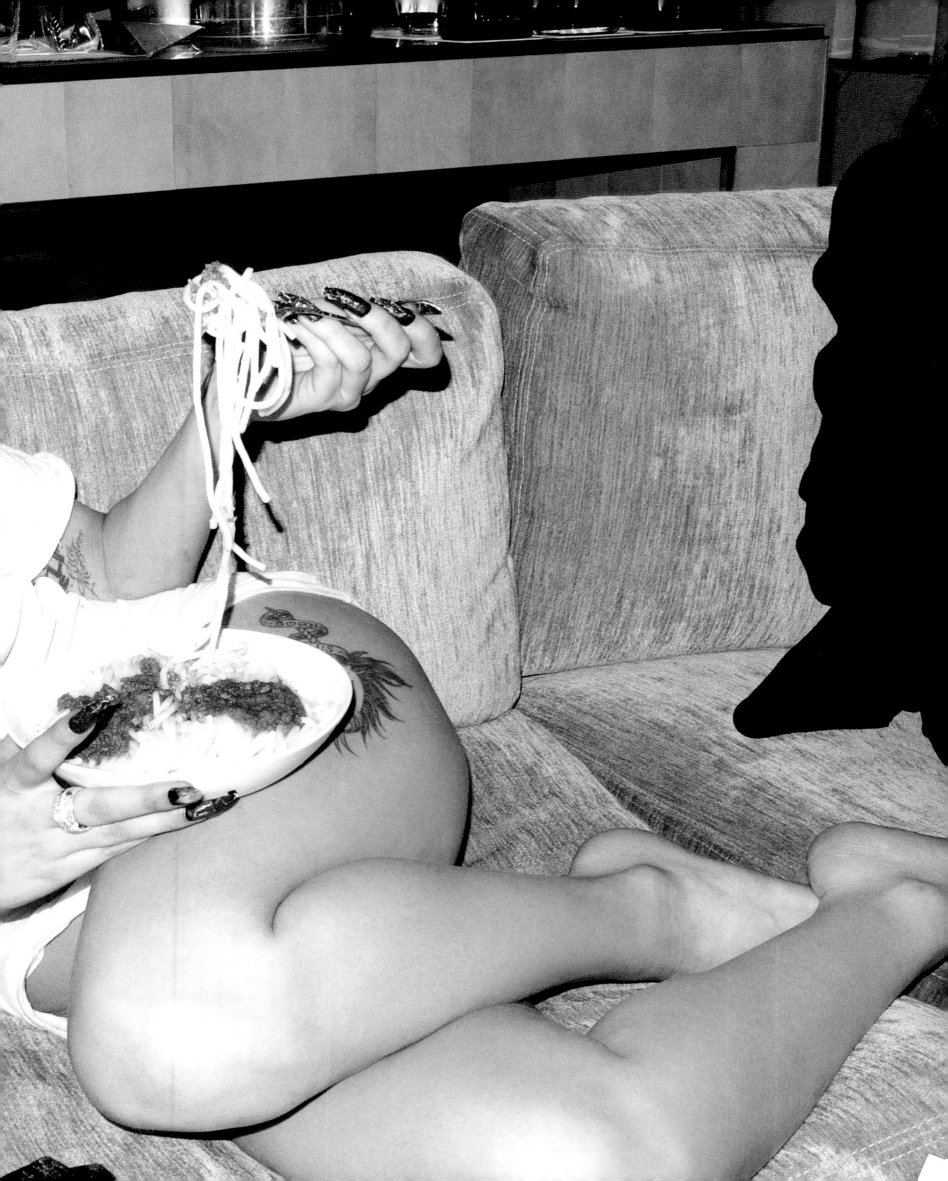

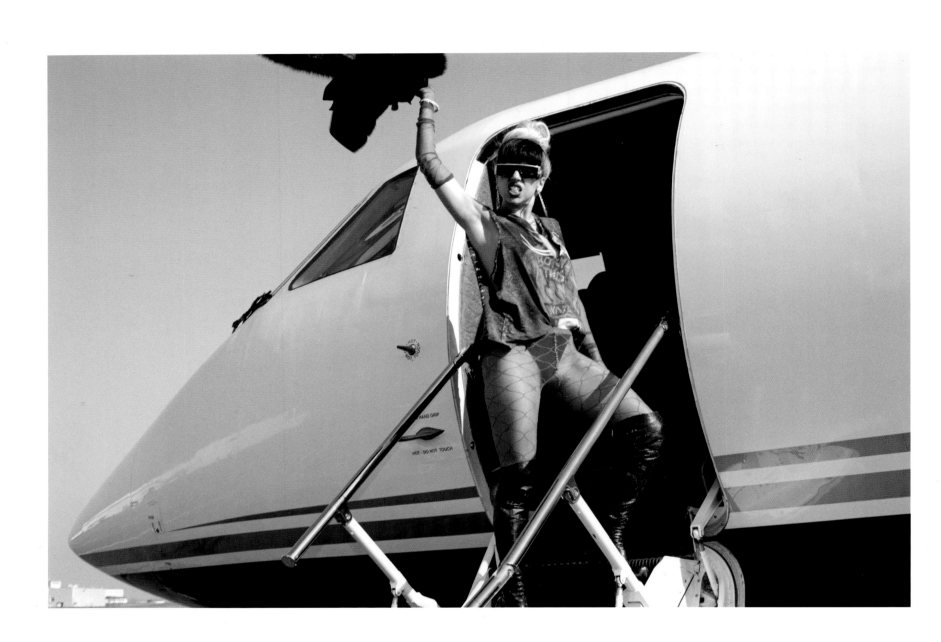

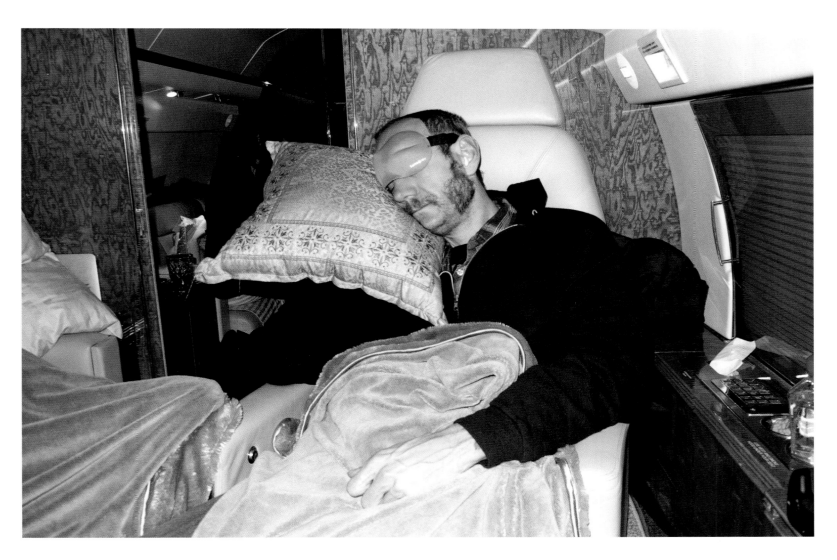

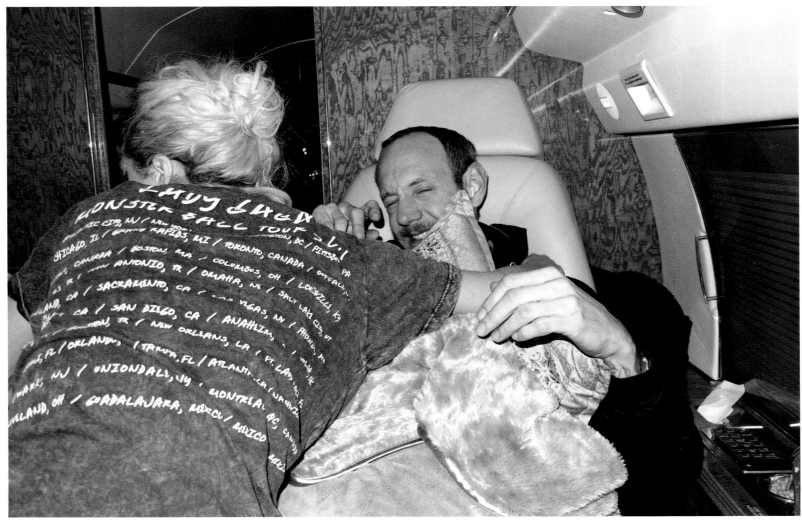

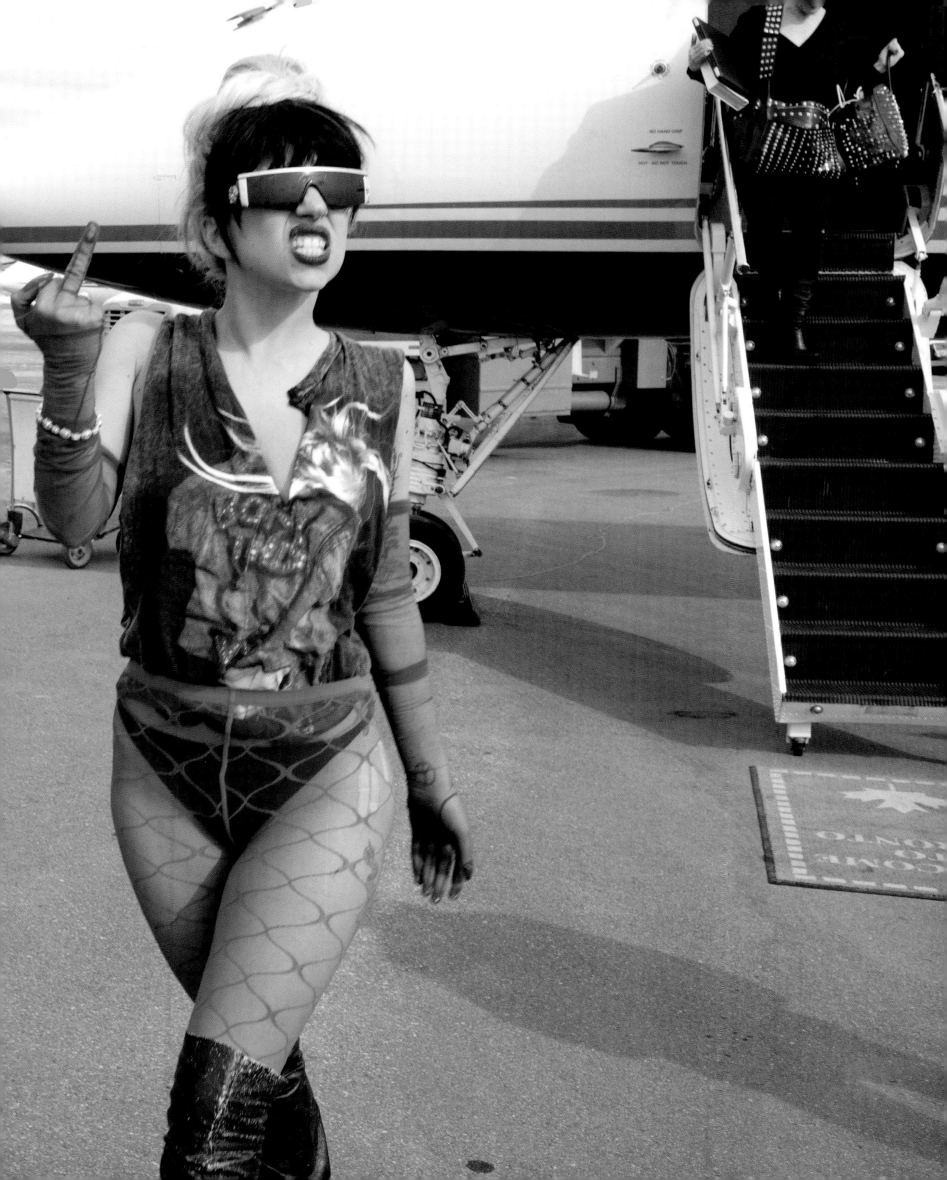

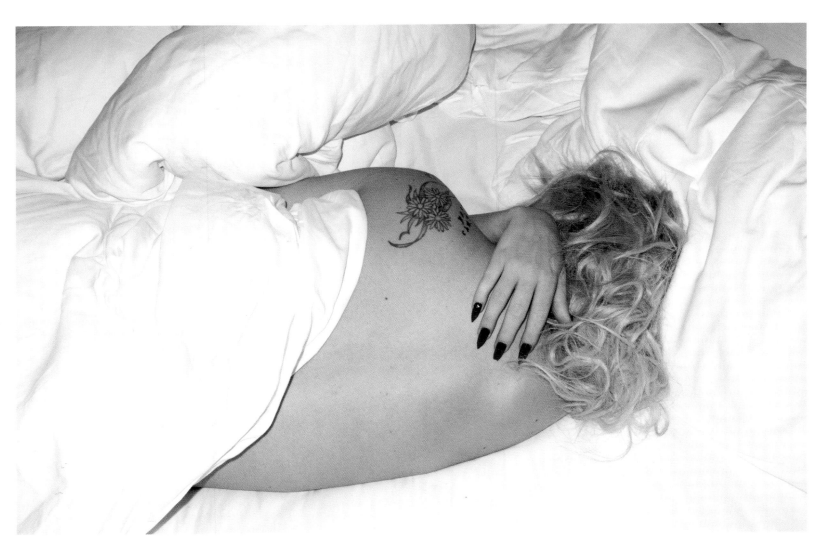
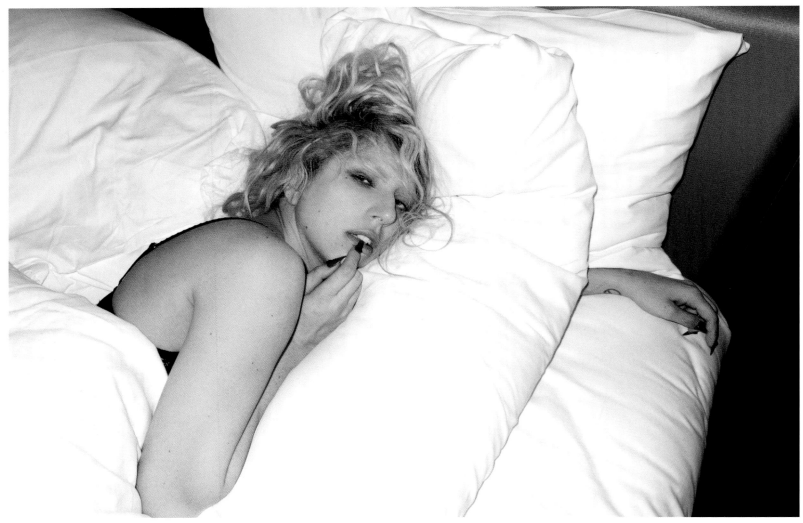

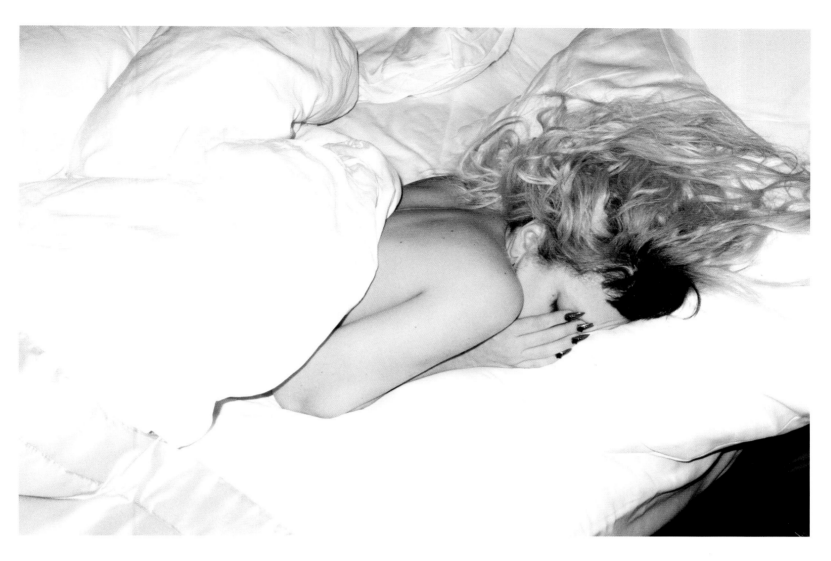

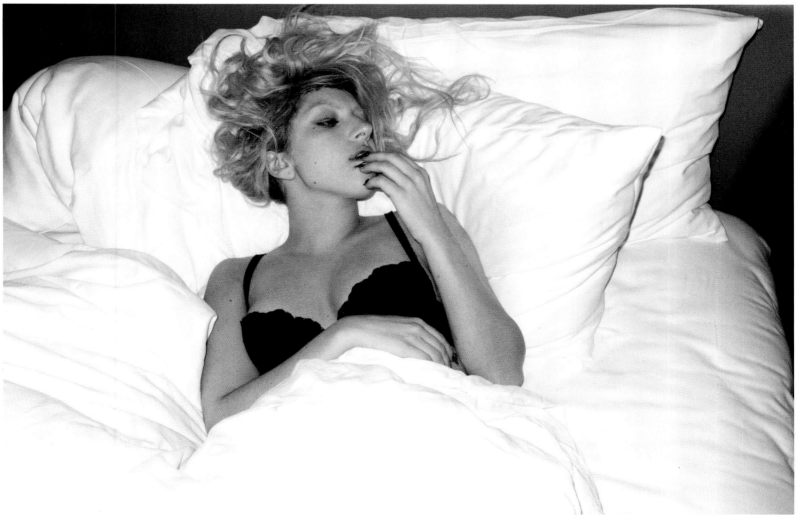

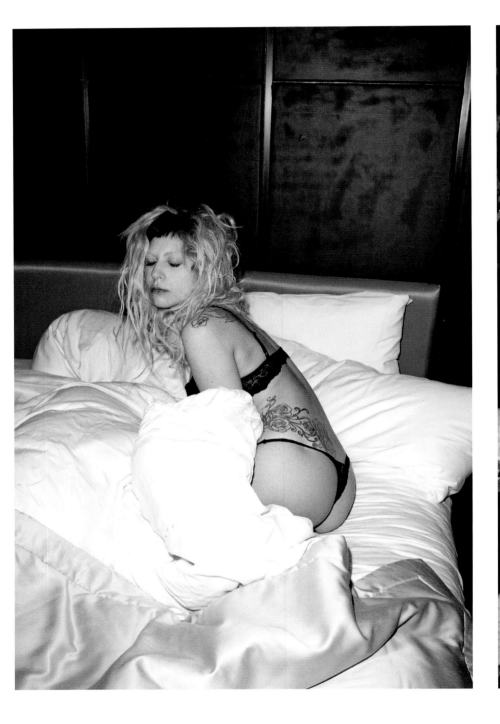

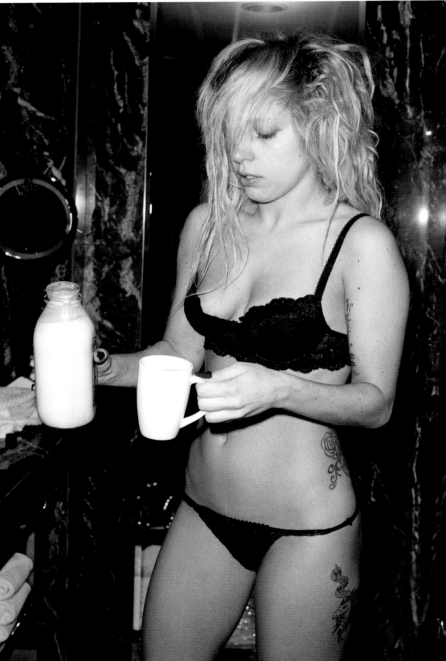

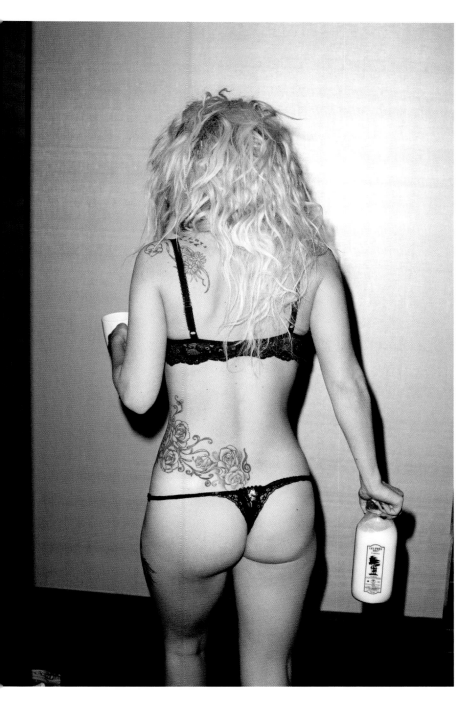
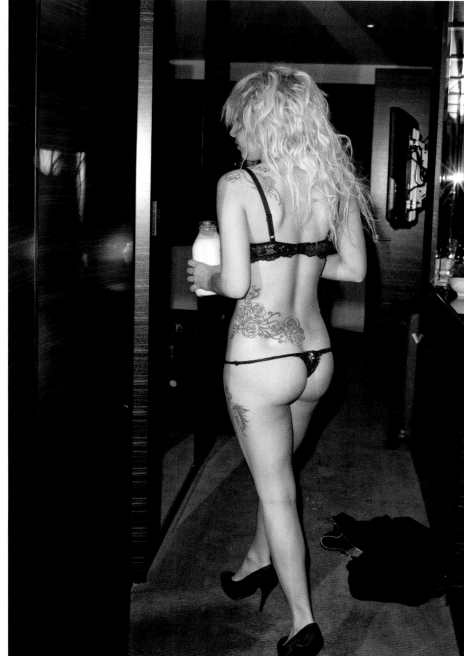

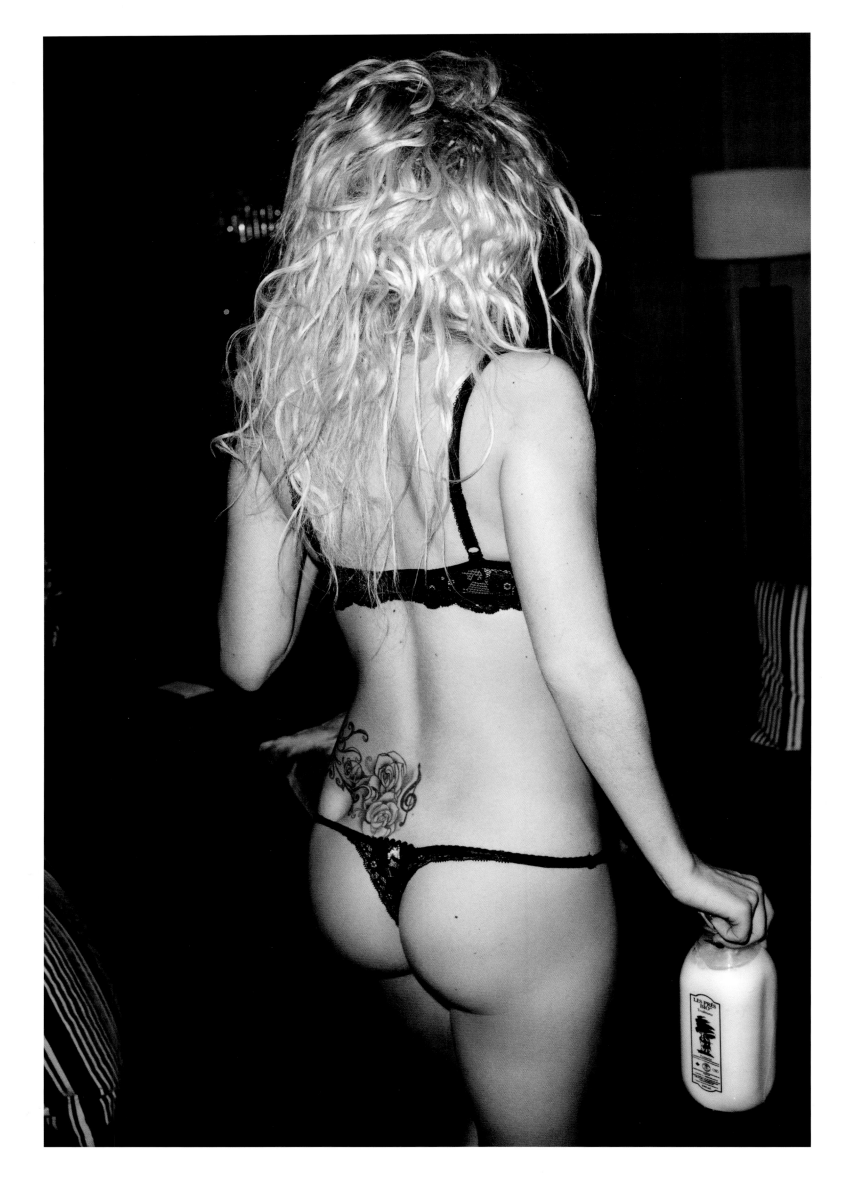

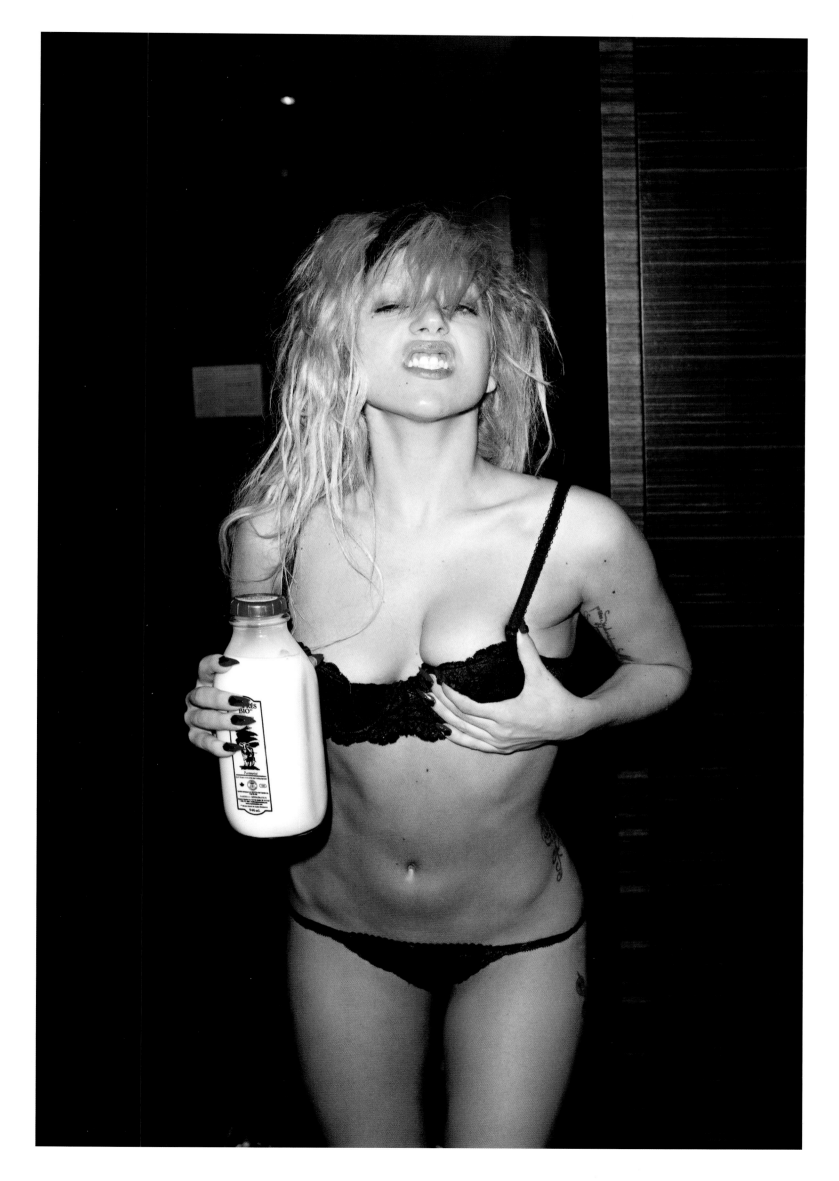

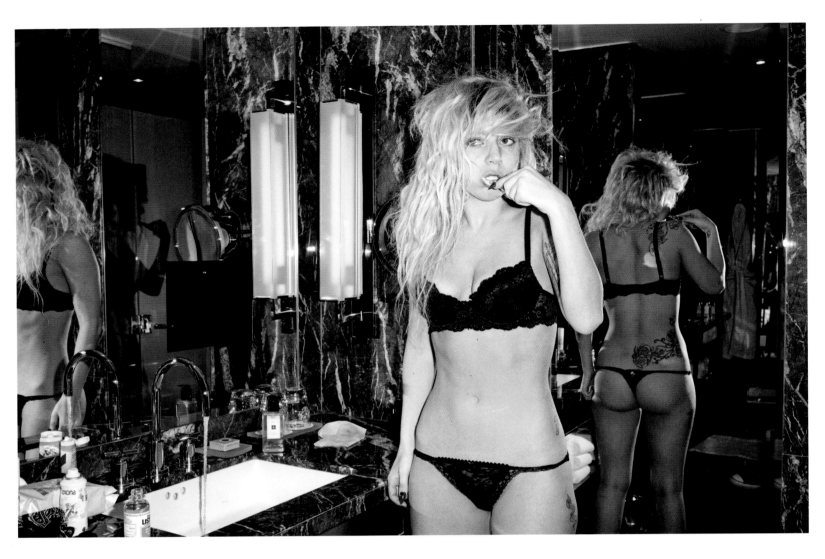

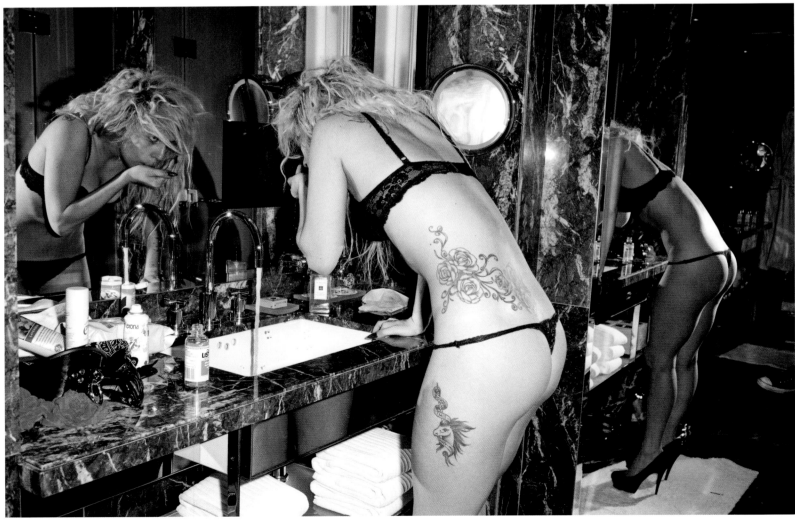

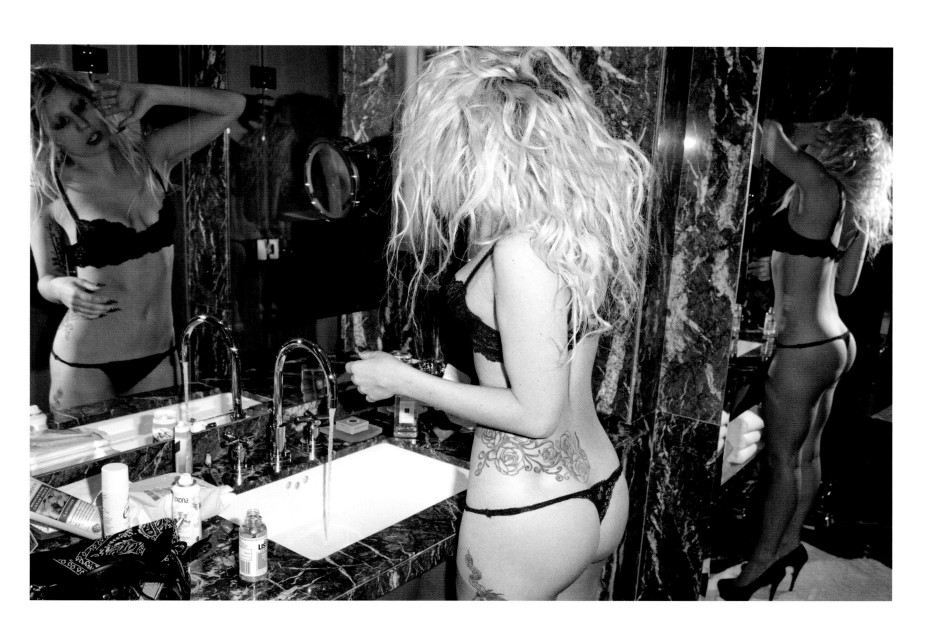

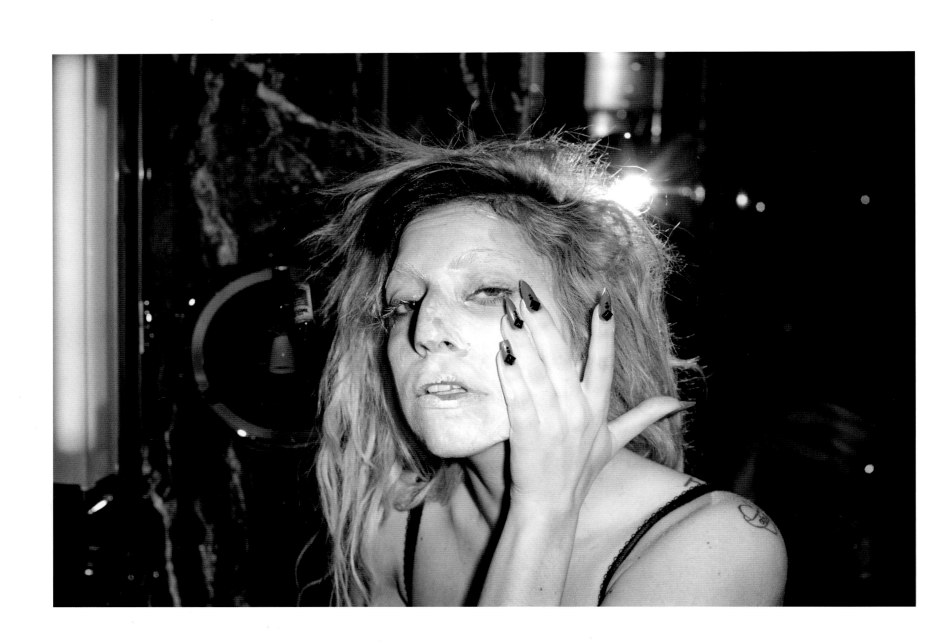

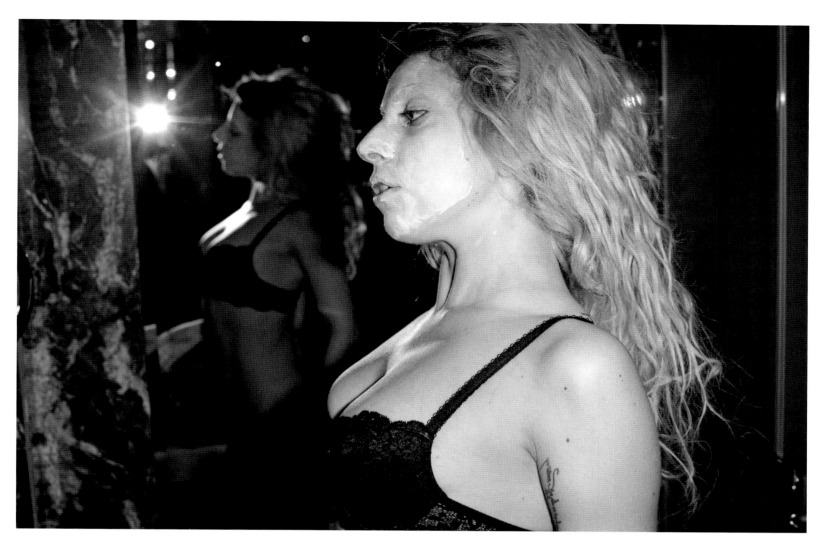
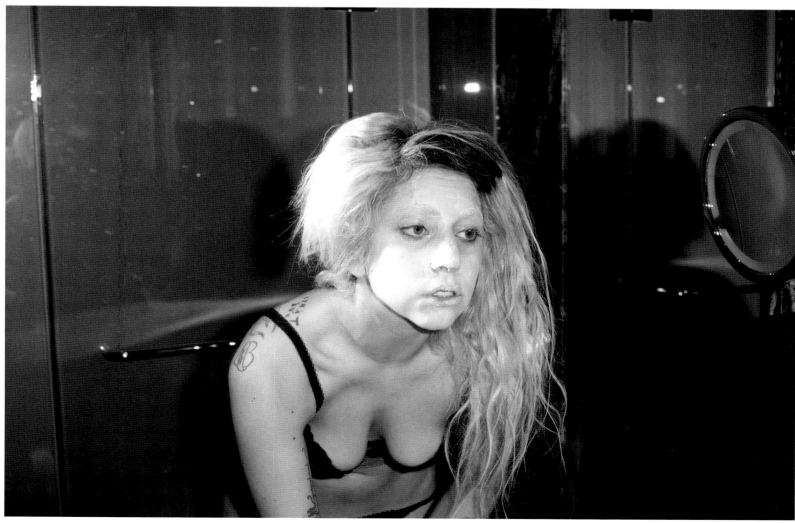

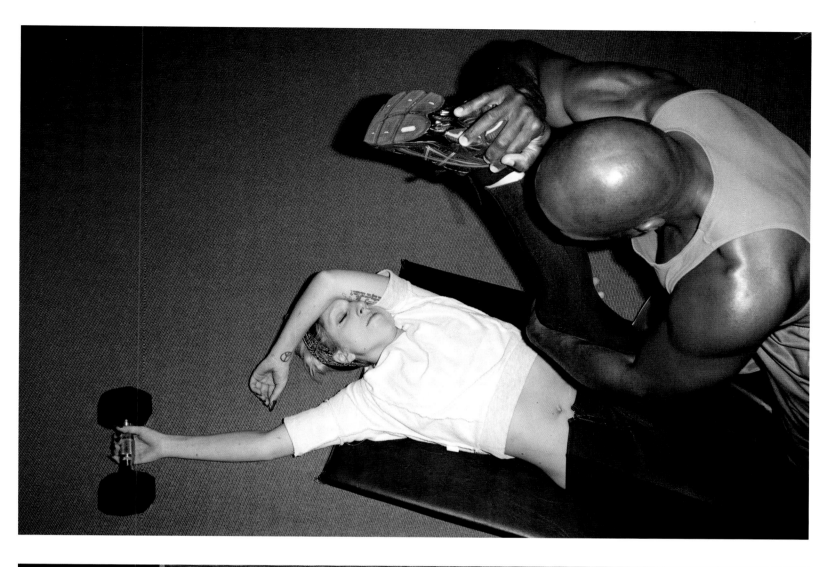
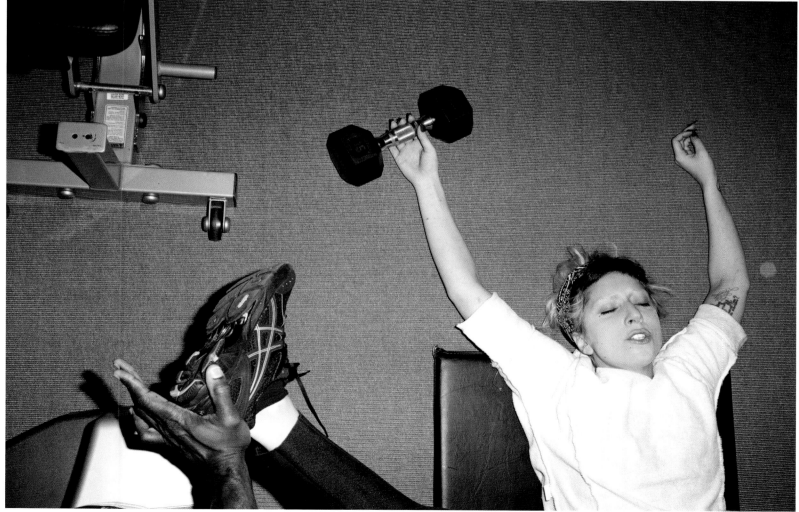

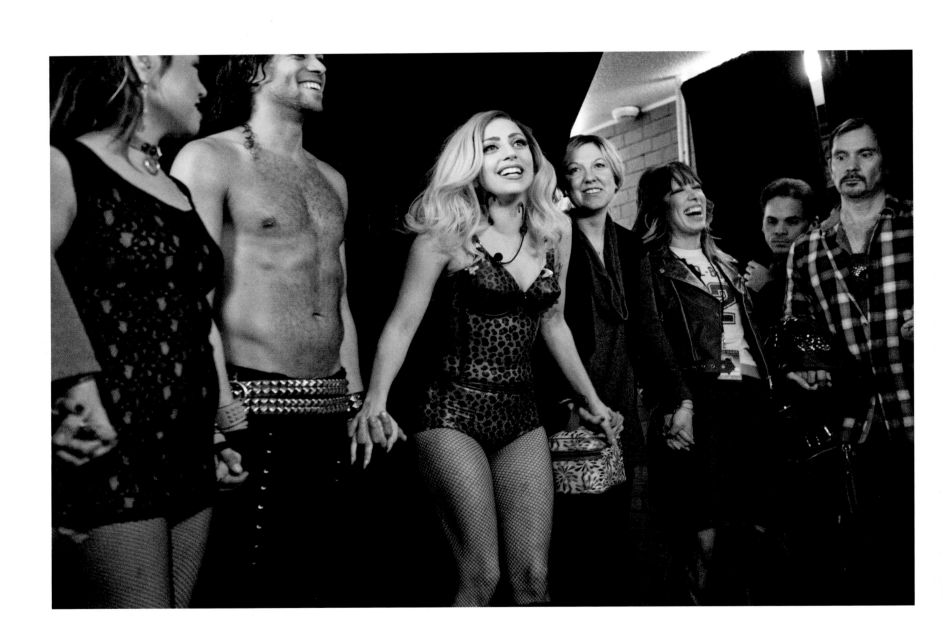

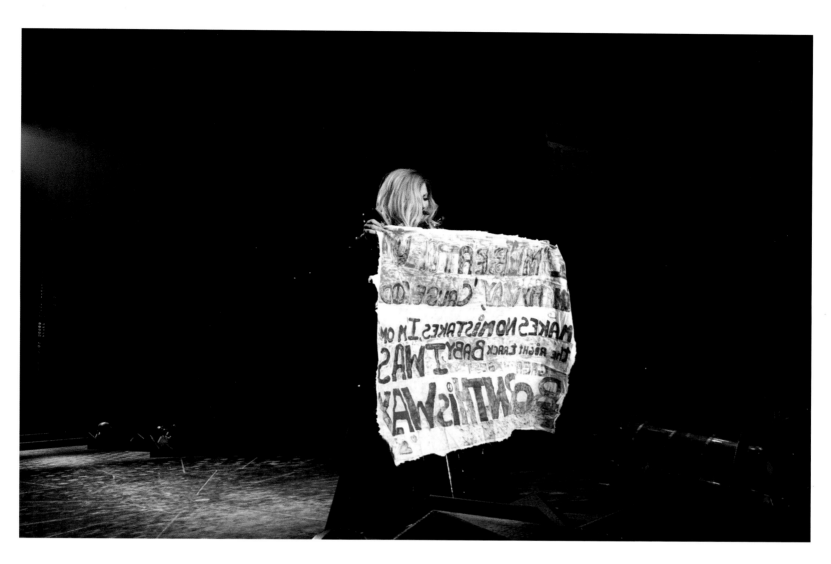

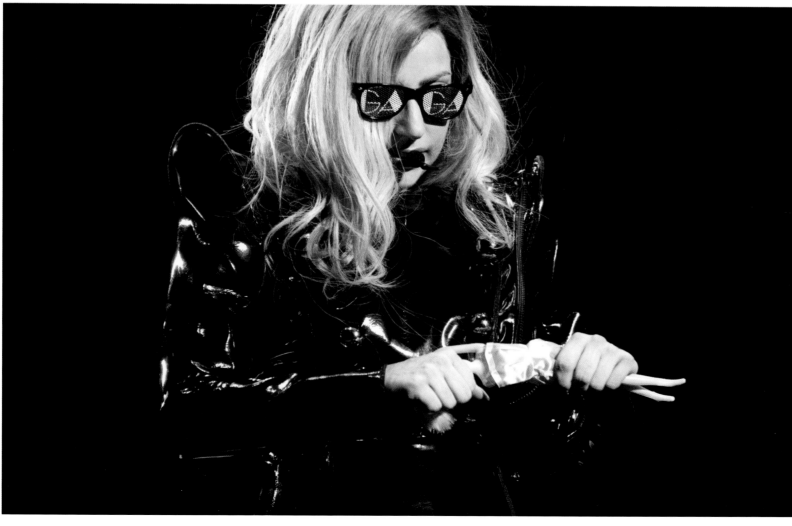

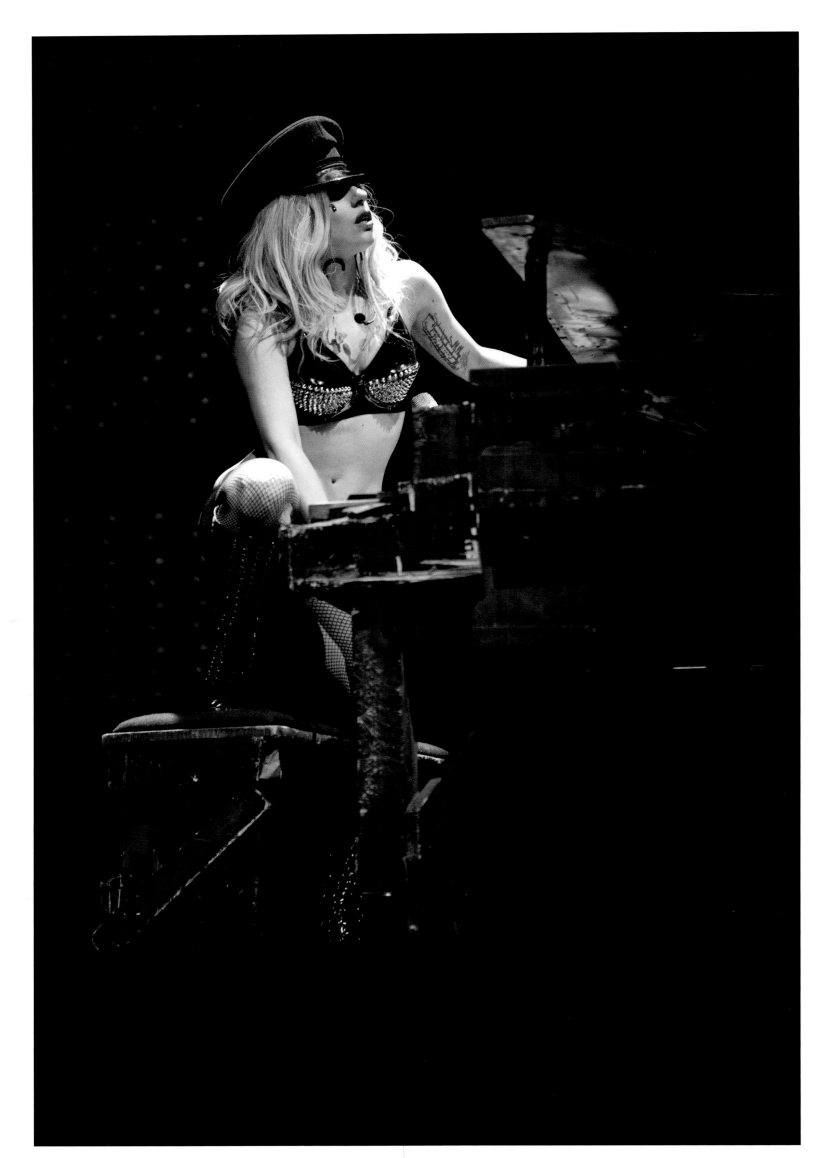

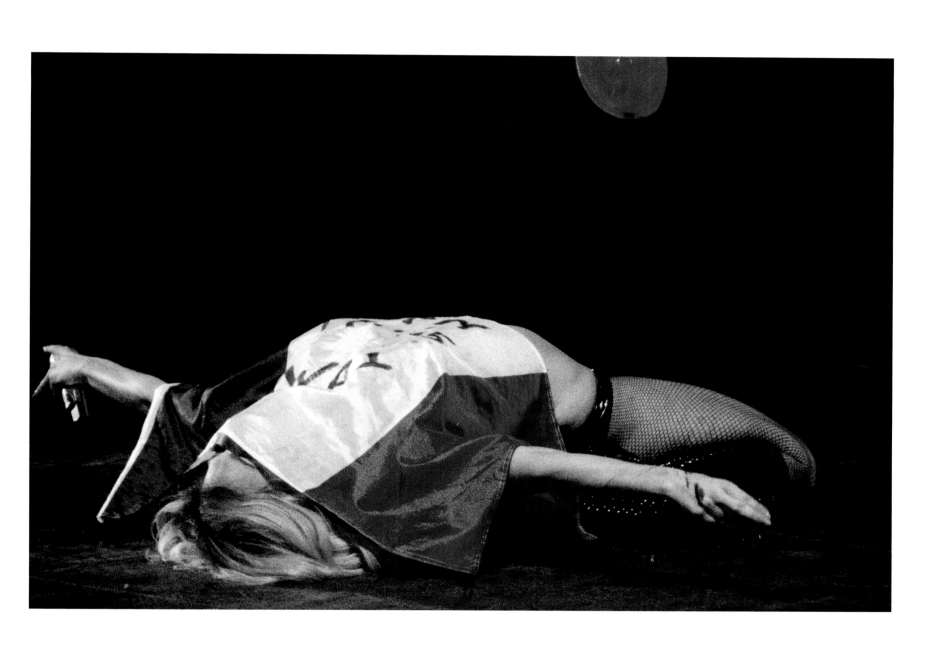

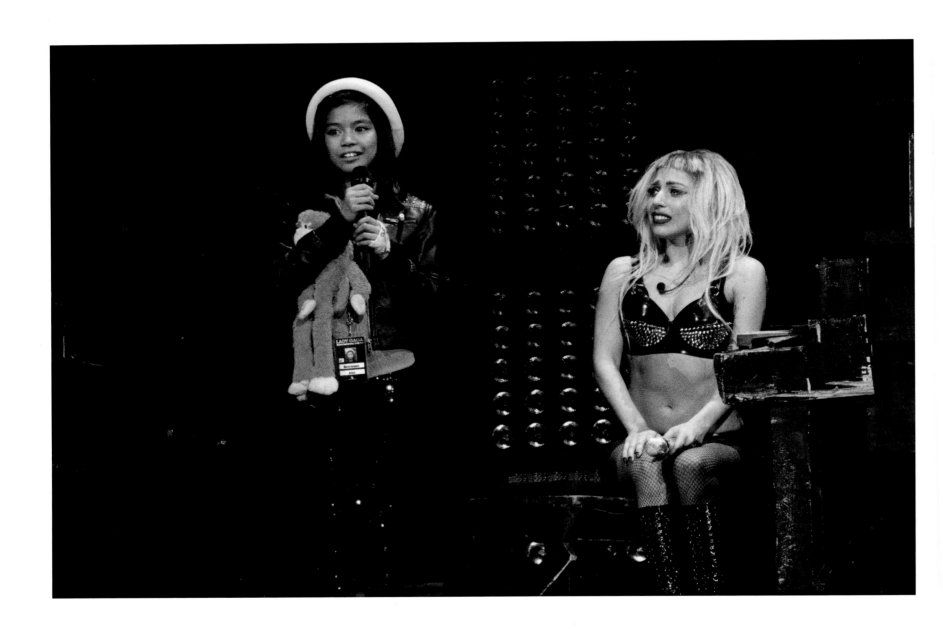

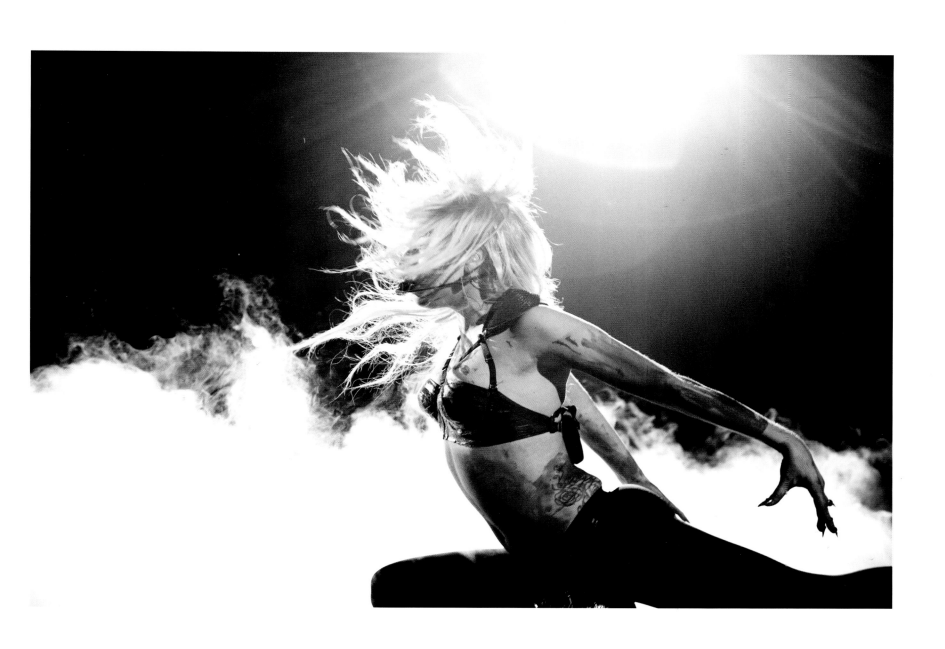

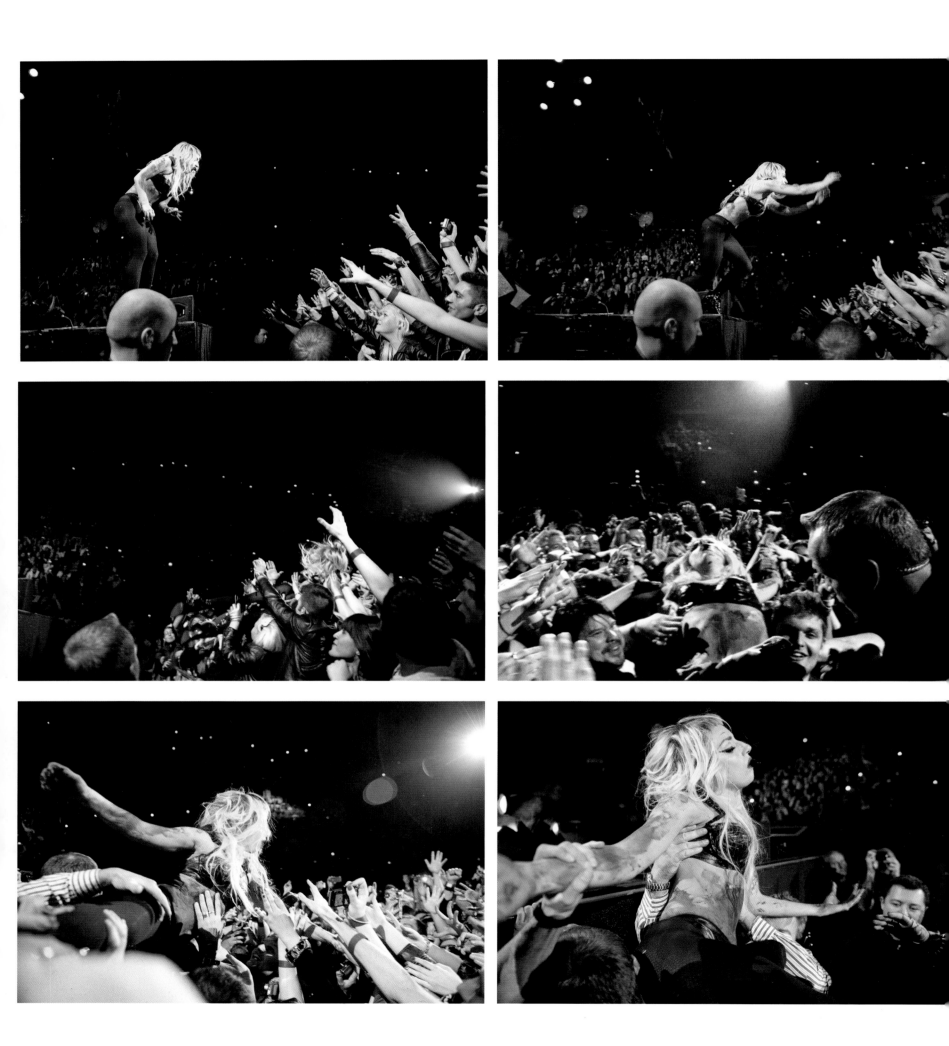

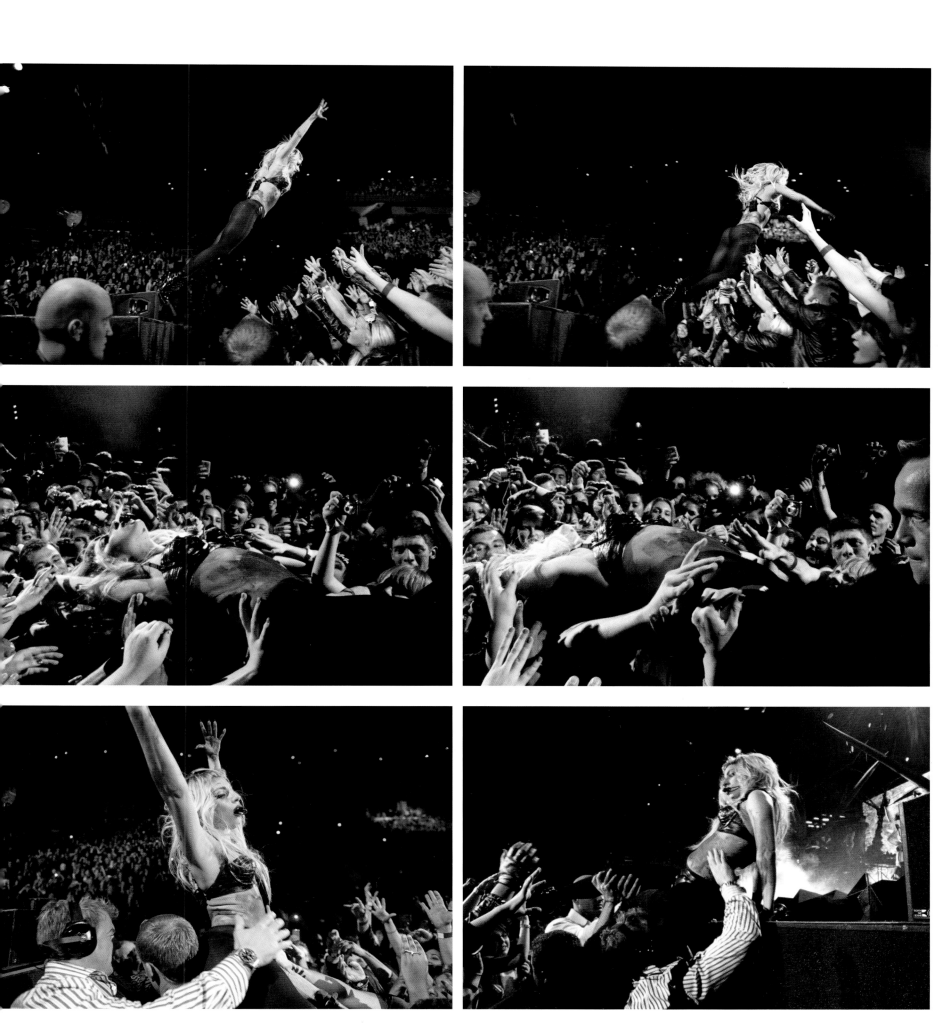

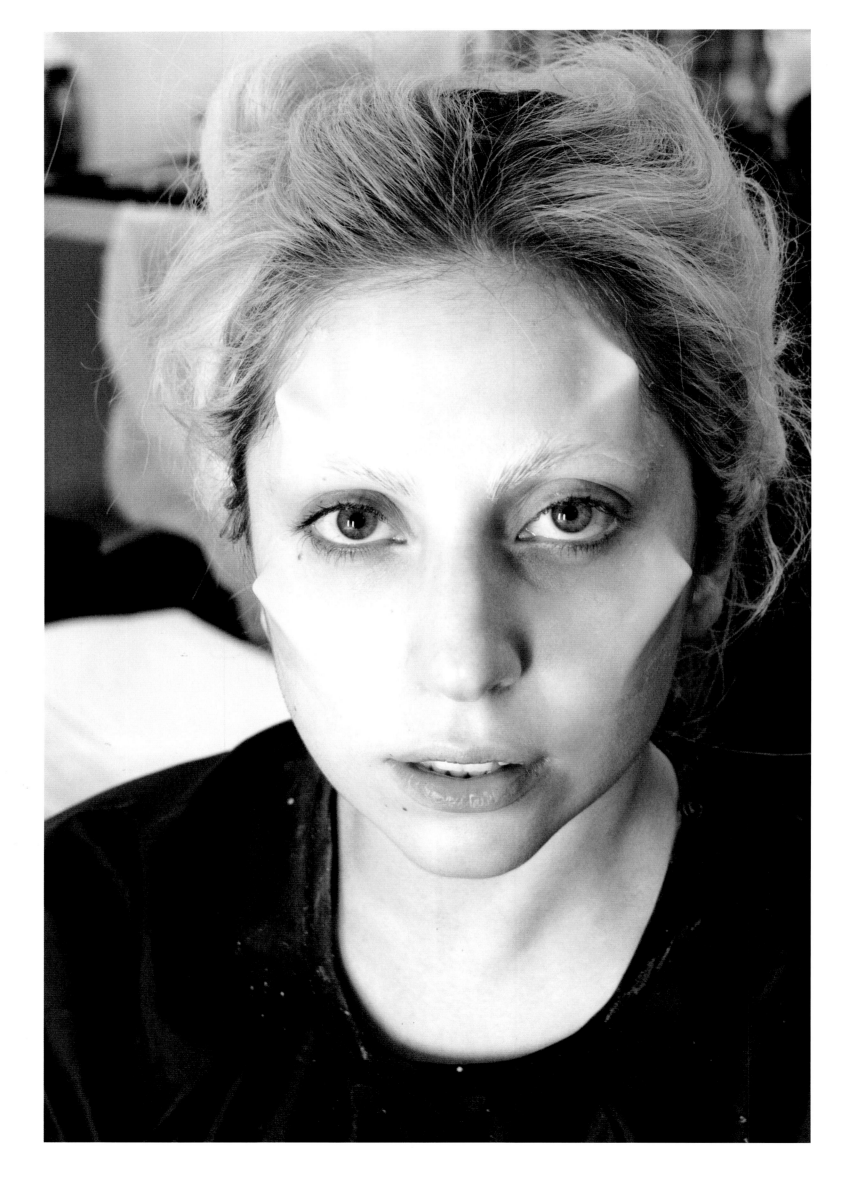

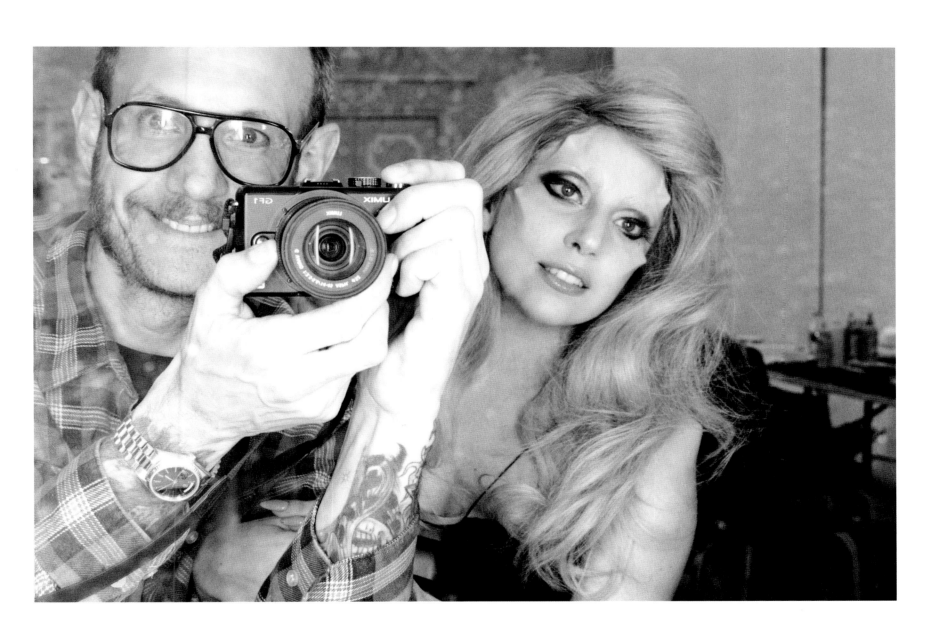

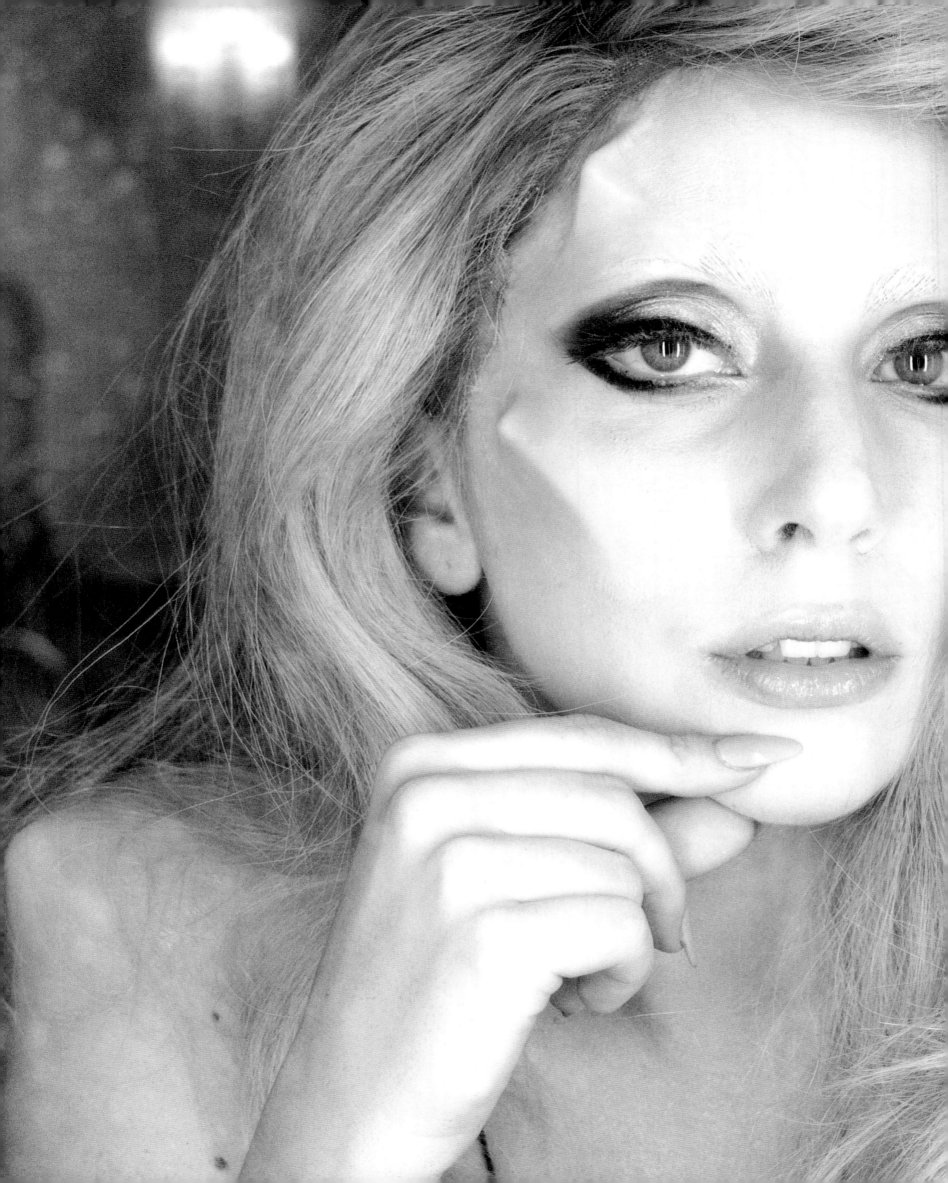

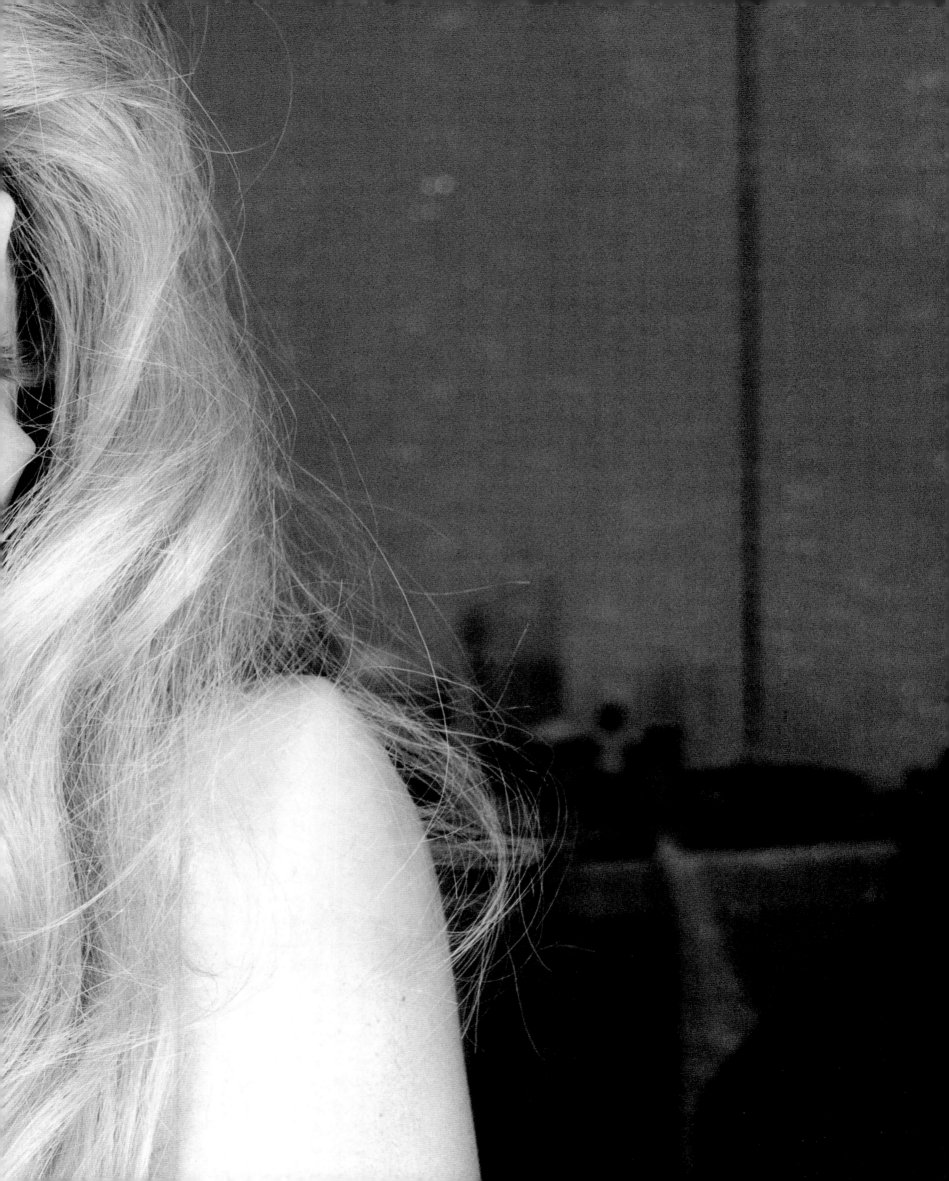

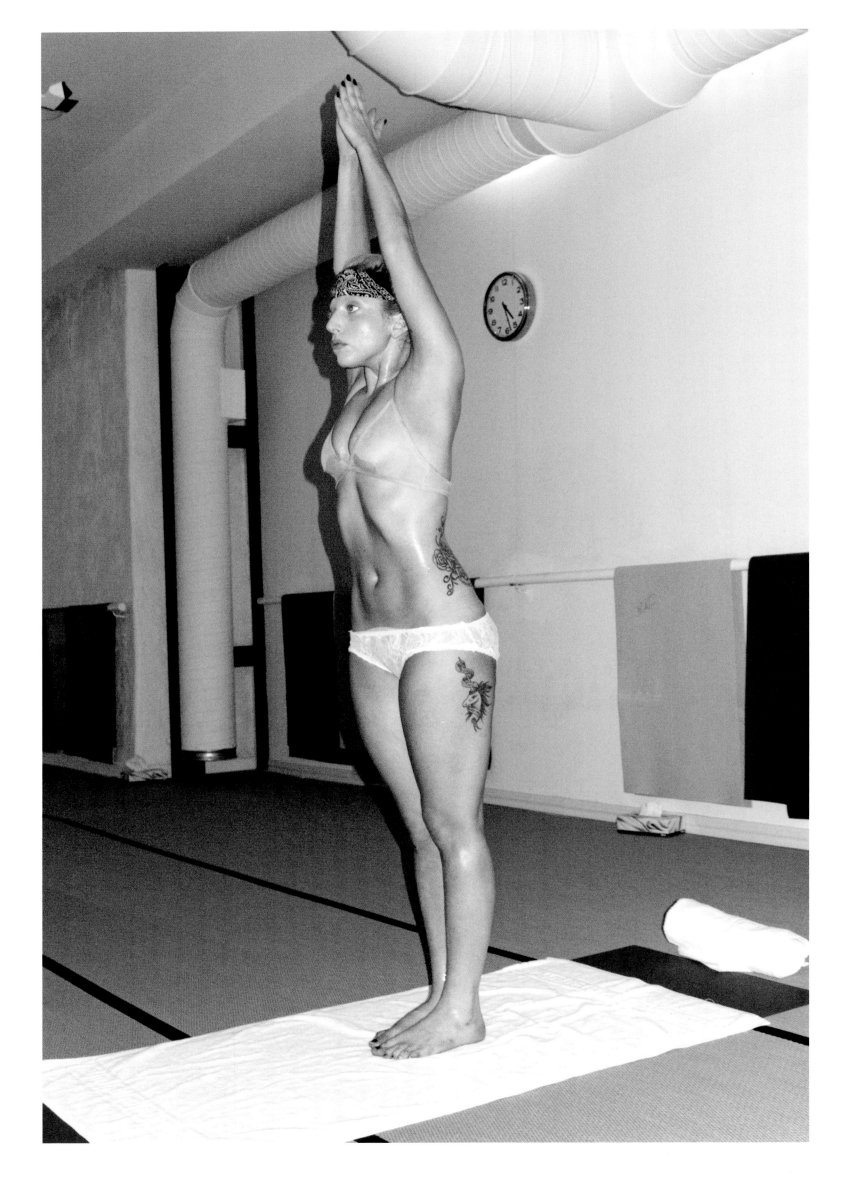

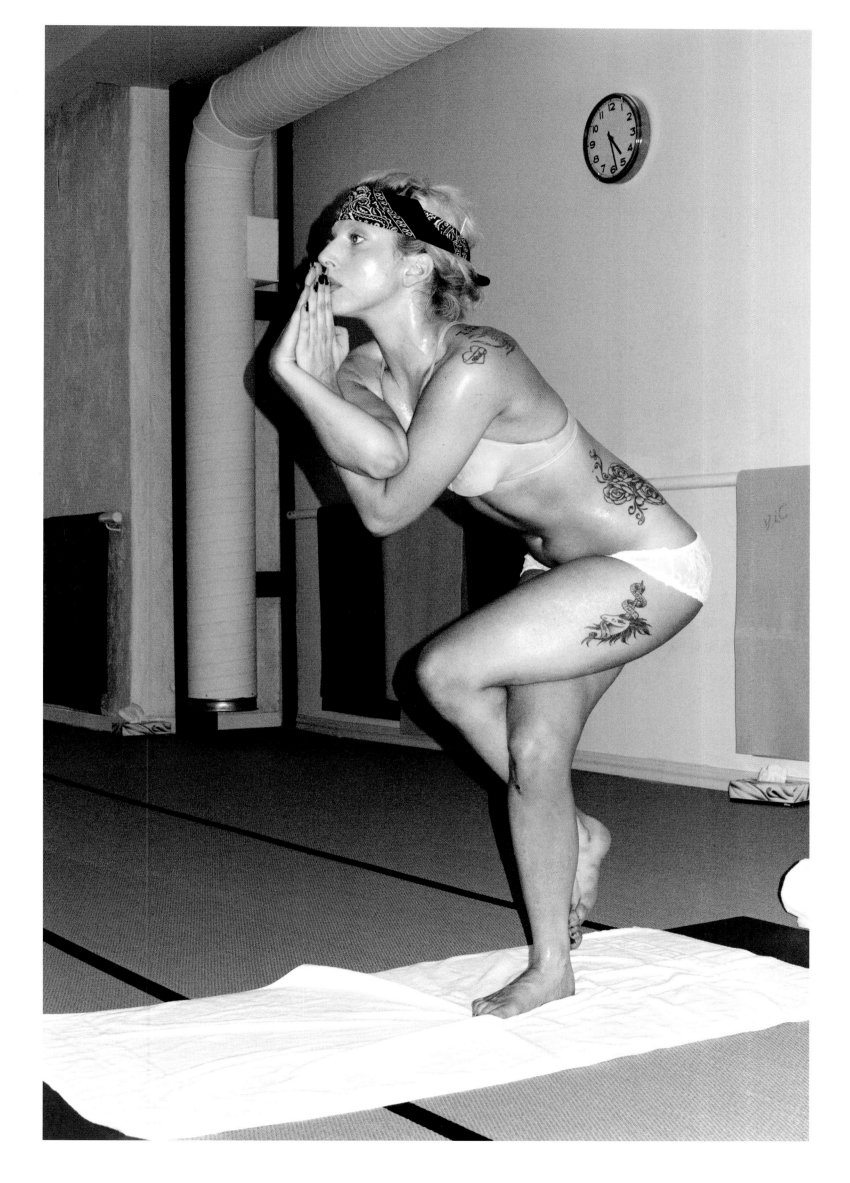

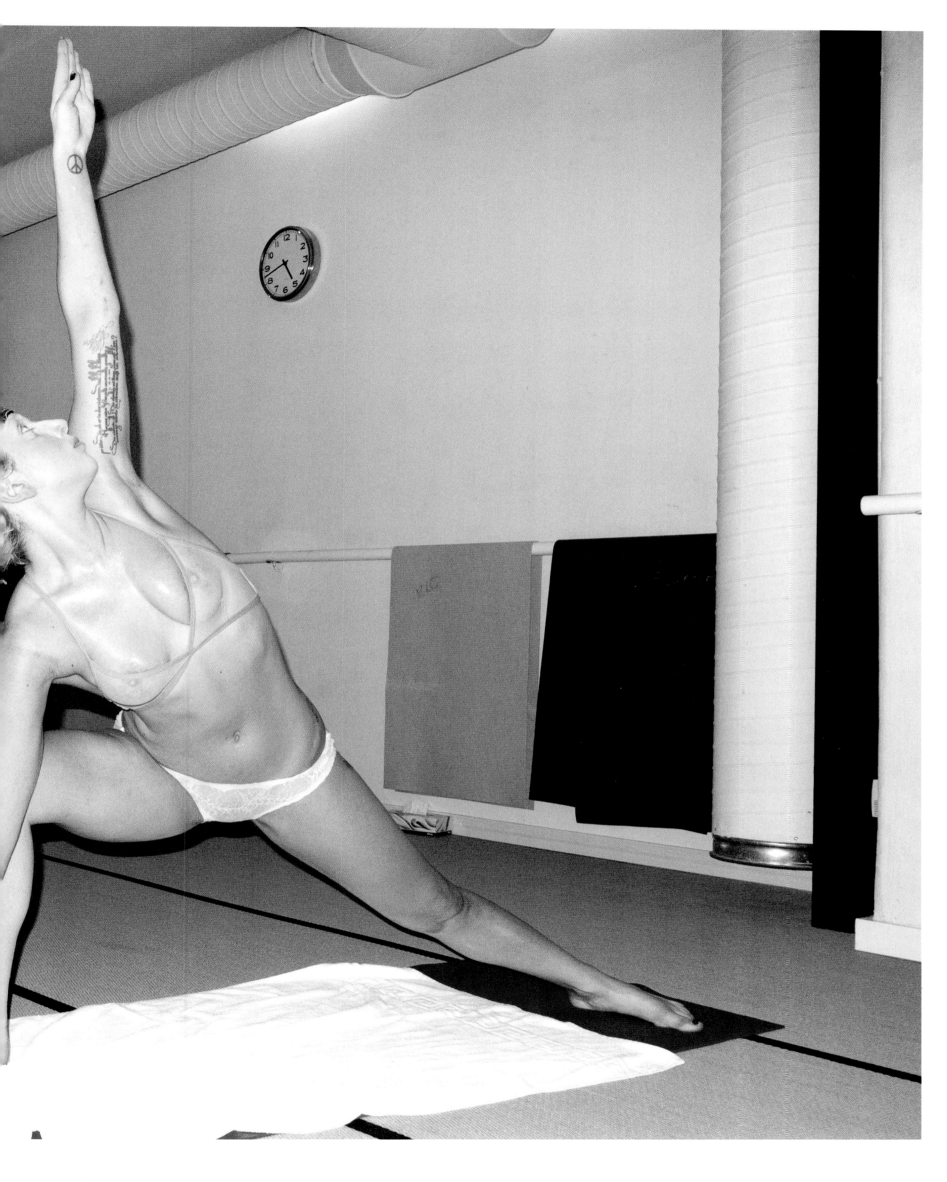

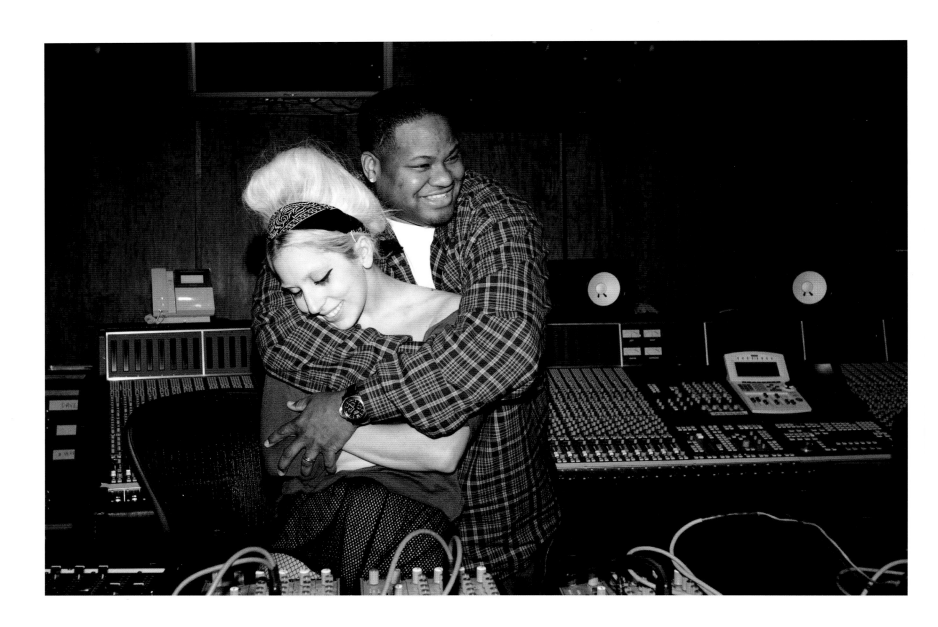

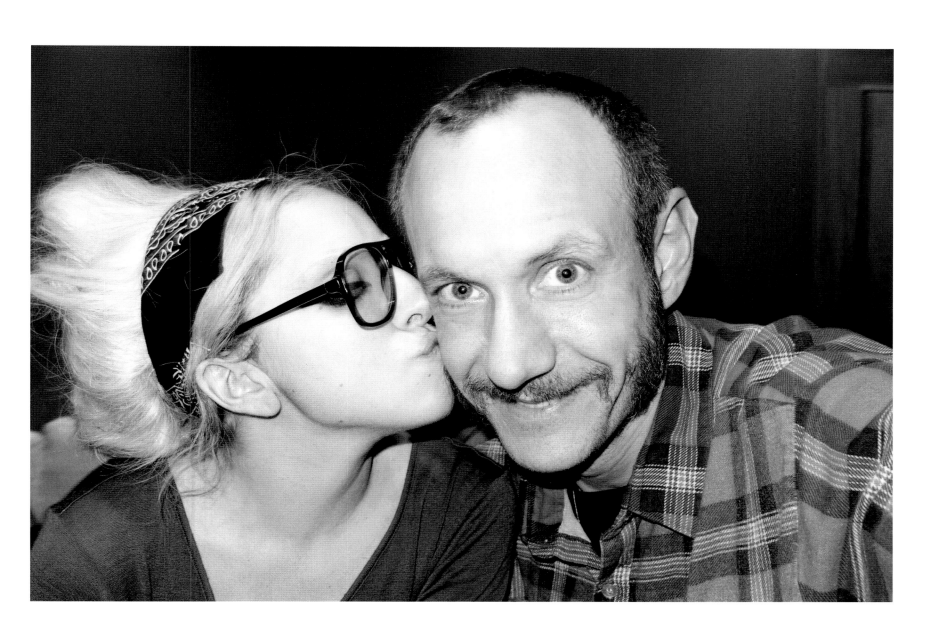

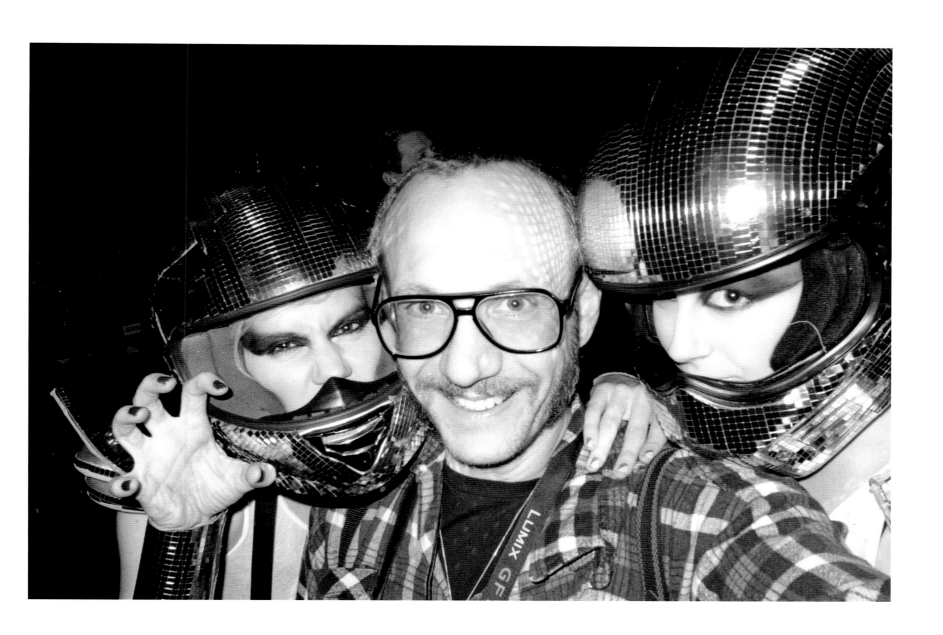

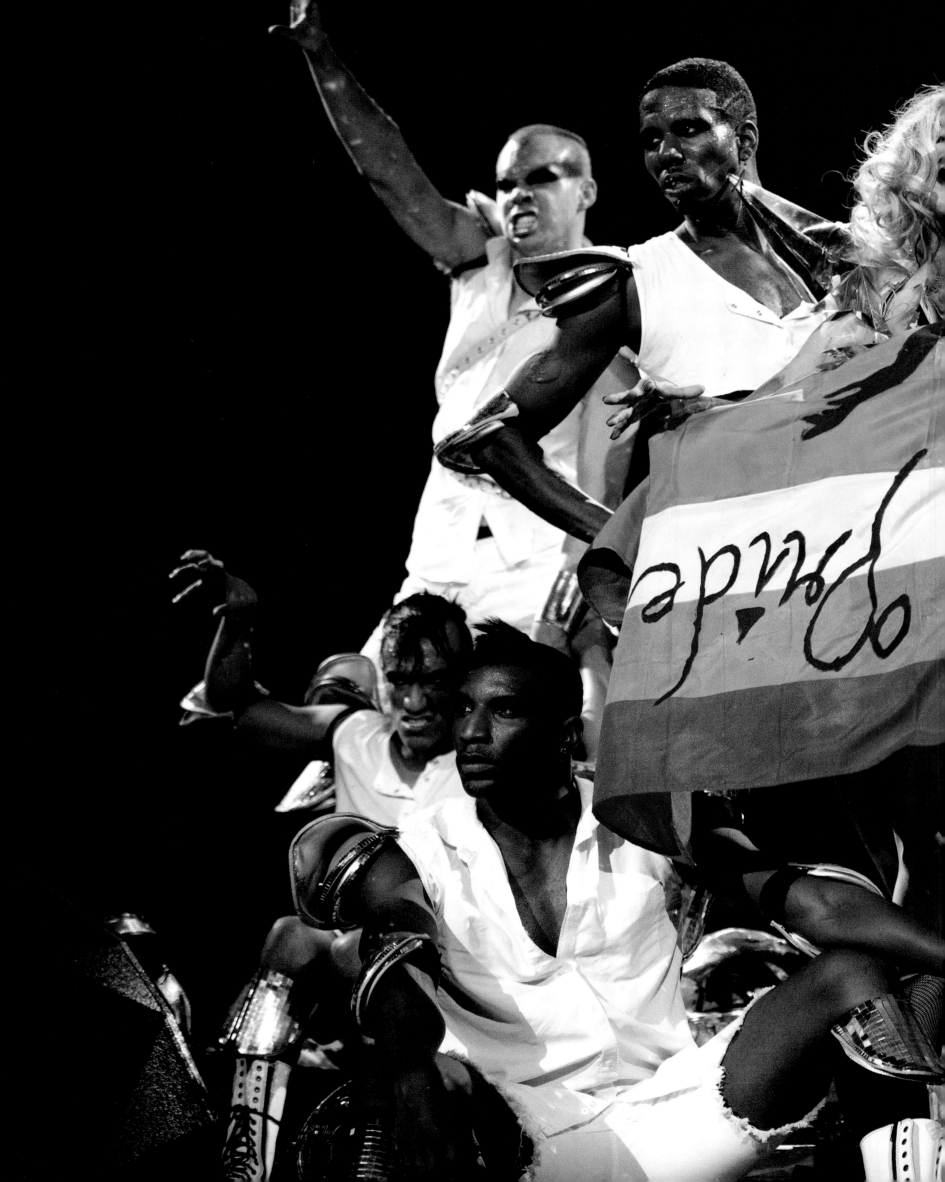

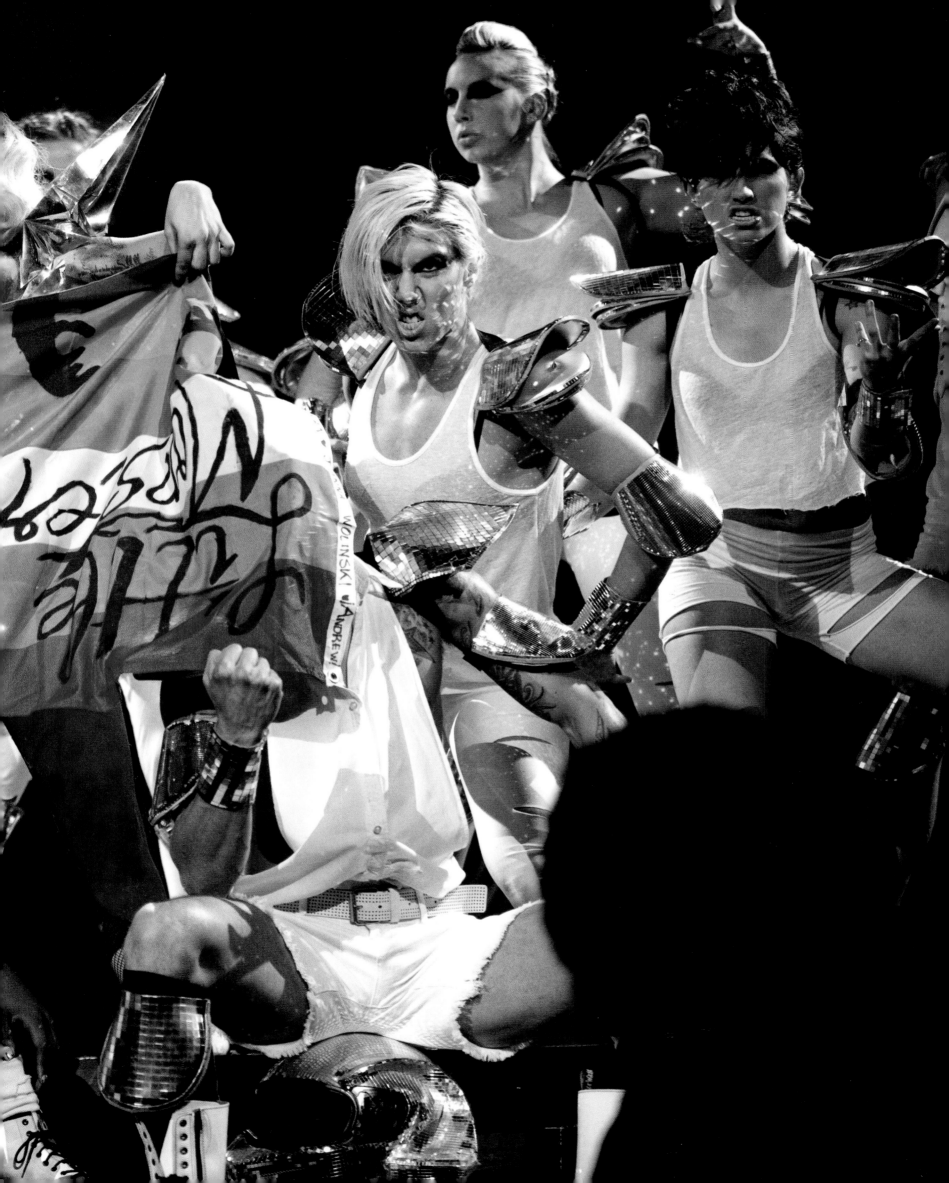

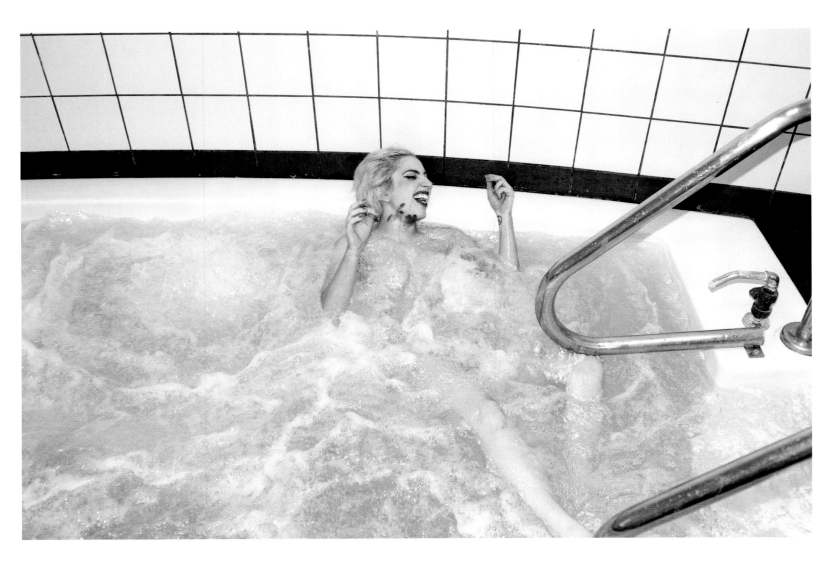
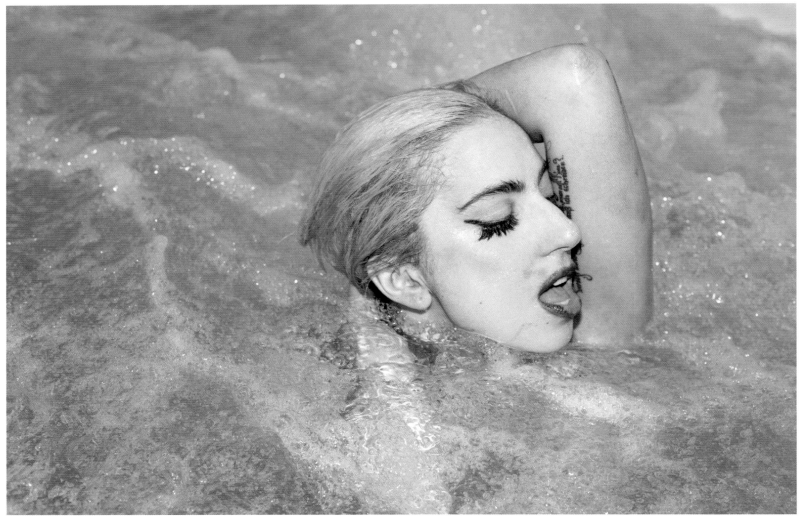

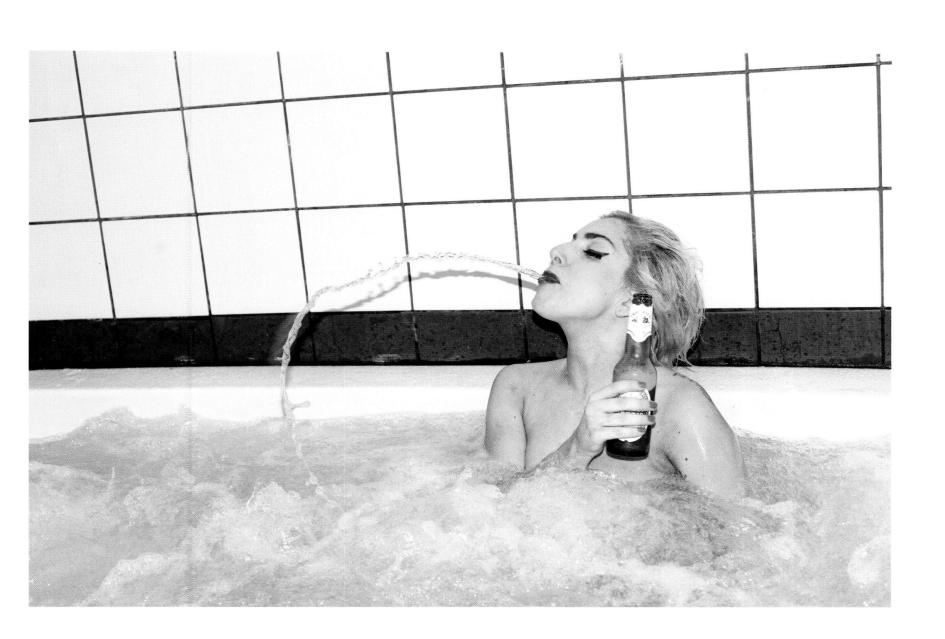

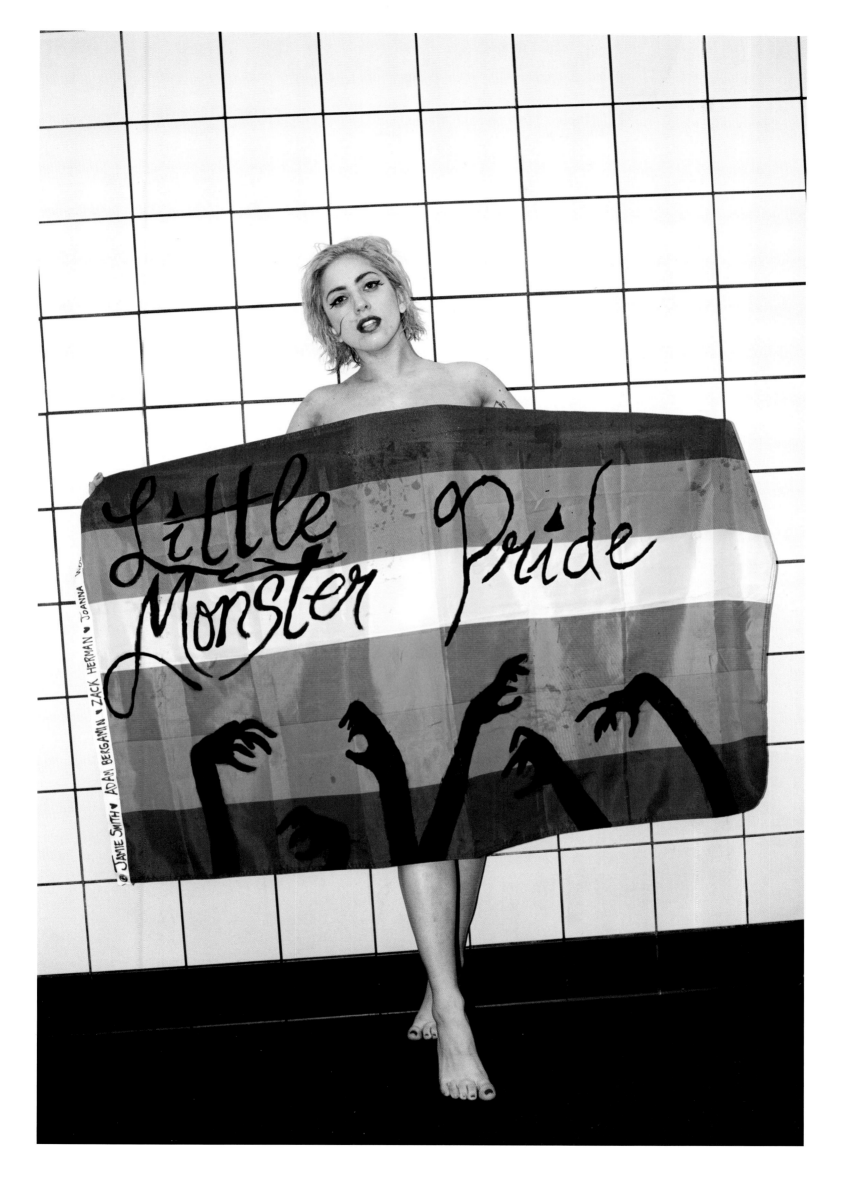

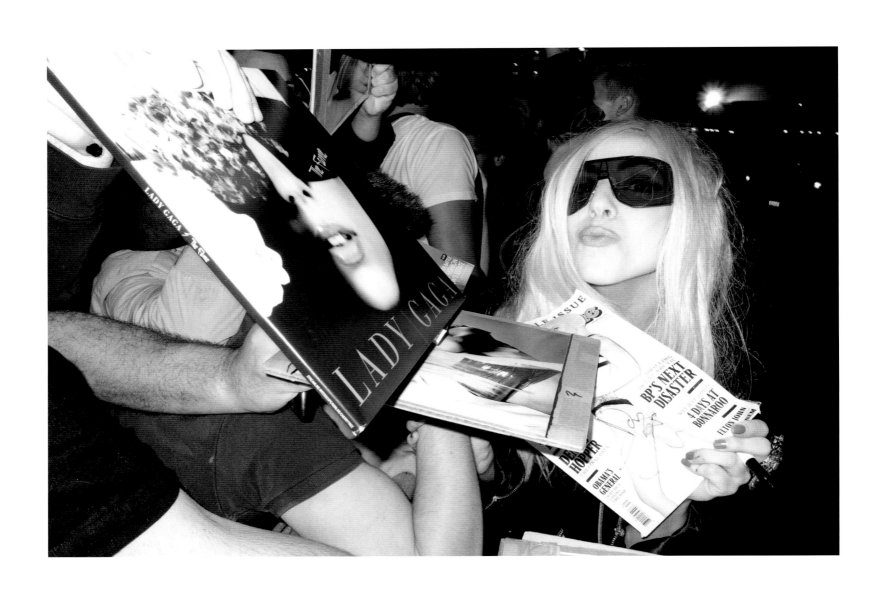

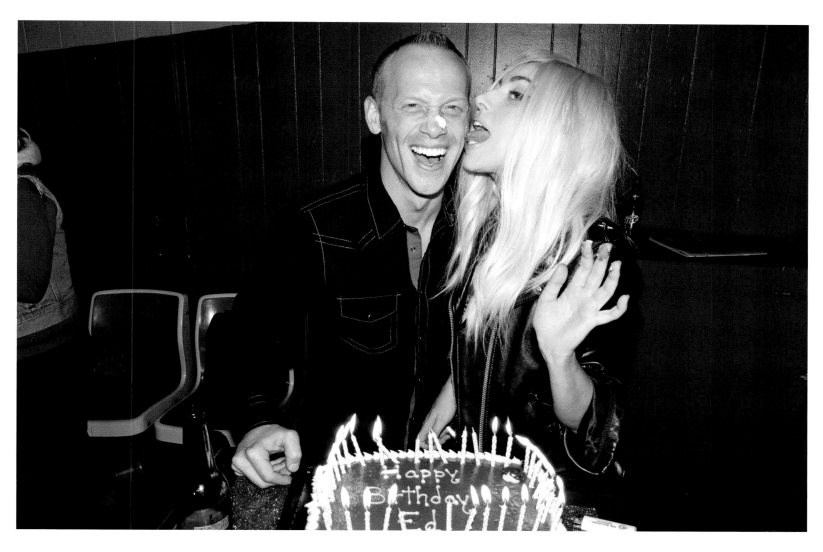

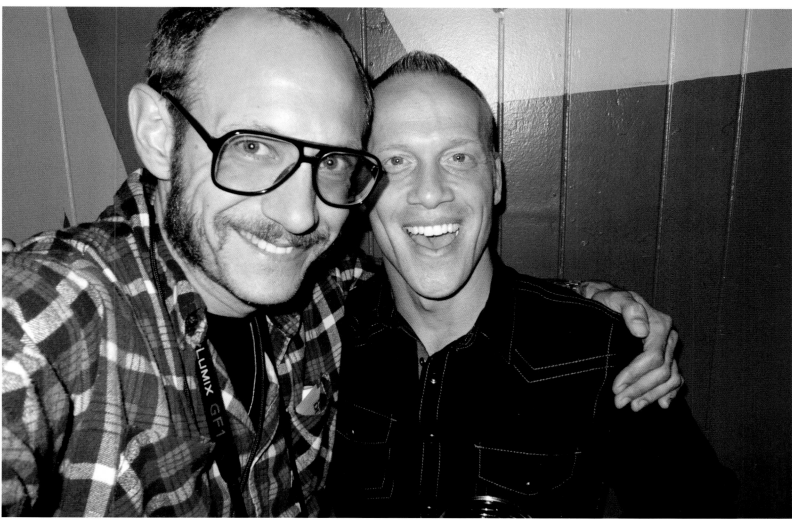

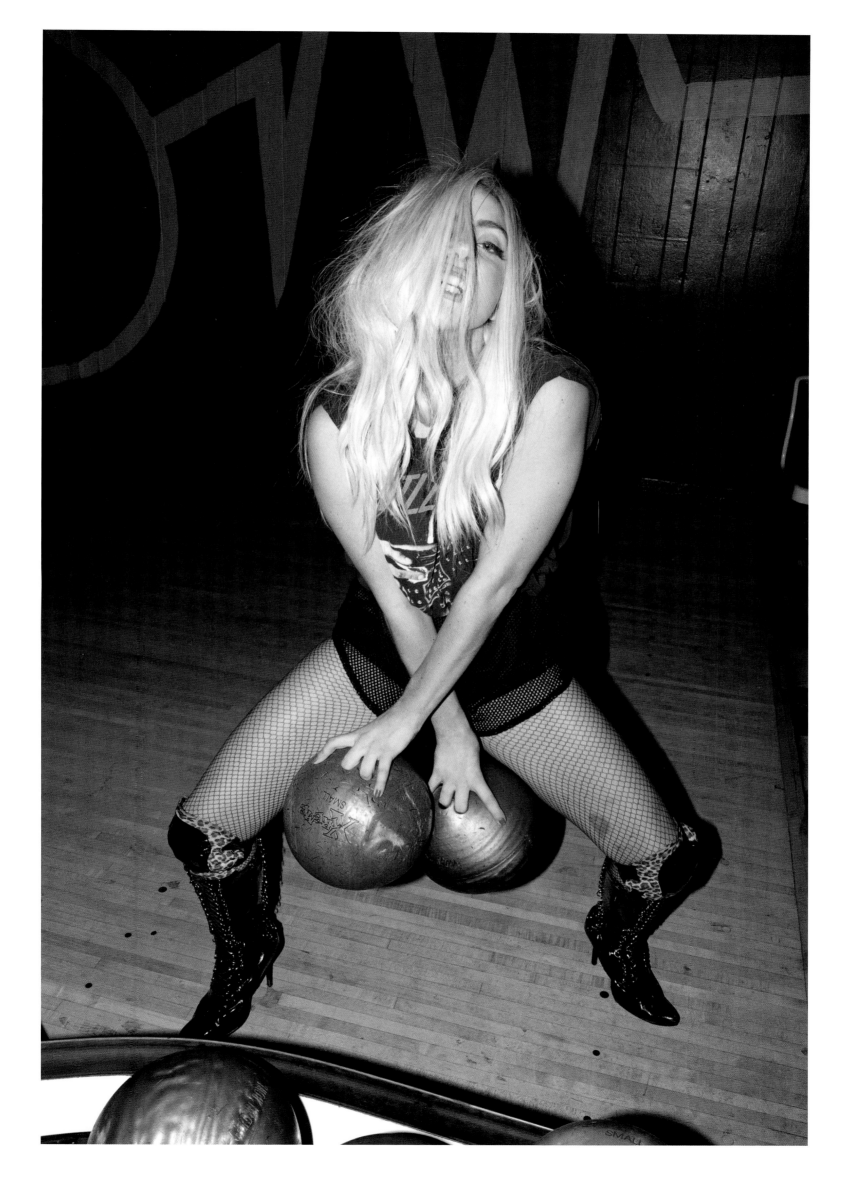

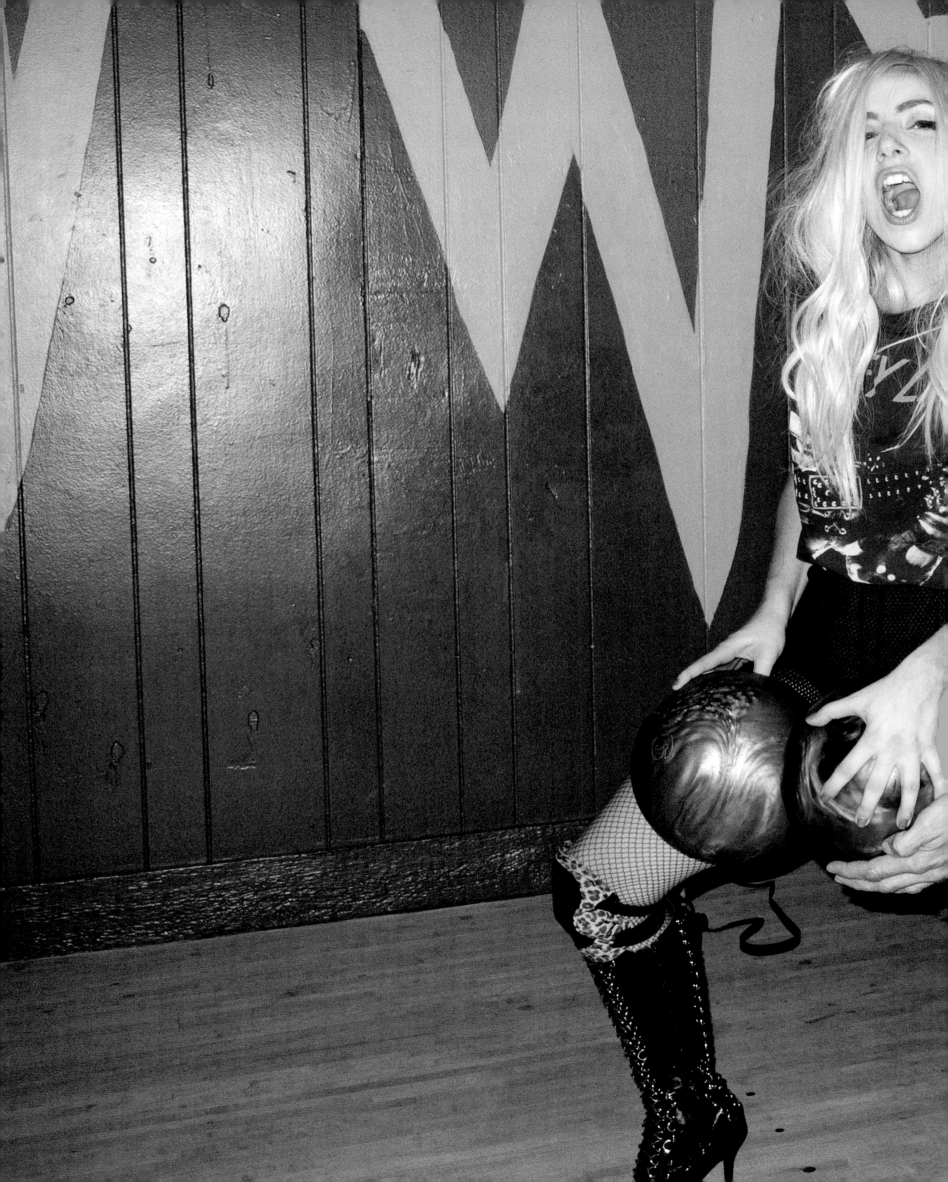

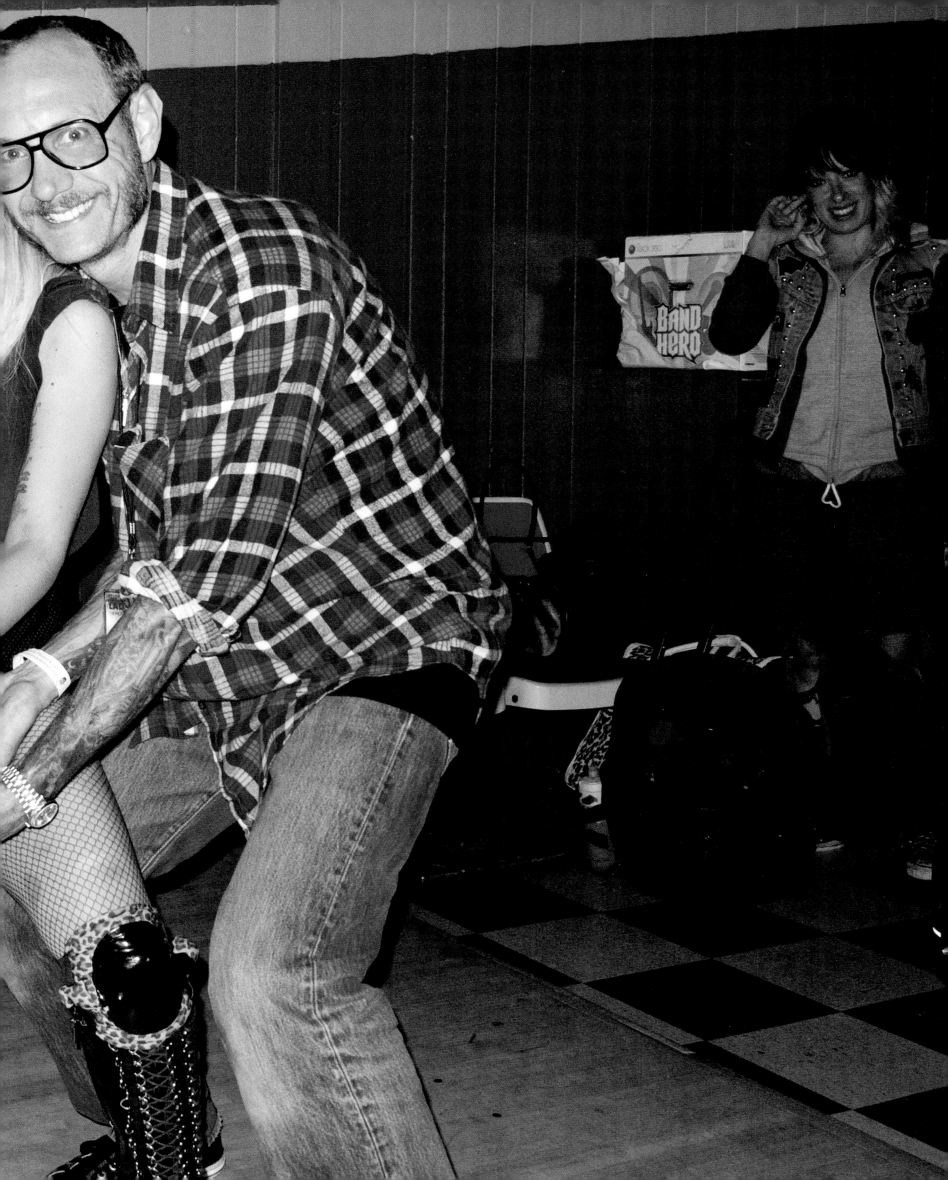

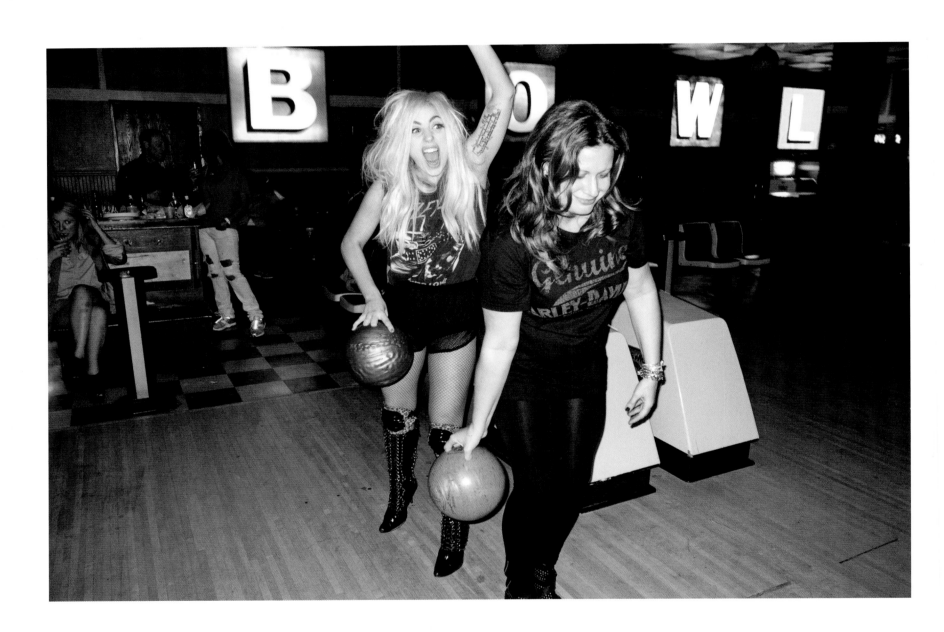

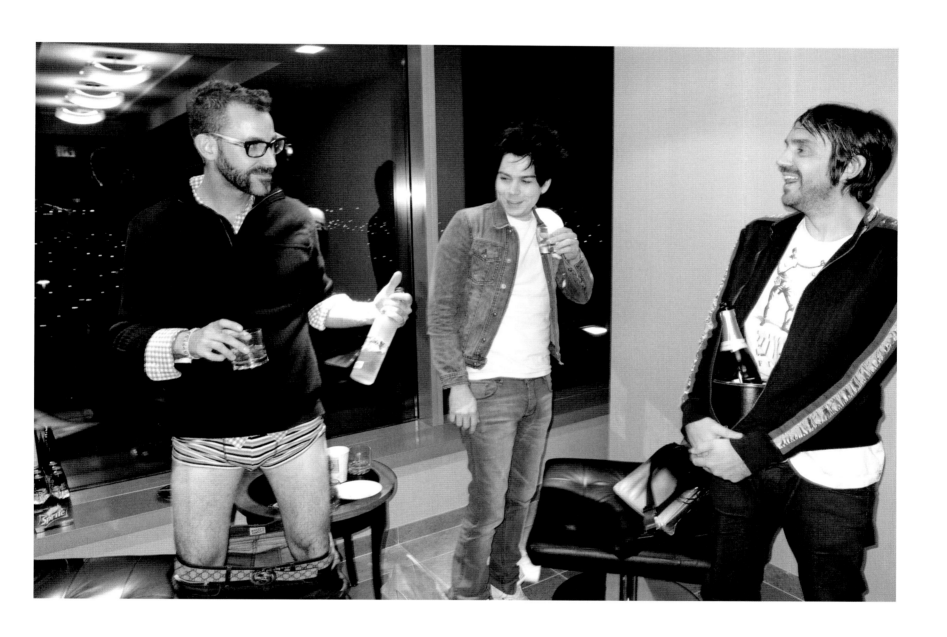

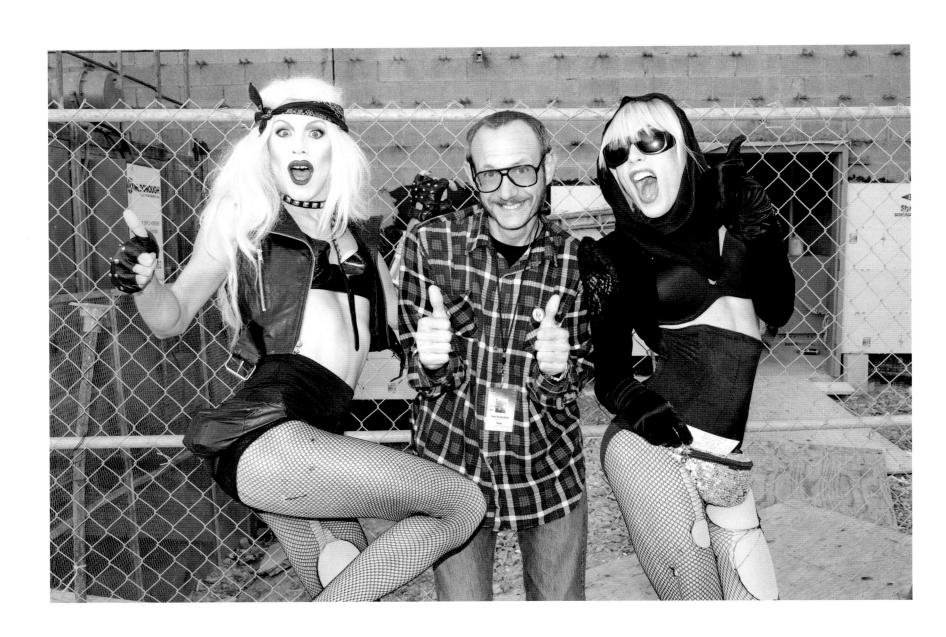

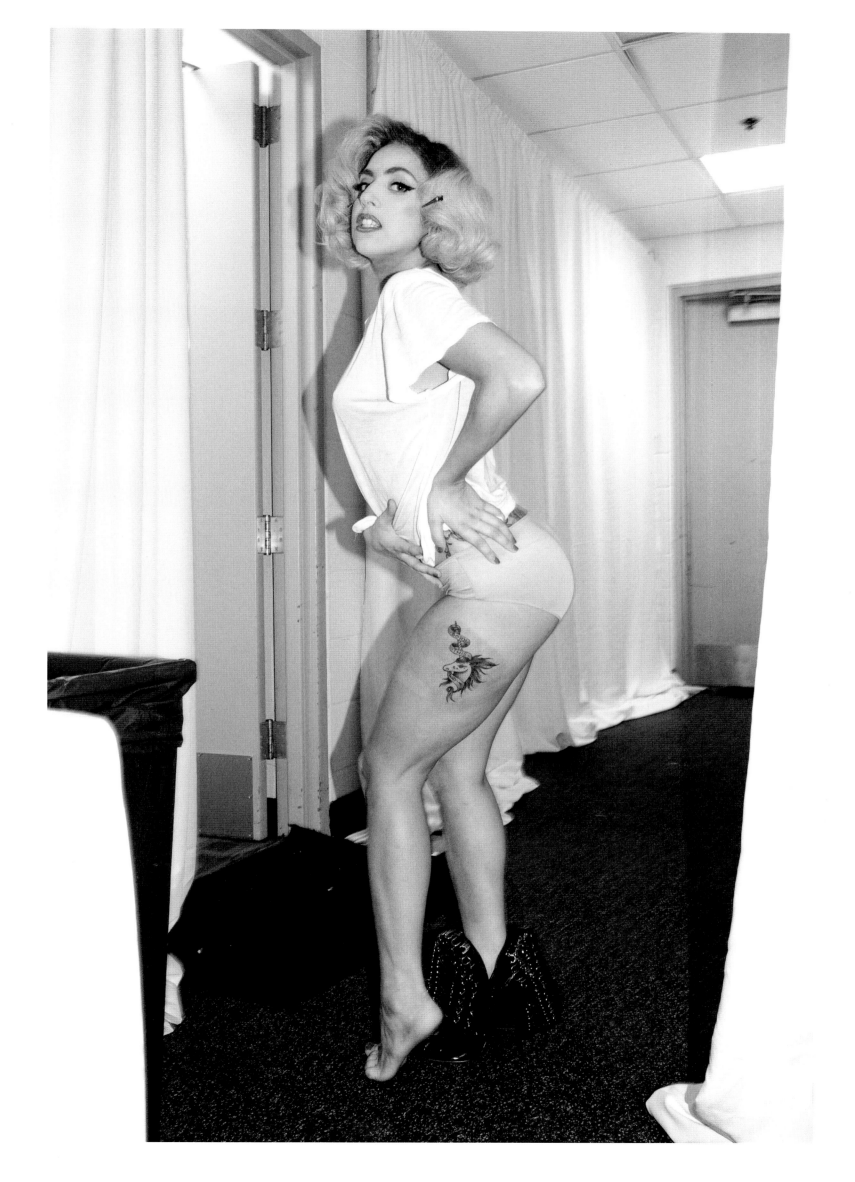

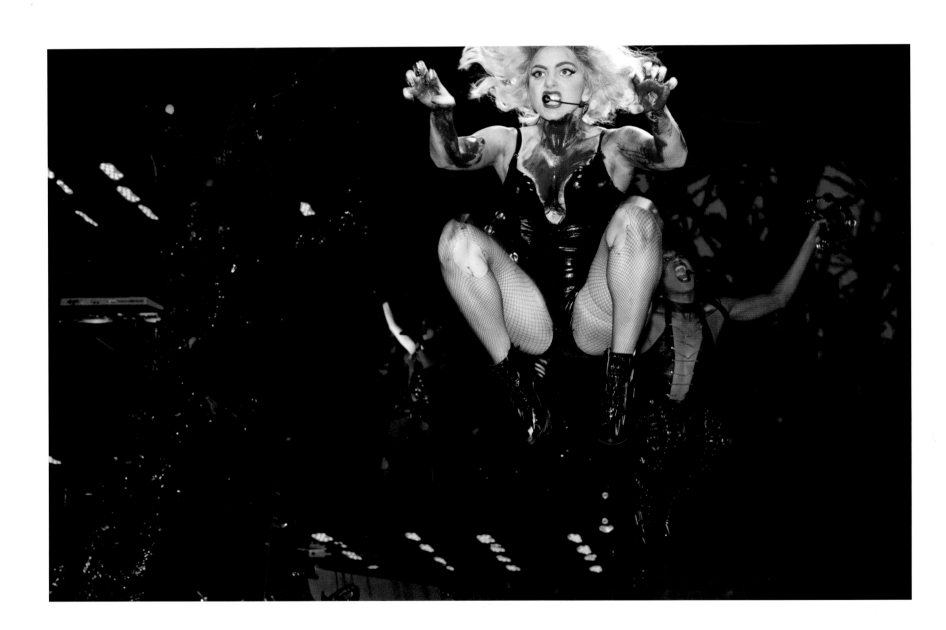

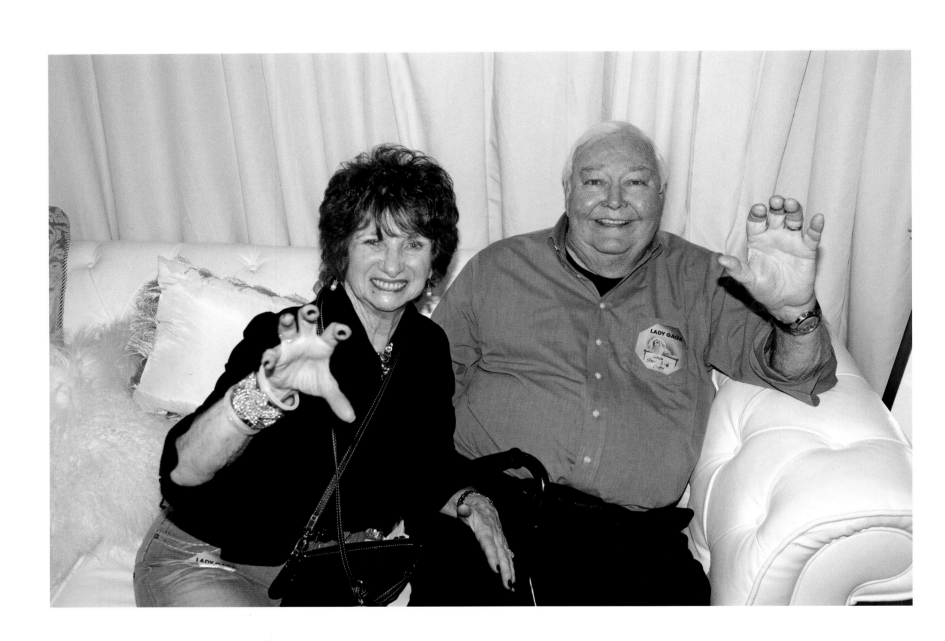

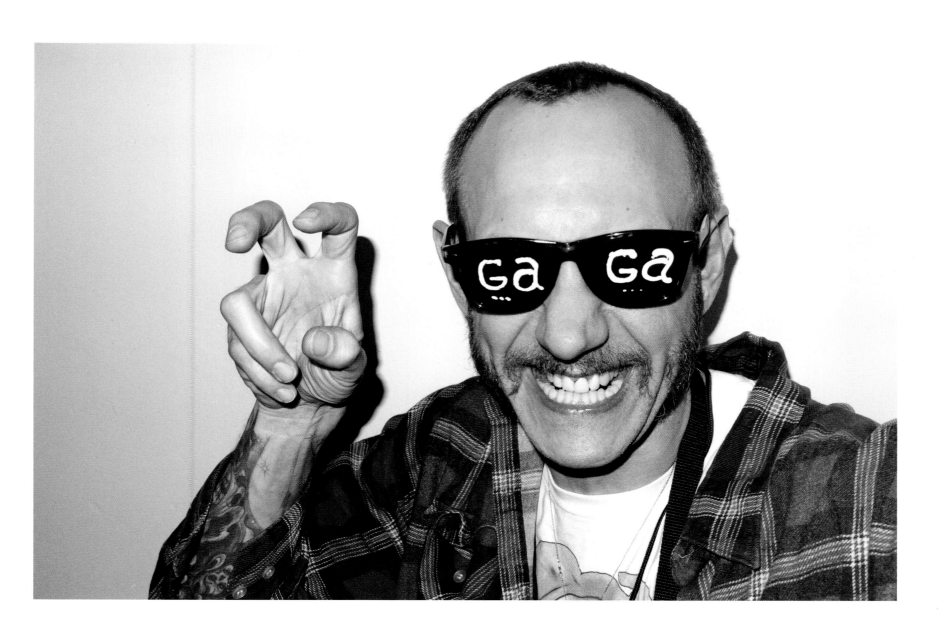

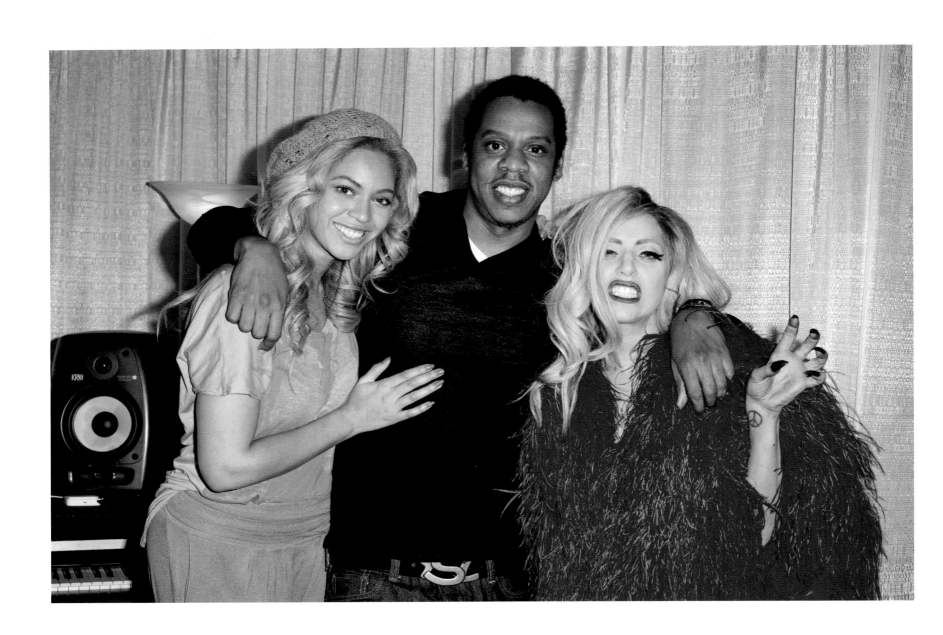

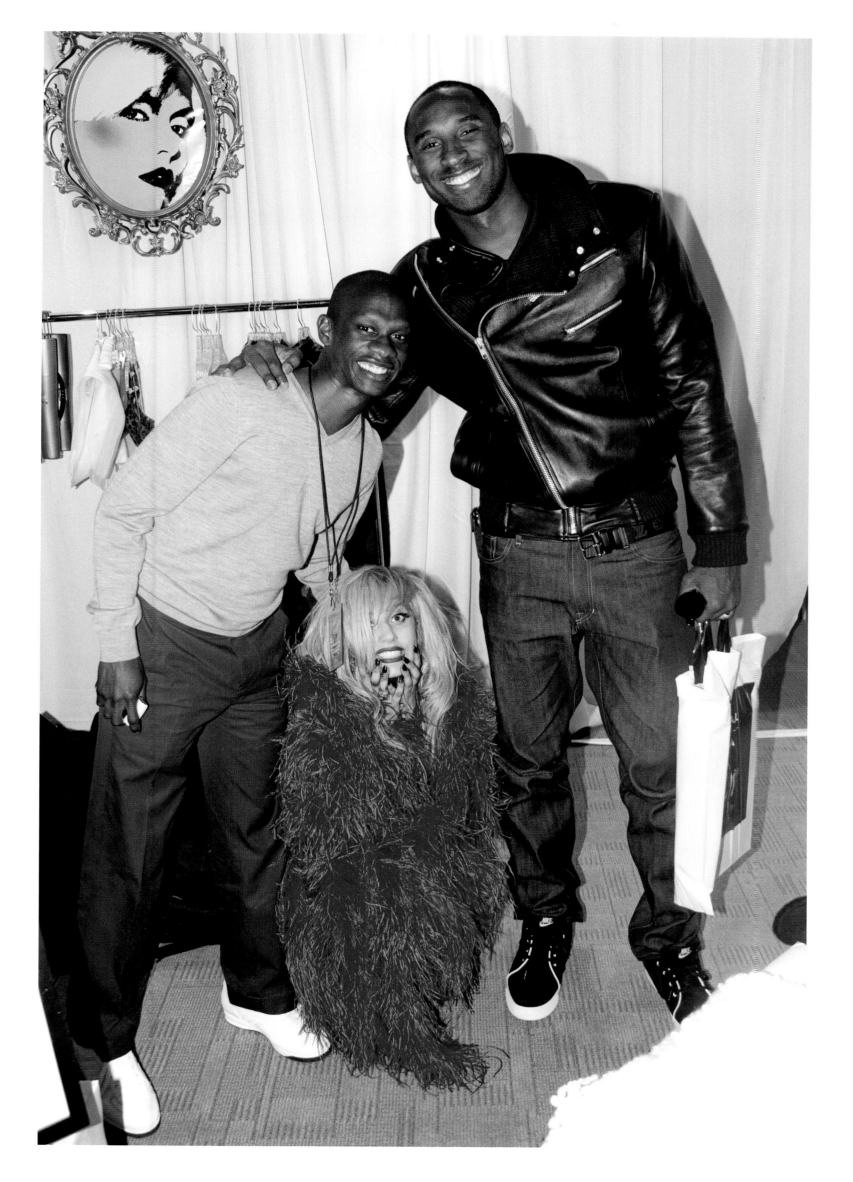

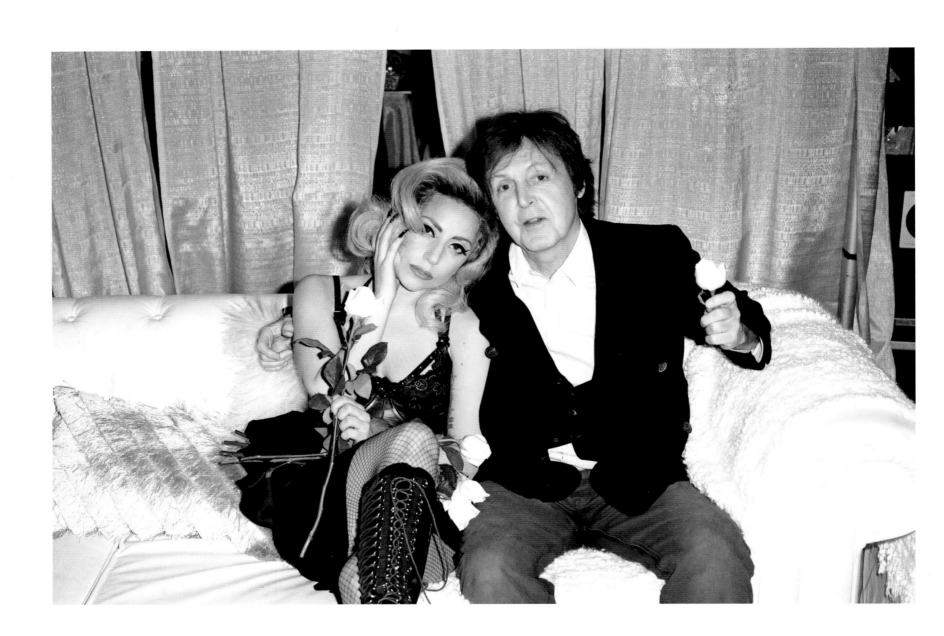

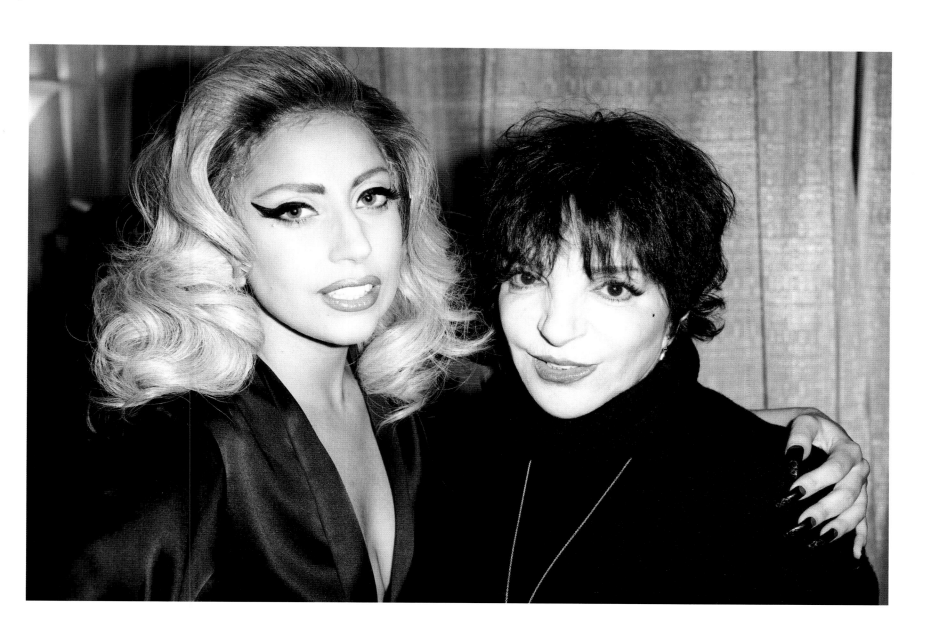

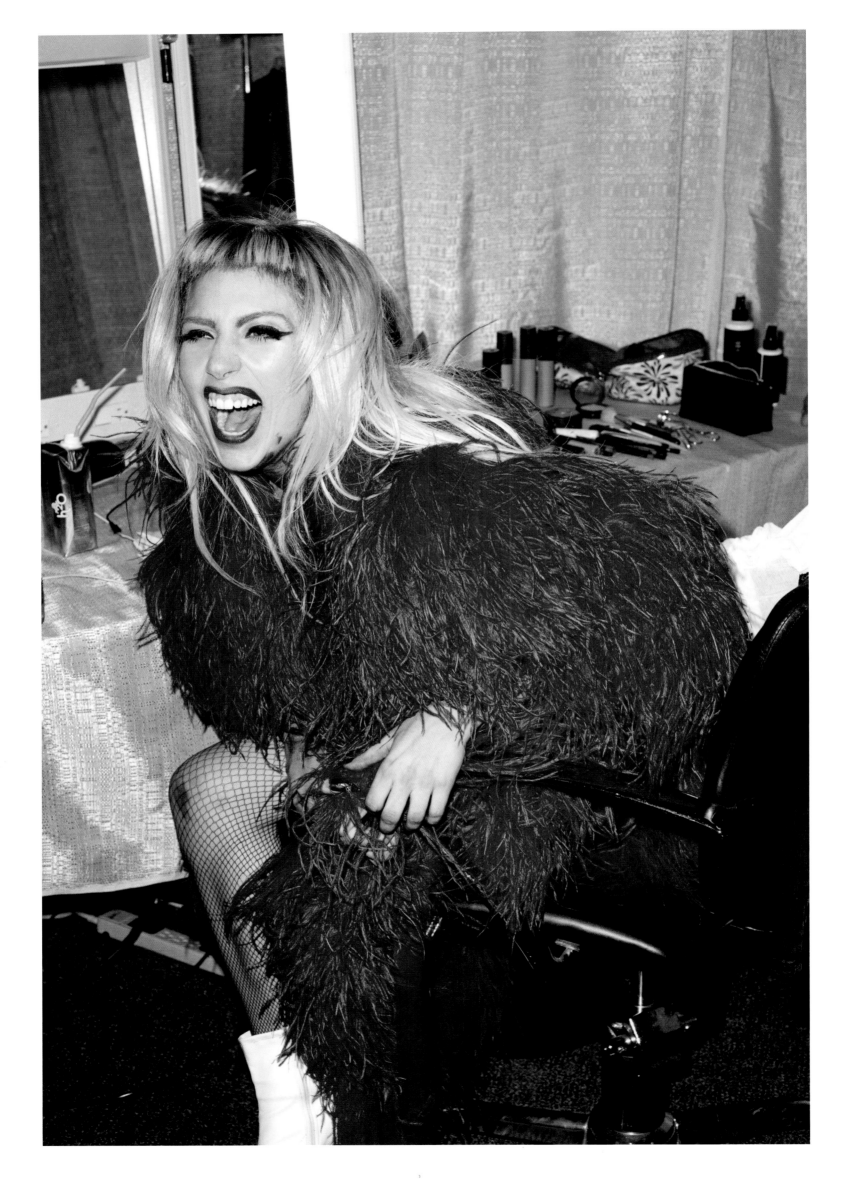

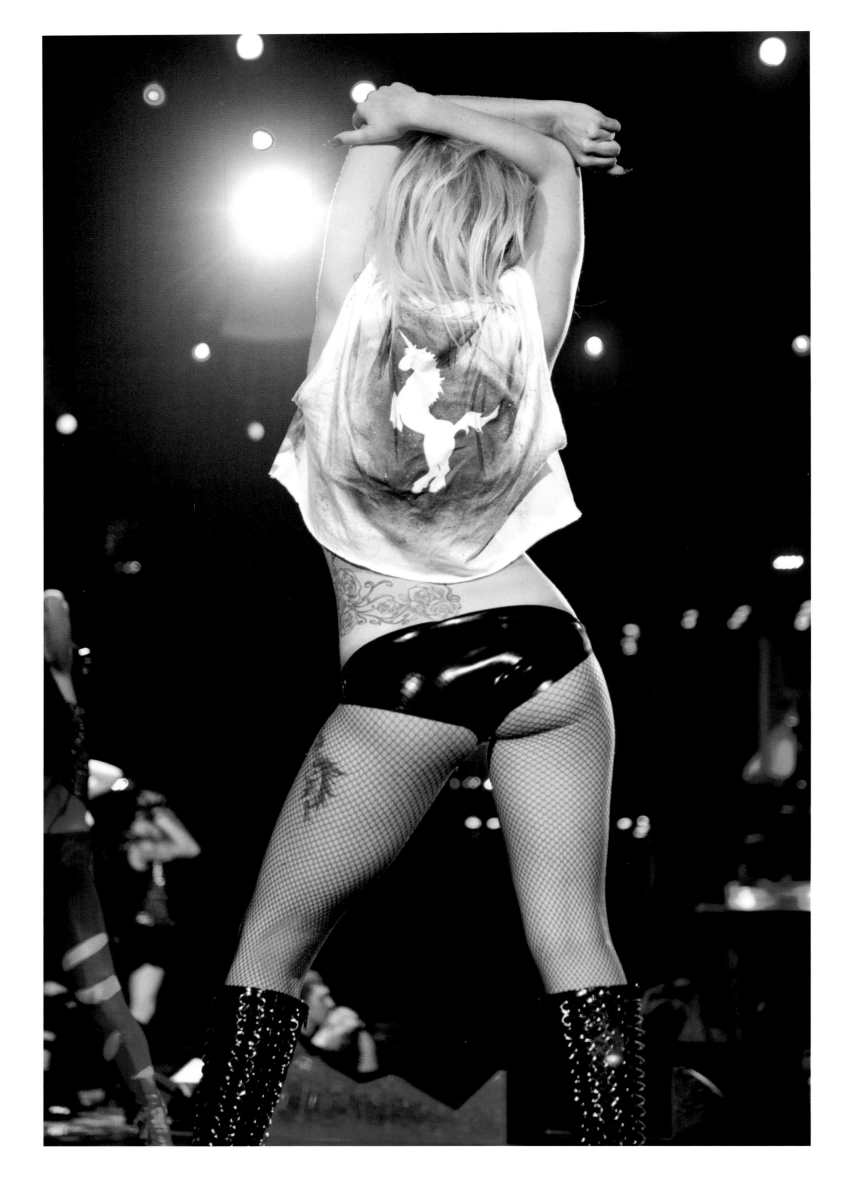

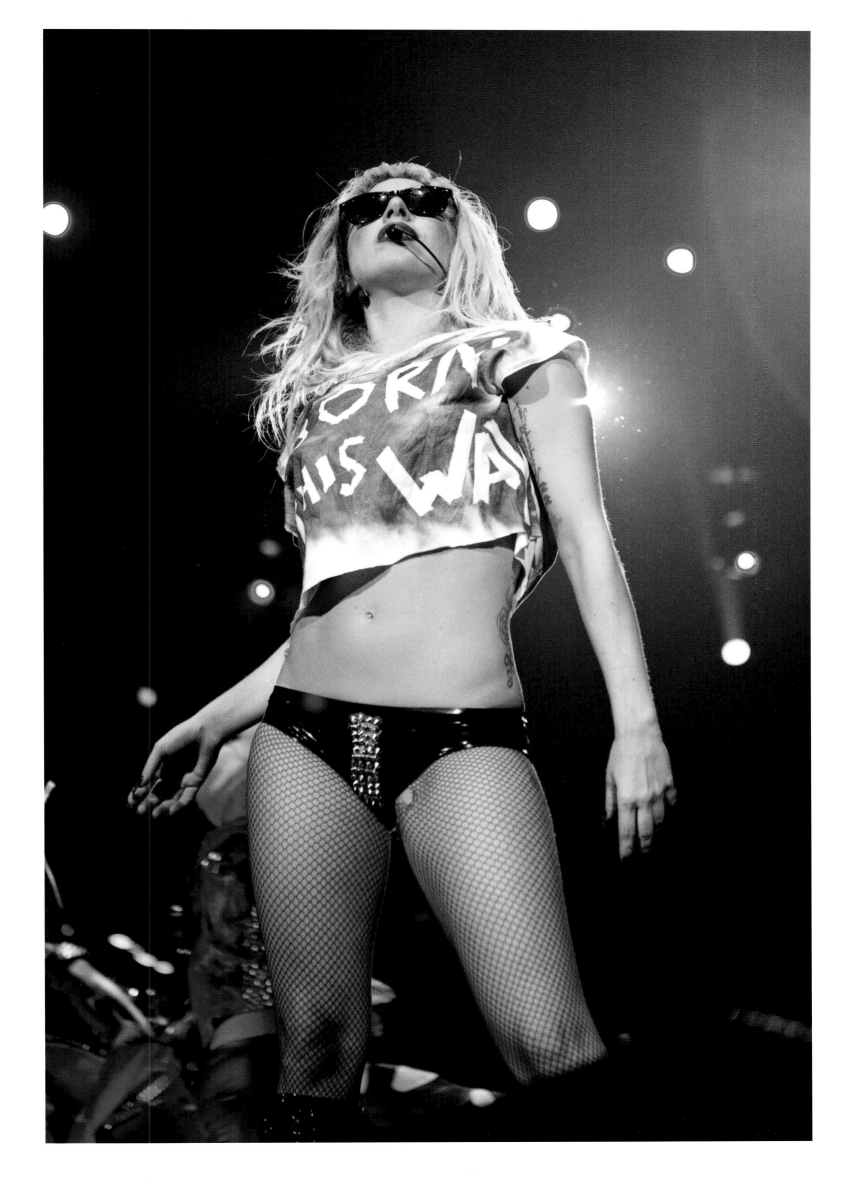

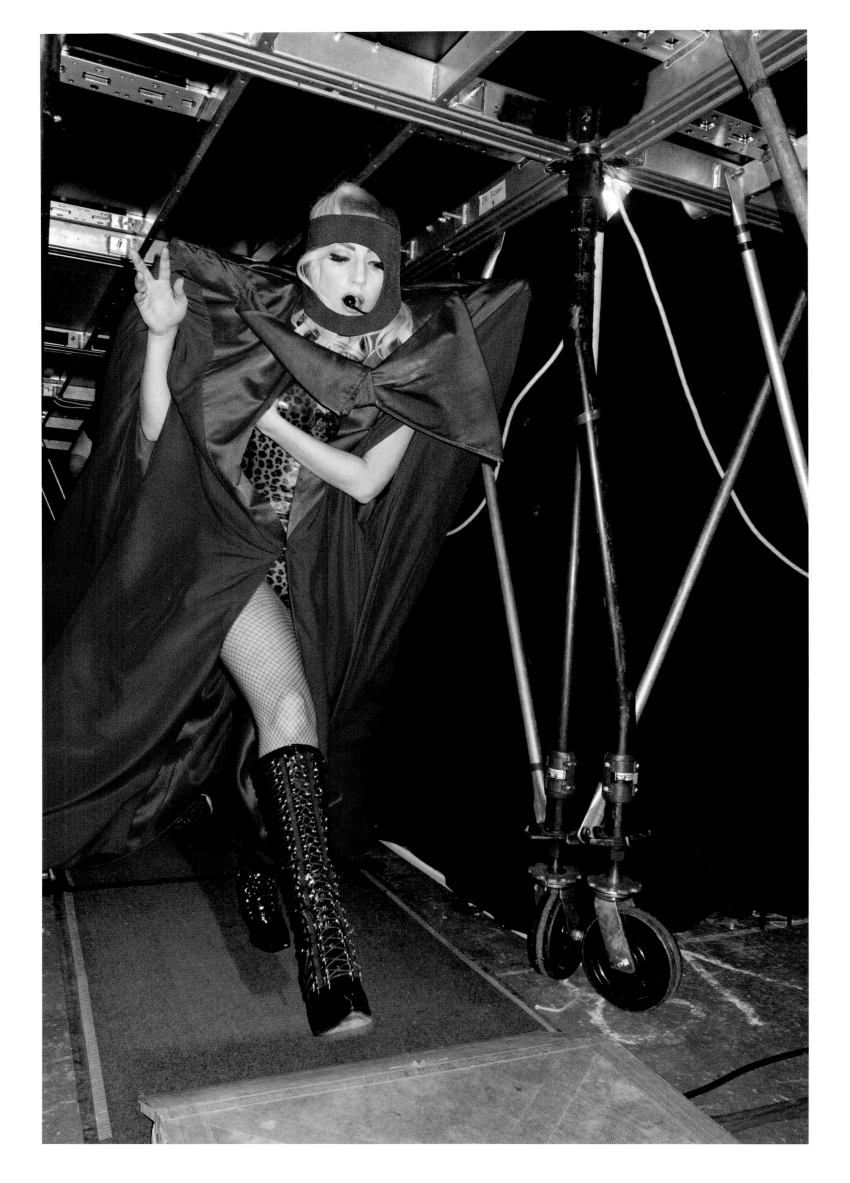

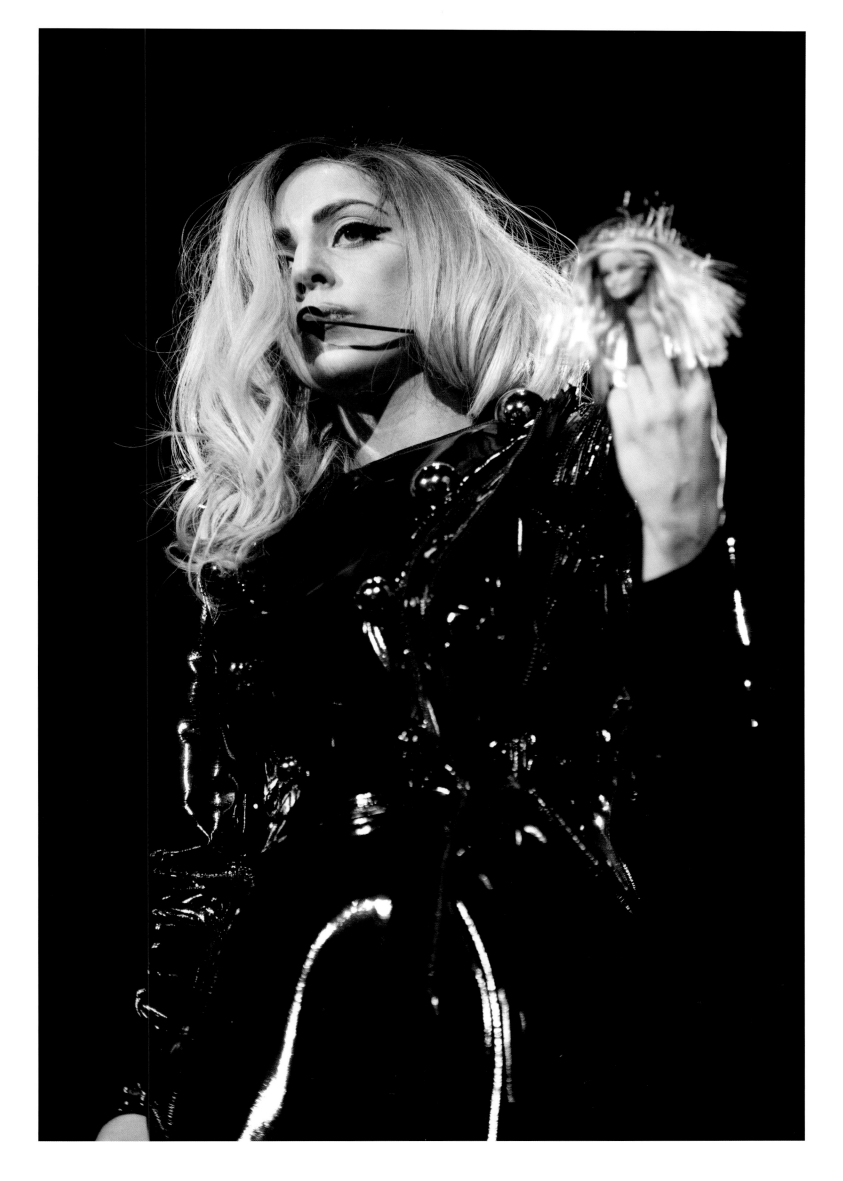

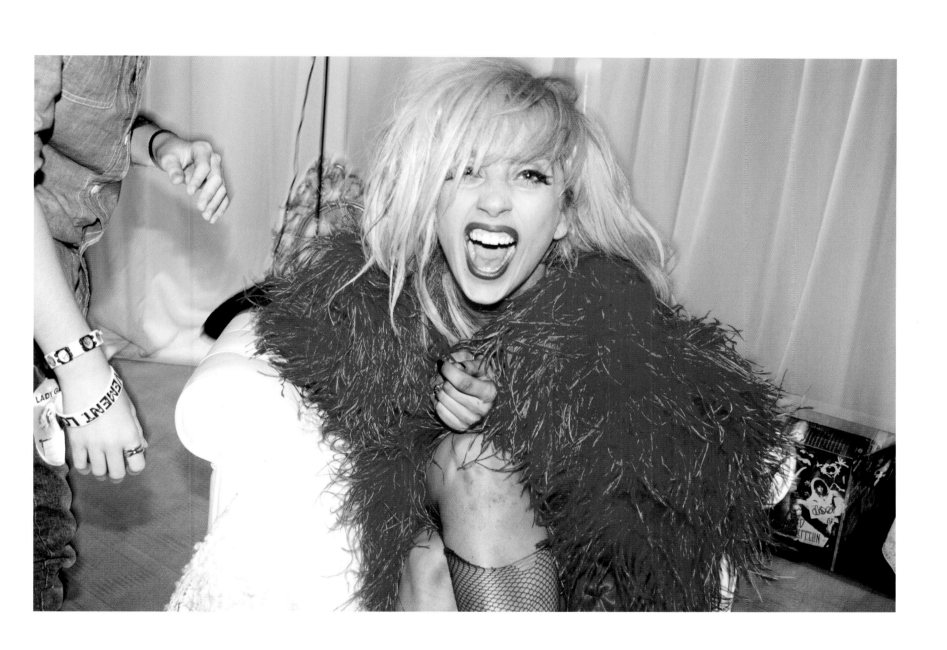

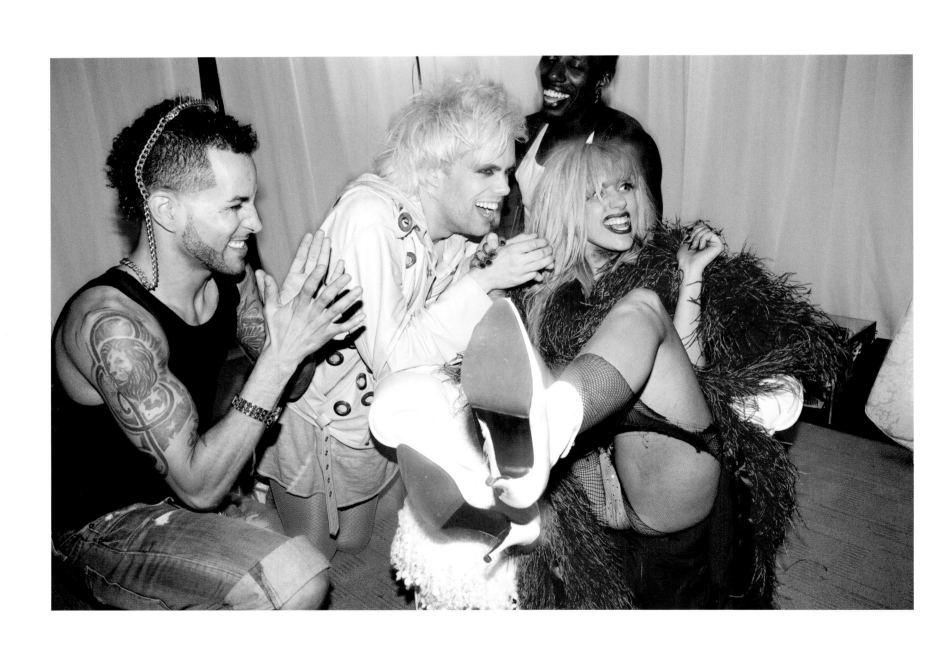

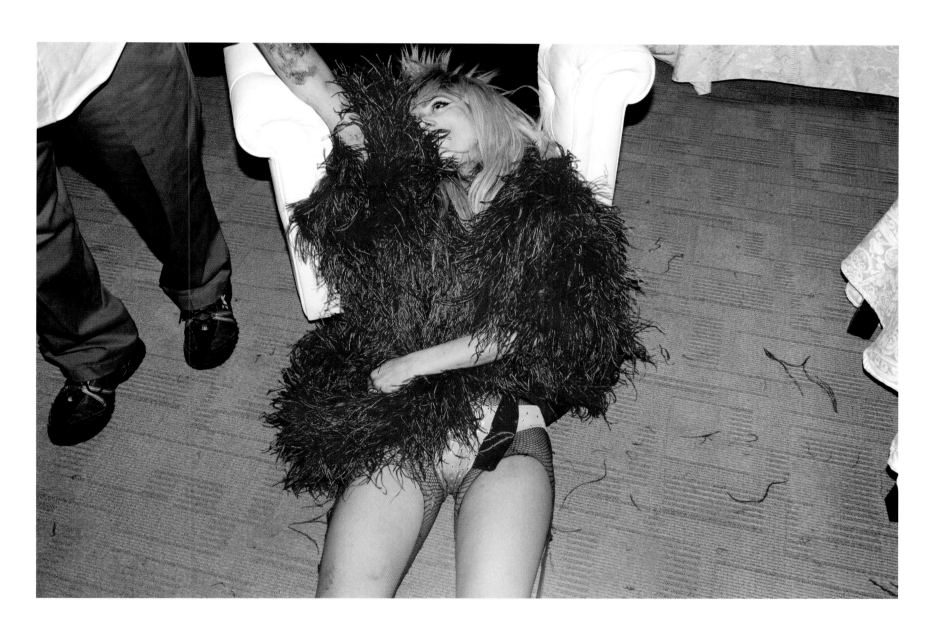

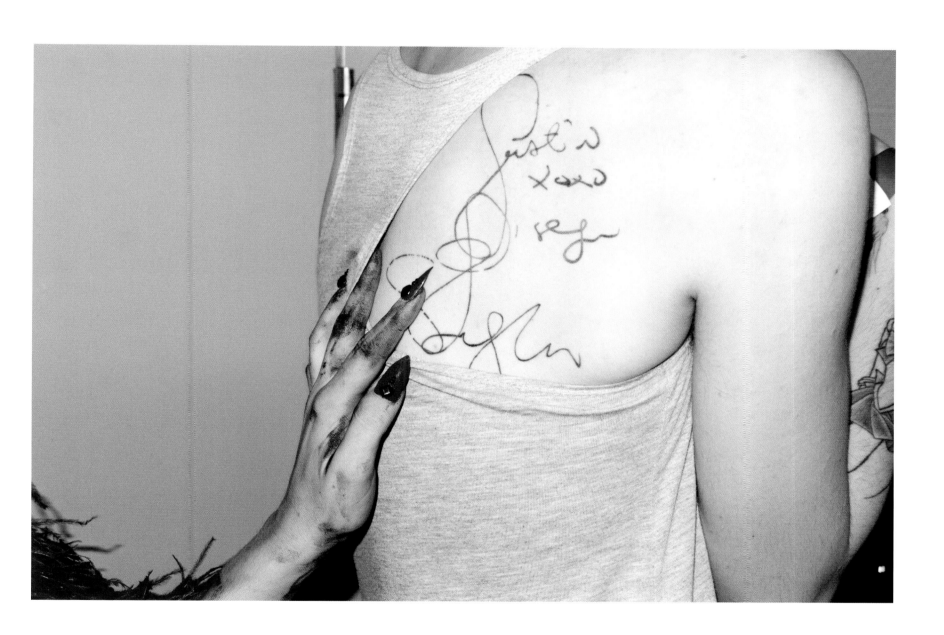

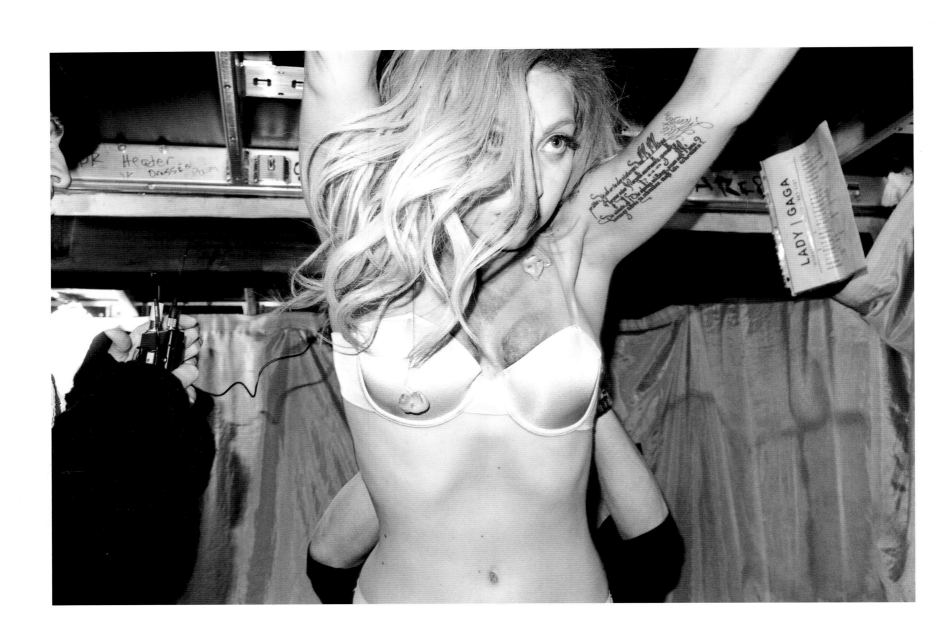

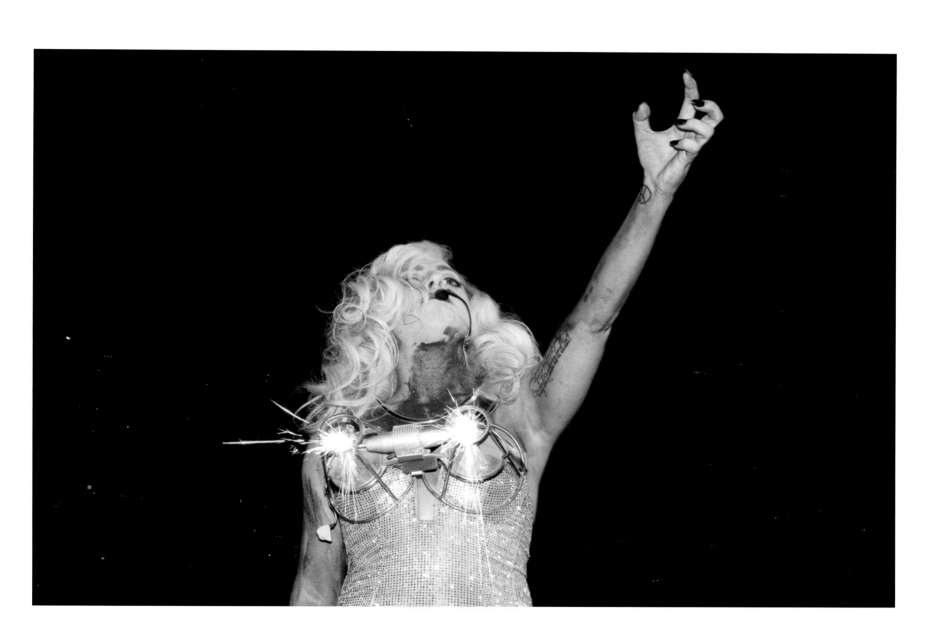

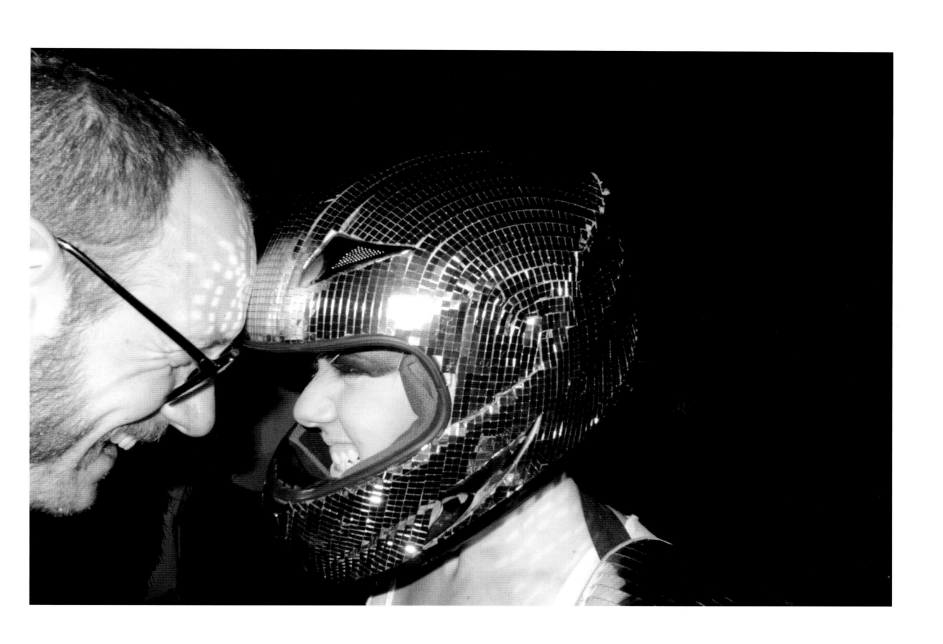

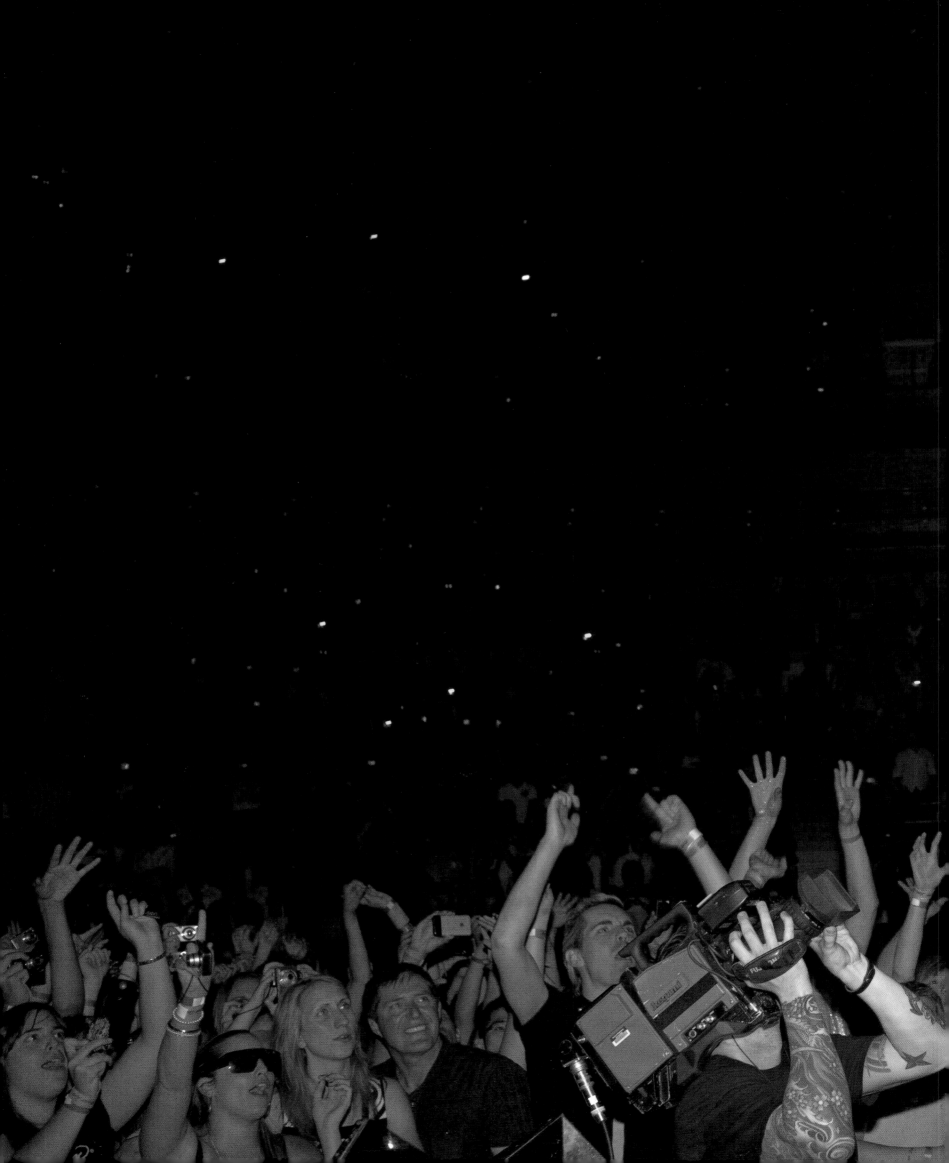

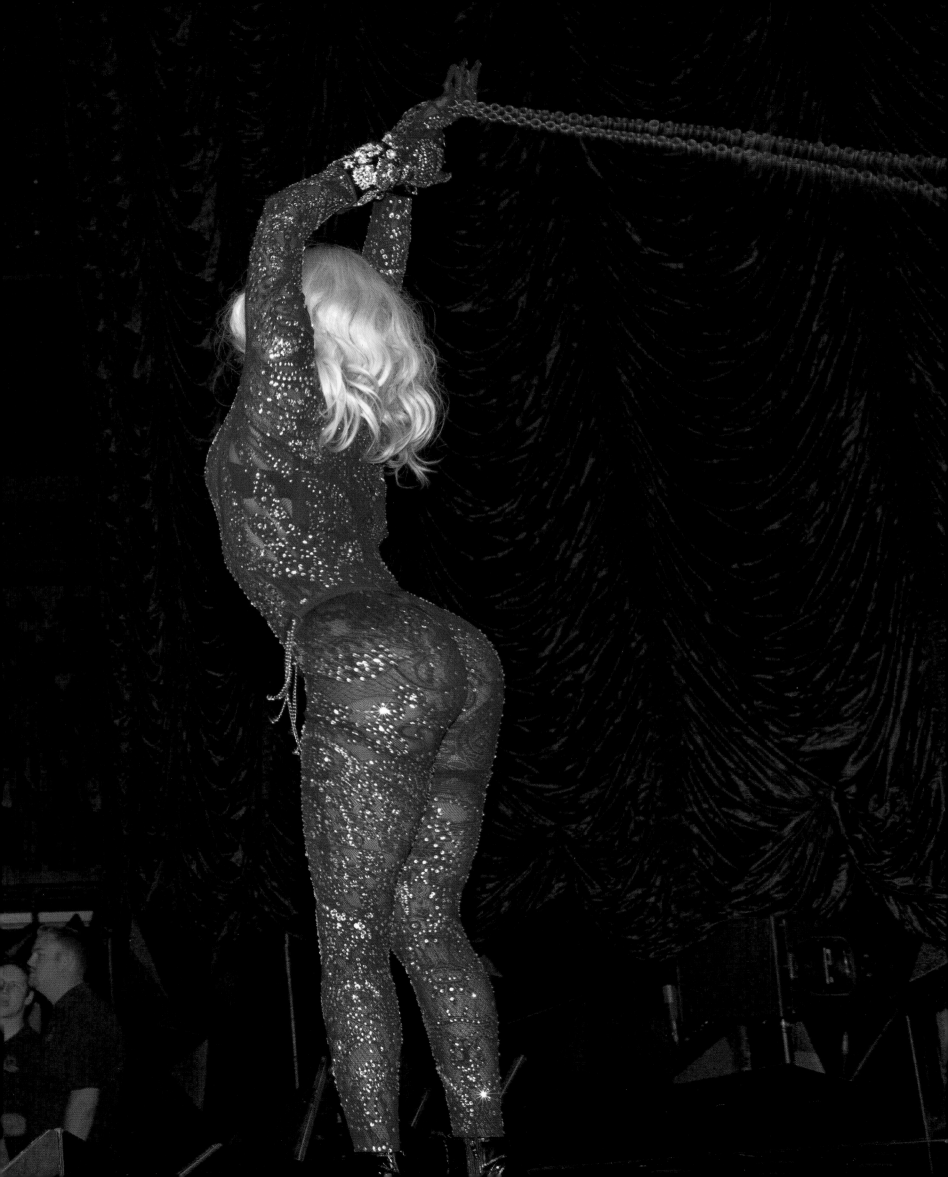

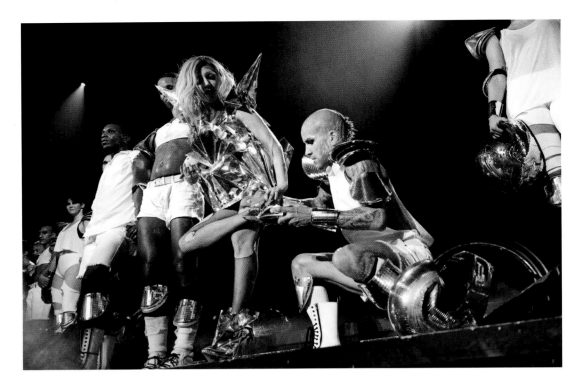

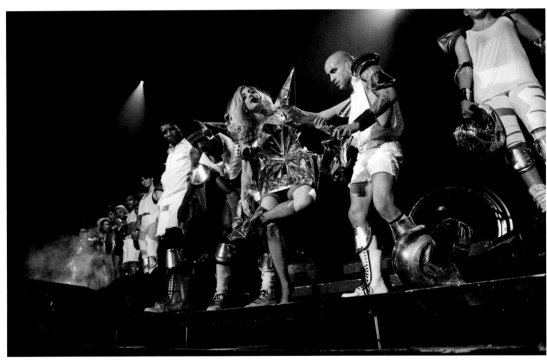

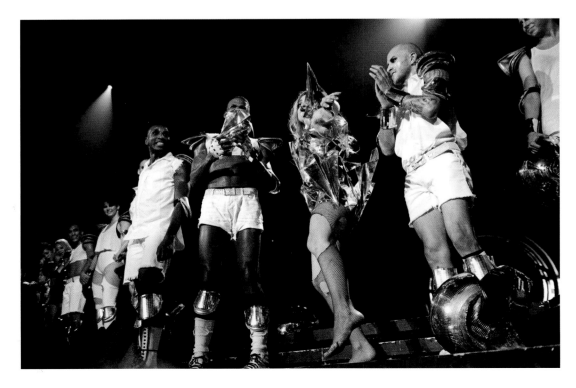

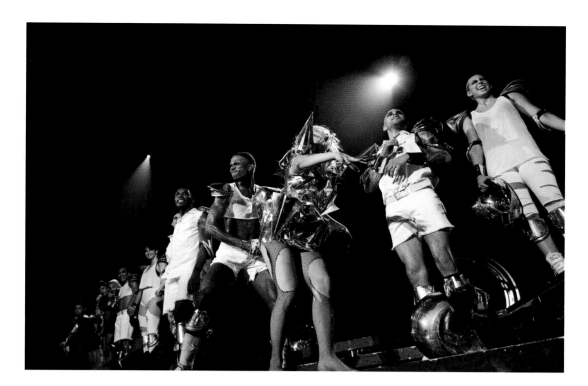

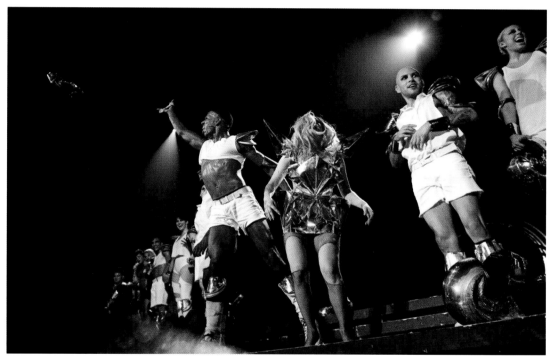

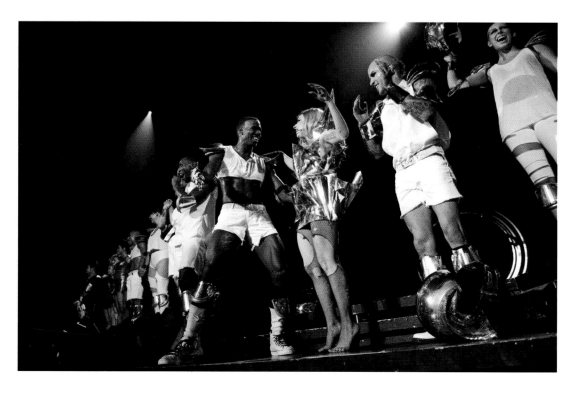

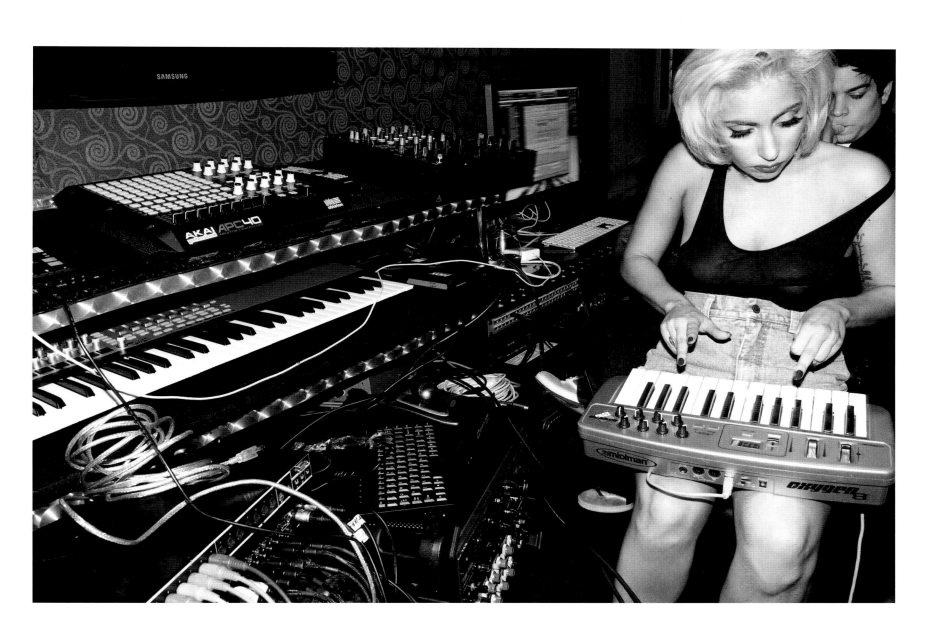

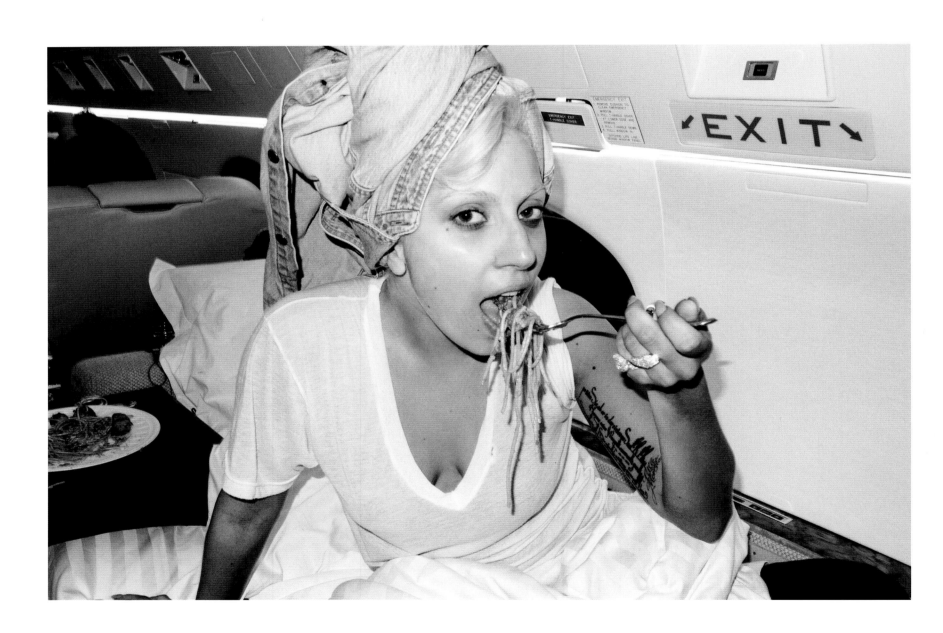

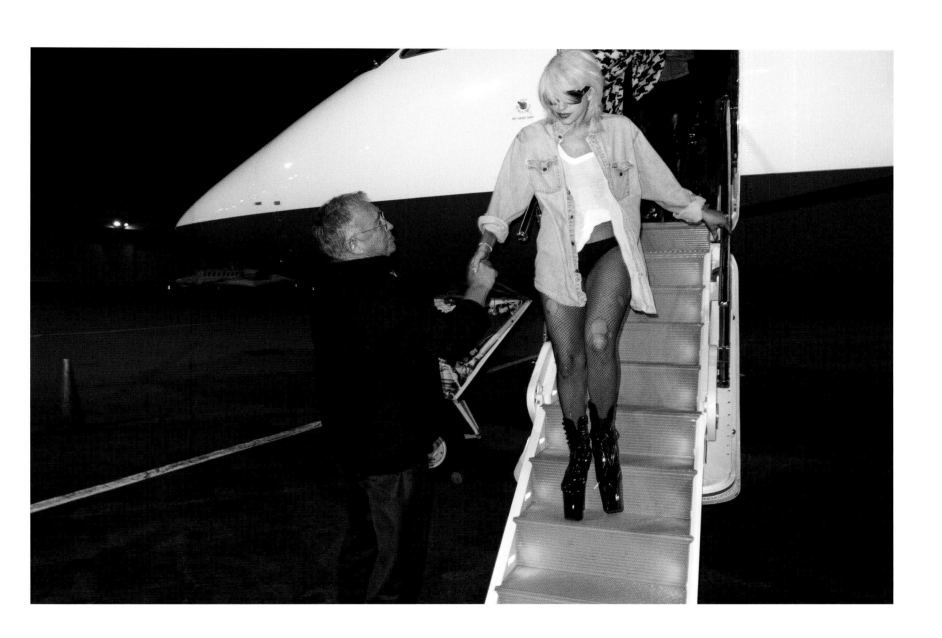

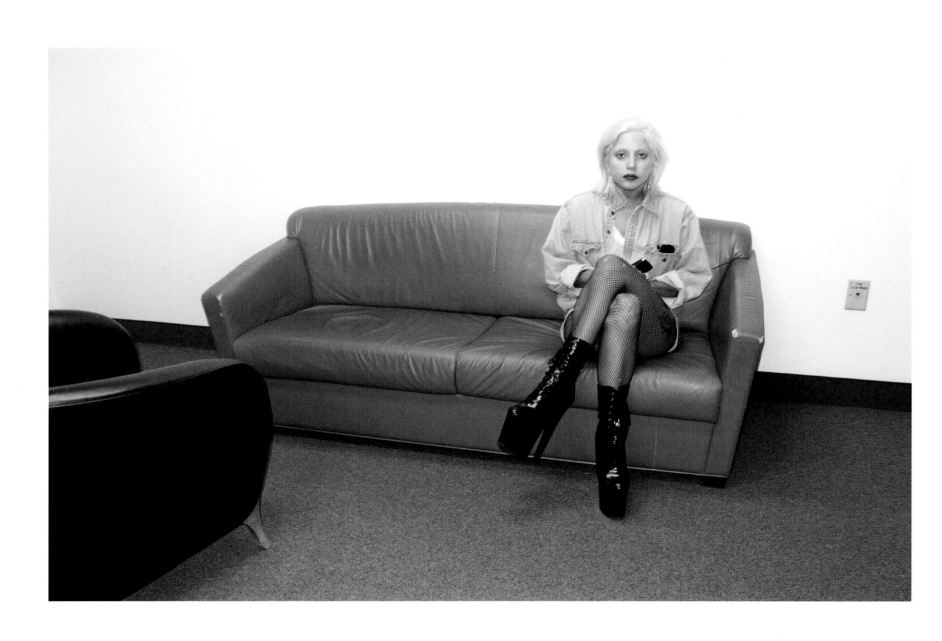

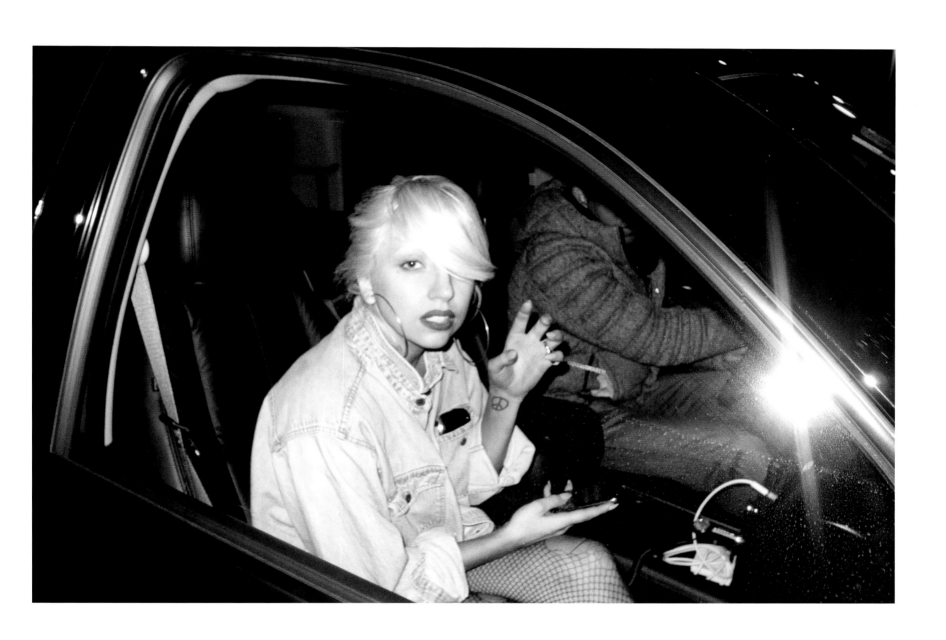

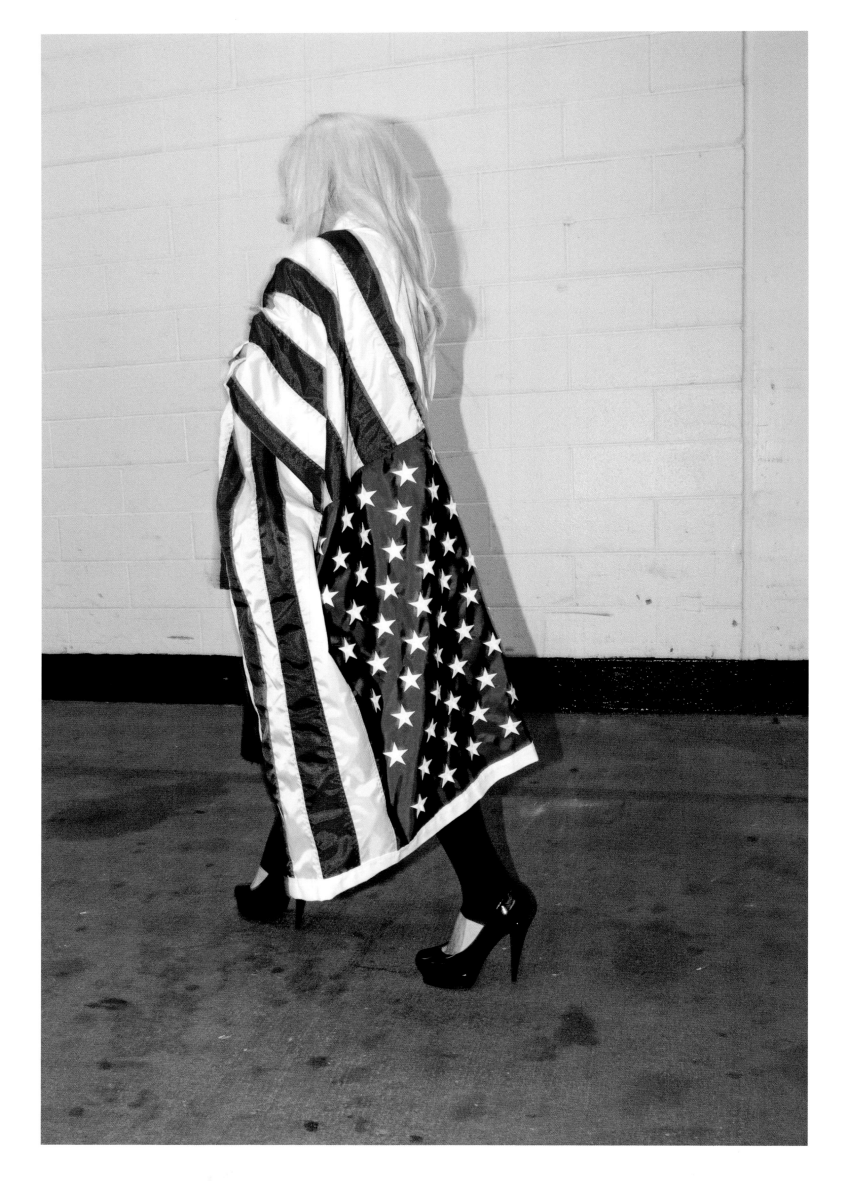

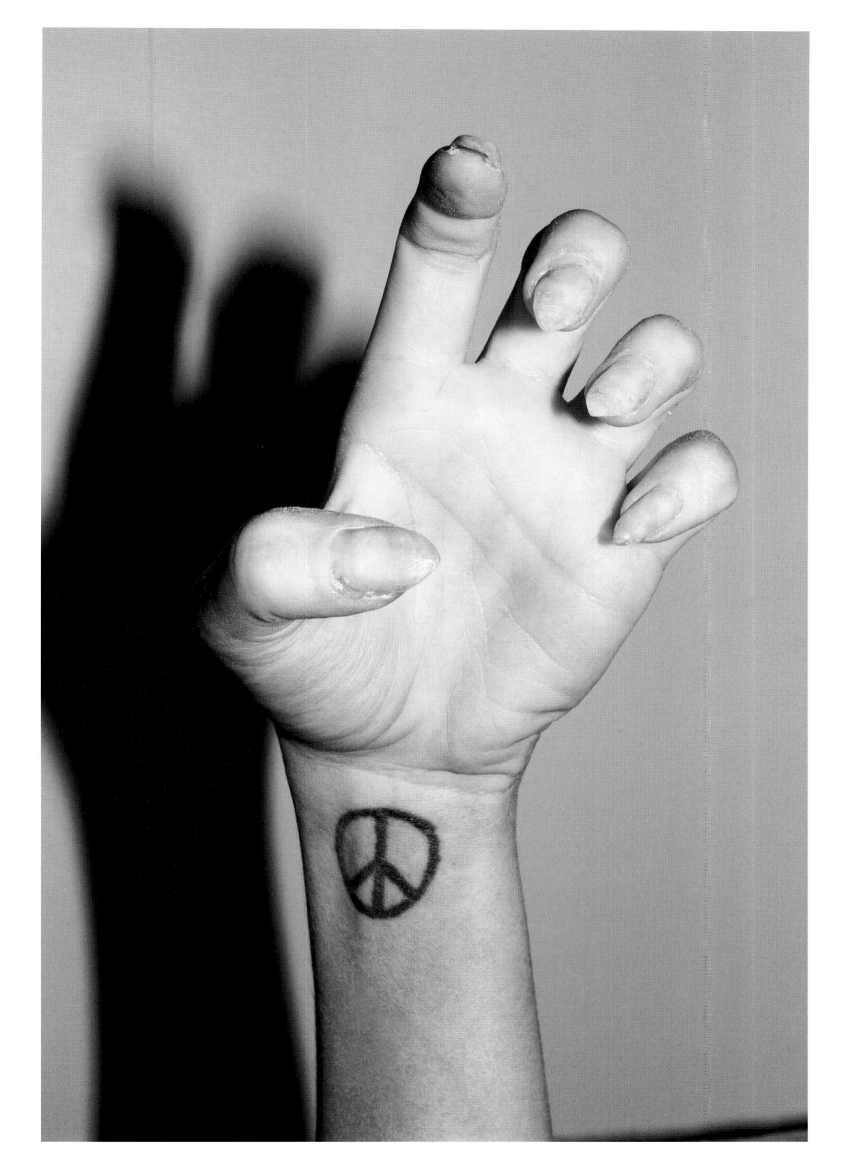

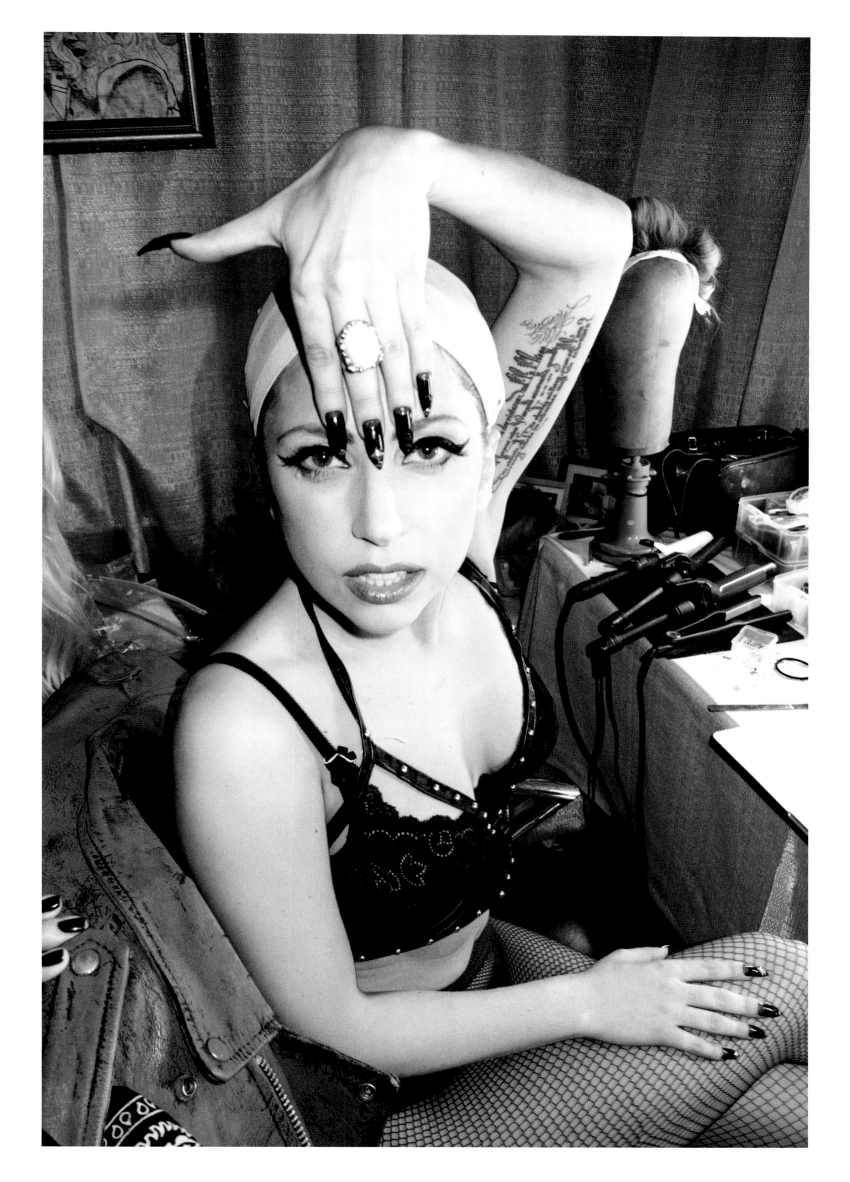

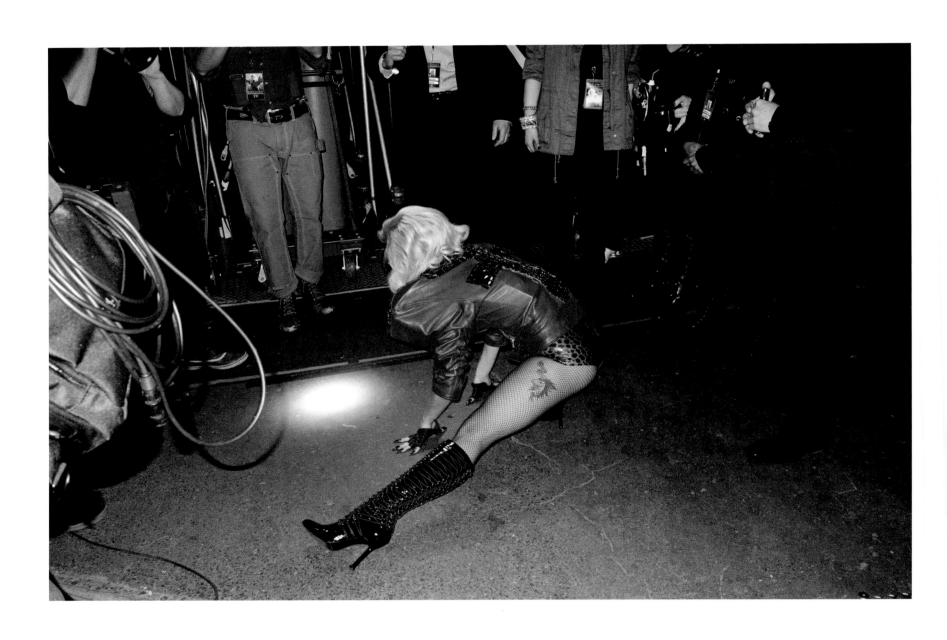

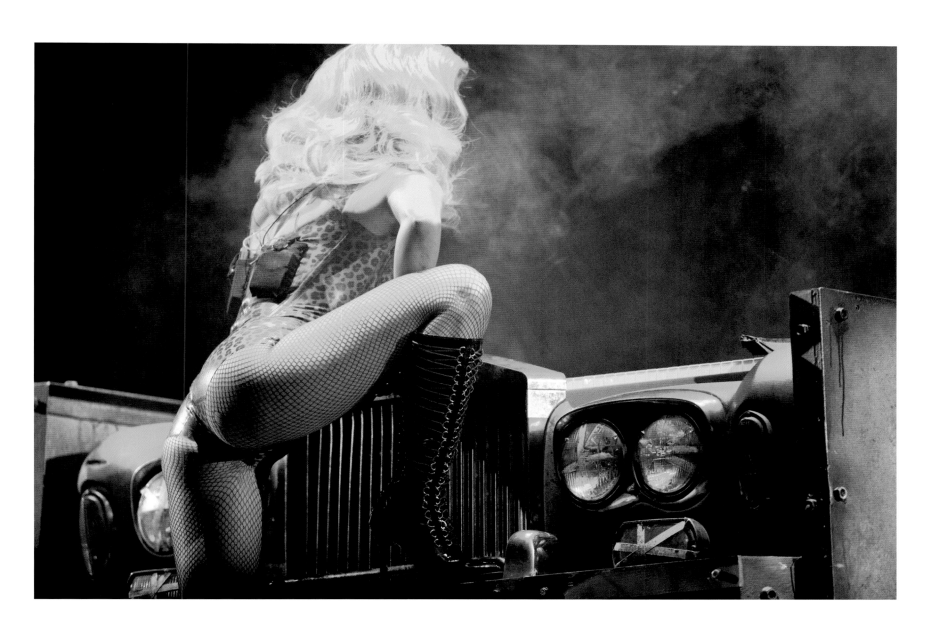

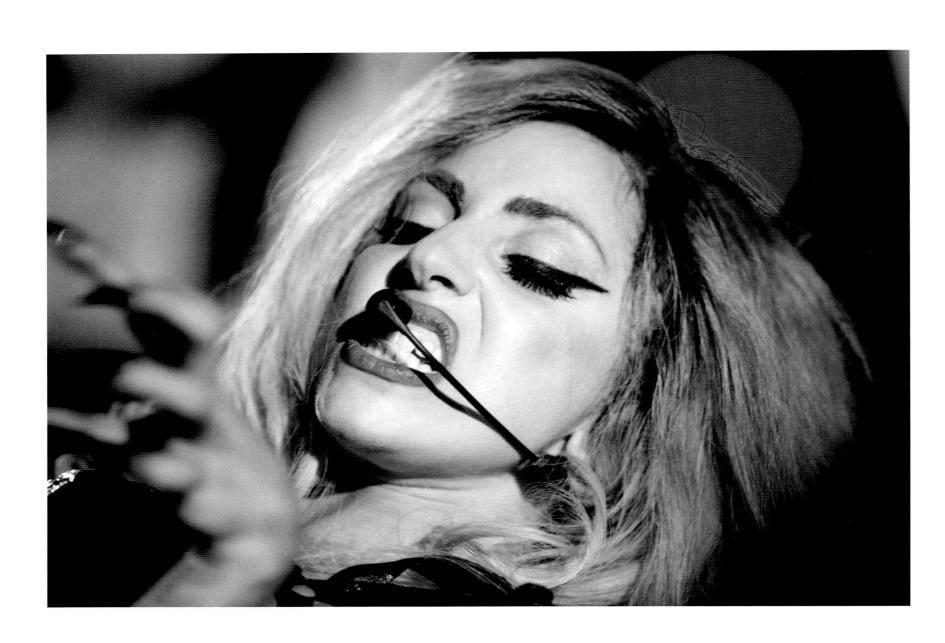

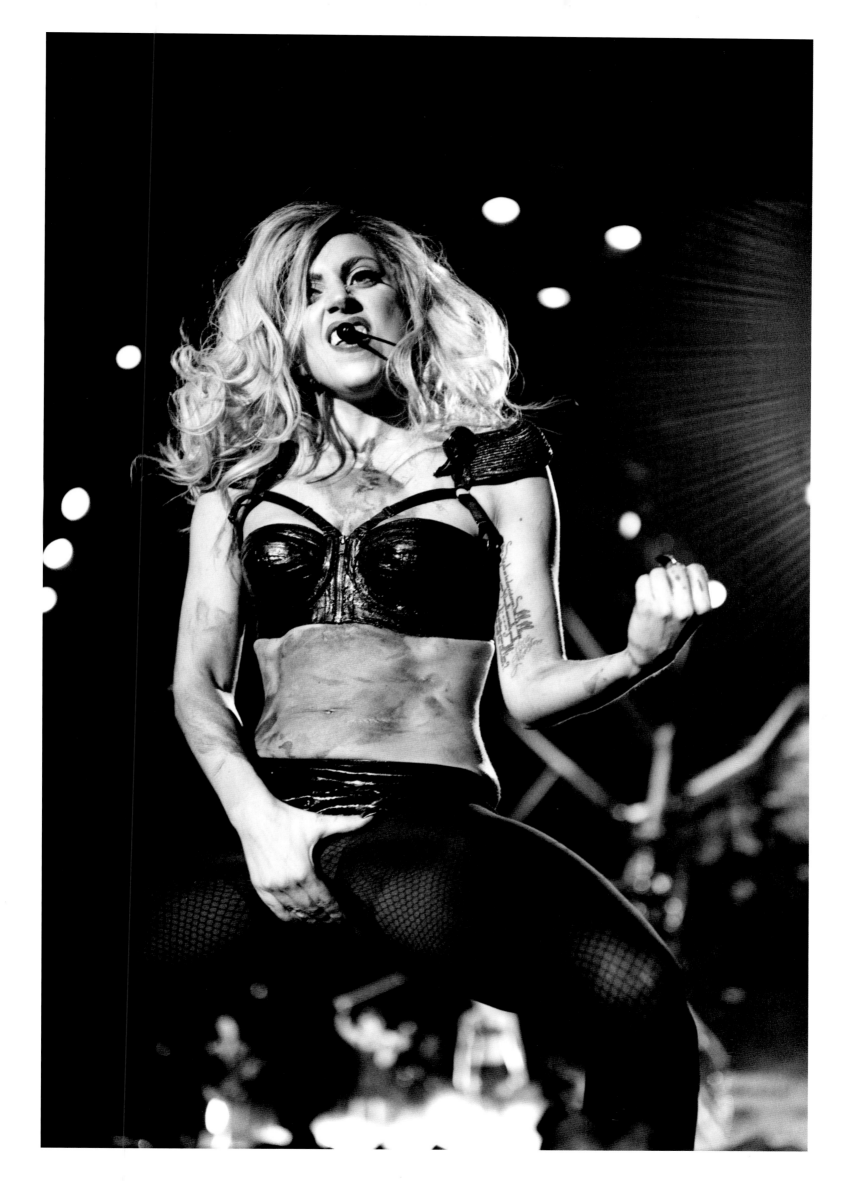

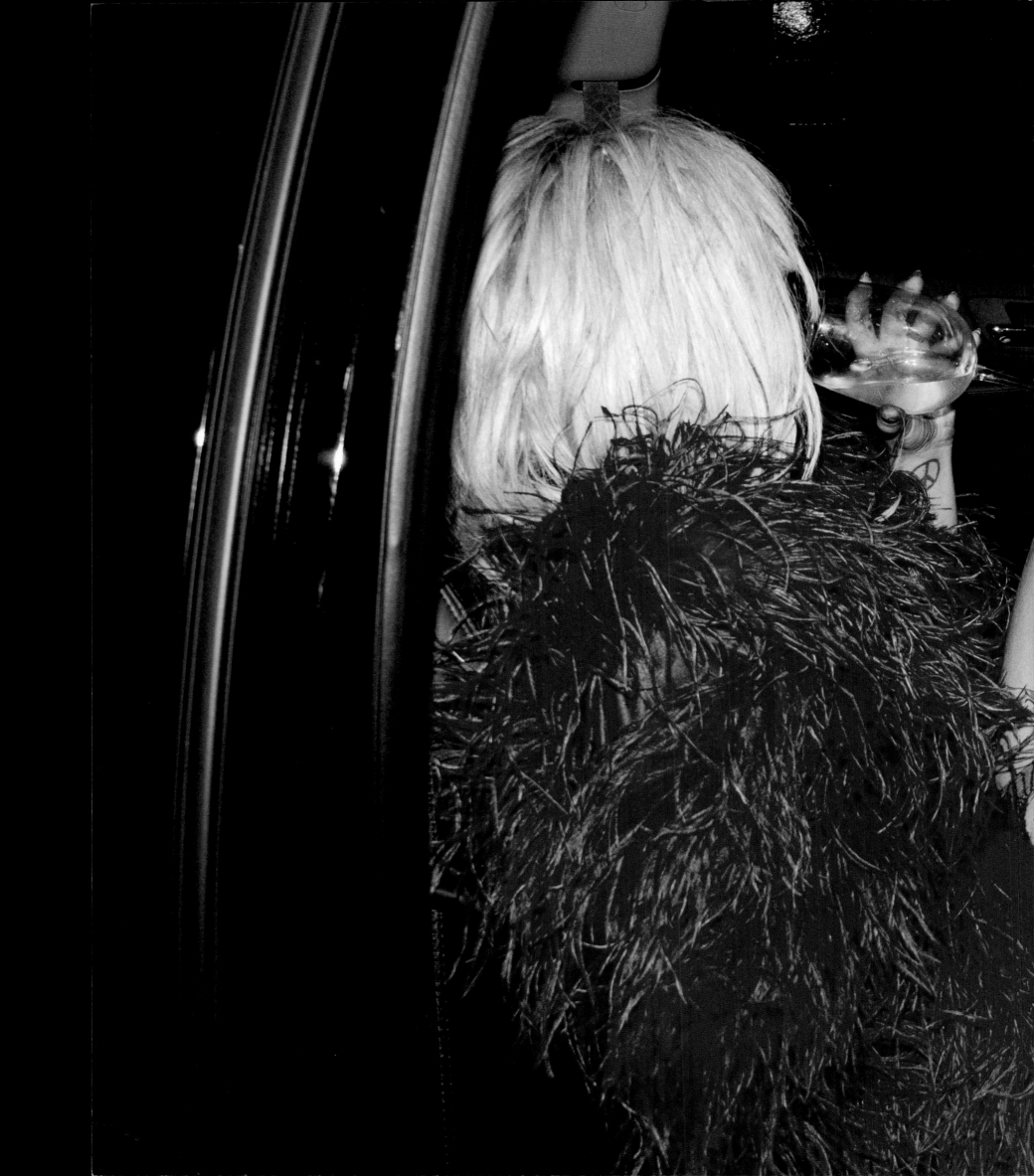

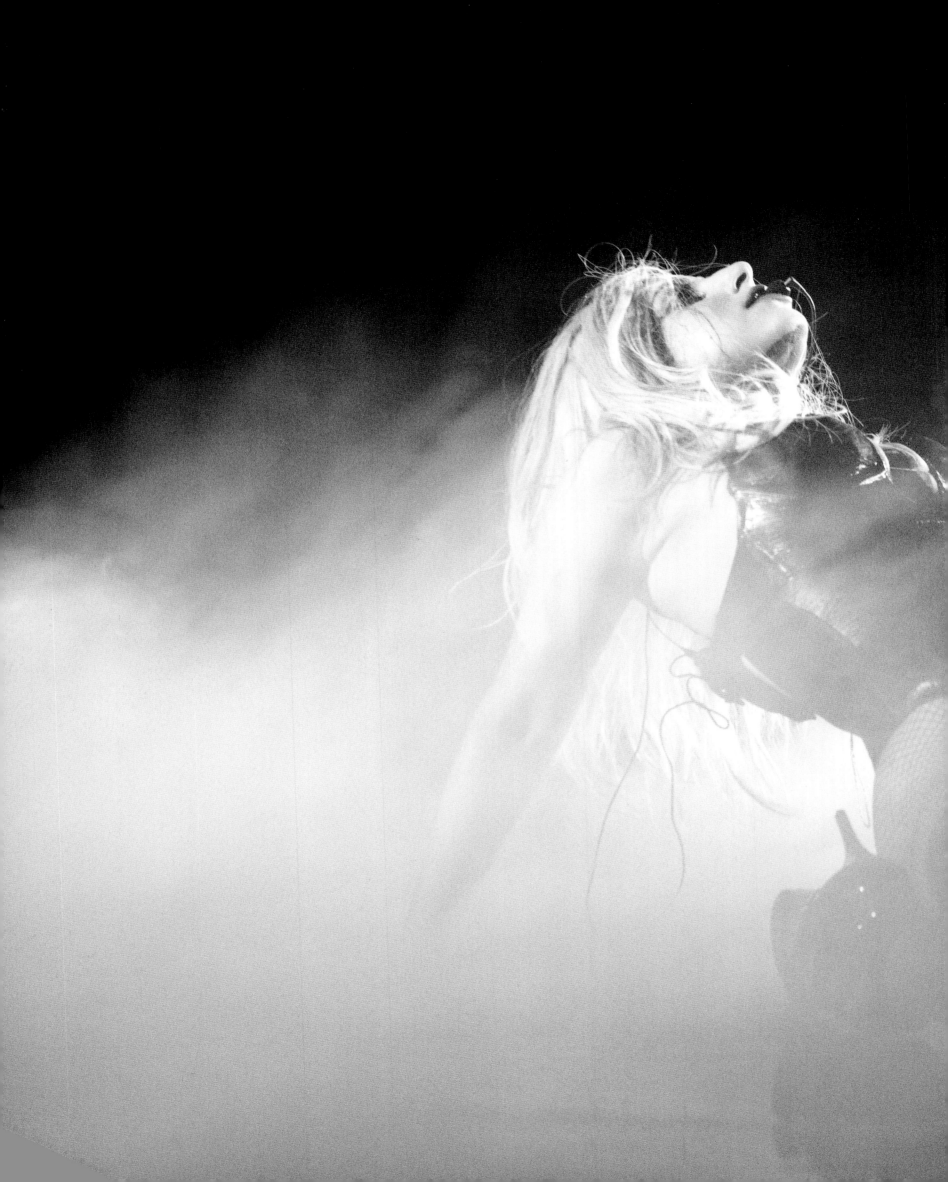

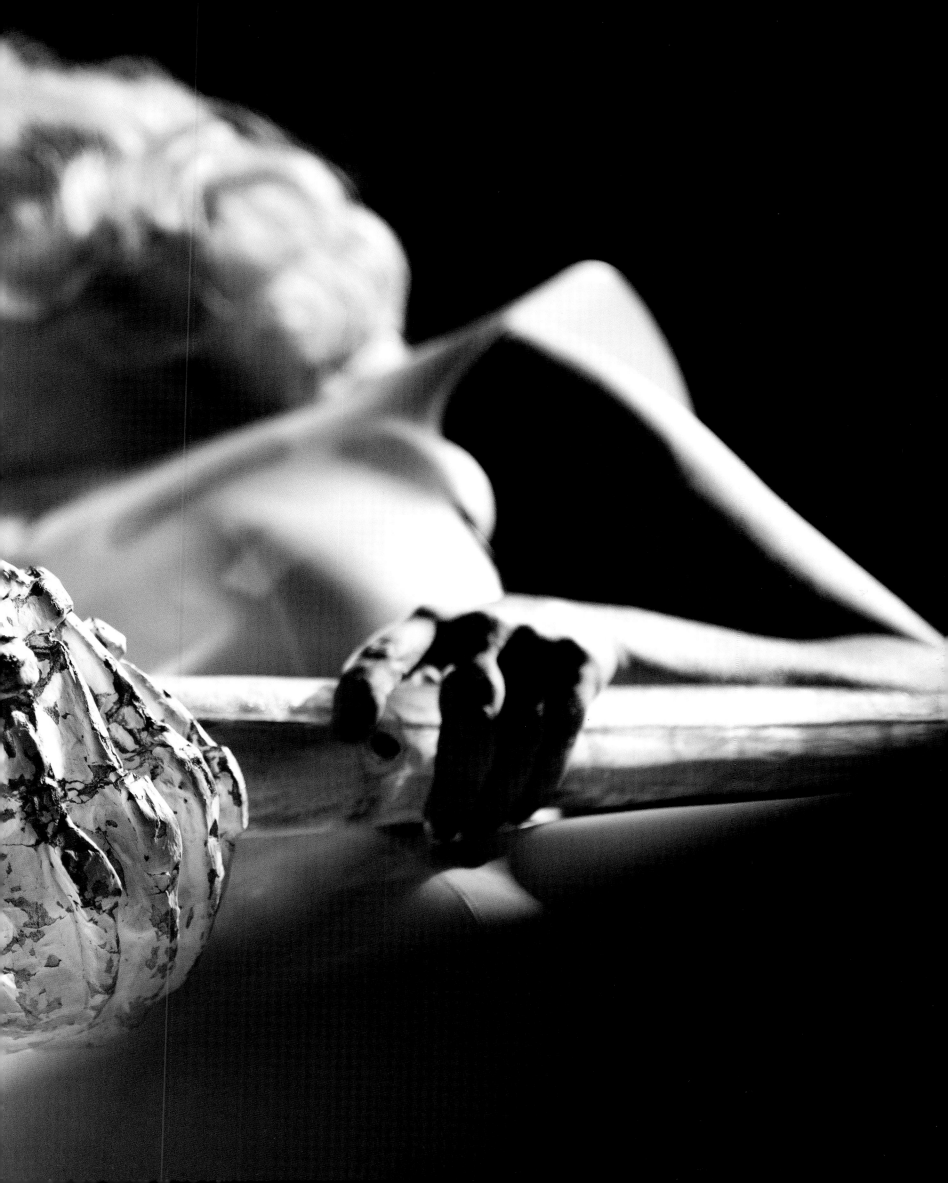

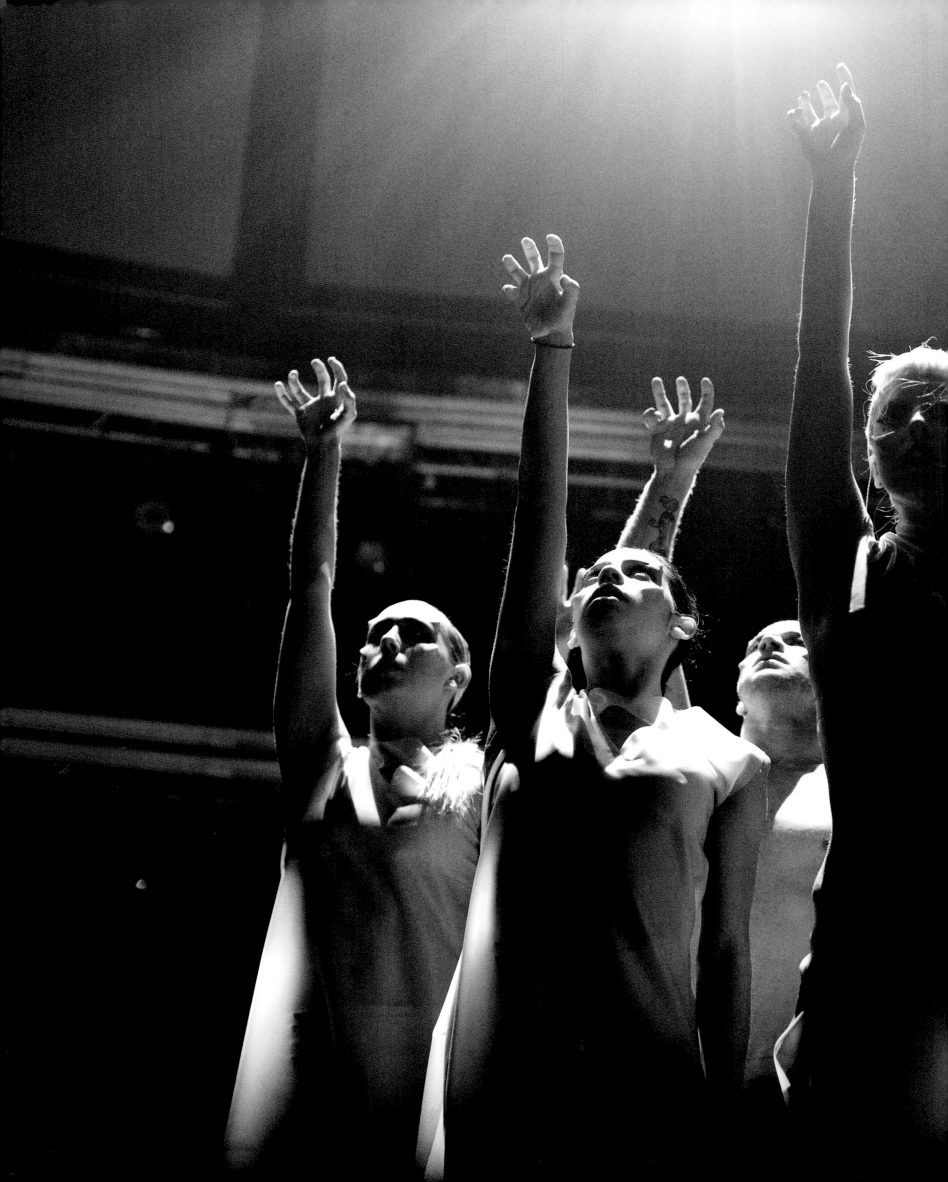

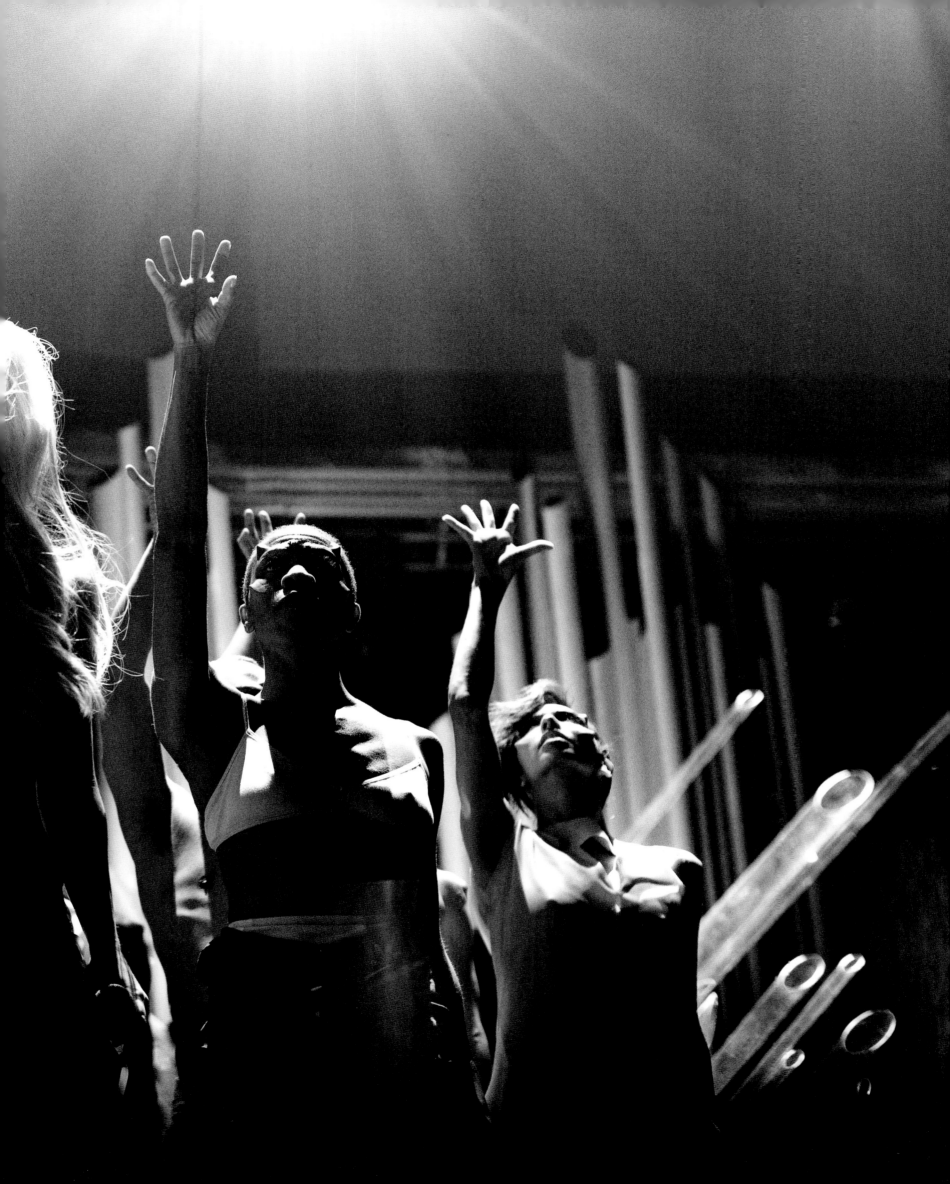

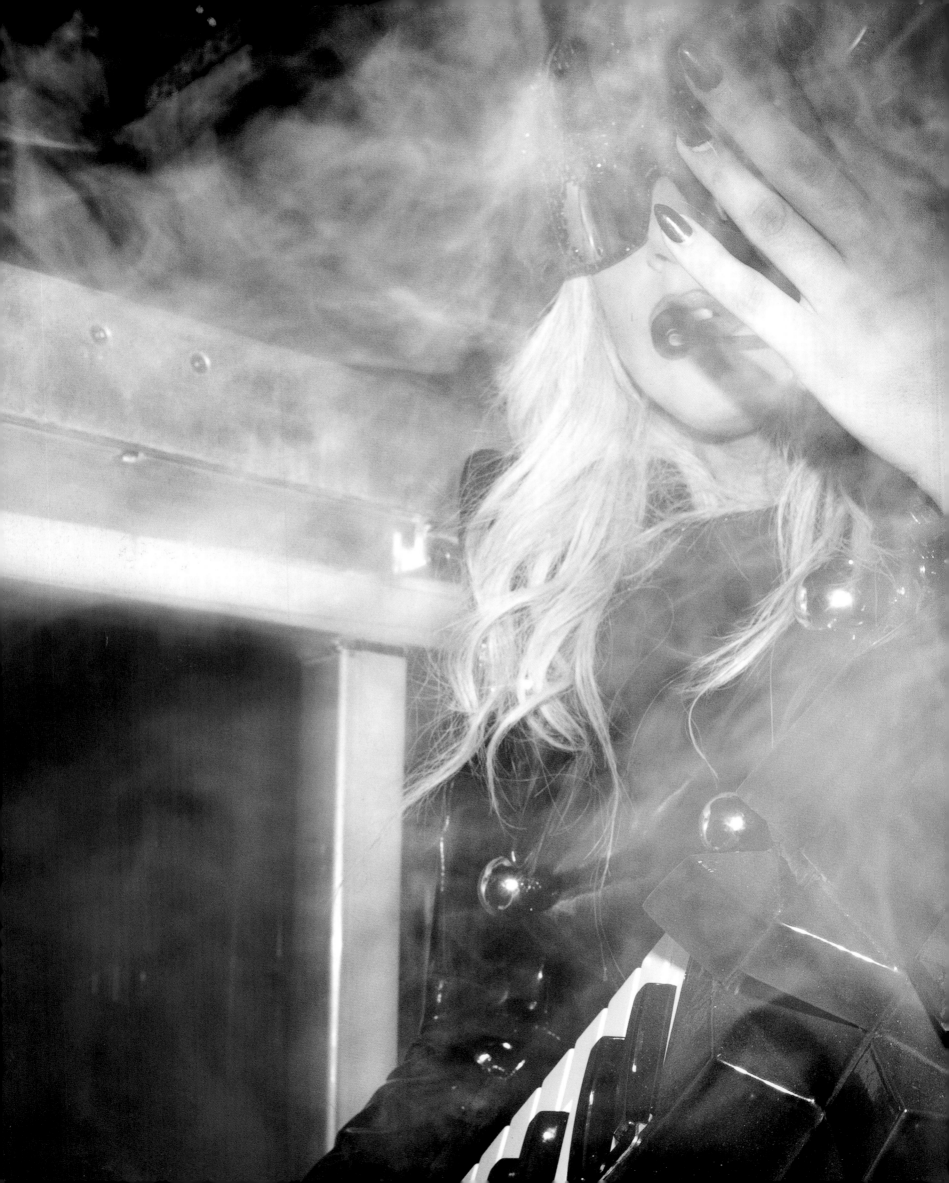

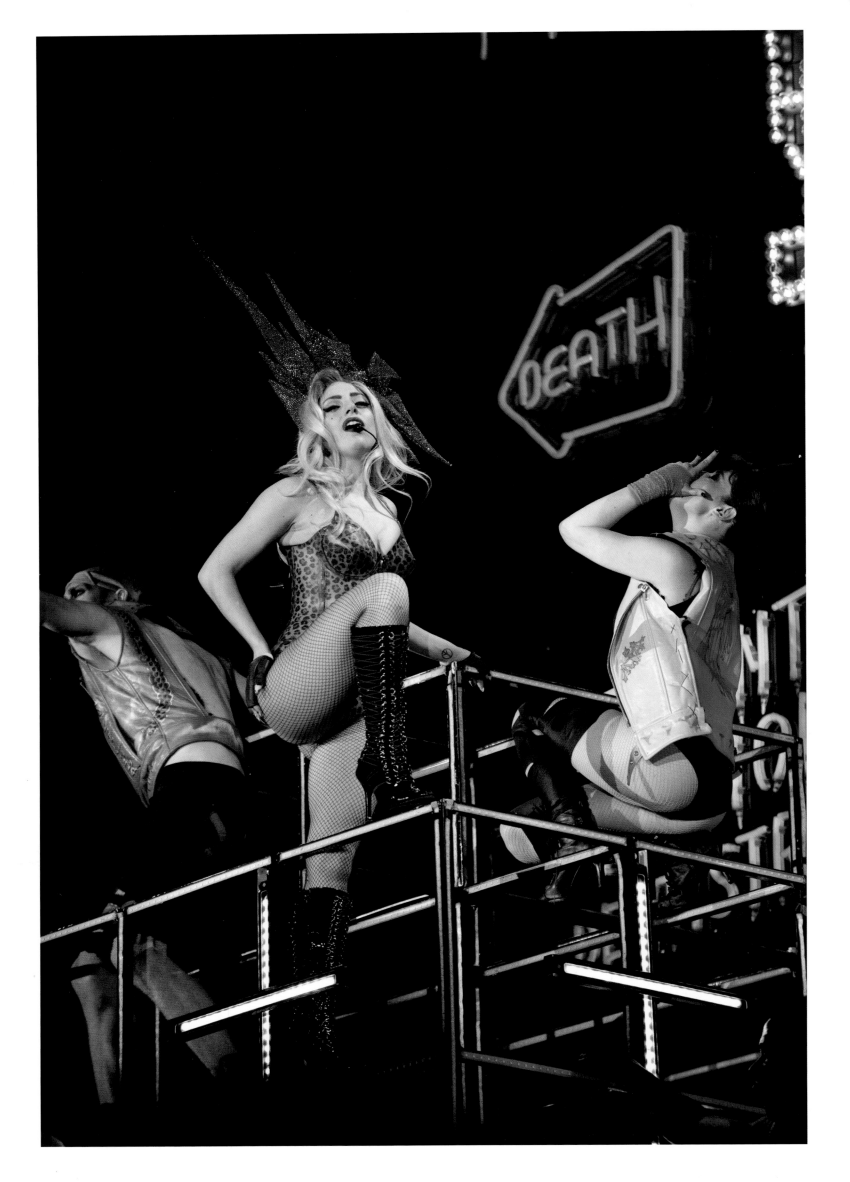

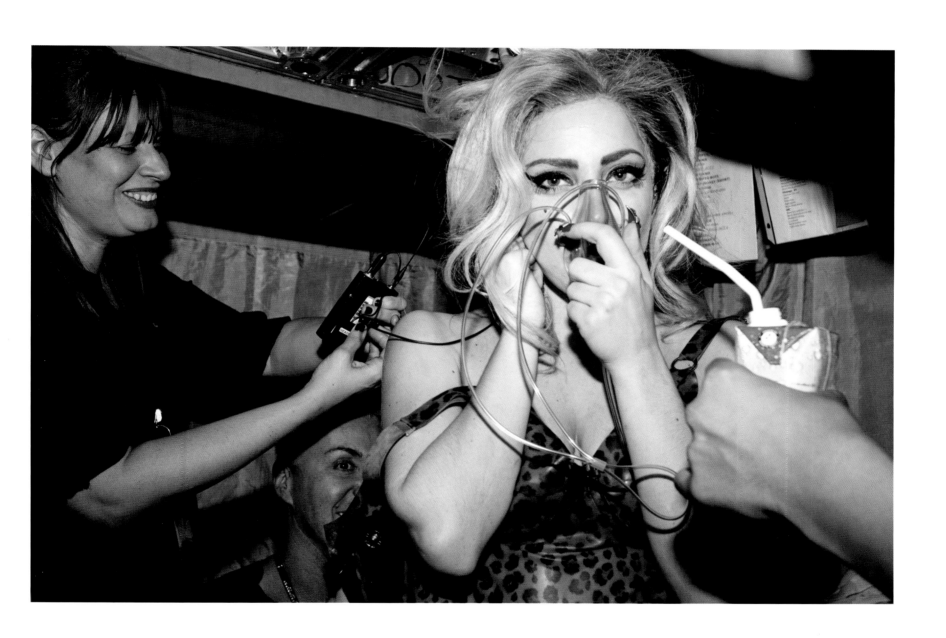

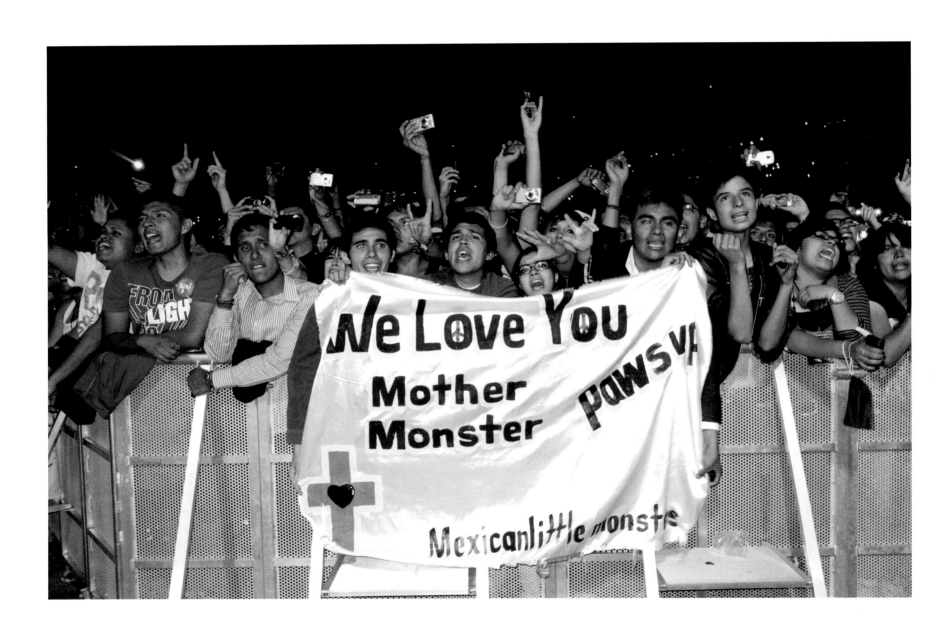

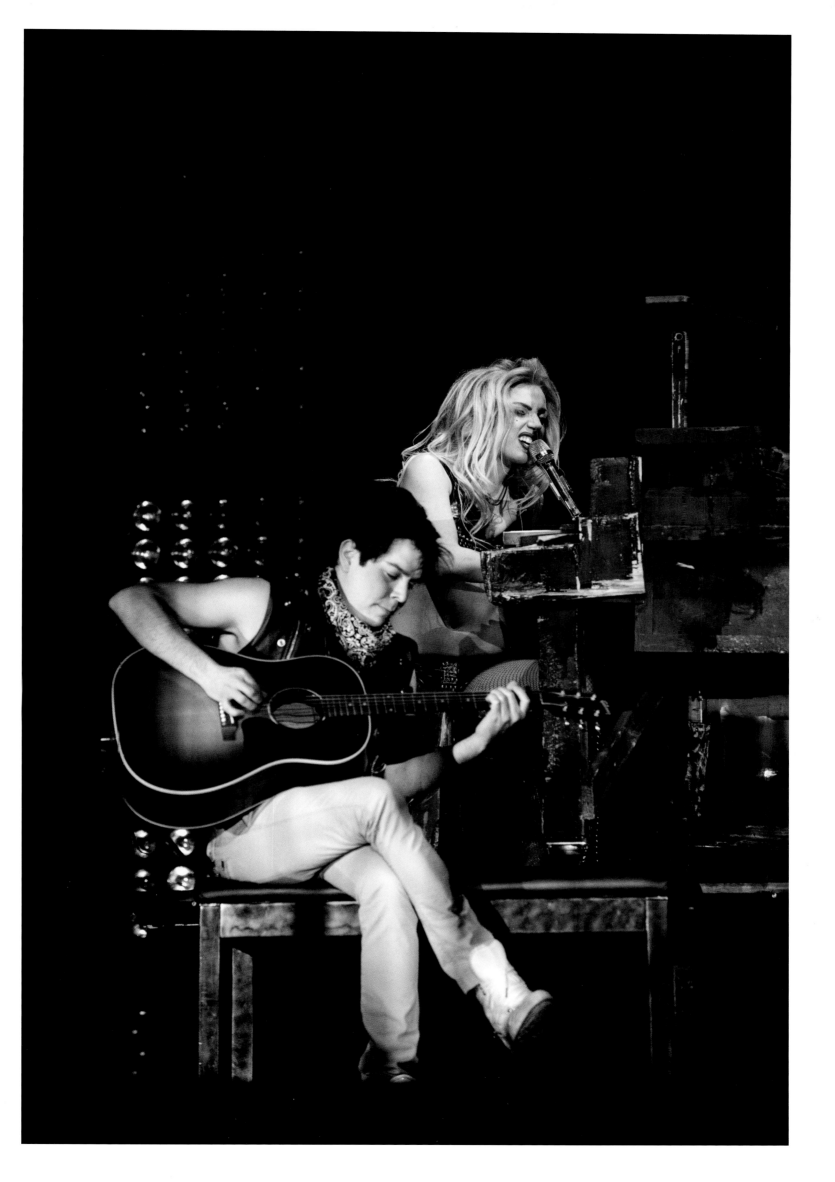

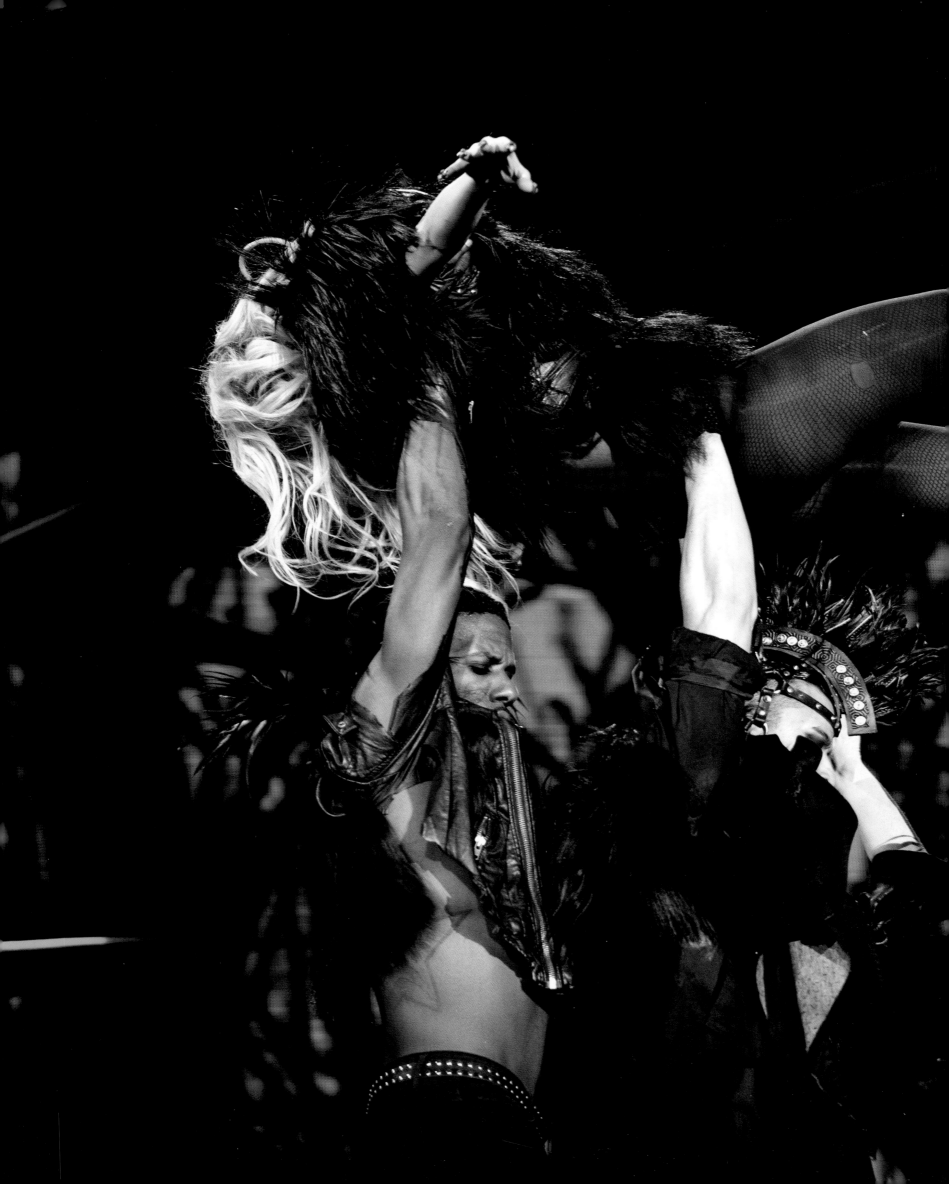

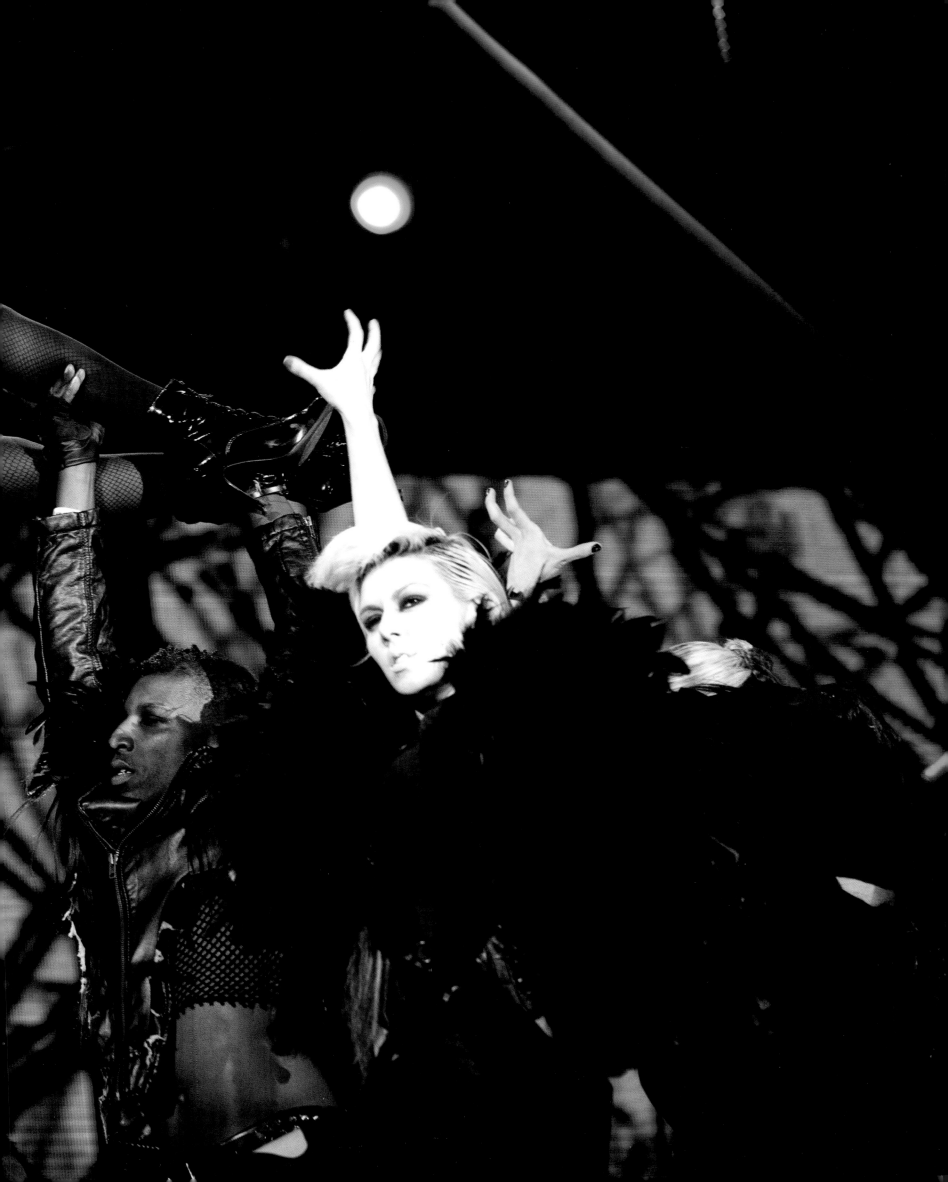

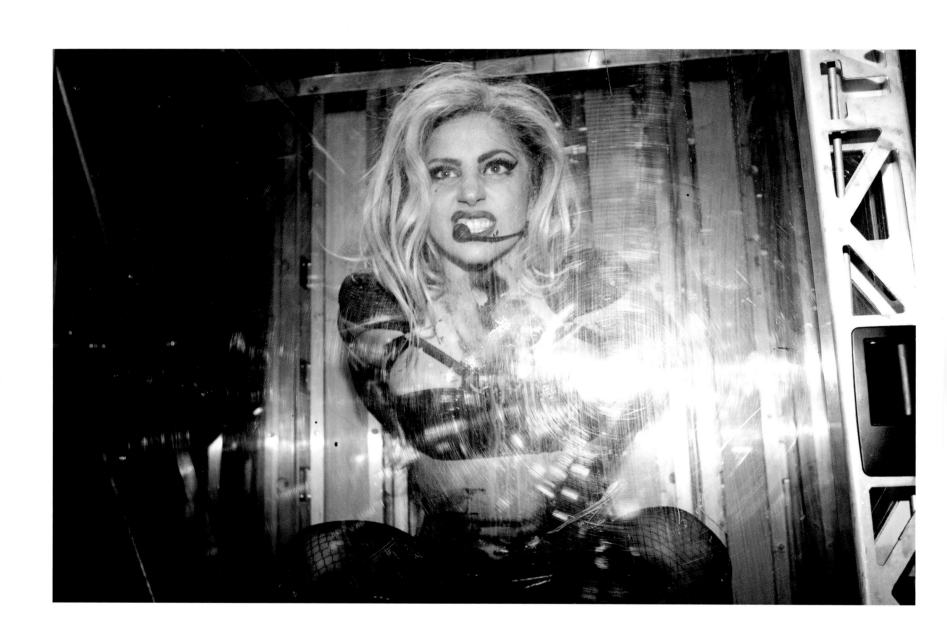

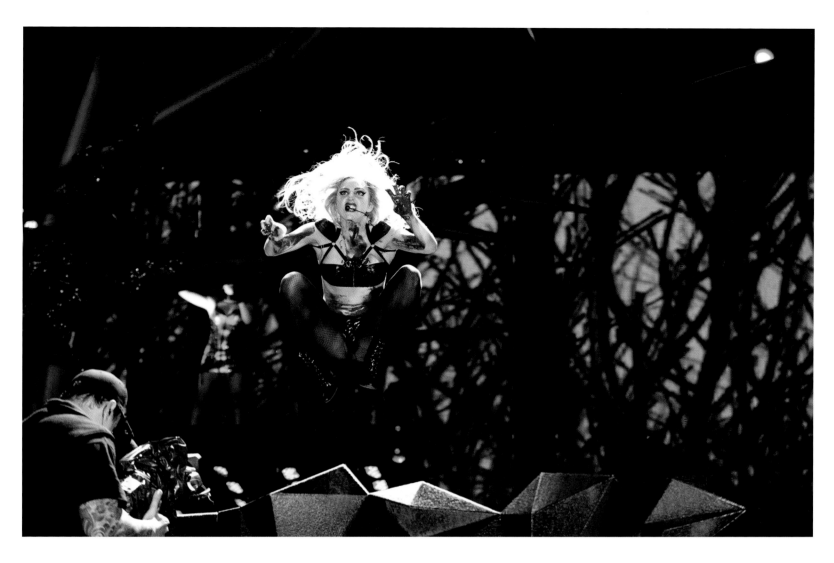

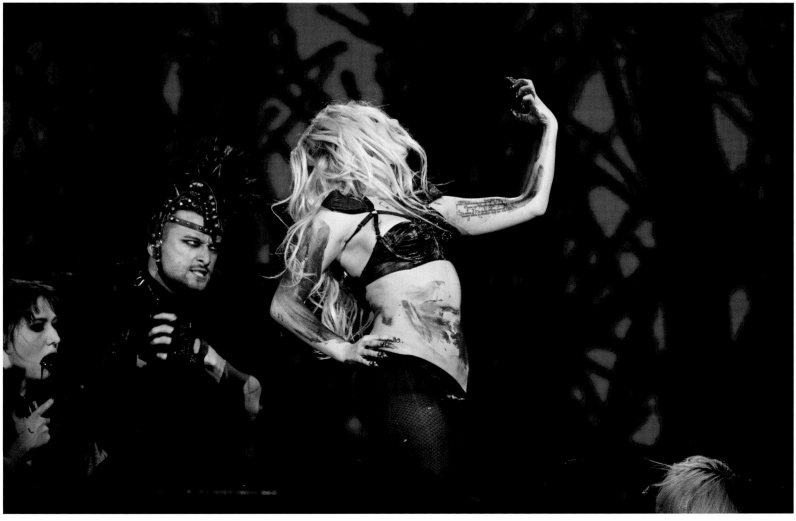

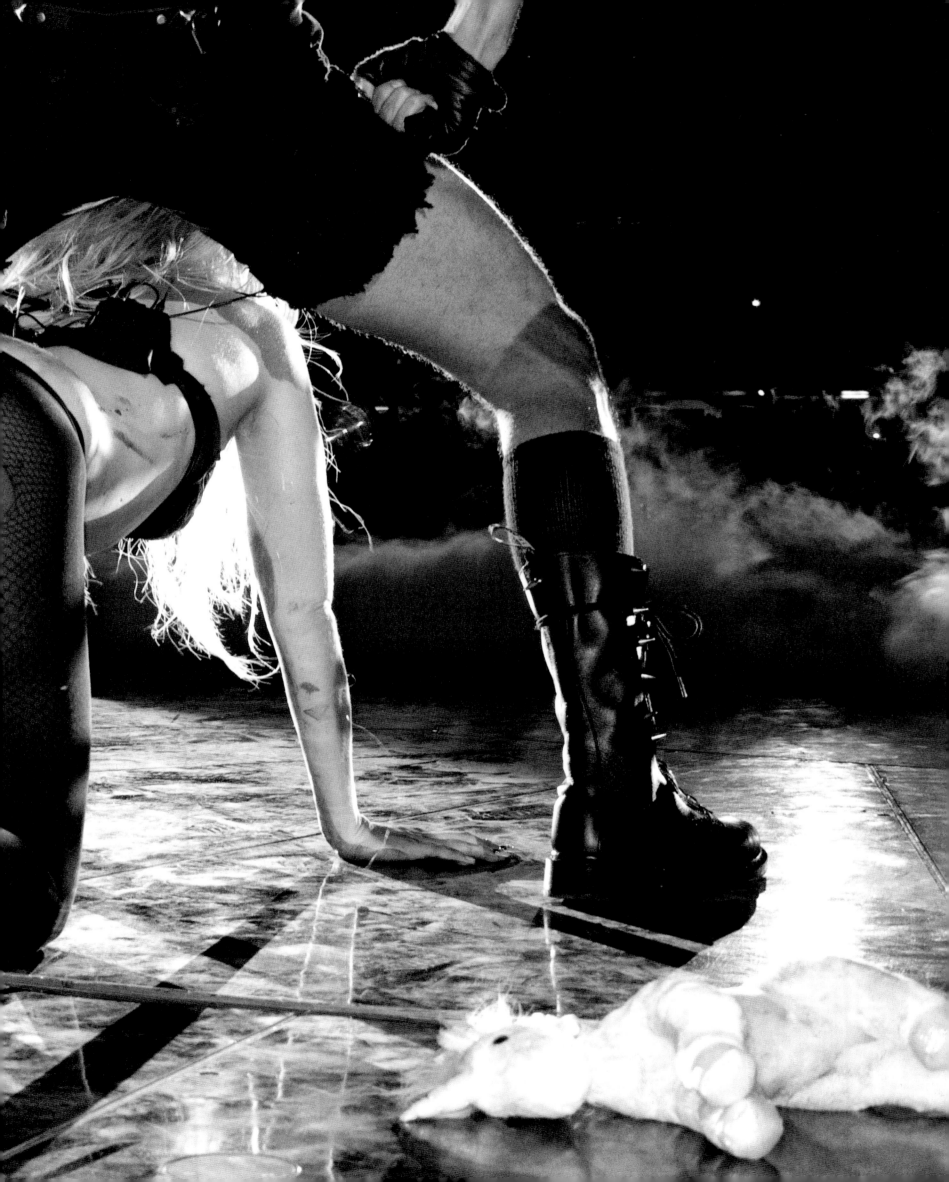

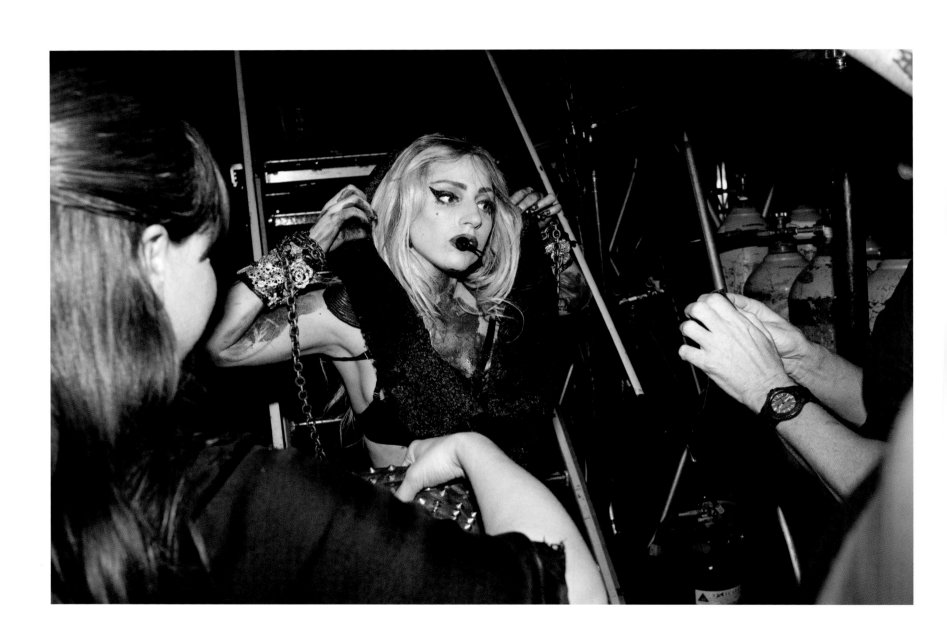

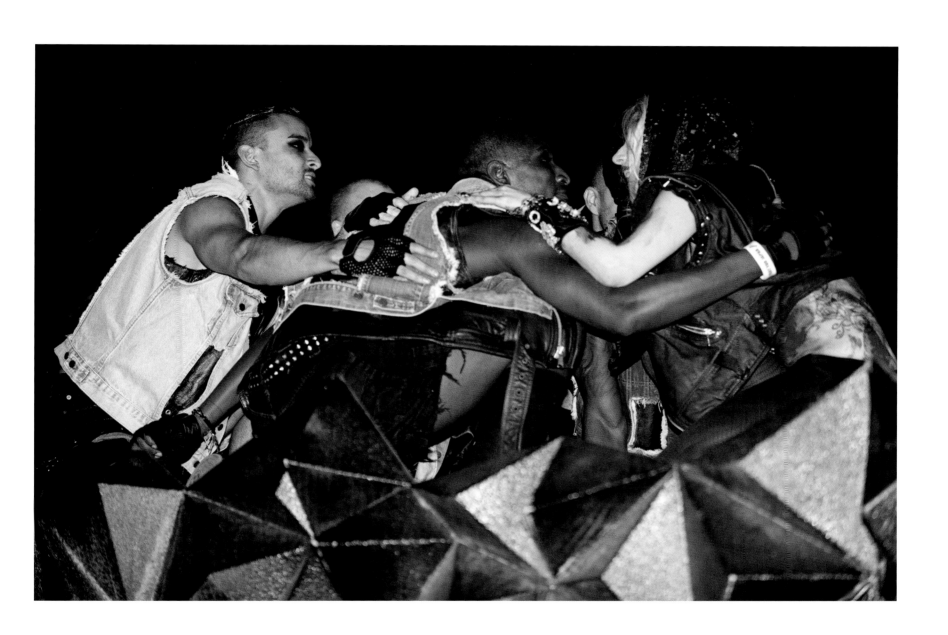

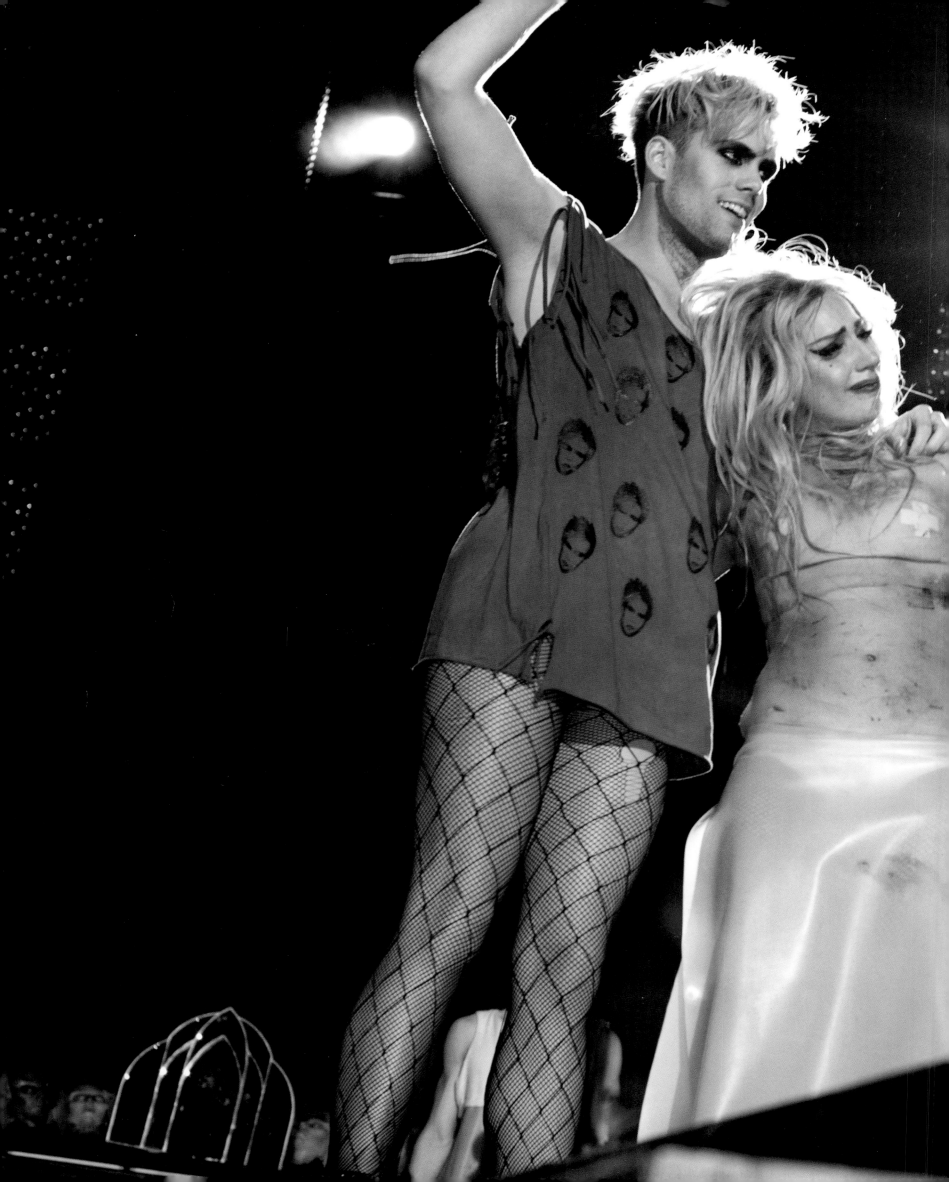

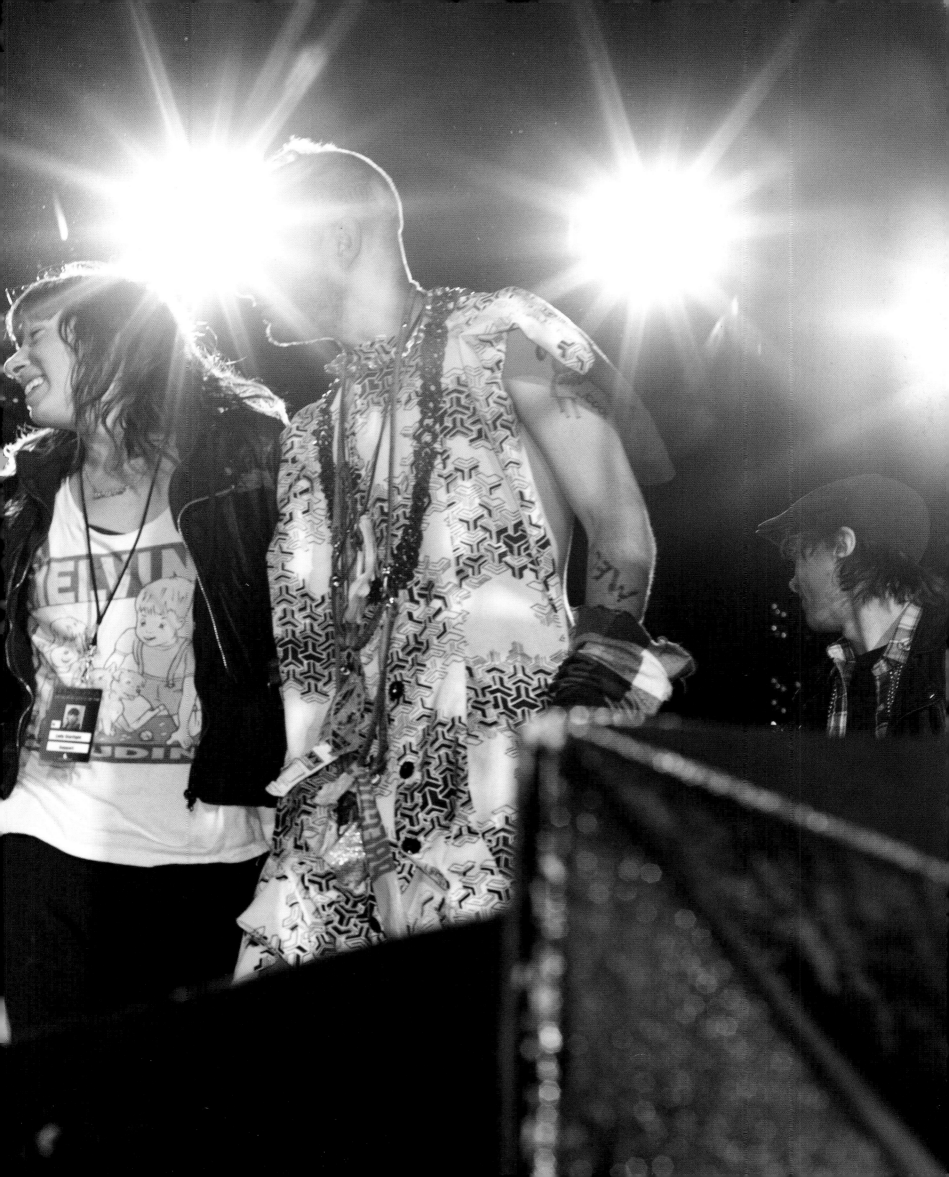

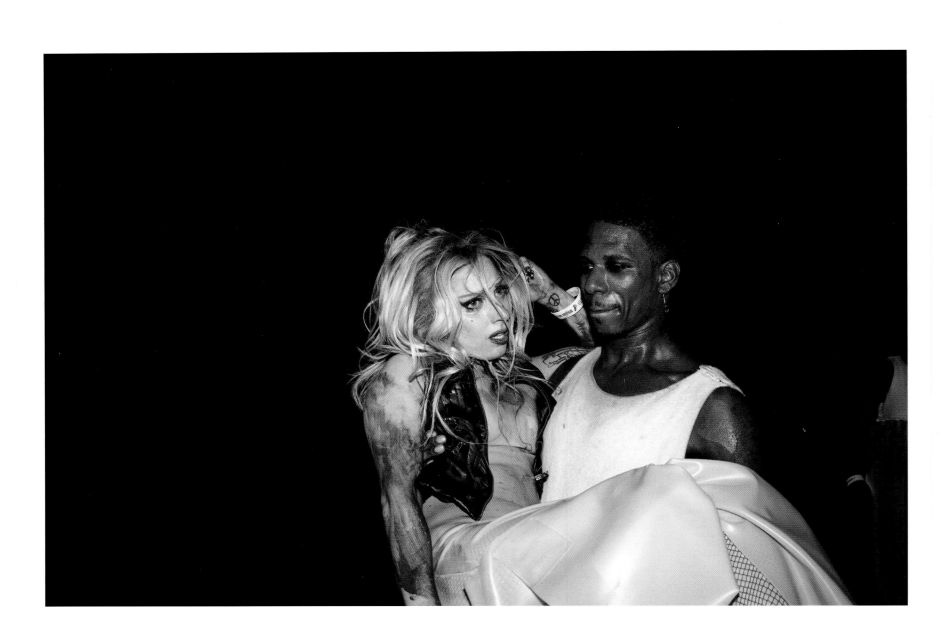

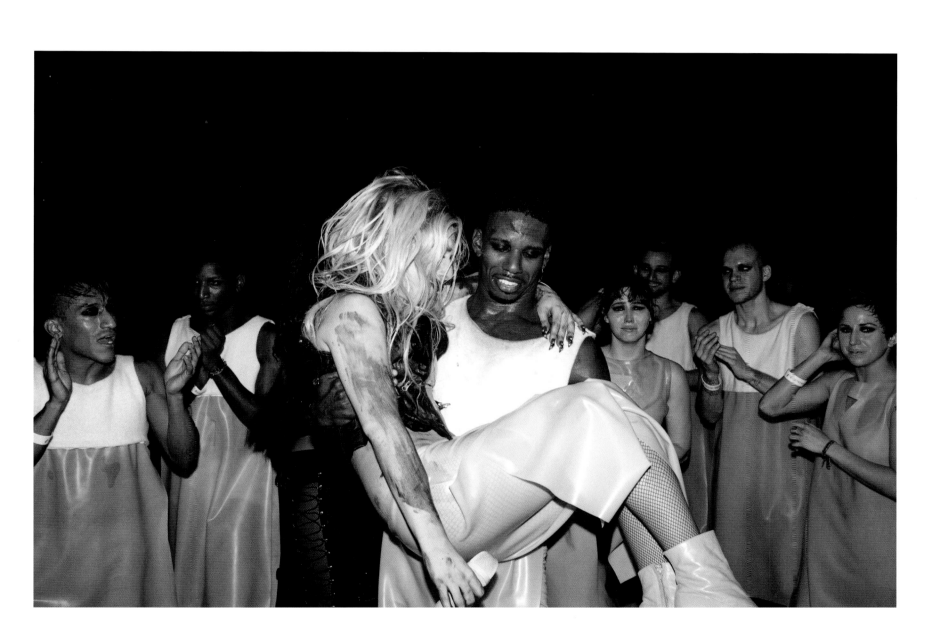

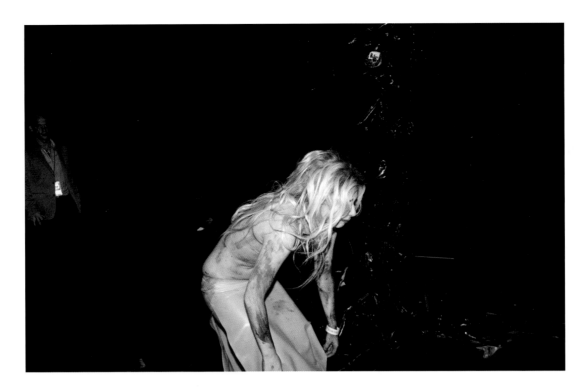

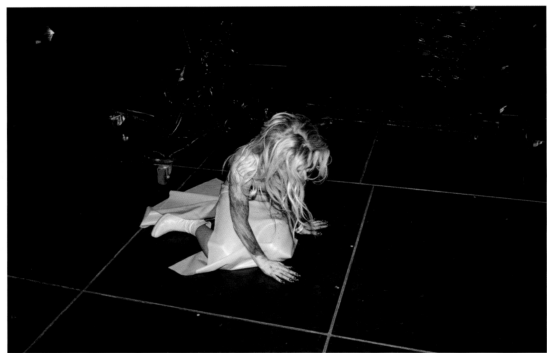

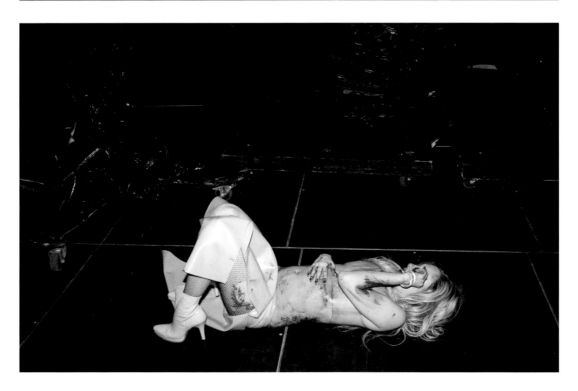

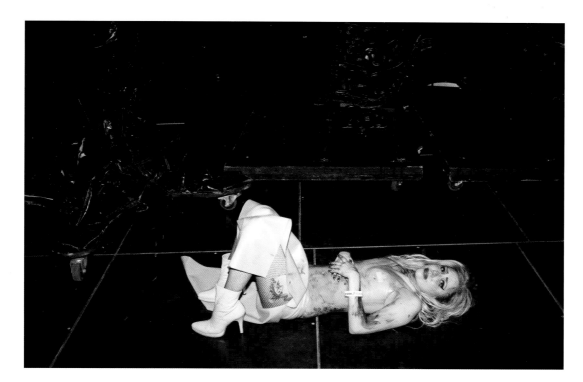

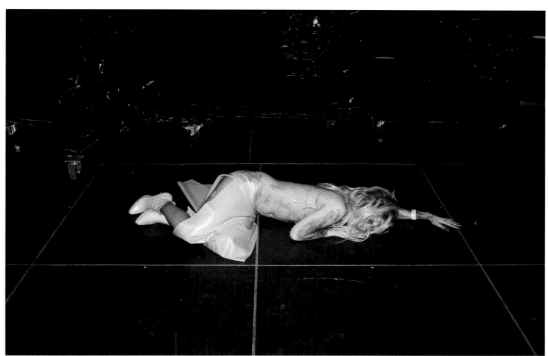

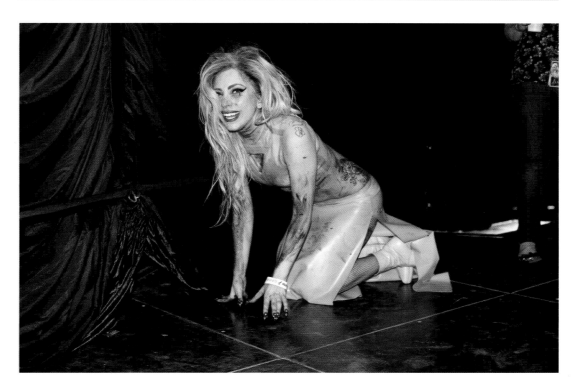

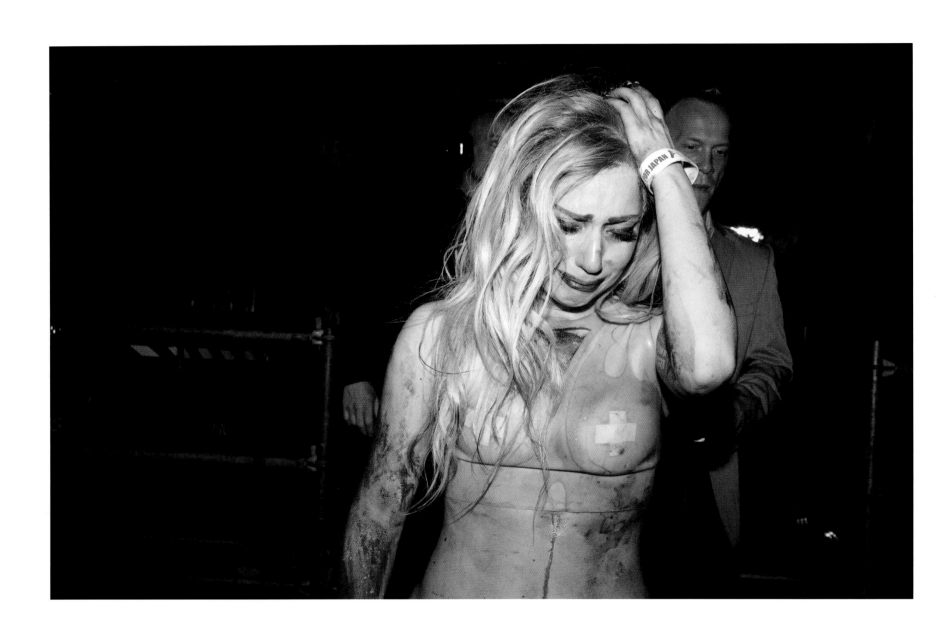

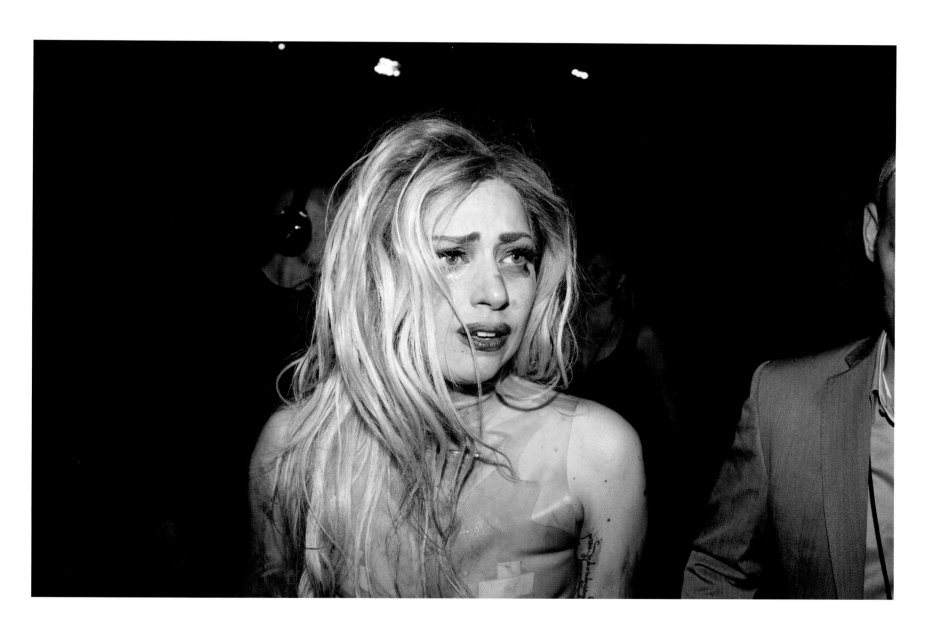

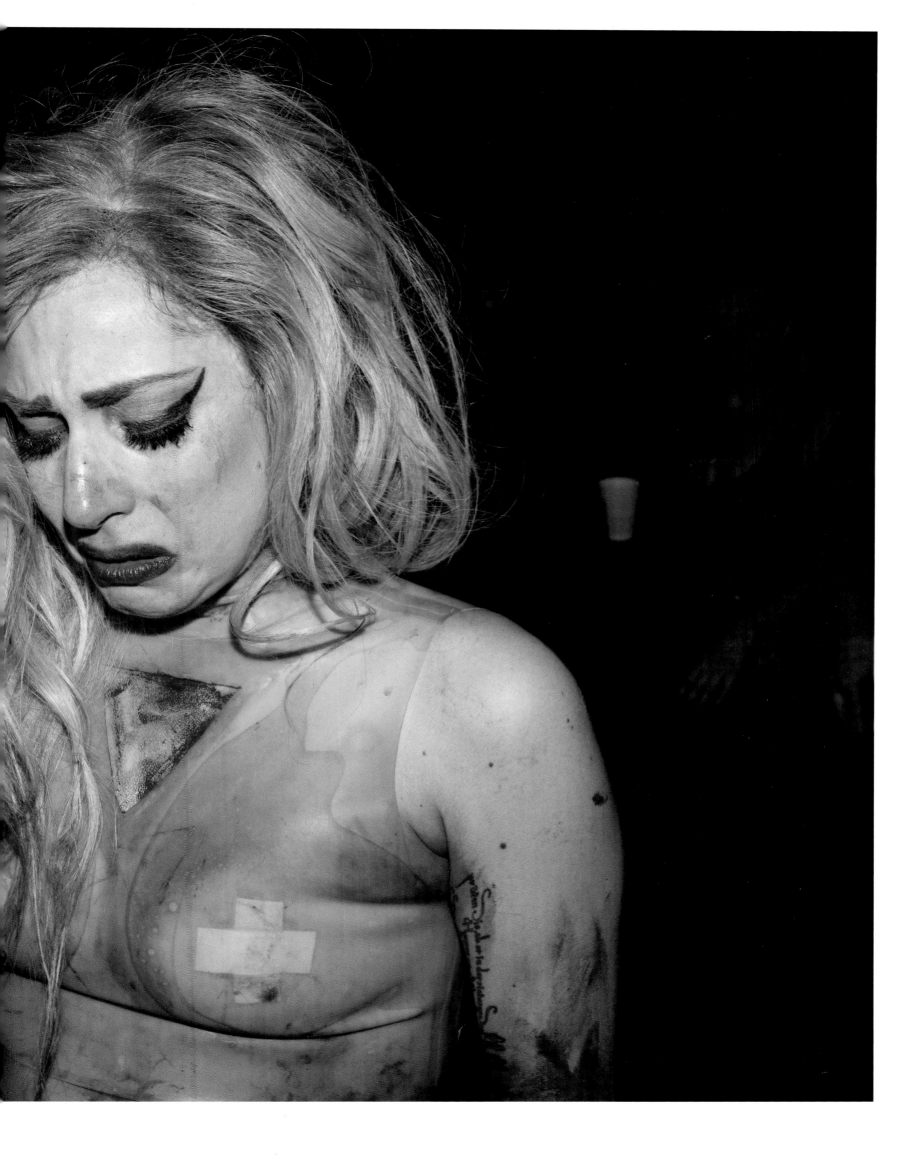

DATES AND SHOWS

August 6, 2010. Lollapalooza, Chicago, Illinois

August 11, 2010. Staples Center, Los Angeles, California

August 12, 2010. Staples Center, Los Angeles, California

August 13, 2010. MGM Grand Garden Arena, Las Vegas, Nevada

August 14, 2010. Las Vegas, Nevada

August 15, 2010. Las Vegas, Nevada

August 16, 2010. HP Pavilion, San Jose, California

August 17, 2010. HP Pavilion, San Jose, California

August 18, 2010. San Jose, California

August 19, 2010. Rose Garden, Portland, Oregon

August 20, 2010. Seattle, Washington

August 21, 2010. Seattle, Washington

August 21, 2010. Tacoma Dome, Tacoma, Washington

August 22, 2010. Seattle, Washington

August 23, 2010. Rogers Arena, Vancouver, Canada

August 24, 2010. Rogers Arena, Vancouver, Canada

September 3, 2010. Detroit, Michigan

September 4, 2010. Palace of Auburn Hills, Detroit, Michigan

September 5, 2010. CONSOL Energy Center, Pittsburgh, Pennsylvania

September 6, 2010. Pittsburgh, Pennsylvania

September 7, 2010. Verizon Center, Washington, D.C.

September 12, 2010. MTV Video Music Awards, Los Angeles, California

September 16, 2010. XL Center, Hartford, Connecticut

September 17, 2010. KISS Party, New York City, New York

September 20, 2010. DADT Rally, Portland, Maine

December 10, 2010. Pavilhão Atlântico, Lisbon, Portugal

December 11, 2010. Madrid, Spain

December 12, 2010. Palacio de Deportes, Madrid, Spain

December 16, 2010. The O2 Arena, London, England

December 17, 2010. The O2 Arena, London, England

December 18, 2010. London, England

December 19, 2010. Paris, France

December 20, 2010. Paris, France

December 21, 2010. Palais Omnisports de Paris-Bercy, Paris, France

December 22, 2010. Palais Omnisports de Paris-Bercy, Paris, France

February 11, 2010. 53rd Grammy Awards, Los Angeles, California

February 12, 2010. 53rd Grammy Awards, Los Angeles, California

February 13, 2010. 53rd Grammy Awards, Los Angeles, California

February 21, 2010. Madison Square Garden, New York City, New York

February 22, 2010. Madison Square Garden, New York City, New York

March 1, 2010. Van Andel Arena, Grand Rapids, Michigan

March 2, 2010. Thierry Mugler Fashion Show, Paris, France

March 3, 2010. Air Canada Centre, Toronto, Canada

March 4, 2010. HSBC Arena, Buffalo, New York

May 5, 2010. Foro Sol, Mexico City, Mexico

May 6, 2010. Foro Sol, Mexico City, Mexico

LADY GAGA THANKS:

Terry Richardson, Seth Goldfarb, David Swanson,
Nick Sethi, Troy Carter, Vincent Herbert, Bobby Campbell,
and Lane Bentley

TERRY RICHARDSON THANKS:

Lady Gaga, Glen Fabian, Alanna Gabin, Brad Holland, Bernie Yuman,
Nicola Formichetti, Jennifer Rudolph Walsh, Andy McNicol, Eric Zohn,
Jamie Raab, Ben Greenberg, Harry Bee, Raja Sethuraman, Magnus Andersson,
Laxman Sethuraman, Kelcey Alonzo, John Kohler, Art Partner

CREDITS

Creative Directors: **Seth Goldfarb, Terry Richardson**

Art Director: **Brian Ziegler**

Layout, Design and Editing: **David Swanson**

Additional Editing: **Marcelo Seba, Nikki Tappa**

Retouching: **Brian Ziegler**

Typograghy: **Catherine Casalino**

Image Proofing and Color Consultants: **Gloss Studio NYC**

LADY GAGA AND TERRY RICHARDSON ALSO THANK:

Lauren Ackert
Lonnie Adams
Jeff Adkisson
James Allen
Frederic Aspiras
Pauline Austin
Wayne Bacon
Amanda Balen
Lenyn Barahona
Le Roy Bennett
Michelle Bernstein
Kimberly Brandon
Lanar "Kern" Brantley
Graham Breitenstein
Matt Bright
Ross Brown
Lisa Bruno
Kareem Devlin Byrne
Philip "Ky" Cabot
Andy Clark
Joya Cleveland
Dave Cockrell
Soozie Coll
Bill Compton
Jeff Condon
Kia Crawford
Molly D'Amour
Jason Danter
Adam Dragosin
Taneka Duggan
Sonja Durham
Philip Ealy
Douglas Eder
Montana Efaw
Dave Evans
Steve Fatone
Kurt Fetty
Ciaran Flaherty
Bill Flugan
Arthur Fogel
Terry Ford
Nicola Formichetti
Dan Gamble
Gil Gamboa
Rob Gardner
Marc Geiger
Laurieann Gibson
Michael Glazer
Don Gordon
Scott Grund
Dan Gurchik
Tony Hammonds
Vincent Asiel Hardison
Jason Harvey

Russ Heroux
Bob Hood
Carl Horahan
Eric Howard
Zeth Huckabay
Andre Hudson
Richard Huggins
Chevonne Ianuzzi
Richard Jackson
Sharon Jackson
Jimmy Johnston
Rashida Jolley
Ron "Bear" Jones
Mark Kanemura
Judy Kang
Brandon Kennedy
Dan Klocker
Steve Kotzur
James La Marca
Cris Lepurage
Adam Lewis
Jason "Lew Lew" Lewis
Robert Liscio
Paul Lovell-Butt
Ed Majcina
Colleen Martin
Karl Martin
John Marx
Brandon Maxwell
George "Spanky" McCurdy
Craig McDonald
Matt McHale
Ian McKenzie
Perry Meek
Tom Mikita
Ramon Morales
Wendi Morris
Mo Morrison
Jasmine Morrow
Calvin "Mac" Mosier
Laura Murek
Sara Newkirk
Chris Organ
Charles Owens
Brockett Parsons
Thomas Pead
Alexander Peters
Jared Petit
Bruno Petrilli
John Pierce
Wayne Pina
Kevin Premer
Brett Premer
Sloan-Taylor Rabinor

Bob Reetz
Bobby Reid
Errol Reinart
Bill Rengstl
Krystena Rice
John Richardson
Eddie Rodriguez
Victor Rojas
Susan Rosenberg
Stacey Saari
Javier Saldana
Ty Saunders
Tara Savelo
Mark Scrimshaw
Ray Seymour
Darren Shead
Lee Shull
Mike Sienkiewicz
Norm Sigal
Michael Silas
Tony Smith
Rick Sobkowiak
Andy Solomon
Laura Spratt
Mike Stamps
Clayton Stewart
Allison Streuter
Kevin Szafraniec
Sarah Tanno
Rebecca Teal
Ryan Textor
Emily Thomas
Ricky Tillo
Anna Trevelyan
Florence Tse
Peter van der Veen
Rod Van Egmond
Tony Villanueva
Chris Vineyard
Kenneth "Scotty" Waller
Horace Ward
Raegan Wexler
Marissa Willinsky
Joe "FLIP" Wilson
Staci Yamano
Eric Zohn